USING

iphoto® '11

Jason R. Rich

800 East 96th Street, Indianapolis, Indiana 46240 USA

Using iPhoto® '11

Copyright © 2011 by Pearson Education, Inc.

ISBN-13: 978-0-7897-4794-5
ISBN-10: 0-7897-4794-4
Library of Congress Cataloging-in-Publication Data is on file.

Printed in the United States of America
First Printing: February 2011

Trademarks

All terms mentioned in this book that are known to be trademarks or service marks have been appropriately capitalized. Que Publishing cannot attest to the accuracy of this information. Use of a term in this book should not be regarded as affecting the validity of any trademark or service mark.

iPhoto '11 is a registered trademark of Apple Inc.

Warning and Disclaimer

Every effort has been made to make this book as complete and as accurate as possible, but no warranty or fitness is implied. The information provided is on an "as is" basis. The author and the publisher shall have neither liability nor responsibility to any person or entity with respect to any loss or damages arising from the information contained in this book.

Bulk Sales

Que Publishing offers excellent discounts on this book when ordered in quantity for bulk purchases or special sales. For more information, please contact

U.S. Corporate and Government Sales
1-800-382-3419
corpsales@pearsontechgroup.com

For sales outside of the U.S., please contact

International Sales
international@pearson.com

Associate Publisher
Greg Wiegand

Acquisitions Editor
Laura Norman

Development Editor
Todd Brakke

Managing Editor
Kristy Hart

Senior Project Editor
Andy Beaster

Copy Editor
Chuck Hutchinson

Indexer
Heather McNeill

Proofreader
Water Crest Publishing

Technical Editor
Lisa Sihvonen-Binder

Publishing Coordinator
Cindy Teeters

Book Designer
Ann Jones

Multimedia Developer
John Herrin

Compositor
Nonie Ratcliff

Contents at a Glance

Introduction

Part I **Introduction to iPhoto '11**

1 What iPhoto '11 Is and What It Does

2 Upgrading to iPhoto '11: What's New and Noteworthy

3 Loading Your Digital Images into iPhoto '11

4 Organizing Your Photos

Part II **Improving Your Picture-Taking Skills Using Any Digital Camera**

5 Taking Professional-Quality Photos

6 Overcoming Common Mistakes and Mishaps

Part III **Using iPhoto '11 to Edit and Enhance Your Digital Images**

7 Using iPhoto '11's Simple Photo Editing Features

8 Adding Effects to Your Images

9 Advanced Photo Editing with iPhoto '11

10 Exporting Your Images

Part IV **Printing Your Photos Using iPhoto '11**

11 Printing Photos Using Your Own Home Photo Printer

12 Creating Prints Using a Professional Photo Lab

13 Creating Photo Projects and Photo Gifts

Part V **Sharing Your Photos Using iPhoto '11**

14 Emailing or Publishing Your Photos Online

15 Creating and Sharing Slideshows

16 Using Apple's MobileMe with iPhoto '11

17 More Ways to Share Your Photos

Part VI **Backing Up and Archiving Your Images**

18 Burning Photos to CD or DVD from iPhoto '11

19 Photo Backup Solutions

Part VII **Appendixes**

A Digital Photography Websites

B iPhoto '11 Keyboard Shortcuts

Index

Audio/Video Files Table of Contents

To register this product and gain access to audio and video files, go to www.infor-mit.com/register to sign in and enter the ISBN. After you register the product, a link to the additional content will be listed on your Account page, under Registered Products.

Chapter 1: **What iPhoto '11 Is and What It Does**

Tell Me More **Media 1.1**—Why digital photography is so much better than traditional, film-based photography for amateurs and hobbyists . 9

Show Me **Media 1.2**—A preview of iPhoto '11's Faces face-recognition capabilities . 15

Show Me **Media 1.3**—A preview of iPhoto '11's Quick Fixes features for editing digital photos . 21

Chapter 2: **Upgrading to iPhoto '11: What's New and Noteworthy**

Tell Me More **Media 2.1**—Multitasking on your Mac when using iPhoto '11 in full-screen mode . 34

Show Me **Media 2.2**—A preview of iPhoto '11's new Slideshow features . 36

Show Me **Media 2.3**—A preview of iPhoto '11's new Letterpress Cards . 39

Chapter 3: **Loading Your Digital Images into iPhoto '11**

Show Me **Media 3.1**—Importing photos from your camera into iPhoto '11 . 43

Show Me **Media 3.2**—Changing event and image filenames within iPhoto '11 . 56

Chapter 4: **Organizing Your Photos**

Show Me **Media 4.1**—View all your iPhoto images using the Photos viewing mode and discover how it differs from viewing Events . 66

Show Me **Media 4.2**—More information about Smart Albums and how to use them . 79

Tell Me More **Media 4.3**—More about deleting images and files using iPhoto '11 . 83

Chapter 5: **Taking Professional-Quality Photos**

Show Me **Media 5.1**—Take the "Rule of Thirds" into account whenever you shoot . 96

Show Me **Media 5.2**—Working with sunlight when taking pictures outdoors . 101

Tell Me More **Media 5.3**—Anticipate what's about to happen 103

Chapter 6: **Overcoming Common Mistakes and Mishaps**

Show Me **Media 6.1**—Using a colorimeter on your Mac's screen114
Show Me **Media 6.2**—Preview how to fix red-eye
using iPhoto '11 ...119
Tell Me More **Media 6.3**—Keeping your camera and lens clean120

Chapter 7: **Using iPhoto '11's Simple Photo Editing Features**

Show Me **Media 7.1**—Using the Zoom mode when editing photos ...129
Show Me **Media 7.2**—See demonstrations of the Quick Fixes
editing features ...131
Show Me **Media 7.3**—See how to crop an image to create a
close-up of your subject ...140

Chapter 8: **Adding Effects to Your Images**

Show Me **Media 8.1**—Lightening or darkening a photo
using iPhoto '11 ...148
Show Me **Media 8.2**—View a sampling of the special effects
you can add to your photos using iPhoto '11152
Show Me **Media 8.3**—Using the Sepia and Edge Blur effects
to make your photos look old ..153
Tell Me More **Media 8.4**—Listen to a brief discussion about
what iPhoto '11's editing features can't do160

Chapter 9: **Advanced Photo Editing with iPhoto '11**

Show Me **Media 9.1**—Use the Shadows slider and other editing
tools to quickly improve a dark (underexposed) image167
Show Me **Media 9.2**—Use the Sharpness and De-Noise sliders
to better focus an image and make it clearer171
Show Me **Media 9.3**—How to use the eye-dropper to fix a photo's
temperature and tint ...172

Chapter 10: **Exporting Your Images**

Tell Me More **Media 10.1**—Learn some money-saving reasons
why you should export images from iPhoto '11177
Show Me **Media 10.2**—Export a single photo from iPhoto '11
using the Export command and options available from the
Export window ..178
Show Me **Media 10.3**—Export an entire Event or Album folder
(all the images stored in that folder) from iPhoto '11 using the
Export command and options available from the Export window179
Show Me **Media 10.4**—Export multiple photos from iPhoto '11
using the Export command and options available from the
Export window ..192

Chapter 11: **Printing Photos Using Your Own Home Photo Printer**

Tell Me More **Media 11.1**—What you should know about photo
printer ink that could save you money ...197
Show Me **Media 11.2**—The print themes and how they differ202
Show Me **Media 11.3**—Create and print a multiphoto collage206

Chapter 12: **Creating Prints Using a Professional Photo Lab**

Show Me **Media 12.1**—See how to use the Order Prints
command in iPhoto '11 ...214
Tell Me More **Media 12.2**—Learn the benefits of using a
local professional photo lab ...219

Chapter 13: **Creating Photo Projects and Photo Gifts**

Tell Me More **Media 13.1**—Learn more about the Blurb
photo book service and other options223
Show Me **Media 13.2**—Create a photo book in iPhoto '11231
Show Me **Media 13.3**—Create a picture calendar in iPhoto '11238

Chapter 14: **Emailing or Publishing Your Photos Online**

Show Me **Media 14.1**—Learn how to send a theme email
containing your photos in iPhoto '11246
Show Me **Media 14.2**—Upload Your Photos to Facebook253

Chapter 15: **Creating and Sharing Slideshows**

Show Me **Media 15.1**—Add titles and text to your slides261
Show Me **Media 15.2**—See how to add music to your slideshow267
Tell Me More **Media 15.3**—Hear a discussion about your
other options for creating slideshows outside iPhoto '11269

Chapter 16: **Using Apple's MobileMe with iPhoto '11**

Show Me **Media 16.1**—See how to create an online gallery
using MobileMe ..277

Chapter 17: **More Ways to Share Your Photos**

Show Me **Media 17.1**—Customize Your Mac's Desktop
Wallpaper and Screen Saver ...284
Show Me **Media 17.2**—See how to transfer photos from
iPhoto '11 to your Apple mobile device (iPhone, iPod, or iPad)286

Chapter 18: **Burning Photos to CD or DVD from iPhoto '11**

Show Me **Media 18.1**—Burn photos to a CD or DVD that can
be read by any computer, including PCs running Windows292

Chapter 19: **Photo Backup Solutions**

Tell Me More **Media 19.1**—Learn how to deal with major
computer problems that result in lost or damaged data files300

Table of Contents

Introduction ... 1

How This Book Is Organized 3

Using This Book .. 4

Special Features .. 5

About the Using Web Edition 5

Part I: Introduction to iPhoto '11

1 What iPhoto '11 Is and What It Does **8**

What iPhoto '11 Can Do for You 8

The Main Functions of iPhoto '11 10

Viewing Your Images 10

Organizing All Your Digital Photos 13

Searching For and Locating Your Images 18

Editing Your Photos to Achieve Professional-Looking Results 19

Enhancing Your Images to Make Them Stand Out 21

Printing Your Digital Photos in Many Different Sizes 21

Sharing Your Photos with Friends, Family, and
 Coworkers with Ease 23

Securely Archiving Your Images 24

Creating Photo Projects Such as Greeting Cards and
 Photo Books ... 25

iPhoto '11 Works Seamlessly with Other Mac Software 26

Taking Advantage of as Much or as Little as You Need 27

2 Upgrading to iPhoto '11: What's New and Noteworthy **28**

It's Time for an Upgrade 28

Welcome to iPhoto '11 .. 30

Overview of iPhoto '11's New Features and Functions 32

Full-Screen Viewing Mode 32

Sharing Photos on Facebook Has Never Been Easier 34

Sharing Photos with Individuals via Email 35

Creating Professional-Looking Slideshows ... 36

Traditional Photo Albums Are a Thing of the Past;
 Photo Books Are the Wave of the Future 37

Customized Photo Greeting Cards Replace the Need
 for Generic Store-Bought Cards 38

3 Loading Your Digital Images into iPhoto '11 **41**

Loading Images Directly from Your Digital Camera 41

Importing Images That iPhoto '11 Detects 42

Wirelessly Transferring Images Between Your Camera and Mac ... 45

Importing Images from a Memory Card Reader Using
a USB Connection 45

Adding Images into iPhoto '11 from Your Computer's Hard Drive ... 46

Importing Photos Received via Email into iPhoto '11 48

Importing Digital Photos from Your iPhone or iPad 51

Importing Digital Photos from Your iPhone or iPad 51

Transferring Images from MobileMe to iPhoto '11 52

Using a Scanner to Transfer Hard-Copy Prints into iPhoto '11 53

Importing Photos from the Web into iPhoto '11 54

Changing Image Filenames After They're Loaded into iPhoto '11 55

The Next Step... 58

4 Organizing Your Photos **59**

iPhoto '11's Source List 59

The Library 61

Events 61

Photos 63

Faces 67

Places 71

The Inside Scoop on Albums 75

Creating a New Album 75

Adding Images to an Album 75

Working with Smart Albums 77

What Else You'll Find Under the Source List 80

Recent 80

Accessing Photos That iPhoto '11 Transferred to the Web 82

Deleting Images 83

Part II: Improving Your Picture-Taking Skills Using Any Digital Camera

5 Taking Professional-Quality Photos **85**

A Good Photographer Is Always Prepared 85

Taking Advantage of Your Camera's Auto Shooting Modes 88

Choosing the Right Shooting Mode for the Situation 89

Dealing with Shutter Lag 90

The Basics of Photo Composition 91

 Using the "Rule of Thirds" When Shooting and
 Framing Your Shots 93

 Prefocusing on Your Subjects 96

 Choosing the Best Subjects, Foreground, and
 Background When Taking Pictures 97

How Light Impacts Your Photos 99

 Positioning Your Subject Based on the Sun's Position 101

Planning Your Shots ... 101

 Posed Photos ... 101

 Candid Photos .. 103

Taking Advantage of Your Camera's Zoom 104

6 Overcoming Common Mistakes and Mishaps **106**

Setting the Right Shooting Mode 106

Avoiding Common Shooting Mistakes and Mishaps 109

 Blurry Images ... 109

 Camera Autofocuses on the Wrong Objects 110

 Color Problems Within Images 112

 Glare and Shadows 115

 Shooting Through Glass or in Front of It 116

 Red-Eye ... 118

 Specks or Dots Appear in Your Photos 120

Part III: Using iPhoto '11 to Edit and Enhance Your Digital Images

7 Using iPhoto '11's Simple Photo Editing Features **123**

Finding Quick and Easy Ways to Improve Your Photos 123

 Exploring iPhoto 11's Edit Screen 125

 Using Full-Screen Mode When Editing 126

 Improving Your Onscreen View with the Zoom Feature 127

 Using iPhoto 11's Edit Window 130

Using the Quick Fixes Editing Tools 131

 Using the Six Quick Fixes Editing Features 131

 Rotate .. 132

 Enhance .. 132

 Fix Red-Eye .. 133

 Straighten .. 134

 Crop .. 136

 Retouch .. 142

8 Adding Effects to Your Images .. **145**

Discovering the Edit Window's Effects Options 145

Lightening or Darkening an Image 147

Adjusting the Contrast in Your Photos 149

Tinkering with a Photo's Coloring 149

Easily Adding Special Effects to Your Pictures 151

Adding Special Effects to Your Photos 152

Transforming a Color Image into B&W 152

Making a Photo Look Old Using the Sepia Effect 153

Instantly Aging an Image with the Antique Effect 154

Adding a Matte or Vignette to the Photo 156

Drawing Focus to Your Subjects by Blurring the
Image's Edges ... 158

Fading or Boosting the Colors in Your Photos 158

Removing Special Effects You've Added 160

9 Advanced Photo Editing with iPhoto '11 **161**

Discovering the Edit Window's Adjust Options 162

Understanding How the Levels Histogram Works 163

Manually Fixing Your Photos Using the Adjust Sliders 167

Using iPhoto '11's Shadows Tool and Other Editing
Tools to Quickly Fix an Underexposed Image 167

Manually Fixing the Exposure of Your Photos 168

Adjusting the Contrast in Your Images 168

Fine-Tuning an Image's Saturation 169

Altering the Definition of an Image 169

Using the Highlights Slider to Improve a Photo's Clarity 170

Using the Shadows Tool to Brighten an Image 170

Eliminating Blurriness with the Sharpness Tool 170

Using De-Noise to Clean Up an Image's Clarity 170

Adjusting a Photo's Temperature and Tint with the Sliders 171

Using the Eye-Dropper Tool to Fix Temperature and Tint 172

10 Exporting Your Images .. **174**

Your Exporting Options ... 176

Exporting Individual Photos 177

Exporting Entire Events ... 179

Exporting to a Web Page ... 180

Exporting to QuickTime ... 184

Exporting a Slideshow ... 186

What You Need to Know Before You Export 187

 Choosing the Right File Format 188

 Selecting the Appropriate Image Quality 189

 Understanding That File Size Does Matter 189

 Keeping Your Filenames Straight 190

iPhoto '11's Export Window 191

 Exporting Multiple Photos 192

Part IV: Printing Your Photos Using iPhoto '11

11 Printing Photos Using Your Own Home Photo Printer **195**

What You Should Know About Photo Printers 195

 What to Consider Before Buying a Photo Printer 196

 Choosing the Right Photo Paper to Meet Your Needs 197

Using iPhoto '11's Print Function 199

 Creating a Contact Sheet 202

Customizing Your Print Job 203

 The Print Command Icons and What They Do 203

12 Creating Prints Using a Professional Photo Lab **211**

Using the Order Prints Feature in iPhoto '11 211

 Ordering Prints in iPhoto '11 215

Setting Up Your Apple ID Account 216

Exporting Your Images and Uploading Them
to Another Online-Based Photo Lab 216

Taking Your Digital Images to a One-Hour Photo Processor 217

Taking Your Digital Images to a Professional Photo Lab 218

13 Creating Photo Projects and Photo Gifts **220**

Creating Photo Projects Using iPhoto '11 220

 Publishing Full-Color, Professionally
Bound Photo Books 222

 Creating Your Own Custom-Imprinted Greeting
or Holiday Cards 232

 Keeping Track of Important Dates with a Picture
Calendar Featuring Your Images 236

Creating Photo Projects and Photo Gifts Outside iPhoto '11 239

Part V: Sharing Your Photos Using iPhoto '11

14 Emailing or Publishing Your Photos Online **242**

Sharing Photos via the Web 242

Sending Emails from iPhoto '11 243

Sending an Email in iPhoto '11 247

Publishing Photos on Flickr.com 247

Sharing Photos on Facebook 250

Uploading Your Photos to Facebook 251

Managing Your Photos, Tags, and Comments on
Facebook Using iPhoto '11 254

15 Creating and Sharing Slideshows **257**

Creating a Slideshow That Tells a Story 257

Incorporating Titles and Text into Your Slides 260

Giving Your Slideshow Pizzazz Using a Theme 261

Using Animated Transitions and Special Effects 265

Adding Music to Your Presentation 266

Sharing Your Slideshow 268

Using Your Other Slideshow Options 269

16 Using Apple's MobileMe with iPhoto '11 **270**

An Introduction to MobileMe 270

What's an Online Photo Gallery? 271

Creating a MobileMe Online Photo Gallery from iPhoto '11 272

Creating an Online Gallery Using MobileMe 277

17 More Ways to Share Your Photos **279**

Creating a Web Page with iWeb 279

Customizing Your Mac's Desktop Wallpaper and Screen Saver 282

Transferring Photos to Your iPhone, iPod, or iPad 284

Transferring Photos from iPhoto '11 to Your
Apple Mobile Device 286

Part VI: Backing Up and Archiving Your Images

18 Burning Photos to CD or DVD from iPhoto '11 **289**

Burning Photos to DVD Using iPhoto '11's Share
Using iDVD Command 290

Copying Photos to CD or DVD Using the Burn Command 291

Burning Photos to a CD or DVD That Can Be
Read by Any Computer 293

19 **Photo Backup Solutions** ..**294**

Apple's Time Machine .. 295

Backing Up Images to CDs or DVDs .. 296

Using Online Photo Services .. 296

Using Remote Data Backup Services .. 298

Choosing the Perfect Backup Solution .. 299

What to Do When Disaster Strikes .. 299

What to Do If Your Camera's Memory Card Malfunctions 300

Part VII: **Appendixes**

A **Digital Photography Websites** ..**302**

Digital Photography Information, News, and Product Reviews 302

Digital Camera Manufacturers .. 302

Online Photo Services for Sharing Images, Creating
Prints, and More .. 303

Specialized Photography Websites .. 304

B **iPhoto '11 Keyboard Shortcuts** ..**306**

Index ..**311**

About the Author

Jason R. Rich (www.JasonRich.com) is the best-selling author of more than 45 books covering a wide range of topics. He also contributes articles on a regular basis to numerous national magazines, major daily newspapers, and popular websites, including the *New York Daily News* newspaper, LowFares.com, and Virgin Atlantic's vTravelled.com.

Some of Jason's recently published books include *How to Do Everything Digital Photography* (McGraw-Hill), *Blogging for Fame and Fortune* (Entrepreneur Press), *Design and Launch an Online e-Commerce Business in a Week* (Entrepreneur Press), and *How to Do Everything Blackberry PlayBook* (McGraw-Hill).

Jason's photographic work (www.JasonRichPhotography.com) often appears in conjunction with his articles and in his books, which include more than a dozen full-length travel guides.

Jason has a passion for travel photography and of photographing animals; however, he continues to help professional models and actors create and expand their portfolios, and get signed with major agencies in cities such as New York, Los Angeles, Boston, and Miami.

Throughout the year, Jason teaches photography workshops and classes through various adult education programs, aboard cruise ships, and at resorts. He lives in Foxboro, Massachusetts.

You can follow Jason on Twitter (www.twitter.com/JasonRich7).

Dedication

To my family and close friends.

Acknowledgments

Thanks to everyone at Pearson/Que for inviting me to work on this book and publishing it as part of the company's popular *Using* series. I'd particularly like to thank Laura Norman for her hard work and guidance as I worked on this entire project.

Thanks also to the models featured in the photos you'll see throughout this book who volunteered their time and effort (not to mention their faces) to participate in photo shoots. Models include Kiel James Patrick, Sarah Vickers, Neil Gibeau, Connor Jon Kuchenmeister, Hannah Lawson, Eric Stevens, Michael Jade Paquette, Emily, Ryan, and my Yorkshire Terrier, Rusty.

We Want to Hear from You!

As the reader of this book, *you* are our most important critic and commentator. We value your opinion and want to know what we're doing right, what we could do better, what areas you'd like to see us publish in, and any other words of wisdom you're willing to pass our way.

As an associate publisher for Que Publishing, I welcome your comments. You can email or write me directly to let me know what you did or didn't like about this book—as well as what we can do to make our books better.

Please note that I cannot help you with technical problems related to the topic of this book. We do have a User Services group, however, where I will forward specific technical questions related to the book.

When you write, please be sure to include this book's title and author as well as your name, email address, and phone number. I will carefully review your comments and share them with the author and editors who worked on the book.

Email: feedback@quepublishing.com

Mail: Greg Wiegand
Associate Publisher
Que Publishing
800 East 96th Street
Indianapolis, IN 46240 USA

Reader Services

Visit our website and register this book at quepublishing.com/register for convenient access to any updates, downloads, or errata that might be available for this book.

Introduction

Taking pictures using any digital camera is fun! With the latest cameras and the technology that's packed into them, you don't need to spend too much time at all to learn how to become an amazingly talented photographer.

Snapping candid and posed photos of your family, friends, pets, coworkers, teammates, and the people you interact with in your everyday life (or at special events, parties, or while on vacation) allows you to capture memories that you can later look back on and reminisce about for many years to come.

After you've taken your photos, the possibilities for what you can do with them and who they can be shared with are limitless. In addition to creating traditional prints of your favorite photos that you can frame, you can showcase your photos within a traditional photo album or scrapbook or simply give out prints to people.

Thanks to the Internet, you also are able to email photos to one or more recipients, publish them online in a variety of ways, and create many different types of Photo Projects that also allow you to showcase and share your favorite shots in a multitude of ways within cyberspace.

Thanks to the immense popularity of online social networking sites, such as Facebook, you can easily create an online presence for yourself and custom-design your personal Facebook page with the photos you take and then share those images with people you know or even total strangers (depending on how you adjust Facebook's privacy settings).

Until just a few years ago, managing, editing, enhancing, sharing, printing, and archiving digital photos was a time-consuming, often confusing, and tedious process that required the use of multiple software packages running on a state-of-the-art computer system.

With the Mac and iPhoto '11 software, Apple has changed all that. Today, the iPhoto '11 software, which comes bundled with all new iMacs and MacBooks, is a single, extremely powerful, yet surprisingly intuitive tool for handling just about everything having to do with digital photography (except actually taking pictures).

iPhoto '11 is designed to make importing photos from your digital camera to your Mac a straightforward, hassle-free process. After loading your digital images into the iPhoto '11 software, you can easily sort and organize them in a variety of ways and then edit your images using powerful photo editing and enhancement tools that can dramatically improve the look of your photos.

These tools are much easier to use than what's offered in competing digital photography software products. iPhoto '11 allows you to fix problems with your photos (such as red-eye, blurriness, contrast, or color issues), improve their overall appearance, and add special effects—all with a few clicks of the mouse.

After investing just a few minutes into editing your favorite images, you can share them with friends via email and the Web (without ever leaving the iPhoto '11 program). Plus, you can print your images using a photo printer, upload your favorite shots and have a professional lab create your prints (and ship them to you), and create a wide range of extremely classy Photo Projects, such as digital slideshows, greeting cards, photo books, calendars, and digital albums, which you can easily share with friends and loved ones.

Best of all, you can do some extremely impressive things with your digital images in just minutes, without having any artistic skill whatsoever. iPhoto '11 comes chock-full of professionally designed templates that allow you to drag and drop your images to showcase and share photos is some exciting new ways—all without ever leaving iPhoto '11.

As you're about to discover, iPhoto '11 is loaded with new features and innovative ways to edit, showcase, and share your digital photos. Using a combination of text, iPhoto '11 screenshots, sample photos, video tutorials, and audio-based content, *Using iPhoto '11* helps you get the most out of this incredibly powerful software; plus, it teaches you how to quickly improve your photo-taking skills. In no time, you'll be proud and excited to share the pictures you take with others!

When it comes to taking digital pictures, you have three main camera options:

- You can use the camera that's probably built into your cell phone (such as your iPhone or Blackberry).

- You can invest between $100 and $300 on any one of the newer, feature-packed, point-and-shoot digital cameras offered by manufacturers such as Canon, Nikon, Kodak, Sony, Olympus, Lumix (Panasonic), Casio, Samsung, Pentax, FujiFilm, Polaroid, or Simga. These point-and-shoot cameras are all self-contained in one unit, have dozens of built-in "auto" shooting modes, and enable you to take extremely high-resolution images in a wide range of situations and in almost any type of lighting—something that was not technologically possible just a few years ago without using extremely expensive, professional-level equipment.

- If you consider yourself to be a hobbyist or want more control over what's possible as you're actually taking pictures, you might want to invest in a mid- to high-end Digital SLR camera (priced between several hundred and several thousand dollars, depending on the make and model, and which accessories and optional equipment you purchase).

Digital SLR cameras, from companies such as Canon and Nikon, have interchangeable lenses, external flash units, and a variety of optional accessories; plus, they provide better manual controls in all shooting situations. These cameras typically also have much better quality lenses than point-and-shoot cameras, which results in more detailed photos that showcase richer colors, greater depth, and more detail in each of your shots.

Regardless of what type of digital camera you use, after your photos are shot, iPhoto '11 for your Mac offers extremely cutting-edge and powerful tools for importing, organizing, editing, enhancing, sharing, printing, archiving, and creating a variety of Photo Projects with your favorite images.

With this amazing software package (which is part of Apple's iLife '11 suite of applications) at your disposal, you're about to discover how rewarding digital photography can be. Plus, you can benefit from all the relatively new ways you can enjoy and share your photos after they're shot.

How This Book Is Organized

This book offers a comprehensive introduction to all aspects of digital photography when using iPhoto '11 for the Mac as your primary tool for managing, editing, sharing, printing, and archiving your photos.

Using iPhoto '11 also provides two chapters that are chock-full of valuable advice about how to improve your picture-taking skills. So, after you enhance your ability to take visually impressive and professional-quality photos and combine this skill with the power and state-of-the-art features built into your digital camera and the tools offered in iPhoto '11, your ability to shoot and create truly eye-catching images that you'll be proud to share with friends and family is well within your reach.

Using iPhoto '11 offers you the following:

- An overview of all new features, functions, and commands built into the latest edition of Apple's iPhoto software for the Mac.

- A step-by-step guide for importing your digital images into iPhoto '11 from your digital camera and a variety of other sources.

- Complete information about how to properly organize your digital photo collection so individual images are easy to find and view.

- Tips and strategies used by professional photographers for taking better pictures using any digital camera.

- Everything you need to know about using each of iPhoto '11's menus and accessing the various functions and commands built into the software.

- Information and step-by-step tutorials for editing and enhancing your photos using the tools built into iPhoto '11.

- Instruction on how to export your images for use in other applications and how to publish your images on the Web.

- A comprehensive discussion about how to print your photos and create a variety of Photo Projects (including slideshows, photo books, greeting cards, and calendars) using iPhoto '11.

- The information you need to safely and securely back up and archive your complete digital photo library.

Using This Book

This book allows you to customize your own learning experience. The step-by-step instructions in the book give you a solid foundation for using iPhoto '11, while content, including video tutorials and audio sidebars, provide the following:

- Demonstrations of step-by-step tasks covered in the book

- Additional tips or information on a topic

- Practical advice and suggestions

- Direction for more advanced tasks not covered in the book

Here's a quick look at a few structural features designed to help you get the most out of this book.

- **Chapter objective:** At the beginning of each chapter is a brief summary of topics addressed in that chapter. This objective enables you to quickly see what is covered in the chapter.

> **NOTES**
> Notes provide additional commentary or explanation that doesn't fit neatly into the surrounding text. Notes give detailed explanations of how something works, alternative ways of performing a task, and other tidbits to get you on your way.

TIPS

Tips give you shortcuts, workarounds, and ways to avoid pitfalls.

CAUTIONS

Every once in a while, there is something that can have serious repercussions if done incorrectly (or rarely, if done at all). Cautions give you a heads-up.

Many topics are connected to other topics in various ways. Cross-references help you link related information together, no matter where that information appears in the book. When another section is related to one you are reading, a cross-reference directs you to a specific location in the book where you can find the related information.

 Let Me Try It Let Me Try It tasks are presented in a step-by-step sequence so you can easily follow along.

 Show Me Show Me videos walks you through tasks you've just got to see—including bonus advanced techniques.

 Tell Me More Tell Me More audios delivers practical insights straight from the experts.

Special Features

More than just a book, your *Using* product integrates step-by-step video tutorials and valuable audio sidebars delivered through the **Free Web Edition** that comes with every *Using* book. For the price of the book, you get online access anywhere with a Web connection. You have no books to carry, content is updated as the technology changes, and you get the benefit of video and audio learning.

About the *Using* Web Edition

The Web Edition of every *Using* book is powered by **Safari Books Online**, allowing you to access the video tutorials and valuable audio sidebars. Plus, you can search the contents of the book, highlight text and attach a note to that text, print your

notes and highlights in a custom summary, and cut and paste directly from Safari Books Online.

To register this product and gain access to the **Free Web Edition** and the audio and video files, go to **http://quepublishing.com/using**.

Introduction to iPhoto '11

1 What iPhoto '11 Is and What It Does ... **8**

2 Upgrading to iPhoto '11: What's New and Noteworthy **28**

3 Loading Your Digital Images into iPhoto '11 **41**

4 Organizing Your Photos ... **59**

Learn why iPhoto '11 is the perfect tool to view, organize, edit, enhance, print, share, and archive all your digital images, as well as create impressive photo projects.

1

What iPhoto '11 Is and What It Does

iPhoto '11 is an extremely powerful, robust, yet surprisingly intuitive software package that is part of Apple's iLife suite of applications. It comes bundled with all iMacs and MacBooks and can be used to help you manage all aspects of digital photography.

iLife also includes powerful software for editing and sharing video (iMovie), producing music (GarageBand), and creating DVDs using your multimedia content (iDVD). It also provides tools for designing and publishing personal websites and sharing your multimedia creations (iWeb).

Using iPhoto '11 focuses on the latest version of Apple's iPhoto software. This chapter introduces you to the many uses of this software, which, like the Macs themselves, has evolved over the past few years. Each new version of iPhoto has added new features and functionality, plus has included major enhancements to existing features, giving you even more creative control over your digital photos.

Whether you consider yourself to be a serious photographer, or you're someone who simply enjoys taking and sharing photos of your kids, pets, family members, and friends, you're about to discover that iPhoto '11 allows you to manipulate and share your digital images in many exciting new ways.

What iPhoto '11 Can Do for You

Not long ago, if you wanted to take pictures, you needed a film-based camera. Each roll of film inserted into your camera allowed you to snap up to 36 images. When that roll of film was fully shot, it needed to be developed into negatives and then into 4" × 6" or 5" × 7" standard-size prints, for example. You could then share those prints with friends, insert them into an album, frame and display them, or store them in a shoebox.

Because the cost of film and having it developed was somewhat high, photographers were often reserved and highly selective when it came to snapping photos.

Thanks to digital photography, however, there's no film, no processing charges, and a typical memory card for a digital camera can store hundreds or even thousands of photos at a time. Using your digital camera, you may take as many photos as you'd like, allowing you to capture memories and share experiences with others in ways that were never before possible.

These days, you can purchase a really good-quality, point-and-shoot digital camera that's chock full of features for just a few hundred dollars. These cameras allow you to shoot amazing images, in a wide range of situations. Just a few years ago, this capability was only possible using the most expensive and advanced professional-level equipment. With the right skills and editing tools, you can take eye-catching photos using any digital camera.

In fact, even cell phones and Smartphones, like the iPhone 4, are now equipped with good-quality digital cameras, allowing you to snap photos just about any-where and immediately share them with friends and family using the wireless web.

You can transfer the digital photos you take to your computer to be viewed, organ-ized, edited, enhanced, printed, shared, and archived. However, until recently, to accomplish each of these tasks required you to utilize multiple and totally separate software packages on your computer. Keeping track of your digital photos and editing them were confusing and time-consuming processes—but not anymore!

Today, Apple has made taking, managing, and sharing pictures a fun and easy process. Just about all the functionality you need to view, organize, edit, enhance, print, share, and archive all your digital images is offered in a single program, called iPhoto, and it comes bundled with every iMac and MacBook.

Although creativity is still useful for taking visually impressive and nicely composed photos, thanks to software like iPhoto '11, you can edit and enhance your images after they're shot to make them look even better. Plus, you can fix any mistakes you might have made while shooting.

By the time you're done reading *Using iPhoto '11*, you'll know everything needed to vastly improve all your digital photos. You will be even prouder to share your pho-tos with others and equally excited to look back on them in the future as you remi-nisce about your most cherished memories captured in photos.

 TELL ME MORE Media 1.1—Why digital photography is so much bet-ter than traditional, film-based photography for amateurs and hobbyists
Access this audio recording through your registered Web Edition at
http://www.quepublishing.com.

The Main Functions of iPhoto '11

As you're about to discover (if you haven't already), iPhoto '11 is one of the most robust applications available when it comes to viewing, organizing, editing, enhancing, printing, sharing, and archiving all your digital images, as well as for creating photo projects. Although most other applications for amateur photographers are designed to handle just one or two of these tasks, iPhoto '11 easily handles just about everything related to digital picture taking, except actually snapping the photos...and it manages these tasks extremely well.

Let's take a closer look at the primary uses of iPhoto '11. Regardless of your photography skill level, you'll find that this application is powerful, yet intuitive to use, especially when you compare it to other photo management and editing applications currently on the market.

 🅖 *Chapter 5, "Taking Professional-Quality Photos," and Chapter 6, "Overcoming Common Mistakes and Mishaps," focus on how to take better photos using any digital camera and teach shooting techniques used by the pros. When you combine these skills with the editing and photo enhancement capabilities of iPhoto '11, you'll quickly discover a dramatic improvement in the overall quality of the photos you take.*

After shooting your pictures using any digital camera, you can easily transfer them from your camera to iPhoto '11. Note that Chapter 3, "Loading Your Digital Images into iPhoto '11," focuses on the various ways you can transfer your digital images from your camera to your computer and load (import) them into iPhoto '11, whereas this chapter offers an overview of what you can do with your images after they've been transferred.

Viewing Your Images

Chances are, your digital camera has a small LCD screen that you can use to preview the photos you shoot. To view your images in crisp detail, transfer them to your Mac and then view them using iPhoto '11 (or the Preview application that also comes bundled with every Mac).

iPhoto '11 offers multiple ways to view your images. You can preview many images at once on your screen by displaying thumbnails of your photos stored within Events or Albums, for example. Figure 1.1 shows thumbnails of multiple photos saved in one particular Event within iPhoto '11.

 🅖 *To learn more about Events, Albums, and other ways to organize your digital photos, be sure to read Chapter 4, "Organizing Your Photos."*

Figure 1.1 *You can view thumbnails of all images stored within an iPhoto '11 Event.*

It's possible to adjust the size of these thumbnails. If you choose a smaller size, you can display more image thumbnails at once on the screen. However, when you choose larger-size thumbnails, you see more detail in your images. You can control the size of the thumbnails being displayed on the iPhoto '11 screen by using the Zoom slider that's located in the lower-left corner of the main screen. Move the slider to the left to shrink the size of the viewable thumbnails or move it to the right to enlarge the thumbnail size displayed on the screen.

In addition to viewing thumbnails, you can view one image at a time that's enlarged on iPhoto '11's main screen or while in full-screen mode. Simply double-click on any of the thumbnails. From the normal viewing mode (shown in Figure 1.2), you can switch to full-screen mode (shown in Figure 1.3) to see your image even larger on the screen. To do this, click on the Full Screen icon located in the lower-left corner of the main iPhoto screen.

To return to the thumbnail view and see all the photos in an Event or Album, for example, click on the left-facing arrow icon, which displays the Event or Album name (Sample Images, in this case). It is located in the upper-left corner of the image display area.

It's also possible to view groups of images together as an animated slideshow on your Mac's screen or quickly create an online photo gallery or slideshow featuring groups of images that can be uploaded and published to an online-based service, such as Flickr, MobileMe, or Facebook.

Figure 1.2 *View one image at a time in iPhoto '11's normal viewing mode.*

Figure 1.3 *View one image at a time in iPhoto '11's new full-screen mode to see it even larger.*

 ⊙ You learn how to create extremely impressive and professional-quality slideshows that feature your images in Chapter 15, "Creating and Sharing Slideshows." Chapter 14, "Emailing or Publishing Your Photos Online," and Chapter 16, "Using Apple's MobileMe with iPhoto '11," explain how to create online-based photo galleries using the various online services.

In iPhoto, when you view an image, you can display just the photo, or you can display detailed information pertaining to that photo. For example, you can open a single image within iPhoto '11 and then click on the Info icon located in the lower-right corner of the screen (see Figure 1.4). This feature allows you to view information about the camera and lens used to shoot that particular image; plus, it shows details about the camera's settings, size of the image file, file format the image is saved in, along with other pertinent data that iPhoto tracks in regard to each and every image you shoot.

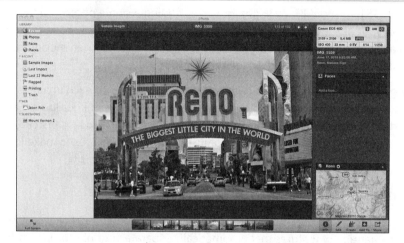

Figure 1.4 *Clicking on the Info icon when viewing a photo allows you to view a lot of detailed information about that particular image.*

NOTE

If you're interested in the technical aspects of photography, the data provided within the Info section that pertains to each of your images will be useful and *highly* relevant. For the average hobbyist, however, some of the technical details provided in this window will be of little interest or relevance, so ignore it.

Organizing All Your Digital Photos

Because many high-capacity camera memory cards can hold literally thousands of images each and you can always replace a full memory card with an empty one while you're shooting, as a photographer, you are not limited to how many photos you can take at any given time. Thus, within a few days of shooting with a digital camera, you could take several hundred photos. Over a period of several months,

you could wind up with thousands of images. After a few years, it's common to acquire a collection of tens of thousands of images. As you can imagine, keeping them all organized can turn into quite a chore. Fortunately, iPhoto '11 is up to the task.

Organizing Images by Filename

When your digital camera shoots a new photo, it automatically assigns a generic but sequential filename to it, such as IMG_1234.jpg. Keeping track of a few dozen images is easy, even if they all have similar filenames, such as IMG_1234.jpg, IMG_1235.jpg, and IMG_1236.jpg. However, finding a single photo you took last year at your office Christmas party could pose a challenge if you have thousands of similarly named photos that aren't well organized, and these generic and numeric-based filenames in no way describe the photo's content.

Using iPhoto '11, you can keep the default filename given to each image or easily change it to something more descriptive, such as Close Up of Erica.jpg or Statue of Liberty – NYC.jpg. However, this can be a time-consuming process. Instead, you might want to change the filenames of just your favorite images to make locating them later a bit easier. How to do this is explained in Chapter 3.

Organizing Photos Within Events or Albums

To make the photo organization process on your computer much easier, iPhoto '11 offers a handful of features that automatically separate your photos into individual Events. If you don't like the Events iPhoto creates, you can create additional Events or Albums (which is explained shortly) on your own and manually sort your own images. You can then create a custom name for each Event.

To keep your images well organized, create separate Events every time you shoot new photos, and name your Events based on what types of photos are stored within them, such as "Winter 2011 Disney World Vacation" or "Visit to the Zoo." Whenever you create a new Event or Album, iPhoto '11 automatically tracks the dates each photo within it was shot.

TIP

You can save time by gathering together groups of related photos and storing each group in its own Event. This way, you don't need to change each image's filename to something descriptive because you know what types of photos are stored in each Event based on the descriptive title you've given to that Event.

Within each Event or Album, you can go through and manually customize the file-name for each image and assign keywords, tags, or a full description to each image

to help you identify and find it later. We'll focus more on keywords and tags, and how they're used to organize your photos, in a bit.

> **TIP**
>
> You can organize how Events are displayed on the screen based on their Name, Date, Rating, or Keyword, or you can manually position them in whatever order you choose. To adjust the arrangement of Events, click on Events in the Source List, access the View pull-down menu from the top of the iPhoto '11 screen, and select the Sort Events command. Events can be rearranged anytime using this command.

iPhoto's Face-Recognition Feature Identifies Who's in Your Photos

Organizing dozens, hundreds, or thousands of individual images using separate Events and Albums is one approach. However, it's not the only way to organize your photos using iPhoto '11. The software also uses proprietary technology to perform automatic face recognition of your photos and then separates and categorizes each of them based on who appears within each image.

After you "teach" iPhoto '11 who each person is in your photos just once, it remembers those faces and later groups all new photos together using iPhoto '11's advanced face-recognition functionality (see Figure 1.5).

 Faces requires an initial setup to use. How to do this is explained in Chapter 4, "Organizing Your Photos." After this feature is set up, it works automatically in the background. In the future, when you click the Faces option within iPhoto, you'll see groups of your photos sorted and displayed based on who appears within them.

> **NOTE**
>
> The iPhoto '11 face-recognition feature is called Faces.

iPhoto '11 allows you to organize and sort your digital photos by filename, date, keyword, description, or Event or Album in which they are placed. There are still several additional ways to organize your photos using this software, however.

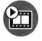 **SHOW ME** Media 1.2—A preview of iPhoto '11's Faces face-recognition capabilities
Access this video file through your registered Web Edition at
http://www.quepublishing.com.

Figure 1.5 *iPhoto '11 automatically sorts your photos and allows you to easily find specific images based on who appears within them.*

Flagging, Tagging, and Rating Your Images

You can pick and choose your favorite photos and flag them for easy reference later (a feature discussed in Chapter 4), or you can rate your images and choose your absolute favorites (using a one- to five-star rating system). This feature is useful if you've just returned from your vacation and have several hundred new photos. As you review your images, you might really like 10 of them, which you decide to print or share with friends via email. You can give those 10 favorite photos a five-star rating or flag them for easy reference.

TIP

When viewing an image, you can rate it by accessing the Photos pull-down menu at the top of the iPhoto '11 screen and then selecting the My Rating option. You can also click on the Info command icon located in the lower-right corner of the screen and then click on your desired Star Rating toward the top of the Photo Information window that appears on the right side of the iPhoto '11 screen. A third way to rate a photo is to press the Command key + the number zero through five when viewing an image or when an image is highlighted in thumbnail mode.

LET ME TRY IT

Rating an Image, Tagging It, and Adding a Description

For each image you take that's stored in iPhoto '11, you can give it a personal rating, tag the image (with the names of the people in it), or add a text-based description. Here's how:

1. From within iPhoto '11, choose the image you want to rate. Open and view that single image on the screen.

2. To rate the image, access the Photos pull-down menu and select My Rating.

3. Click on the number of stars you want to rate that image (between one and five, with five stars being your absolute favorite).

4. To add a description of the photo, click on the Info command icon located in the lower-right corner of the screen. A new Information window appears on the right side of the main iPhoto screen. Move toward the top of this window. Beneath the image's date, click on the Add a Description option. You can now type in a text-based description of that photo, which can include full sentences, keywords, or search phrases that will help you identify that photo later.

5. To tag the photo with the names of the people featured within it, keep the Info screen open, but using the mouse (or touchpad), move the cursor to the main image viewing area of the iPhoto '11 screen and place the cursor over each subject's face. A white box appears. Click the mouse, and a Name field appears below the box. Type in the name of the person whose face is surrounded by the white box. Repeat this step for each person in the photo. Tagging a photo makes it easier for iPhoto's Faces feature to identify who is in your pictures. Each time you shoot someone new, you need to identify that person using this method so iPhoto's Faces feature can automatically use its face-recognition capabilities to identify him or her in the future.

 Photo tagging is covered in greater detail within Chapter 4, "Organizing Your Photos."

Organizing Photos Based on Where They're Shot (Geographically)

Another cutting-edge way to organize your photos, especially if you vacation or travel extensively, is to use iPhoto 11's Places feature. Many of the newer digital

cameras and cell phones with built-in cameras keep track of exactly where each of your photos is shot geographically.

By combining geo-tagging associated with your pictures with the capabilities of Google Maps and iPhoto '11's Places feature (all of which work seamlessly together), you can view on a map exactly where each of your photos was shot and see the maps in a variety of formats.

When the Places feature is set up within iPhoto '11, a process explained in greater detail in Chapter 4, you are able to organize and sort your photos based on where they were shot.

TIP

If your camera doesn't offer geo-tagging of photos, which means it keeps track of exactly where geographically each photo is shot using GPS coordinates, you can add this useful feature to any digital camera with an Eye-Fi Geo X2 digital memory card offered by Eye-Fi, Inc. (Price: $69.99 for a 4GB memory card that stores up to 2,000 photos.) For more information about wireless geo-tagging memory cards for any digital camera, visit www.eye.fi.

Searching For and Locating Your Images

iPhoto '11 allows you to sort, organize, and group together your images in many ways. How you ultimately organize your photos on your computer is entirely up to you. However, iPhoto '11 makes the process straightforward by automatically dividing your images into Events based on when they were shot as they're being imported into the iPhoto '11 software.

ⓒ *Chapter 4 covers how to combine (merge) Event folders, add new Event folders, or delete unwanted folders from within iPhoto '11.*

When you're using iPhoto '11, you can always locate a particular photo or group of photos you shot by searching based on an image's filename, keyword, description, date shot, rating, location where it was taken, or person who appears within the photo using the software's built-in Search feature.

On the main iPhoto '11 screen, the Search command icon is located in the lower-left corner (see Figure 1.6).

To search for a photo, click the Search command icon. When the Search field appears, enter the desired photo's filename/title, description, date, keyword, or rating and then press Return. The results of your search are displayed in the form of photo thumbnails within the main viewing area of the iPhoto screen.

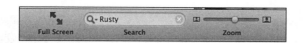

Figure 1.6 *Even if you have thousands of photos stored within iPhoto '11, you can find a single image in seconds by using the powerful Search feature.*

Another way to search for photos is to click on the Photos, Faces, or Places controls located on the left side of iPhoto's main screen. When you click on Faces, for example, a corkboard screen appears with thumbnails of each person for which you have photos stored within iPhoto (refer to Figure 1.5). You can then look at all photos of that particular person.

Editing Your Photos to Achieve Professional-Looking Results

Even if you're a professional photographer with the very best, state-of-the-art digital camera equipment, not every single one of your shots will turn out perfectly. When shooting, all photographers face many challenges, such as poor lighting, too much light, shadows, glare, the inability to hold the camera steady, or a fast-moving subject.

Many of the most basic point-and-shoot digital cameras are capable of helping you overcome common shooting obstacles, but the results are not always perfect. That's when photo editing comes in handy. Using basic photo editing techniques, after a photo is shot and transferred to your Mac, you can quickly edit it using a variety of tools built into iPhoto '11.

For example, using iPhoto's powerful editing tools, you can rotate or crop images, automatically adjust the colorization and lighting within a photo with a single click of the mouse, fix red-eye, straighten a crooked image, or retouch images to remove unwanted elements (such as a blemish on someone's face or something distracting from the photo's background).

🌀 *How to use each of these editing features and a discussion of when and why you'd use them are the focus of Chapter 7, "Using iPhoto 11's Simple Photo Editing Features."*

All these easy photo editing options can be found within the Quick Fixes window, which appears when you click the Edit command icon in the lower-right corner of the main iPhoto '11 screen (see Figure 1.7).

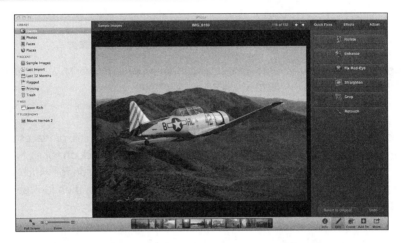

Figure 1.7 *One-click photo editing is easy with iPhoto '11. You can quickly but dramatically improve the quality of an image plus fix common mistakes or mishaps that occurred when shooting.*

TIP

Before you share or showcase your images, it's a good idea to edit them to ensure that they look their absolute best. Even a few simple edits can dramatically improve the overall look and composition of any photo.

Using the features and functions found in the Quick Fixes window of iPhoto '11, you can literally transform an image within seconds and vastly improve its overall appearance and quality.

After you become familiar with the Quick Fixes editing capabilities of iPhoto '11, you can experiment with the more advanced and powerful editing features, which give you maximum control over many aspects of your photos' appearance. You can find the advanced photo editing tools within iPhoto '11 by clicking on the Edit command icon and then clicking on the Adjustments tab located at the top of the window that appears.

☺ *Using a series of sliders, you can manually adjust an image's exposure, contrast, saturation, definition, shadows, temperature, and tint. Plus, you can "de-noise" an image. How to use each of these more advanced editing techniques is explained, in detail, in Chapter 9, "Advanced Photo Editing with iPhoto '11." As you'll discover, the result of using these tools on your images can be dramatic, allowing you to transform a basic image into a photograph that's worth displaying or sharing.*

SHOW ME Media 1.3—A preview of iPhoto '11's Quick Fixes features for editing digital photos
Access this video file through your registered Web Edition at http://www.quepublishing.com.

Enhancing Your Images to Make Them Stand Out

Typically, photographers choose to edit their digital images to make them look better or to fix a problem within the images. However, iPhoto '11 allows you to go beyond just fixing problems. By clicking on the Edit command icon and then on the Effects tab, you can quickly add a wide range of visual effects to each of your images to either improve them visually or give them more of an artistic appearance. Using the Effects features built into iPhoto '11, which are vastly improved over previous versions of the iPhoto software, you can significantly alter the appearance of a photo.

You learn how to add special effects to your photos in Chapter 8, "Adding Effects to Your Images." For example, with a few clicks of the mouse, you can transform a color image into black and white or dramatically boost the colors of an image to make it more vibrant.

Printing Your Digital Photos in Many Different Sizes

Aside from viewing your digital photos on a computer's screen, you can print images using any photo printer in a wide range of standard or nonstandard sizes.

You can also use the printing features within iPhoto '11 to add borders, digital mattes, and captions to your photos just before you print them.

> **TIP**
>
> Depending on the photo printer, type of photo paper, and ink you use, the prints you can create at home will be as professional looking as the prints you can have made using a traditional photo lab. However, when you print your photos at home using a photo printer, you can have the print, which will be suitable for framing or inclusion within a photo album or scrapbook, in your hands within minutes.

Using a photo printer and iPhoto '11, you can choose to create prints in almost any size, from wallet-size photos to standard 4" × 6" or 5" × 7" prints. Creating 8" × 10" or 8.5" × 11" prints is just as easy. If you happen to have a wide-carriage photo printer, you can also create poster-size images (up to 13" × 19"). A good-quality photo printer can be purchased for under $200.

In addition to using iPhoto '11 with a good-quality photo printer, from a company such as Kodak, HP, Canon, or Epson, you'll want to use high-quality (four- or five-star rated) photo paper and choose between glossy, semi-gloss, matte, or luster paper finish.

🔘 *Learn more about choosing the best photo printer, photo paper, and ink and why this is important. These topics are covered in Chapter 11, "Printing Photos Using Your Own Home Photo Printer."*

If you don't want to invest in a full-color photo printer but still want professional-looking prints from within iPhoto '11, you can order prints in specific sizes from a professional photo lab and have those prints shipped directly to your door within a few business days.

Apple has teamed up with professional photo lab services to offer the capability to conveniently order prints of your images via the Web, with a few clicks of the mouse, and without ever having to leave iPhoto '11. (An Internet connection is required, however.)

To order prints from a professional photo lab using iPhoto '11, choose the images from which you want prints created, click on the Share command icon located in the lower-right corner of the screen, and then choose the Order Prints option.

From the Order Prints screen that appears (see Figure 1.8), choose the size of the prints you want created. The prices you'll pay are reasonable, compared to one-hour photo labs across America; however, you are also responsible for shipping and handling charges associated with your order.

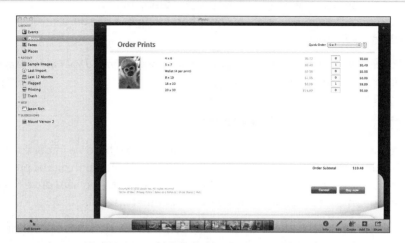

Figure 1.8 *Order professional prints created from your images directly from within iPhoto '11. There's no need to export your images into another program.*

TIP

You can order prints from any photo lab by exporting the images from which you want prints made; storing them on a CD, DVD, or thumb drive; and then taking them to a one-hour or professional photo lab in your area. You can also export your images to .JPG format and order prints from other photo labs online, but to do this, you need to exit iPhoto '11 and use Safari to access a specific online photo service, such as Shutterfly.com, Snapfish.com, CVSPhoto.com, KodakGallery.com, SmugMug.com, or MPix.com.

There are a handful of things to consider before having your photos professionally printed at a lab. Chapter 12, "Creating Prints Using a Professional Photo Lab," focuses on using a professional lab or a local one-hour photo service to create prints from your digital images.

Sharing Your Photos with Friends, Family, and Coworkers with Ease

Creating prints is just one way of sharing your digital photos with your family, friends, and coworkers. Again, without leaving iPhoto '11, you can share one or more images electronically via email or by uploading your photos to a free Flickr.com account, to a MobileMe gallery (annual membership required), or to Facebook.

Sharing photos electronically via email or by posting or publishing them on an online service is a fun way to share your photos with one person, a small group of people, or even the general public.

◉ *Chapters 14, 15, 16, and 17 focus on various ways of sharing your favorite photos with others from within iPhoto '11.*

Securely Archiving Your Images

Your digital photos will contain cherished memories and become important keepsakes that you'll want to enjoy for many years to come. Although digital photos are electronic files that can't fade or tear, like traditional prints, the hard drive they're stored on can crash, get damaged, be stolen, or otherwise fail.

For all these reasons, it is absolutely essential that you create and maintain secure backups of your digital photos. Many backup and archiving options are available to you. For example, from within iPhoto '11, you can burn your images to some form of external storage, such as CD or DVD, back them up to an external hard drive (either manually or automatically using the Mac's Time Machine software), or you can use a remote online backup service.

CAUTION

Some online photo services and social networking sites, including Facebook, automatically shrink the resolution and file size of your digital images when they're uploaded. Although this is fine for viewing purposes, it is not suitable for creating a reliable online-based archive or backup of your photos. If you use an online-based photo service to store and maintain backup copies of your images, make sure they remain in their original, high-resolution format.

◉ *You learn about the various photo backup and archiving solutions available to you in Chapter 18, "Burning Photos to CD or DVD from iPhoto '11," and Chapter 19, "Photo Backup Solutions."*

Be sure that you invest the time necessary to create and maintain at least one reliable backup of your digital images. If your computer crashes (and yes, Macs do crash occasionally), and your hard drive becomes corrupted or needs to be reformatted but you don't have a backup of your photos, they could be lost forever. Or you might have to pay hundreds, perhaps thousands, of dollars to a data recovery service to retrieve your images from a damaged hard drive.

TIP

To ensure that your digital photos remain safe, consider maintaining a backup copy of them on an external hard drive that's connected to your Mac. Plus, use an offsite, online-based remote backup service.

Creating Photo Projects Such as Greeting Cards and Photo Books

Sharing your photos by creating prints and distributing and publishing them online are two very viable options. However, iPhoto '11 also enables you to tap your own creativity and create wonderful and unique photo projects and gifts using professional templates. These products can be created and ordered from within iPhoto '11 and arrive at your door within a few days. (An Internet connection is required.)

For example, iPhoto '11 allows you to create extremely impressive printed greeting cards (featuring your photos) suitable for any occasion, which also incorporate your own custom messages. The cards you create will look as professional as anything you'd buy at a greeting card store. However, your photo greeting cards will show-case your own photo(s) and have your own custom message imprinted within them.

Photo Books Can Replace the Need for Traditional Photo Albums and Scrapbooks

iPhoto '11 has greatly enhanced the functionality for creating amazing-looking photo books. Instead of creating an old-fashioned photo album or scrapbook, you can create fully customized hard-cover or soft-cover photo books, using templates and design tools built into iPhoto '11.

The photo books you can create using this software will look like books you pur-chased at a bookstore, except that all your own photos, captions, and design ele-ments will be imprinted within them. Thanks to the latest digital printing technologies, photo books have dropped dramatically in price, and creating profes-sional results has never been easier.

TIP

Although you can create impressive photo books from within iPhoto '11 and use an Apple-authorized photo book printer to publish your books, an alternative is to download the free BookSmart photo book design software from Blurb.com

(www.blurb.com) and use Blurb's incredibly robust photo book design elements and printing services to create incredible results, even if you have no artistic skills whatsoever. Blurb offers different page templates and photo book designs than what's built into iPhoto '11. Blurb's BookSmart software is, however, compatible with iPhoto '11, so you can drag and drop photos from iPhoto into the BookSmart software without having to first export your images from iPhoto and then import them into BookSmart.

NOTE

One of the great features of iPhoto's photo book creation tools, as well as all the tools available for creating other photo projects, is that you don't need any artistic abilities whatsoever to create visually stunning results. The templates built into iPhoto '11 are professionally designed. Although you can customize the templates and use your own creativity and artistic abilities, you don't have to.

iPhoto '11 Works Seamlessly with Other Mac Software

If you're an avid Mac user, you'll discover that the photos you store and edit within iPhoto '11 can easily be dragged and dropped, cut and pasted, or exported into a wide range of other Mac applications, including all programs in the Microsoft Office suite and Apple's iWork suite. You can also drag and drop photos from within iPhoto to the Mac's Address Book application (that comes bundled with all Macs), as well as into many other third-party software packages.

You can even select your favorite photos stored within iPhoto '11 and use them for your Mac's Desktop Wallpaper or Screensaver. This can be done either from within iPhoto '11 or by using the options available from Mac OS X's System Preferences.

TIP

After selecting an image to use as your Desktop Wallpaper, from iPhoto 11's Share pull-down menu, choose the Set Desktop command to instantly display that photo as your Mac's main Desktop Wallpaper image.

Taking Advantage of as Much or as Little as You Need

Using iPhoto '11 will help you become acquainted with just about everything you can do with iPhoto when it comes to viewing, organizing, editing, enhancing, printing, sharing, and archiving all your digital images. However, based on your own wants and needs when it comes to digital photography, you might discover that not all the features and functions built into this software are suitable for you.

iPhoto '11 is designed so you can use whichever features and functions you want yet totally ignore whatever isn't relevant to your needs. For example, you can use Events to organize all your photos but not utilize the Faces or Places functionality.

When you become better at snapping really good photos using your digital camera (after reading Chapters 5 and 6, for example), and you've discovered how to edit them using the features and functions built into iPhoto '11, chances are you'll be excited to share your creations with friends, family, and coworkers and want to showcase your images using the many different methods available to you using iPhoto '11.

Digital photography is a fun and rewarding hobby. It's a great way to express your creativity and capture important moments in your life (and in the lives of those around you) so you can reminisce later. It's also a wonderful way to share memories with the people in your life who are important to you.

As you'll soon discover, iPhoto is a powerful tool you can use to handle just about every task associated with digital photography, without getting bogged down with having to use complex, confusing, or highly technical software.

Discover how to upgrade your Mac with the iPhoto
'11 software and then learn about some of the new
features added to this version of the software.

2

Upgrading to iPhoto '11: What's New and Noteworthy

There are two ways Mac users can acquire iPhoto '11. If you purchase a new Mac, the entire iLife '11 suite, including iPhoto '11, comes pre-installed and ready to use on your computer. However, if you've had your Mac since before mid-October 2010, you need to upgrade to iPhoto '11 from an older version of the software.

This chapter explains your options for upgrading to iPhoto '11 and then provides an overview of the exciting new features and functions this powerful software offers when it comes to organizing, editing, enhancing, printing, sharing, and archiving all your digital photographs.

It's Time for an Upgrade

Over the years, Apple has consistently improved the operating system for the Mac, as well as the popular first-party applications bundled with it. If you purchased your Mac before mid-October 2010, it came with an older version of iLife, such as iLife '09, already installed.

In its day, iPhoto '09 was a powerful and feature-packed program for managing, editing, archiving, printing, and sharing digital photos. However, iPhoto '11 is even better!

TIP

If you're using iPhoto '11 on a recently purchased iMac or MacBook (purchased after mid-October 2010), it comes with iPhoto '11 already installed. However, you may still need to download an updated version of the software. From the iPhoto pull-down menu located in the upper-left corner of the screen, select Check for Updates to see whether a new version of iPhoto '11 is available. If so, you should download and install it.

After you decide to upgrade your iPhoto software, you have three options for purchasing iPhoto '11:

1. You can purchase iLife '11 on disc from any retail location that sells Apple products, including Apple Stores, Best Buy, or the Apple.com online store. The price of the iLife '11 suite upgrade is $49.00 for the single user version, which means you can upgrade one Mac computer (either an iMac or MacBook). The iLife '11 suite includes iPhoto '11, iMovie '11, and GarageBand '11, as well as iDVD v7.1 and iWeb v3.0.2.

2. You can purchase the iLife '11 Family Pack for $79.00 on disc, which allows you to install the iLife '11 software on up to five Macs.

3. You can purchase, download, and automatically install the standalone iPhoto '11 software from the new Mac App Store ($14.99).

If you purchase iLife '11 on disc, simply insert it into your Mac and follow the installation instructions. The installation process could take up to 30 minutes. If you download the iPhoto '11 software from the Mac App Store, the installation process happens automatically.

The first time you launch iPhoto '11 (if you're upgrading from an older version), you need to update your photo library. When you see the message "The photo library needs to be upgraded to work with this version of iPhoto," click on the Upgrade icon to continue (see Figure 2.1).

Figure 2.1 *After iPhoto '11 is installed, you may need to upgrade your photo library.*

Depending on how many photos you already have stored in iPhoto (using the older version), this upgrade process could take up to an additional hour. During this time, you are able to continue using your Mac, but the iPhoto software isn't functional. However, if you're running iPhoto '11 on a brand-new Mac, there is no need to update your photo library because there are no pre-existing photos stored on the computer.

When the upgrade process is complete, you see the main iPhoto '11 screen, which will look somewhat familiar if you've been using iPhoto '09.

At the top of the screen are iPhoto '11's pull-down menus. On the left side of the screen are additional commands and navigation options, and at the bottom of the screen, as you can see in Figure 2.2, is a selection of new command icons, with which you'll soon become acquainted. The main portion of the screen is the place where you view your images, either as thumbnails or in a larger format, depending on the iPhoto '11 viewing feature you're utilizing.

Figure 2.2 *Some of the new command icons located at the bottom of the main iPhoto '11 screen.*

One of the new and most important command icons you'll notice is located in the lower-left corner of the iPhoto '11 main screen. It's the Full Screen icon. Click on it, and the entire user interface and viewing mode of iPhoto '11 change to the impressive new full-screen mode. You explore how to navigate around the program in full-screen mode and access all the various commands, features, and functions built into iPhoto '11 shortly.

Welcome to iPhoto '11

As soon as you install and load iPhoto '11 for the first time, you'll quickly discover that this latest version of the software is chock full of new features; plus, it has a new look. Although the core functionality of iPhoto '11 is to help you organize, edit, enhance, print, share, and archive your digital photos, the software's new, but optional, full-screen mode allows you to interact with the software and view your images in some exciting new ways.

When you look at the new full-screen mode, notice that all the software's menus are no longer anchored at the top and side of the program screen, like they were in iPhoto '09 (see Figure 2.3). The Mac's program Dock at the bottom of the screen is also no longer visible.

Now, look at iPhoto '11's new main screen, shown in regular viewing mode. As you can see in Figure 2.4, some new commands and options in iPhoto '11 are displayed as command icons at the bottom of the screen.

Aside from the new onscreen look of iPhoto '11, you'll discover major improvements when you begin to organize, edit, enhance, share, print, and archive your photos, or if you use your digital images to create slideshows, photo books, or custom greeting cards, for example.

Figure 2.3 *Flashback to iPhoto '09...the program's old look.*

Figure 2.4 *iPhoto '11's main screen shown in its regular viewing mode.*

Sharing your digital photos with friends, loved ones, and coworkers has also never been easier, whether you want to email your photos directly to selected recipients without ever exiting iPhoto '11, or you choose to publish your favorite images on Facebook or in an online photo gallery using a service such as MobileMe or Flickr.

iPhoto '11 also gives you greater ability to create prints from your digital images, whether you're using your own photo printer or you opt to order prints online from a professional photo lab from within iPhoto '11.

Overview of iPhoto '11's New Features and Functions

Let's take a closer look at some of the new features and functions iPhoto '11 now offers (compared to iPhoto '09) and focus on why and how these new additions to the program can be useful.

Full-Screen Viewing Mode

The most obvious new feature of iPhoto '11 is the full-screen viewing mode. When you use this feature, iPhoto '11 utilizes more real estate on your Mac's display, giving you more space to view and edit your images. The full-screen mode works with the main Events screen, as well as the Faces, Places, Albums, Projects, and Editing screens, all of which you'll become acquainted with shortly.

When you enter into the full-screen viewing mode, all your menus and commands are available from the bottom of the screen. The benefit to this viewing mode is that all the ancillary content that typically appears on your Mac's display when running any application, such as the menu bar at the top of the screen and the Dock at the bottom, is no longer present.

Any time you open a single photo, you'll also notice the new Filmstrip preview located at the bottom center of the screen. Figure 2.5 shows a single image being viewed in iPhoto '11. The new Filmstrip feature is visible at the bottom of the screen. This is a way to quickly preview thumbnail images of photos in the same Event or Album, for example, as you're viewing a single image in the main image viewing area of iPhoto '11. Use the left and right arrow keys on your keyboard to scroll through the thumbnails in the Filmstrip.

Multitasking When in iPhoto '11's Full-Screen Mode

When you use iPhoto '11 in full-screen mode, you'll notice that your program icons, which are traditionally displayed along the bottom of the screen as part of the Dock, are no longer present. This does not stop you from running multiple applications simultaneously on your Mac, however.

When you have multiple applications running on your Mac, including iPhoto '11 in full-screen mode, to switch between programs, simply press the F3 (Expose) key on your keyboard. As you can see in Figure 2.6, Expose allows you to view all open windows and applications running on your Mac simultaneously and then click on the one you want to use.

Figure 2.5 *The Filmstrip mode allows you to see other photos stored in the same Event or Album of the image you're currently viewing.*

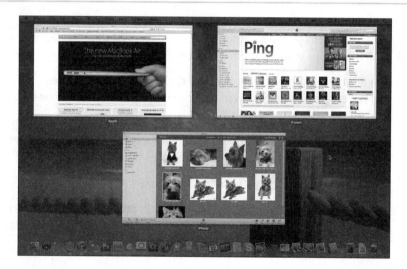

Figure 2.6 *Press F3 on your keyboard to access Expose and switch between applications when running iPhoto '11 in full-screen mode.*

NOTE

When you switch between applications on a Mac, they all continue running, so you can return to iPhoto '11 at any time and pick up where you left off. When you return to iPhoto '11, however, you are no longer in full-screen mode.

> **TIP**
> You can also use Spaces to quickly switch between applications simultaneously running on a Mac. This feature is built into the OS X operating system. To learn more about Spaces, visit http://support.apple.com/kb/HT1624.

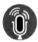 **TELL ME MORE** Media 2.1—Multitasking on your Mac when using iPhoto '11 in full-screen mode

Access this audio recording through your registered Web Edition at
http://www.quepublishing.com.

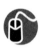 **LET ME TRY IT**

Switching Between Applications When Running iPhoto '11

Whenever iPhoto '11 is running in full-screen mode, you can quickly switch between applications your Mac is currently running, even though you can't see the Dock, which contains your program icons, on the screen:

1. Run iPhoto '11 in full-screen mode by clicking on the Full Screen command icon located in the lower-left corner of most iPhoto '11 screens.

2. When you need to access another application that is currently running, press the F3 key on the keyboard to activate Expose. On a single screen, large thumbnails of each application that's running are displayed.

3. Click on the application you want to switch to.

4. You can return to iPhoto '11 any time by again pressing the F3 key and then clicking on the iPhoto '11 thumbnail that appears. You do, however, have to re-enter into full-screen mode, if you so desire.

Sharing Photos on Facebook Has Never Been Easier

More than a half billion people around the world are now active Facebook users. One reason why this free online social networking site is so popular is that it allows you to easily share photos with friends, family, or the general public, depending on how you set your account's privacy features.

iPhoto '11 now works even better with Facebook, allowing you to upload single photos to your Facebook wall or create entire Facebook photo galleries from within iPhoto '11 when your computer is connected to the web. Another related enhancement is the ability to add and view photo comments on Facebook from within iPhoto '11. You also can tag Facebook photos (a concept discussed further in Chapter 3, "Loading Your Digital Images into iPhoto '11," and Chapter 4, "Organizing Your Photos") from within iPhoto '11, as opposed to having to access your Facebook photo albums via a web browser such as Safari.

NOTE

Tagging a photo allows you to attach the names of the people appearing within a particular photo to the image file itself. So, after a photo has been tagged, you can use someone's name to search for that photo. Tagging also enables you to identify people in photos on Facebook.

Sharing Photos with Individuals via Email

Older versions of iPhoto allowed you to choose one or more photos, automatically open the Mac's Mail program, and easily share your selected images with individuals via email, as opposed to publishing them within a public online forum, such as Facebook or Flickr.

Now, the process of selecting and emailing images to individuals is more streamlined. Simply choose the photo(s) you want to send, click on the Share command icon, choose the Email option, and insert the recipient's email address into the onscreen email message that iPhoto '11 creates. Again, you do all this now from within iPhoto '11, as shown in Figure 2.7, so you don't need to access the Mac's Mail program to email and share photos with individuals or small groups.

Another related enhancement when it comes to emailing photos, which you learn more about in Chapter 14, "Emailing or Publishing Your Photos Online," is the ability to quickly create themed emails, such as postcards or digital greeting cards, with a single click of the mouse as you select from a handful of templates displayed on the right side of the screen.

Using this feature, if you're planning a party or want to email an announcement about a new baby or engagement, for example, you can create a digital announcement card or invitation that incorporates your own photo(s) and email it to everyone on your list, all in under a minute.

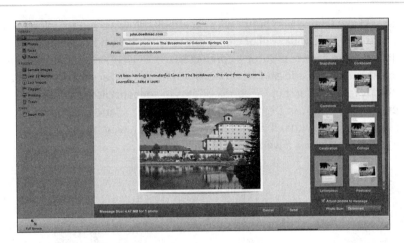

Figure 2.7 *Directly email photos from within iPhoto '11.*

Creating Professional-Looking Slideshows

Among the most impressive enhancements to iPhoto '11 are the new templates and features for easily creating animated slideshows that can be used to showcase groups of digital photos. The animated, themed slideshow templates allow you to simply drag and drop your selected photos into a slideshow that features music and professional-quality animations.

Select the photos you want to showcase in a slideshow, click on the Create icon, and choose the Slideshow option from within iPhoto '11. When you click the Themes icon, you can choose from a dozen precreated slideshow templates that can be fully customized with your own titles, choice of music, and visual effects.

When the slideshow is complete, click on the Export icon and select how you want to share your creation. iPhoto '11 custom-formats the presentation to be displayed on an iPhone, iPad, Apple TV, the MobileMe service, or on any Mac or PC computer screen. You can even upload your animated slideshows to YouTube, for example.

🌀 *As you'll discover in Chapter 15, "Creating and Sharing Slideshows," the slideshow creation process is easier than ever before; plus, this latest version of iPhoto gives you more power to create and share presentations that are extremely professional looking and engaging.*

 SHOW ME **Media 2.2—A preview of iPhoto '11's new Slideshow features**
Access this video file through your registered Web Edition at
http://www.quepublishing.com.

Traditional Photo Albums Are a Thing of the Past; Photo Books Are the Wave of the Future

In the past, if you wanted to create a photo album or scrapbook, you needed to print out all your photos, purchase a traditional album, and then insert one image at a time into that album. Depending on the type of album page you purchased, your ability to truly customize each page of your traditional photo album was limited, and unless you took the time to create prints in different sizes, you were limited to displaying each of your photos within the album using standard-size 4" × 6" or 5" × 7" prints, for example.

Photo books are a totally different concept that involves using basic desktop publishing techniques to design and lay out each page of a photo book to showcase your own digital images. By dragging and dropping your images into page templates, you can create a highly personalized and professional-looking book that can also include graphics, photo captions, paragraphs of text, and unique page layouts.

When the book is fully designed, the digital file is uploaded (via the Internet) to a print-on-demand printing service that transforms your photo book into a hardcover or soft-cover book that resembles something you'd purchase in a bookstore in terms of its appearance, binding, and overall quality.

Blurb.com has been a pioneer in creating highly professional yet inexpensive photo books. Now, this capability has been enhanced and made available from within iPhoto '11. As you create your book using templates, you can spend as much or as little time and creative effort as you want to design the overall look of your photo book.

iPhoto '11 can automatically place your images within the pages of the book and add appropriate design elements to each page. Alternatively, you can customize each page yourself, pick and choose how each image will be displayed, and then add your own theme. When the book is fully designed, from within iPhoto '11, you can order your photo book (a fee applies) and have the finished printed book mailed to you within a few days.

iPhoto '11 enables you to choose your photo book's theme, overall book layout, individual page layouts, and the appearance of each photo to be published within your book.

⊙ *To discover strategies for creating incredible-looking photo book keepsakes, gifts, and family heirlooms that showcase your photos and cherished memories, see Chapter 13, "Creating Photo Projects and Photo Gifts."*

Customized Photo Greeting Cards Replace the Need for Generic Store-Bought Cards

The concept of being able to create custom-printed greeting cards using your own photos is nothing new. The technology to do this inexpensively has been around for several years. However, in conjunction with iPhoto '11, Apple has taken the photo greeting card concept to a whole new level, with what it calls Letterpress Cards.

Letterpress Cards can be created and professionally printed one at a time or in any quantity of your choice. These cards combine traditional printing techniques with state-of-the-art digital printing technology, enabling you to create professional-looking, textured (embossed) greeting cards with your personalized text and your own photo(s) actually printed as part of the card.

In terms of quality, the result is equivalent, if not more impressive, than any greeting card you'd purchase at a store. However, the cards you create in just minutes using iPhoto '11 can showcase your own photos and personalized text messages. To create professional-looking results, however, you don't need to have any artistic abilities or even tap your own creativity. iPhoto '11 has 15 card templates, shown in Figure 2.8, that you can customize to create your own unique cards suitable for any holiday or occasion.

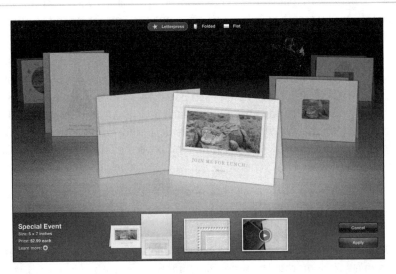

Figure 2.8 *Directly email photos from within iPhoto '11.*

NOTE
Each 5" × 7" card you create comes with a matching envelope and is priced at $2.99, which is less than many generic greeting cards sold in stores.

From within iPhoto '11, you simply create a card design, insert your photo(s) and personalized text into the template, and click the Buy Card icon. Within a few days, your professionally printed greeting card(s) will arrive at your door.

🅖 *When you combine your own photos with personalized messages and the easy-to-use card design tools offered within iPhoto '11, which you learn about in Chapter 13, "Creating Photo Projects and Photo Gifts," you'll never have to purchase generic greeting cards from a store again.*

SHOW ME Media 2.3—A preview of iPhoto '11's new Letterpress Cards
Access this video file through your registered Web Edition at http://www.quepublishing.com.

Enhanced Photo Editing Capabilities and Much More

Many of the editing and photo enhancement features built into iPhoto have also been improved within this latest version, as have the features associated with organizing, printing, sharing, and archiving your digital images.

One of the wonderful things about iPhoto '11 is that you can rely on the automated features of this application to help you enhance and edit your photos and make them look their absolute best even if you've made some mistakes when actually shooting the photos with your digital camera.

🅖 *Chapter 5, "Taking Professional-Quality Photos," and Chapter 6, "Overcoming Common Mistakes and Mishaps," teach easy-to-learn photography techniques used by the pros to help you dramatically improve the quality of the photos you take using any digital camera.*

As you'll discover, iPhoto '11 can help you correct shooting mistakes after the fact by improving the color, clarity, sharpness, lighting, and composition of your images. You can also fix common problems, such as red-eye, or add special effects to your photos with relative ease.

🅖 *How to use the simple photo editing tools built into iPhoto 11 is covered in Chapter 7, "Using iPhoto '11's Simple Photo Editing Features." You learn how to add special effects to your images in Chapter 8, "Adding Effects to Your Images."*

Going beyond the automated features that allow you to improve your digital photos, iPhoto '11 also allows you to manually edit and enhance your images by making some extremely powerful tools available to you. For example, you can manually adjust a photo's exposure, contrast, saturation, definition, shadows, sharpness, temperature, and tint to truly bring out the detail of an image or add a more creative or artistic quality to it.

Advanced photo editing techniques using iPhoto '11 are covered in Chapter 10, "Exporting Your Images."

iPhoto '11 is one of the most intuitive, feature-packed, and advanced Mac applications available for organizing, editing, enhancing, printing, sharing, and archiving all your digital photos.

Whether you want to invest just a few seconds editing or enhancing a photo, or you're willing to spend several minutes tapping iPhoto '11's more advanced editing features to create the perfect visual images before you share, print, or archive them, you can count on one thing: Even if you never improve your picture-taking abilities using your digital camera, you are able to improve the appearance of your photos after they're shot and more easily view and share them using this powerful application.

Explore the various ways to import photos into iPhoto '11, allowing you to view, organize, edit, enhance, print, share, and archive them.

3

Loading Your Digital Images into iPhoto '11

After shooting a photo using any digital camera, you need to import (or copy) it into iPhoto '11 to take advantage of the features and functions this program has to offer.

This chapter explains how to import digital images into iPhoto '11 from the following sources:

- A digital camera
- A memory card via USB-connected memory card reader
- Your Mac's internal hard drive, an external hard drive, or another storage device
- An iPhone or iPad
- Apple's MobileMe service
- An incoming email attachment
- A scanner41
- The Web

As you import your photos, you definitely should keep them organized within separate Event folders or Albums, a concept focused on later in this chapter, as well as in Chapter 4, "Organizing Your Photos."

Loading Images Directly from Your Digital Camera

Your digital camera came with a cable that connects it to your iMac or MacBook via the USB ports on both devices. Your camera most likely has a small, proprietary-size USB connection port. With your camera turned off, connect the USB cable to the camera and your Mac. Your Mac can either be turned on or off.

TIP

Some digital cameras must be set to a particular mode to be able to transfer photos to a computer, so consult the owner's manual for your camera to determine whether this step is necessary.

When both devices are connected to each other and turned on, your Mac detects the camera and automatically loads iPhoto '11 if the program isn't already running. Within a minute after the connection is established, iPhoto '11 displays thumbnails for the images currently on your camera's memory card that are available to be imported, as shown in Figure 3.1.

When both devices are connected to each other and turned on, your Mac will detect the camera and automatically load iPhoto '11 if the program isn't already running. Within a minute after the connection is established, iPhoto '11 will display thumbnails for the images currently on your camera's memory card that are available to be imported (as shown in Figure 3.1).

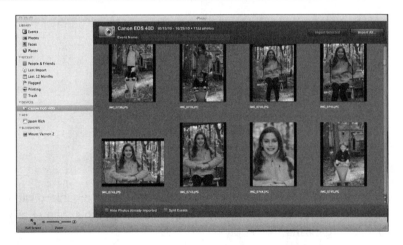

Figure 3.1 *When your Mac is connected directly to a digital camera, iPhoto '11 automatically prompts you to import the available photos.*

Importing Images That iPhoto '11 Detects

When the thumbnails of the images available for importing are displayed on the iPhoto '11 screen, you have a variety of options for importing those photos.

SHOW ME Media 3.1—Importing photos from your camera into iPhoto '11

Access this video file through your registered Web Edition at http://www.quepublishing.com.

LET ME TRY IT

Importing Photos from a Digital Camera into iPhoto '11

Before you can begin using all of the features built into iPhoto '11 to manage almost all aspects of your digital photography (except actually shooting the photos), you must transfer your images from a digital camera's memory card (or another source) into iPhoto '11. Here's how:

1. Turn off your digital camera and connect the USB cable that came with your camera to both the camera and your Mac. (Your Mac can be either turned on or off.)

2. After the two devices are connected, turn them on. Depending on your camera, you may need to set it to the appropriate mode for transferring images.

3. When your Mac detects that images are present on the camera's memory card that have not yet been imported into iPhoto, the iPhoto program will automatically launch and you'll be prompted to import your photos.

4. In the upper-left corner of the image display area of iPhoto '11, your camera name is displayed, along with the date range during which the images you're about to import were shot. The number of images available for transfer is also displayed.

5. Directly below the camera is an Event Name field. Within this field, you can type a custom name, such as **Joey's 6th Birthday Party**, for the Event folder iPhoto is about to create. The default Event name is the current date.

6. At the bottom-left corner of the image display area of iPhoto '11 are two options; you can place check marks next to them using the mouse if you want to activate them. The first option is Hide Photos Already Imported. When this option is checked, you are not given the option to import images you've previously imported into iPhoto '11. The second option is Split Events. As you import your photos, iPhoto '11 can automatically create multiple Events, based on the different dates the images were shot, if

this option is checked. So, if your memory card contains images that were shot over a three-day period, separate Event folders for your images are created in iPhoto '11 for each day. Thus, your photos are sorted chronologically.

7. Within the main image viewing area of the iPhoto '11 screen are thumbnails for the images currently stored on your camera's memory card that are available to be imported into iPhoto '11. You can either import all the photos on that memory card or manually select which images you want to import. To select specific photos, press the Command key on the keyboard while clicking on each photo thumbnail you want to import. Doing this highlights each thumbnail. When the appropriate images are highlighted, click on the Import Selected icon located in the upper-right corner of the screen.

8. To import all the available photos, click on the Import All icon also located in the upper-right corner of the screen. Your images are then copied from your digital camera's memory card to your computer and stored within iPhoto. Depending on the resolution in which the images were shot and the number of images being transferred, this process could take several minutes. In the upper-left corner of the screen, an animated blue progress bar is displayed during the transfer process.

9. When the transfer process is complete, thumbnails of the images you copied into iPhoto '11 are displayed under the heading Last Import. If you click on the Events option on the left side of the iPhoto '11 screen, you'll discover your newly created Event folder(s). Your images are now ready to be viewed, edited, enhanced, printed, shared, or used within photo projects.

10. Click the Eject button on your Mac's keyboard or drag the camera's icon to the iPhoto Trash in the Source list on the left side of the screen to close the connection between your camera and the Mac. You can now turn off your digital camera and disconnect the USB cable.

CAUTION

After the images are copied from your camera's memory card into iPhoto '11, you have the option to delete the images from your camera's memory card. For now, click on the Keep Photos icon until you have confirmed that all your images have transferred correctly. You're better off keeping copies of the photos on the camera's memory card for now as a backup and then manually formatting your camera's memory card later, after you know the images have transferred safely and have been backed up.

> **TIP**
>
> Before initiating an image transfer between your camera and Mac, make sure your digital camera's battery has ample power remaining; otherwise, the transfer process could stop mid-session if the battery dies. This could result in image data being lost or corrupted.

Wirelessly Transferring Images Between Your Camera and Mac

It is possible to wirelessly transfer images between your digital camera's memory card and your Mac if a Wi-Fi Internet connection is available, you possess a Wi-Fi–compatible memory card or camera, and on your Mac you have Wi-Fi turned on.

Follow the transfer directions provided by your wireless memory card or camera manufacturer because the process varies based on what equipment you're using.

> **NOTE**
>
> Eye-Fi, Inc. (www.eye.fi) offers wireless camera memory cards, starting at $49.95 (4GB capacity), which are compatible with virtually all digital cameras. A memory card adapter may be required, however, to use an Eye-Fi card with your camera.

Importing Images from a Memory Card Reader Using a USB Connection

Instead of transferring images into iPhoto '11 directly from a memory card that's inserted into your digital camera, you can use a separate memory card reader (with the camera's memory card inserted), which also connects to your Mac via a USB cable.

The benefit to using a memory card reader is that you can leave it connected to your Mac, and it doesn't require battery power from your camera to operate. You simply insert the camera's memory card into the appropriate slot of the memory card reader, connect the card reader to your computer via a supplied USB cable, and you're ready to transfer files.

Memory card readers are readily available from consumer electronics and photography stores. Some support just one memory card format, whereas others have multiple slots and are compatible with many different memory card formats. The cost of a good-quality memory card reader is between $15 and $40.

CAUTION

When purchasing a memory card reader, make sure it is compatible with the memory card format your camera uses. There are more than a dozen different memory card formats.

To transfer (or copy) your digital photos from your camera's memory card using a memory card reader, first connect the memory card reader to your Mac using the supplied USB cable. Your Mac can be turned on or off while you make this connection.

With the Mac turned on and the memory card reader connected, insert the camera's memory card containing your digital images into the memory card reader. Your Mac detects that a memory card containing new digital images for import has been connected, and iPhoto '11 loads automatically. At this point, follow the import directions described earlier in the "Importing Images That iPhoto '11 Detects" section.

Adding Images into iPhoto '11 from Your Computer's Hard Drive

If you have digital images stored on your computer's internal hard drive, an external hard drive, or a flash drive that you'd like to import (copy) into iPhoto '11, connect the external drive containing the image files, if applicable, to your computer.

After the drive is connected (a step that isn't necessary if you're loading images from the Mac's internal hard drive), open Finder on your Mac by clicking the Finder icon located on the Dock at the bottom of the screen (see Figure 3.2).

Next, locate and highlight the directory containing the photos you want to import. You can import all images in a directory by simply dragging and dropping the entire directory from the Finder into the iPhoto '11 main viewing window. Alternatively, you can open a specific directory within Finder, select and highlight one or more images to import, and then drag and drop those images into the main photo viewing area of iPhoto '11.

Another way to import photos that are stored on a hard drive (or flash drive) into iPhoto '11, without using Finder, is to select the Import to Library command under iPhoto '11's File pull-down menu (see Figure 3.3).

Figure 3.2 *Use Finder to easily drag and drop images from a hard drive to iPhoto '11.*

Figure 3.3 *You can import files from your computer's hard drive, an external hard drive, or a flash drive, for example, using the Import to Library command under iPhoto '11's File pull-down menu.*

When you use any of these methods to import photos from your hard drive, a new Event folder is created in iPhoto '11 to accommodate those images.

TIP

The Import to Library command can also be used to import image files into iPhoto '11 from a CD or DVD that's inserted into your Mac's drive. During the import (copying process), do not eject the disc. Using this method, you can import entire directories of photos, or you can select one or more individual image files.

Importing Photos Received via Email into iPhoto '11

One of the convenient new features of iPhoto '11 is that you can send and share photos via email without ever leaving the iPhoto program (assuming your Mac is connected to the Internet). It's also easy to import photos you receive from other people via email; however, you need to use your regular email program to do this.

If you're using Apple's Mail application, follow these steps:

1. Open the email message containing the photo attachment.

2. Open iPhoto '11 but manually shrink the program window so that you can see the Mail application and iPhoto '11 simultaneously on your Mac's screen. You can do this by positioning the mouse on the extreme lower-right corner of the iPhoto '11 program window. Hold down the mouse button and drag the program window diagonally up and to the left. Do the same for the Mail program window.

3. From the Mail application, drag the photo that's attached to the email directly into iPhoto '11's photo viewing window to import it, as shown in Figure 3.4.

4. Alternatively, with the email message open, you can click on the Save icon within the email message header and choose the Add to iPhoto command, as shown in Figure 3.5. Using this method, you don't need to drag and drop any files. The image or images are saved in a newly created Event folder within iPhoto '11. (The default name for the Event folder is the current date.)

Ⓖ *Chapter 14, "Emailing or Publishing Your Photos Online," explains how to email images to others from within iPhoto '11.*

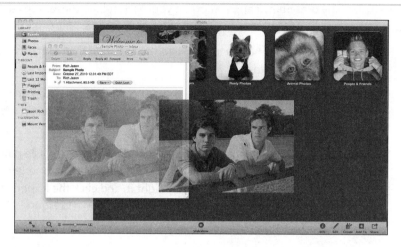

Figure 3.4　*Drag the photo attachment from an email to the photo viewing area of iPhoto 11 to import it.*

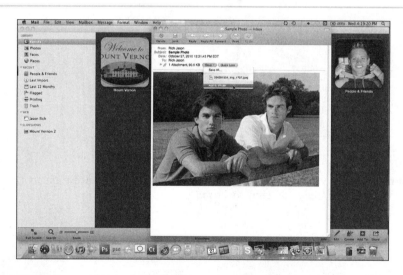

Figure 3.5　*From within Apple's Mail application, you can also transfer a photo that's attached to an incoming email directly into iPhoto '11 using the Add to iPhoto command.*

If you're using any other email application on your Mac, follow these steps to import a photo that's attached to an incoming email message:

1. Use your email program to open and read the message that contains the attached photo or photos.

2. Save the attached photo to your Mac's hard drive (on the Desktop or within the Pictures or Downloads folder, for example). Remember in which directory you save the image.

3. From iPhoto '11, use the Import to Library command under the File pull-down menu. When the Import Photos window appears, access the directory where you saved the emailed image, highlight it, and click the Import icon located in the lower-right corner of the window, as shown in Figure 3.6.

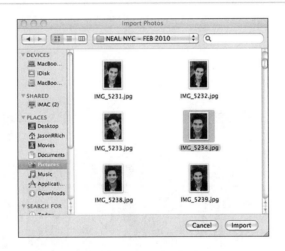

Figure 3.6 *After you save a photo that was attached to an email, you can import it into iPhoto '11 using the Import to Library command.*

TIP

From the Safari web browser, if you're accessing Google Gmail, Yahoo! Mail, or Microsoft Hotmail and want to import a photo that's attached to an email message, open the message to view the image. While viewing the image, press the Control key while simultaneously clicking on the image and then select the Add Image to iPhoto Library option.

Importing Digital Photos from Your iPhone or iPad

Just as you transfer or sync many other types of data between your computer and your iPhone/iPad, you use a sync process to transfer photos between an iPhone or iPad and iPhoto on a Mac.

 LET ME TRY IT

Importing Digital Photos from Your iPhone or iPad

Follow these steps to quickly move photos shot and stored on your iPhone (or stored on your iPad) into iPhoto '11:

1. Connect your iPhone/iPad to your computer using the standard Dock Connector to USB cable that came with your phone.

2. iPhoto should automatically open when the iTunes Sync process begins because iPhoto automatically detects there are images stored on your iPhone (or iPad) that need to be transferred.

3. After a minute or two (sometimes less, depending on the number of photos to be imported), thumbnails of the images stored on your iPhone/iPad appear within the iPhoto image viewing area. You can now choose which images you want to import or opt to import all the images.

4. Follow the directions offered with the "Importing Images That iPhoto '11 Detects" section earlier in this chapter.

5. The photos you import from your iPhone/iPad are included within a newly created Event folder within iPhoto '11. The default name of the Event is the current date.

CAUTION

Do not disconnect your iPhone/iPad from your Mac during the file transfer process. Also, when the transfer is complete, make sure the images have been copied correctly before you delete them from your iPhone or iPad.

> **NOTE**
>
> It is possible to import photos into iPhoto that were taken using another type of cell phone, Smartphone, or tablet. Follow the directions that came with your mobile device for transferring images to your Mac's hard drive. When the photos are stored on your Mac's hard drive or on an external hard drive, for example, follow the directions described in the "Adding Images into iPhoto '11 from Your Computer's Hard Drive" section earlier in this chapter.

From within iTunes, you can customize the photo-syncing process between your Mac and iPhone or iPad. Connect your Apple mobile device to your Mac and allow iTunes to load. On the left side of the iTunes screen, under the Devices heading, highlight your iPhone or iPad. The Summary screen appears for that device. At the top center of the iTunes screen, click on the Photos icon. You can now customize your photo-syncing preferences.

Transferring Images from MobileMe to iPhoto '11

Apple's MobileMe is designed to work seamlessly with iPhoto '11. The process for creating, publishing, and sharing online photo galleries on MobileMe is covered in Chapter 16, "Using Apple's MobileMe with iPhoto '11." Although you can upload and publish photos to MobileMe, you can also import or copy photos from MobileMe to iPhoto '11 using the following steps:

1. Assuming you have a MobileMe account already set up, it is displayed under the Web heading on the left side of the main iPhoto '11 screen. Click on the MobileMe icon to access photos already on the site.

2. The main iPhoto '11 image viewing window contains thumbnails that represent online Galleries already published on MobileMe. Open any online photo Gallery by double-clicking it; then choose which photos you want to import into iPhoto '11 by selecting each of them. To do this, hold down the Command button while clicking on the desired images. As shown in Figure 3.7, a yellow border appears around the selected image or images.

3. Using the mouse, drag the highlighted/selected images to the Events heading that's located at the top-left side of the iPhoto '11 screen.

4. A new Event folder is created, and the photos from MobileMe you selected are downloaded and placed within this Event folder. The default Event name is the current date.

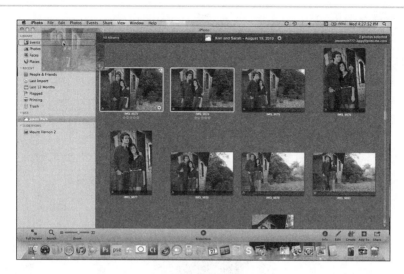

Figure 3.7 *Select images stored on MobileMe that you want to import into iPhoto.*

Using a Scanner to Transfer Hard-Copy Prints into iPhoto '11

A scanner allows you to create a digital image file from any type of hard-copy photo or artwork. Depending on the scanner you have, use the method outlined in its manual to create a digital image scan and save the scanned image on your hard drive in a .JPG or .TIFF format. Remember within which directory you store the saved image.

To load the saved image that was just scanned and is now stored on your computer's hard drive, follow the steps described in the "Adding Images into iPhoto '11 from Your Computer's Hard Drive" section earlier in this chapter.

Your scanner may have come with its own photo-scanning software; however, after the scanner is connected to your Mac, you can also use the Import from Scanner command under the File pull-down menu within the Preview program that comes bundled with all Macs.

Using Preview, select the Import from Scanner command, place your hard-copy photo (print) on the scanner bed, and adjust the options that appear in the Import from [Scanner Name] window, as shown in Figure 3.8.

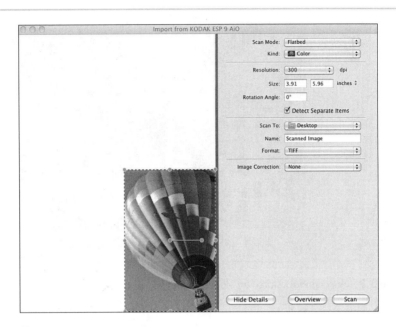

Figure 3.8 *You can scan any hard-copy image using a scanner and save it in a popular graphic file format, such as .JPG or .TIFF. Choose a directory in which to store the scanned image on your hard drive (such as Pictures or Downloads).*

After the hard-copy picture (or print) is scanned, choose the Save command to store it in the directory and in the file format you desire. To import the image into iPhoto '11, follow the steps described in the "Adding Images into iPhoto '11 from Your Computer's Hard Drive" section earlier in this chapter.

Importing Photos from the Web into iPhoto '11

As you surf the Web, you may come across photos you want to save and import into iPhoto. To copy a photo you see on a website (provided that it's not protected), simply hold down the Control key on the Mac's keyboard and simultaneously click on the desired photo.

A window appears, giving you multiple options for saving that image. The fifth option from the top is Add Image to iPhoto Library (as shown in Figure 3.9). Select this command by clicking on it. That selected photo from the Web is automatically copied into iPhoto and inserted into a newly created Event folder, with the default name being the current date.

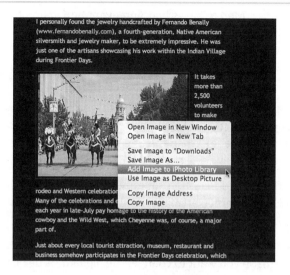

Figure 3.9 *You can import a photo from a webpage into iPhoto using the Add Image to iPhoto Library option.*

CAUTION

Copyright laws apply to all images and photos displayed on the Web, so be careful how you use the images you copy directly from websites or blogs operated by other people or businesses.

NOTE

Not all artwork on the Web can be copied using this method. It is possible for website designers to add copy protection to images displayed on websites, in which case the method for importing photos from the Web described in this section does not work.

Changing Image Filenames After They're Loaded into iPhoto '11

Regardless of how you import photos into iPhoto '11, after they're placed into Events, you have the option to custom name each Event folder. You can also change the default filename given to each image, plus associate a description, rating, or keywords with the image, and also add Faces and Places tags.

SHOW ME Media 3.2—Changing event and image filenames
within iPhoto '11
Access this video file through your registered Web Edition at
http://www.quepublishing.com.

When looking at the Event folders within iPhoto, you can change the name of an
Event by clicking on the current Event name once (it's displayed below the Event's
Key Photo thumbnail image). When the title field becomes active, and the text is
highlighted in blue, simply type in the new Event name you want.

To change the filename, description, rating, keyword, as well as the Faces or Places
tags associated with a particular image, double-click the Event folder in which the
desired image is stored.

When the thumbnails for the images within that Event appear, click on the current
filename of the image you want to change. The filename is displayed below the
image thumbnail, as shown in Figure 3.10.

Figure 3.10 *To change the filename for an image, click on the current filename displayed
under the image's thumbnail and type in a new filename.*

With the desired image highlighted (surrounded by a yellow border), to associate a
description, rating, or keywords to that image, click on the Info command icon
located in the lower-right corner of the screen.

In the Add a Description box that appears on the right side of the screen, as shown
in Figure 3.11, you can add a text-based description to be associated with that
photo.

Also in the Info window that appears on the right side of the screen, you can add a
rating for that image by clicking on the number of stars (between one and five)
that appear next to the image's filename.

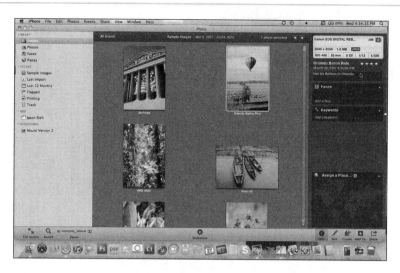

Figure 3.11 *A photo's description can be a short phrase or sentence.*

About halfway down the Info window is a field for entering keywords to associate with that image. Enter a keyword or phrase and then press the Return key. You can enter multiple keywords or phrases for each photo.

To tag the photo with the names of the people featured within it, place the cursor directly on one of the faces appearing in the photo. A white box appears. Adjust the size of the box to accommodate the person's entire face. Below the box, in the Name field, enter the person's name (see Figure 3.12). Repeat this process to tag each person appearing in a photo.

Finally, if your camera or its memory card doesn't have geo-tagging built in, you can manually enter the geographic location where the photo was taken. To do this, refer back to the Info screen and click on the Assign Place command located toward the bottom of it. Manually enter the city, state, or country where the photo was shot. A Google Map appears displaying that location.

TIP

The more information you enter about each of your photos, the easier it will be to find them later when using iPhoto '11's Search feature.

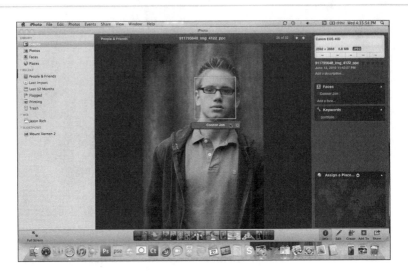

Figure 3.12 *Tag the people in your photos so you can later use the Faces feature of iPhoto '11 to sort your images based on who appears within them.*

> **TIP**
>
> If you don't want to spend time renaming each individual image stored within an Event, you can also add a description, keywords, face tags, and geo-tagging to an entire Event by highlighting just the Event from iPhoto's main screen and then clicking on the Info command icon.

ⓖ *More information about how to organize and sort Events, Albums, and individual images is included in Chapter 4, "Organizing Your Photos."*

The Next Step...

After importing photos into iPhoto '11, you can begin to view, organize, edit, enhance, print, share, and archive them using the many features and functions built into the software.

> **TIP**
>
> After image files are safely transferred from your camera's memory card, you can erase or reformat that card and reuse it over and over again.

4

Organizing Your Photos

On the left side of the iPhoto '11 main screen is the Source list. From here, you have access to images stored in iPhoto and can choose which photos to view, edit, or print at any given time. You can also use the options available in the Source list, as well as the program's pull-down menus, to organize your images.

When you first start using iPhoto, the concept of organizing all your digital images might not seem important. However, after you amass a collection of hundreds, thousands, or even tens of thousands of unique images, you'll discover a need to keep your images well organized within properly labeled Events and Albums so that you can easily refer back to and find particular images later.

This chapter focuses on organizing all your digital photos using iPhoto '11, whether they're stored on your Mac's internal hard drive, an external hard drive, or any of the online-based photo storage services with which iPhoto '11 is compatible (including MobileMe, Flickr.com, and Facebook).

Because this chapter emphasizes the tools available from iPhoto's Source list, displayed on the left side of the main screen, you also learn how to keep your various Photo Projects created using iPhoto organized, properly labeled, and easily accessible.

In addition to explaining how to organize and sort your digital images, this chapter describes how to search for images based on their filename/title, date, keywords, location, rating, tags, or people who appear within them.

Finally, this chapter discusses how to delete individual images or entire collections or groups of images (stored within Events or Albums).

iPhoto '11's Source List

When using iPhoto, you can find the majority of the commands for accessing and using the program's many features in one of four main areas: at the top of the screen in the form of pull-down menus, at the bottom of the screen in the form of command icons, on the left side of the screen in the form of functions and features

available from the Source list, and occasionally on the right side of the screen (when certain program windows, such as Info, are open).

Unless you're using iPhoto '11's new full-screen viewing mode, on the left side of the screen, the Source list is displayed (see Figure 4.1). What appears within the list changes based on how you use iPhoto.

Figure 4.1 *iPhoto '11's Source list.*

The options available from the Source list allow you not only to organize and quickly access images stored in iPhoto '11, but also easily access images iPhoto '11 uploaded and published to certain online services, including MobileMe, Flickr.com, and Facebook. If applicable, these web sources are listed under the Web heading in the Source list.

As you know, iPhoto '11 also allows you to create a wide range of Photo Projects using your photos combined with templates and features built into the program. For example, you can create impressive animated slideshows, design professional-quality photo greeting cards, publish fully customized photo books, and group together images into virtual Albums.

All the Photo Projects you create can be accessed with a click of the mouse from the Source list. They're available under headings displayed based on the Photo Projects you create, including Projects and Slideshows, for example.

The Library

The Library section of the Source list gives you instant access to various options used to view and organize your images. Keep in mind that iPhoto '11 always showcases thumbnail versions of your images to help you view and organize them. You can adjust the size of the thumbnails being displayed using the Zoom slider located in the lower-left corner of the screen.

Events

When you click and highlight the Events heading at the top of the Source list, each Event folder containing your images is displayed in the main image viewing area of the screen.

Every time you import new images into iPhoto '11 from your digital camera or another source, a new Event folder is created that contains those images. By default, Events are labeled and sorted based on date.

You can easily change the name of each Event folder and then organize your folders on the screen alphabetically, by keyword, title, rating, or manually using the commands under the View pull-down menu when the Events screen is displayed (see Figure 4.2).

Every individual photo you import into iPhoto '11 must have a permanent home within a single Event folder. That same image, however, can be utilized and showcased in any number of separate Albums or Photo Projects, for example, but it can be stored in only one Event folder.

TIP

If you want the same image to appear in multiple Event folders, you must copy and rename that photo. For example, if you alter a full-color image into black and white, or you edit an image but also want to retain the original version, this is possible as long as you assign different filenames to each version of the photo.

Events can be organized in many different ways, based on your personal preference. Again, by default, whenever you import new images into iPhoto, a new Event folder is created using the current date as the Event folder name. Thus, even if you

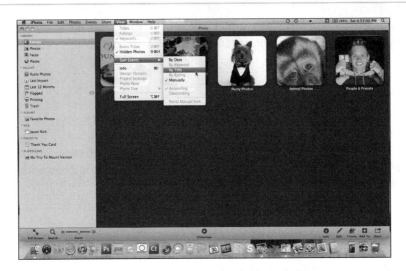

Figure 4.2 *You can reorganize how Event folders are displayed on the screen using the commands found under the View pull-down menu.*

change the names of your Event folders, iPhoto '11 automatically sorts and organizes your photos based on date. There are many other ways, however, to sort your images.

When the Events option is highlighted on the Source list, and your Event folder thumbnails are displayed in the main image viewing area of iPhoto, use the commands under the Events pull-down menu to perform a variety of functions to help you better organize and manage your photos.

From the Events pull-down menu, you can choose the following:

- **Create Event**—You use this option to create a new Event folder when new images are imported into iPhoto '11.

- **Create Event from Flagged Photos**—If you flag photos from other Event folders, you use this command to transfer those selected images into a newly created Event folder (keeping in mind that each image can be stored within only one Event folder).

- **Merge Events**—You can combine the contents of multiple, currently separate Event folders into a single folder by using this command. To use this command, select and highlight two or more Event folders and click on this command, or drag and drop one folder on top of the other. You can then rename the newly merged Event folder.

- **Make Key Photo**—By default, iPhoto '11 displays a random thumbnail of an image stored within each Event folder. Using this command, you can choose to have a single photo of your choice always used as the thumbnail image that's displayed to represent that particular folder.

- **Add Flagged Photos to Selected Event**—If you flag individual images currently located in other Event folders, you can transfer them into another pre-existing Event folder by using this command.

- **Autosplit Selected Elements**—In situations in which you have an existing Event that contains lots of photos, you can it divide into multiple separate Events automatically, based on the dates. Photos shot on the same day or within a time period can be split into their own Event folders.

TIP

If you want to split an Event containing photos all taken on the same day, you can use the Autosplit Selected Elements feature to automatically divide the photos based on a specific time increment. To do this, go to the iPhoto pull-down menu and select Preferences. From the General Preferences window that appears, it's possible to autosplit events based on the options One Event Per Day, One Event Per Week, Two-Hour Gaps, or Eight-Hour Gaps.

Photos

Under the Source list on the left-side of the iPhoto '11 screen, when you click on the Photos option, within the main image viewing area of iPhoto, thumbnails of all of your stored images are displayed. A divider bar, shown in Figure 4.3, is displayed as you scroll downward, to visually separate the Events where images are stored.

As part of the divider bar, the Event folder's name, date range of the images contained within it, and the total number of photos within the Event folder are displayed.

By adjusting the Zoom slider (in the lower-left corner of the screen), you can make the thumbnails of your images appear larger or smaller on the screen. The smaller the thumbnail size, the more images you are able to see at once on the screen. Use the scrollbar on the extreme right side of the iPhoto screen (or your mouse's scroll ball) to scroll downward and view all your images.

When in this Photos viewing mode, use the commands found under the Photos pull-down menu to help you organize and sort your images. For example, you can manually change the dates associated with your images, rotate images, or display them in order based on rating (as opposed to date). From this pull-down menu,

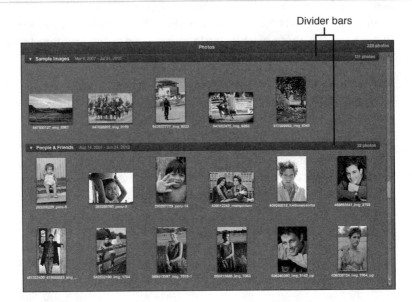

Figure 4.3 *When you view all your photos in the Photos mode, a divider appears to visually tell you when you're viewing images in different Event folders.*

you can also duplicate or delete images or revert them to their original appearance after they've somehow been edited, enhanced, or altered.

As you view your images in the Photos mode, you can also control how much information pertaining to each image is displayed on the screen, in addition to its thumbnail. This is done from the View pull-down menu. For example, in addition to each thumbnail, you can view each image's filename/title, rating, and related keywords. You can also sort the images based on a wide range of criteria offered by the Sort Photos command (also located under the View pull-down menu).

When you have the View image filename and ratings options selected, as you're viewing your images in the main viewing area of iPhoto, you can move the mouse cursor over any individual image to add a rating or click on the filename itself to manually change it.

By placing the mouse cursor on a specific thumbnail, a small circle with an arrow pointing downward appears in the lower-right corner of that thumbnail. Click on this icon to access a new window that allows you to quickly rotate an image, hide the image, delete the image, or add a star-based rating. You also can cut, copy, or paste the image and show the images just within the Event folder where it's stored (see Figure 4.4).

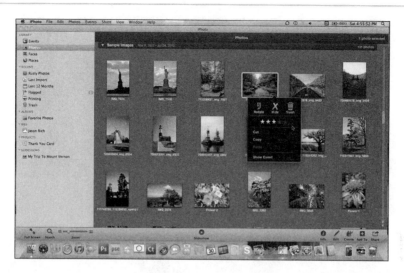

Figure 4.4 *In the Photos view, you can perform some editing, organizational, and sorting tasks related to individual images.*

As you're looking at thumbnails for all your images currently stored within iPhoto, view details about specific images by clicking on the Info command icon located in the lower-right corner of the screen. This Info screen displays information about the entire Event folder, unless a specific image is selected and highlighted, in which case the Info window displays details about that particular image on the right side of the screen.

After you click the Info icon while in Photos viewing mode, the iPhoto screen is divided into three main sections (see Figure 4.5). On the left is the Source list. In the middle of the screen is the image viewing area, and on the right is the Info window.

When the Info window is open, it is possible to add information about a particular photo by selecting/highlighting that photo. To do this, place the mouse on the photo and click once. A yellow border appears around the image's thumbnail.

Double-click on the image within Photos mode to view the image in full size. To return to the thumbnail view in Photos mode, click the Photos arrow icon displayed in the upper-left corner above the photo. You can also view an individual image even in a large size by entering into full-screen mode.

When an image is highlighted (even if you're just looking at its thumbnail in the Photos viewing mode), you can move over to the Info window and add information, such as a description, keywords, or Faces tags.

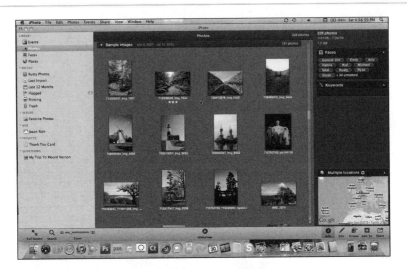

Figure 4.5 *When you use the Photos viewing mode, if you click on the Info icon, the screen is divided into three main sections.*

 SHOW ME Media 4.1—View all your iPhoto images using the Photos viewing mode and discover how it differs from viewing Events

Access this video file through your registered Web Edition at http://www.quepublishing.com.

 LET ME TRY IT

Viewing All Images in iPhoto '11 Using the Photos Viewing Mode

The Photos viewing mode is a great way to quickly view thumbnails for all your images stored within iPhoto '11. To use this feature, follow these steps:

1. Click on the Photos command under the Source list on the left side of the iPhoto screen.

2. Within the main image viewing area, thumbnails for all your images appear. Use the scrollbar on the extreme right side of the screen to make your way downward and see all your images, or use the scroll ball of your mouse.

3. Although all your images are displayed in thumbnail form when you select the Photos option, you can tell in which Event folder each is stored because iPhoto displays dividers. To quickly select all images within a particular Event, click the mouse on the divider bar for that Event. To hide the thumbnails within a particular Event folder, click on the small arrow icon located on the extreme left side of the divider bar for that Event. When the arrow icon points to the right, the thumbnail images are hidden from view. When the arrow icon points downward, the thumbnails for the images associated with that Event folder are displayed.

4. In addition to viewing the thumbnails for your images using the Photos view mode, display each image's filename (title), rating, or related keywords, based on the options you choose from the View pull-down menu.

Faces

The Faces function built into iPhoto '11 allows you to sort and organize your photo library based on who actually appears within each of your photos—both in solo and group shots.

So, even if you have thousands of photos stored within iPhoto, you can quickly perform a search for all photos featuring a particular person and see thumbnails of those images within seconds.

Initially, you need to identify and tag the various people appearing in photos you shoot. However, the cutting-edge programming used in the Faces feature allows the software to eventually learn to identify and tag recurring people automatically.

Faces utilizes the face-recognition functionality that was originally added to iPhoto '09. In this latest edition of iPhoto, this functionality has been enhanced a bit to improve accuracy and make it even easier to organize photos based on who appears within them.

When you select the Faces option from the Source list, the iPhoto image viewing area displays a virtual corkboard with square thumbnails featuring images of people's faces (see Figure 4.6). Each thumbnail represents one person that iPhoto has been able to identify in your digital photo collection.

When you double-click on a thumbnail, you see thumbnails of all photos stored in iPhoto that feature that particular person. From this screen, shown in Figure 4.7, you have several command icons available. For example, in the upper-right corner of the display, you can use the slider to select to view thumbnails that showcase each entire image featuring that person, or you can have the thumbnails zoom in on just the person's face.

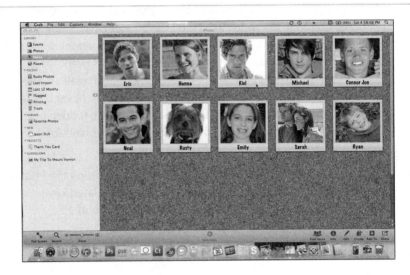

Figure 4.6 *Faces uses face-recognition capabilities to automatically sort your images based on who appears within them.*

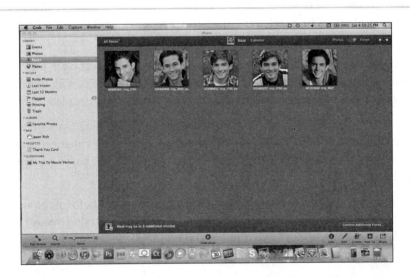

Figure 4.7 *You can get a close-up look at all photos of a particular person that you have stored within iPhoto '11.*

The Faces functionality isn't always 100% accurate. Sometimes, iPhoto is not sure of someone's identity but makes an educated guess and classifies the person in that photo as an "Unconfirmed Face" at the bottom of the display. You then have the

opportunity to confirm that person's identity, after which his or her photos are grouped together with other images that person appears in.

> **TIP**
>
> Occasionally, iPhoto '11 will wrongly identify someone in a photo. When this happens, you can quickly fix the misidentification by highlighting and selecting the photo to view it. Next, click on the Info command, and then on the Faces label within the Info window. Place the cursor over the person's face in the photo. Double-click on the person's name under the Faces box that appears in the photo, and manually type the subject's correct name.

Every time someone new appears in one or more of your photos, if you want Faces to be able to sort your images based on who appears within them, you need to tag each new person after his or her photo has been imported into iPhoto '11.

To tag someone using the Faces feature, double-click on that photo's icon so it appears enlarged in iPhoto's image viewing area. Glide the cursor over each person's face until a white box appears. Click the mouse once and then enter the person's name in the field that appears below the white box (see Figure 4.8).

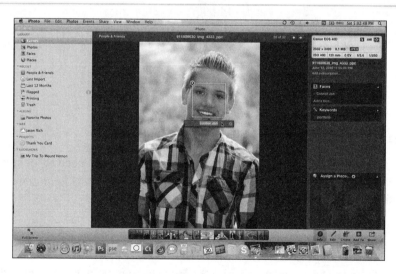

Figure 4.8 *You need to tag each person at least a few times in your photos to help iPhoto's face-recognition function learn to identify that person accurately in the future.*

You can also add face tags by clicking the Info command icon when an image is open, move the cursor to the Faces area within this window, and then click on the Add a Face option.

After you have manually added face tags to the same person in several different photos, iPhoto will begin to automatically recognize that person in the future. At that point, manually adding the face tags for recurring people is not necessary.

Although Faces groups together photos featuring individual people and allows you to view those photos simultaneously, the actual location where these photos are stored remains within the original Event folder, unless you manually move them.

> **NOTE**
> Faces, which sorts photos based on the individual people featured within them, is just one of the ways iPhoto '11 allows you to sort, organize, locate, and view your images.

> **NOTE**
> If you plan to use Faces to help you identify people in photos quickly and want the ability to find images using people's names with the Search feature, you should make sure that the people who appear within each of your photos are properly tagged.

 LET ME TRY IT

Manually Adding a Face Tag to an Image

Each time a new person appears in one of your photos, you'll need to identify him or her so that iPhoto '11 can use its face-recognition technology to automatically identify that person in the future. Here's how:

1. Highlight and select the photo.

2. Click on the Info command icon.

3. Within the Info window, click on the Faces heading and then on the "Add A Face" option.

4. Move the cursor into the image viewing area and place the white Faces box that appears around the subject's face.

5. Click on the "Click To Name" field below the white Faces boxes and manually type the subject's name.

6. You may need to identify the same person in a few different photos before iPhoto '11 automatically and consistently is able to identify them accurately as you import new photos.

Places

From the Source list on the iPhoto '11 screen, when you click on the Places option, which is located under the Library heading, you discover that the familiar thumbnails of images you're accustomed to seeing in the image viewing area of iPhoto are replaced by a map (see Figure 4.9).

Figure 4.9 *Using the Places feature, you can view maps and see exactly where your photos were shot.*

By clicking the options in the upper-left corner of the map screen, you can see a pull-down list of all the countries, states, cities, and places where you have taken photos.

In the upper-right corner of the iPhoto's map screen, you can choose to view a Terrain Map (shown in Figure 4.10), Satellite Map, or Hybrid Map (shown in Figure 4.11), just as you can when using the popular Google Maps website online (http://maps.google.com).

Figure 4.10 *The Terrain Map viewing mode using iPhoto's Places feature.*

Figure 4.11 *The Hybrid Map viewing mode using iPhoto's Places feature.*

iPhoto '11 works seamlessly with Google Maps, as well as the geo-tagging capabilities of your digital camera or camera's memory card. Thus, where photos were taken (geographically) is another way you can sort, organize, and view your images.

If your digital camera or camera's memory card does not support geo-tagging, which automatically records the GPS coordinates where each photo is shot, you can manually associate a location for each image in iPhoto.

To manually add geo-tagging information to a photo, highlight and select a photo and click on the Info command icon. In the lower-right corner of the Information window, click on the Assign a Place option and manually type the location where the photo was taken. You can enter the country, state, or city, for example. The location you enter is automatically located and displayed on the map within iPhoto.

You also can quickly and manually geo-tag all photos stored within a specific Event by highlighting that Event, clicking on the Info icon, and then clicking on the Assign a Place field in the Info window. The location you enter once is applied to all photos within that particular Event.

As you're looking at the Map view while in Places mode, notice the red pushpins on the map that represent specific locations where you've taken photos. Click on any red pushpin to reveal a tag where one or more images were shot. Now, click on the small right-pointing arrow icon to reveal an image thumbnail viewing screen that shows all images taken at that location (see Figure 4.12). If you have the Info window open as well, a small map of that location is also displayed on the iPhoto '11 screen.

The current Places location

Figure 4.12 *iPhoto '11's Places feature allows you to sort your images based on where (geographically) your photos were taken.*

 LET ME TRY IT

Manually Adding a Place (Geo-Tag) to a Photo

If your digital camera or memory card doesn't automatically geo-tag your images, you can manually associate a geographic location with any of your photos. Here's how:

1. Highlight and select a photo to which you want to add a Places tag.

2. Click on the Info command icon.

3. Near the bottom of the Info window, click on the "Assign A Place" heading.

4. When the field becomes blank, manually type the Places information you want to associate with this photo. You can be very specific by including the Country, State, and City, or just one of these geographic references.

5. If you click on the small right-pointing arrow icon next to the "Assign A Place" field, Google Maps will open within iPhoto '11 and allow you to pinpoint the location the photo was taken on an actual map.

The Inside Scoop on Albums

Albums are like Events; however, you can create them from scratch by picking and choosing any photographs stored within iPhoto. You can custom name an album (giving it a unique title) and then assign a description, date, and keywords to it. Keep in mind, each of your images is stored in one specific Event folder. However, that same photo can appear in an unlimited number of Albums.

Albums can be created to group together photos you select by subject matter, location, date, or whatever criteria you decide are relevant. You can also include the same image in multiple Albums.

There are several reasons why creating Albums (in addition to Events) is beneficial. For example, as you're going through your images, you might want to gather together specific photos from a handful of past vacations so you can create a montage slideshow or photo book. Currently, these photos may be stored in separate Events.

Albums you create are displayed under the Albums heading on the Source list. You can create an unlimited number of albums. If you're familiar with creating Playlists using your favorite songs within iTunes, Albums work in a very similar way.

Creating a New Album

To create a new Album, select at least one photo to start with, click on the Create command icon located in the lower-right corner of the screen, and choose the Album option.

The main image viewing area of iPhoto is replaced by thumbnails for the images you selected. At the top of this screen is the title "Untitled Album." At the same time, within the Source list, under the Albums heading, the Untitled Album is listed, and you are given the opportunity to type in an original title or name for your newly created Album (see Figure 4.13). This title is immediately reflected at the top of the screen. At any time, you can edit or rename an Album.

Adding Images to an Album

At any time, you can add images to an Album by accessing their respective Events, highlighting and selecting the images you want to add, and then dragging those thumbnails to the left onto the Album name located on the Source list. When you do this, the images remain in their original Event, but a copy now also appears in your Album.

Album title

Figure 4.13 *As soon as you create a new Album, you can give it a customized name.*

An alternative method for adding photos to an Album is to access the Photos option on the Source list, which reveals thumbnails of all images stored within iPhoto. You can then drag and drop any images you want from the main image viewing area to the Album title listed in the Source list (see Figure 4.14).

A third way to add photos to an existing album is to highlight and select one or more images at a time, click on the Add To command icon located in the lower-right corner of the screen, and then choose the Album option.

You can change the order in which images appear within an Album by using the commands available from the View pull-down menu's Sort Photos option. Virtually all the same commands and controls you have over images appearing in an Event are also available when viewing and organizing images with Albums.

For example, with a specific Album selected and highlighted on the Source list (with the thumbnails for the images it contains being displayed on the main view-ing image viewing area), you can click on the Info command icon and associate a description, Faces, keywords, or geo-tags to that Album as a whole. Alternatively, you can select and view a single image, click on the Info command icon, and alter information associated with that particular image.

While viewing images within an Album, you can also edit or enhance them by clicking on the Edit command icon located in the lower-right corner of the screen.

Figure 4.14 *Drag and drop new images into an Album from the Events or Photos view modes.*

*To learn more about editing and enhancing photos within Albums or Events, **see** Chapter 7, "Using iPhoto '11's Simple Photo Editing Features," Chapter 8, "Adding Effects to Your Images," and Chapter 9, "Advanced Photo Editing with iPhoto '11."*

> **TIP**
>
> To delete an Album, highlight it on the Source list and press the Delete key on your keyboard. Alternatively, you can highlight and select a specific Album and use the Delete Album command near the bottom of the Photos pull-down menu.

Working with Smart Albums

In addition to creating and working with regular Albums within iPhoto, you can set up iPhoto to autocreate customized Smart Albums for you. These albums automatically gather new photos and add them based on specific criteria you specify in advance.

A Smart Album can be created from all images that are shot at a certain location, shot with a particular camera, have a specific rating, or have a specific keyword or Faces tag associated with them, for example.

To create a Smart Album, access the File pull-down menu, highlight New, and select the Smart Album option. A new Smart Album creation window, shown in Figure 4.15, appears, allowing you to custom set the criteria to determine what images iPhoto should include within this album now and in the future as new images are imported.

From the Smart Album creation window, enter the name for the album as prompted. To customize the album's image selection criteria, use the pull-down menu options under the Match the Following Condition heading displayed in this window. You can add as many conditions as you'd like, one at a time.

To create a condition for importing specific types of images into your Smart Album, first choose an option from the leftmost pull-down option (see Figure 4.15). These options include the following choices: Album, Any Text, Description, Date, Event, Face, Filename, Keyword, My Rating, Place, Photo, Title, Aperture, Camera Model, Flash, Focal Length, ISO, and Shutter Speed.

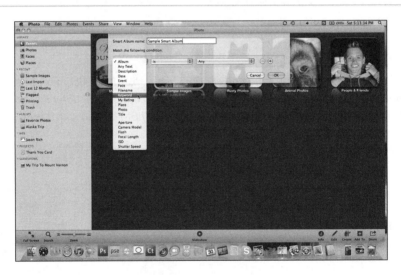

Figure 4.15 *When creating a Smart Album, you can determine the exact criteria iPhoto will use to gather images for that album now and in the future as new images are imported.*

From the middle pull-down menu, choose one of the listed options. Your choices vary, based on the option you selected from the leftmost pull-down menu.

From the rightmost pull-down menu, if applicable, select the Any option to pull relevant images from any or all of your Events, Albums, or Photo Projects. Alternatively, choose the name of a specific Event, Album, or Photo Project that's listed.

In some cases, a specific field (such as a date or keyword field) for typing relevant information is provided instead of a third pull-down menu.

To add another set of criteria for gathering photos for the same Smart Album, click on the plus sign icon located next to the pull-down menus and choose your additional criteria. Or click on the OK button located in the lower-right corner of the window.

After you set all the conditions for gathering images for this new Smart Album, the album is listed under the Albums heading in the Source list; however, it has a purple icon next to it (instead of a blue one) to signify that it's a Smart Album, as opposed to a regular Album. After the Smart Album is created, iPhoto automatically collects the appropriate images and adds them to the Smart Album. In the future, as you import new photos that match the criteria you specified, iPhoto will automatically import those photos into the Smart Album as well.

 SHOW ME Media 4.2—More information about Smart Albums and how to use them
Access this video file through your registered Web Edition at
http://www.quepublishing.com.

 LET ME TRY IT

Setting Criteria for a Smart Album

To create a Smart Album and select specific criteria for it, follow these steps:

1. Access the File pull-down menu.

2. Highlight the New option and select Smart Album.

3. When the Smart Album creation window appears, type in a filename for that album.

4. Use the pull-down menus to select specific criteria for that Smart Album. For example, if you want to gather photos in a Smart Album that have the keyword *flower* associated with them, from the first pull-down menu, select the Keyword option.

5. From the middle pull-down menu, select Contains, and in the blank field that appears to the right, type **flower**.

6. If, however, you want to gather only flower-related images shot after a specific date, click the plus sign icon and add a second set of criteria.

7. This time, choose Date from the first pull-down menu. From the middle pull-down menu, select Is After, and in the Date field that appears, enter a specific date (see Figure 4.16). Click on the OK icon to finalize these selections.

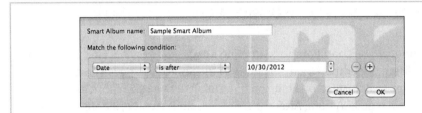

Figure 4.16 *You can set several different criteria for gathering photos in a Smart Album, such as keywords associated with an image or the date the images were shot.*

What Else You'll Find Under the Source List

In addition to the options for finding, sorting, and viewing images under the Library section of the Source list is another section called Recent. The options under this heading allow you to look back at Events, Albums, Photo Projects, and images you've viewed or utilized recently.

Recent

The first listing under the Recent heading on the Source list is always the name of the last Event you opened and accessed in iPhoto '11. If you refer to Figure 4.1, note that the last Event I opened was called Rusty Photos. When you click on this selection from the Source list, that Event folder opens and you see thumbnails of images from that Event in the main image viewing area.

Last Import

The second listing under Recent is the Last Import option. When you click on this option, you see thumbnails of the last images you imported into iPhoto.

Last 12 Months

When you click on the third option under the Recent heading, called Last 12 Months, thumbnails of all images imported into iPhoto in the past 12-month period are displayed in the main image viewing area. You can select any of these images for editing, drag and drop them into Albums, or adjust any settings for these images in the Info window.

Flagged

Within iPhoto, flagging is a way to temporarily mark images so that you can quickly separate them, find them, and do something specific with them. For example, if there are 10 images scattered through several Events that you want to include within an Album or that you want to add to a slideshow or create prints from, you can flag each of those images.

To flag an image, place the cursor over its thumbnail in Events, Photos, Faces, or Places mode. In the upper-left corner of the thumbnail, a grayscale flag icon appears. Click on that Flag icon. You know the image is flagged when an orange Flag icon appears in the upper-right corner of its thumbnail (see Figure 4.17). To unflag an image, simply click on the orange Flag icon again.

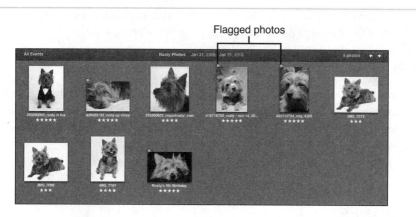

Figure 4.17 *You know an image has been flagged because a small orange Flag icon appears in the upper-left corner of the thumbnail.*

Another way to flag a photo is to highlight and select it (so a yellow border appears around it) when viewing the thumbnail or the full-size image and then choose the Flag Photo command under the Photos pull-down menu. The keyboard shortcut is to press Command + period (.).

Each time an image is flagged, the number of flagged images displayed next to the Flagged option on the Source list increases. At any time, when you highlight and select the Flagged option from the Source list, thumbnails of all currently flagged photos are displayed.

Printing

When you print anything from within iPhoto, whether it's an individual photo or a Photo Project, that print job is saved and accessible from the Printing option on the Source list.

To learn more about printing photos using your own photo printer, **see** Chapter 11, "Printing Photos Using Your Own Home Photo Printer."

Trash

The Trash icon is used much the same as the Trash icon found on the Mac's Dock for deleting files, except that this option is for deleting photos, Events, Albums, and Photo Projects within iPhoto. See the "Deleting Images" section later in this chapter for more information about deleting items from iPhoto '11.

Accessing Photos That iPhoto '11 Transferred to the Web

If you've used iPhoto to publish photos online to an Album or Gallery on Apple's MobileMe, or you've uploaded photos to Flickr.com or Facebook, you can access those web-based accounts instantly in iPhoto '11 by clicking on one of the headings under the Web option on the Source list. These options appear only after you've uploaded images to MobileMe, Flickr.com, or Facebook.

To learn more about publishing and sharing photos online, **see** Chapter 14, "Emailing or Publishing Your Photos Online," and Chapter 16, "Using Apple's MobileMe with iPhoto '11."

Deleting Images

When it comes to deleting images, Events, Albums, or Photo Projects within iPhoto '11, the Trash feature works just like the Trash feature of the Mac OS X operating system, although the items moved to the Trash in iPhoto are kept within iPhoto's own Trash folder until you permanently delete the Trash's contents.

CAUTION

To permanently delete the Trash in iPhoto, choose the Empty iPhoto Trash command under the iPhoto pull-down menu. When you do this, those files are deleted forever. Until you execute the Empty iPhoto Trash command, however, you can recover items placed in the Trash and move them back into iPhoto.

When you click on the Trash command on the Source list, the contents of iPhoto's Trash folder are displayed within the main image viewing area. As long as deleted items can still be displayed within the Trash folder, you can drag and drop or cut and paste images from the Trash folder and move them back into their original locations or create new Events or Albums with them.

To delete an image, highlight and select one or more image thumbnails, and press the Delete key on your keyboard or drag it to the Trash option displayed on the Source list. This method also works with Events or Albums, as well as Photo Projects or slideshow files.

TIP

Before executing the Empty iPhoto Trash command, which permanently erases anything found in iPhoto's Trash folder, check the folder to make sure you didn't accidentally delete a file, project, or image you want to keep.

NOTE

The Trash folder used by the Mac OS X operating system and by all your other programs is separate from the iPhoto Trash folder. Thus, even if you empty the Mac's regular Trash folder, it does not impact the iPhoto Trash folder, which you must empty separately.

 TELL ME MORE Media 4.3—More about deleting images and files using iPhoto '11

To listen to a free audio recording about creating good passwords, log on to http://www.quepublishing.com.

II

Improving Your Picture-Taking Skills Using Any Digital Camera

5 Taking Professional-Quality Photos**85**

6 Overcoming Common Mistakes and Mishaps**106**

Learn basic picture-taking techniques that pros use to help you shoot professional-quality photos with any digital camera.

5

Taking Professional-Quality Photos

iPhoto '11 is an incredible tool for handling almost every aspect of digital photography, except for one key thing...actually taking pictures. This chapter offers a handful of techniques to help you quickly and easily improve your picture-taking abilities using any digital camera.

Later, you'll want to apply some of these techniques related to photo composition when cropping and editing photos you've already taken.

Of course, if you do happen to make a minor mistake while shooting, the editing and photo enhancement tools built into iPhoto '11 can help you fix them after the fact.

Most point-and-shoot digital cameras allow you to set the resolution you want to shoot in. As a general rule, shoot in the highest resolution available to your camera. This gives you the most flexibility later when you're ready to edit your images and make large-size prints, for example. Keep in mind, the higher the image resolution, the larger the image file will be and the more storage space it will require on your computer's hard drive.

To learn how to avoid making some of the most common mistakes while actually taking pictures, **see** Chapter 6, "Overcoming Common Mistakes and Mishaps."

A Good Photographer Is Always Prepared

Many of the most basic point-and-shoot digital cameras available today (including those built into cell phones) are compact, easy to use, and chock full of features designed to make taking quality pictures in virtually any situation a straightforward process. With this fact in mind, however, as the photographer, you still need to make some important decisions when snapping photos.

Regardless of what you're photographing, if you want to improve your picture-taking skills, be prepared to follow these 10 basic steps to help you get started:

- **Learn how to use your camera**—Every camera has its own combination of dials, buttons, menus, shooting modes, and features. Invest the time to get to know your camera. This way, when you're actually taking pictures, you don't have to fumble around looking for the right button, dial, or menu option or miss out on photo opportunities because you needed to consult with the owner's manual to figure out how to turn the flash on or off, for example.

TIP

As you practice using your camera, get into the habit of turning it on and off quickly, removing the lens cap (if applicable), and setting the menu options to their appropriate settings for the types of photos you'll be taking. In general, when you're not taking pictures, you should protect your camera lens by keeping the lens cap on, plus preserve battery life by turning off the power when it's not being used.

- **Be prepared with the batteries and memory cards you'll need**—One of the biggest mistakes amateur photographers make is forgetting to charge their camera's battery or transfer older images from their camera's memory card to their computer before setting out to take more pictures. Especially if you're taking vacation photos or shooting some type of party or event that happens only once, it's essential for you to be prepared with multiple fully charged camera batteries on hand, plus at least one extra (empty) memory card.

- **Make sure the lens is clean**—Have a microfiber cleaning cloth on hand to remove dust, dirt, water drops, fingerprints, or smudges that appear on the lens. A dirty lens results in poor-quality photos.

- **Evaluate the setting and your subjects**—After you decide who or what you want to shoot, figure out the best way to position your subjects in whatever setting you're in, taking into account the foreground, background, and available lighting.

- **Pay attention to available lighting**—Don't shoot directly into oncoming light (unless you're shooting a sunset). As a general rule, the main light source for your photos should be behind you (the photographer) and shining onto your subjects.

- **Choose an interesting shooting angle**—The most interesting photos are not always shot with the photographer simply facing his or her subject head

on. You can often create visually impressive effects by positioning yourself at an angle from your subject—either to the left or right. Sometimes you can also create very interesting effects by crouching down and shooting upward toward a subject, or positioning yourself above a subject and shooting at a downward angle (as shown in Figure 5.1).

Figure 5.1 *Sometimes you can create interesting photos by shooting downward, toward your subject from above.*

- **Think about your shot's composition**—One thing that sets professional photographers apart from amateurs is their ability to properly frame images as they're shooting, while taking into account the "Rule of Thirds"; highlighting the subject; and fully utilizing the foreground, background, and available lighting in their shots. You learn more about what photo composition is and how to utilize it later in this chapter.

- **Hold the camera very still**—As you press your camera's shutter button to take a photo, to avoid blurry or out-of-focus images, hold your camera steady, even if it has image stabilization built in. This is particularly important when shooting in low-light situations. Regardless of what type of camera you're using, try to brace your entire body against something stable, such as

a wall or tree; hold the camera with both hands (making sure your fingers are not blocking the lens or flash); and hold your breath for a few moments as you snap each photo. In some situations (especially when there is minimal light), using a tripod is necessary to keep the camera perfectly still when shooting.

- **Understand that timing is essential**—Even if you're taking posed photos of your kids, friends, pets, or family members and have time to carefully plan out your shots, knowing exactly when to press your camera's shutter button is essential. Timing becomes even more important when shooting subjects that are in motion or visuals that occur in real-time, such as a child blowing out the candles on a birthday cake or hitting a home run during a Little League game.

- **Tap your creativity**—Photography is both a skill and an art form. Essential skills include knowing how to operate your camera and frame your images. However, your ability to tap your own creativity to create photographic art each time you snap a photo will ultimately play a major role when it comes to improving the overall quality of your photos.

🔄 *To discover how to edit and enhance your photos using iPhoto '11,* **see** *Chapter 7, "Using iPhoto '11's Simple Photo Editing Features," and Chapter 9, "Advanced Photo Editing with iPhoto '11."*

Taking Advantage of Your Camera's Auto Shooting Modes

Every digital camera has a selection of "auto" shooting modes. Each is designed to take the guesswork out of picture taking but is designed to be used in a particular shooting situation.

When you set your camera to shoot in an auto mode, all the technical camera settings are automatically adjusted on your behalf. As a result, your only job as the photographer is to look through the viewfinder (or at the viewfinder display on the camera), compose and frame your shot, and press the shutter button to snap the photo.

Depending on your camera's make and model, it might just have a few different auto shooting modes for taking close-ups, landscape shots, action shots, portraits (shown in Figure 5.2), or shots without using the camera's flash. Most digital cameras also have an image stabilizer feature that automatically compensates for camera movement as you're snapping photos.

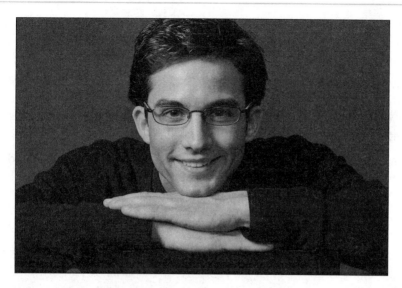

Figure 5.2 *Whenever you're shooting a portrait, for example, select the appropriate shooting mode that's built into your camera.*

> **TIP**
>
> Some cameras have very specific modes. For example, you might find one mode available for shooting portraits indoors and another for shooting portraits out-doors. Your camera may also have additional modes for shooting in specific types of weather, such as bright and sunny skies versus cloudy or overcast conditions.

> **TIP**
>
> Even with a camera's image stabilizer feature turned on, you should still hold your camera as steady as possible when taking pictures. Camera movement as you're pressing the shutter button results in blurry or out-of-focus pictures.

Choosing the Right Shooting Mode for the Situation

Even less-expensive point-and-shoot digital cameras often offer a dozen or more shooting modes for taking pictures in a wide range of situations. For example, they

allow you to shoot through glass, take pictures of fireworks, or capture large areas by shooting multiple photos that automatically are transformed into a single panoramic shot.

Many of the newer digital cameras have not only built-in face detection, which is a handy feature for taking well-focused shots of people, but also built-in smile detection, which analyzes each person's face and determines whether he or she is looking at the camera and smiling before the camera lets you snap the photo.

Depending on your camera's make and model, you adjust the shooting mode either by physically pressing or rotating a button or dial on your camera or by accessing the camera's onscreen menu options.

TIP

To ensure that your pictures turn out clear, well lit, and blurry free, you need to select the proper auto shooting mode based on the situation in which you're shooting. Get to know what shooting modes are available using your particular camera so you don't have to waste a lot of time figuring out the most suitable mode each time you snap a photo.

All Digital SLR and many point-and-shoot digital cameras also have manual or semi-automatic shooting modes. They require a more advanced understanding of the technical aspects of photography, such as how to set the proper shutter speed, aperture, ISO, and white balance. For the vast majority of pictures you'll be taking as an amateur photographer, the various auto shooting modes built into your digital camera are more than adequate.

Dealing with Shutter Lag

One of the biggest drawbacks to almost all point-and-shoot digital cameras and the less-expensive Digital SLR cameras is that they have a shutter lag. This means that there's a slight delay between the time you press the camera's shutter button to snap a photo and when the photo is actually shot.

If you happen to be shooting a moving subject, such as your child playing a sport, not properly compensating for your camera's shutter lag could result in your constantly taking photos a second or two too late, and not capturing those important moments.

Although you can't avoid shutter lag in less-expensive digital cameras, you can learn to compensate for it by following these steps:

1. Practice using your camera to become familiar with how long the shutter lag is on your camera.

2. Prefocus on what you want to shoot. This means choosing and/or zooming in on your subject, and then pressing the camera's shutter button halfway down to activate the camera's autofocus sensors so they're focused on that subject, but not yet actually shooting the photo.

3. Anticipate the action. If you know you want to take a very specific shot and timing is important, learn to press the shutter button in advance of the action taking place.

4. Take advantage of your camera's continuous shooting mode when you absolutely must capture something that's time sensitive. (This is a feature built into almost all digital cameras these days.) The continuous shooting mode allows you to press and hold down the camera's shutter button so that you can snap multiple photos in quick succession. Depending on the make and model of your digital camera, you might be able to capture 3, 5, 8, or even 10 frames per second using this shooting mode.

5. Make sure the camera battery is fully charged, and for time-sensitive photos, try to avoid using the flash, which often slows down a camera's shutter lag.

6. When purchasing a memory card for your camera, choose one with the fastest read/write speed possible (600x or 90MBps, for example). Check the technical specifications of your camera to determine its speed when saving images, and then purchase a memory card that operates as close to that speed as possible.

The Basics of Photo Composition

The difference between a truly masterful photograph and a generic snapshot is often a result of how the photographer framed an image and used basic photo composition principles in conjunction with his or her own creativity to choose the right setting, light, background, foreground, and, of course, the perfect subject. A photographer's timing is also essential, because a fraction of a second can mean the difference between capturing a perfect smile on someone's face and that same person looking away from the camera or blinking, for example.

To help you take the best possible shot each and every time, follow these steps:

- **Choose your subject**—Figure out what you want the primary focus of your photo to be, whether it's a person, an object, or a particular piece of scenery in a landscape shot. When people look at your photo later, what do you want their eyes to focus on and pay the most attention to?

- **Be creative when selecting your subject**—Determine the best way to shoot your subject to make the photo visually interesting. For example, if you're shooting a person, do you want to take a close-up of his or her face, a mid-range shot (from the waist up), a full body shot, or an extreme close-up (which might mean zooming in and focusing on the subject's eyes, while cutting the top of his or her head out of the photo). As the photographer, you can also choose the best shooting angle from which to capture your subjects.

- **Frame your subject**—Determine where you want the subject to appear within the overall frame of the image. As you learn in the next section, when you apply the "Rule of Thirds," the subject should not always be in the center of the frame. Also, you can choose to shoot while holding the camera horizontally (landscape mode) or vertically (portrait mode), which dramatically alters the appearance of the shot and helps determine how much foreground or background appears within a photo. If you're taking vacation photos of your loved ones in front of a famous tourist attraction, for example, shooting images in landscape mode makes sense because you capture more background. If you want the focus of your photo to be on the subject, and the background isn't as relevant, using your camera lens's zoom and shooting in portrait mode usually work best.

- **Choose the most appropriate shooting mode**—Selecting the right shooting mode helps to ensure the best possible outcome from a technical standpoint. Selecting the wrong mode for the situation, however, could result in light issues (overexposed or underexposed images), blurry images, or poor detail.

- **Take multiple photos of the same thing**—Especially when snapping photos of people or objects in motion, timing plays an important role when capturing your subject. By taking multiple shots back to back, you can capture the same subjects and setting, but over a several-second period. During that time, someone can change body position, change facial expression, or blink. As you take multiple shots, consider quickly switching between portrait and landscape mode (by rotating your camera) and utilizing the camera lens's zoom either more or less. You can also adjust your shooting angle slightly to reposition your subject within the frame, without you (the photographer) or your subject having to change where you're physically standing. Alternatively, you can move your position and alter your shooting perspective. (As the photographer, you'll quickly discover that even slight movements on your part make a huge difference in photos.) Also, taking multiple photos in quick succession increases the likelihood of capturing at least one perfect shot.

- **When shooting, keep your camera very still**—Use a tripod when possible. The slightest camera movement could result in a blurry image, even if your camera or its lens has a built-in image stabilization feature. Keeping your camera steady when shooting is even more important in low-light situations.

TIP

As you're taking pictures, periodically preview them in Preview mode on your camera's built-in display. Make sure the shots are in focus and see how they look. You can always make adjustments to your shooting technique as you go, as long as you know what you need to change or fix. If you wait until you return home to transfer your photos onto your Mac before previewing them, you miss the chance to retake photos and fix minor problems while you're still out shooting.

CAUTION

Refrain from deleting photos while you're out shooting. The image quality of the display built into your camera is vastly inferior to the resolution of your computer screen or what an image will look like when it's printed. Chances are, you have space for thousands of photos on your camera's memory card, so keep shooting. Wait to delete any images until after you've transferred them into iPhoto and viewed them on the computer's screen. Using iPhoto's editing and enhancement tools, you often are able to fix problems with photos. When you see the photo, in full size, on your computer screen, it may be much better quality than you initially thought.

Using the "Rule of Thirds" When Shooting and Framing Your Shots

One of the most useful shooting strategies when taking any type of picture is to incorporate the "Rule of Thirds" when looking through your camera's viewfinder and framing your images before you press the camera's shutter button.

The "Rule of Thirds" is actually simple, but when you apply it, you'll immediately notice that your photos become much more visually interesting. It's a common habit for amateur photographers to look through their camera's viewfinder at their subject when taking a photo, position the subject in the center of the frame, and then snap the photo.

The "Rule of Thirds" encourages you to position your subjects elsewhere in the frame and to fully utilize the foreground and background. To use the "Rule of Thirds," simply imagine a tic-tac-toe board being placed over your image as you look through the viewfinder. Thus, the single frame is now divided into nine boxes.

Some digital cameras allow you to display a "Rule of Thirds" grid in your viewfinder, without it appearing in your actual photos. However, on most cameras, this isn't an option, so you need to use your imagination while you're framing your shots. In your mind's eye, overlay the tic-tac-toe board (a.k.a., the "Rule of Thirds" grid), like the one shown in Figure 5.3.

Out of habit, you'd probably position your subject in the center of the middle box because that's where your eyes instinctively look. If you pay attention to the lines used to create the "Rule of Thirds" grid, however, you'll notice that within the frame, the lines intersect in four spots near the center of the image (shown in Figure 5.3).

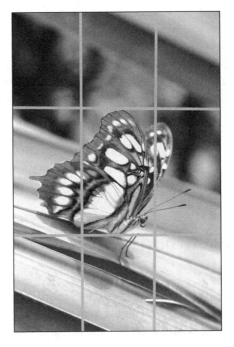

Figure 5.3 *Most amateur photographers position their subject directly in the center of the frame, as shown here. This is usually a visually boring approach to photography.*

If you adjust the positioning of your subject ever so slightly so that the main focus of your image appears centered around one of the intersection points (that is, the

subject is no longer centered within the frame), the image becomes much more visually interesting.

You can also be creative and position your subject along one of the imaginary horizontal or vertical lines of the "Rule of Thirds" grid. The goal is to avoid placing your subject in the center of the frame, but to set a scene by showcasing your subject and the foreground and/or background in a visually interesting way.

Figure 5.4 showcases a common placement for a subject within a photo, taking the "Rule of Thirds" into account. Notice in this example where the subject is positioned in reference to the gridline's intersection points.

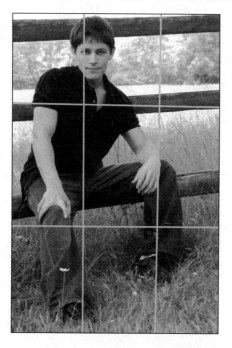

Figure 5.4 *In this photo, the main subject is positioned off-center, so it's placed at of the intersection points of the "Rule of Thirds" grid.*

TIP

As you place your subject in the frame, pay attention to which way the subject is facing. When shooting a person or animal, for example, the direction of the body as well as the direction the eyes are looking is important.

> **TIP**
>
> When you are trying to demonstrate movement or motion in your photos, that motion should always be headed into the frame, not out of it. Thus, the person viewing the photo can see where the subject is coming from and imagine where it's headed.

Prefocusing on Your Subjects

As you're taking pictures, begin by looking at your subject through the camera's viewfinder; then center the subject in the frame. Next, press and hold the camera's shutter button halfway down so the camera uses its autofocus mode to focus on your main subject. Now, move the camera slightly (or adjust the zoom lens) and reposition the main subject within the frame using the "Rule of Thirds." Determine where in the frame your subject is most visually appealing.

Next, fully press the camera's shutter button and take the photo. This ensures that regardless of where your subject is within the frame, the camera autofocuses on the subject, not on anything in the foreground or background.

> **TIP**
>
> When shooting close-ups of people, prefocus on the middle of their face. However, when shooting animals, make sure you focus specifically on their eyes. If your camera has a face-detection feature, this step isn't necessary when shooting people, but you'll want to deactivate it when shooting animals. While people can show emotions with all of their facial expressions, including their smile, animals are most expressive with their eyes.

 SHOW ME Media 5.1—Take the "Rule of Thirds" into account whenever you shoot
Access this video file through your registered Web Edition at
http://www.quepublishing.com.

 LET ME TRY IT

Using the "Rule of Thirds"

When looking through your camera's viewfinder to frame your images as you're about to snap photos, take the "Rule of Thirds" into account. Follow these steps:

1. Adjust your camera to the appropriate shooting mode based on the situation.

2. Look at your subject through the camera's viewfinder and center the subject in the frame. Next, press the camera's shutter halfway down so the camera focuses on your subject.

3. Reposition the subject in the frame using the "Rule of Thirds" and determine where in the frame your subject is most visually appealing. Next, fully press the camera's shutter button to snap the photo. This ensures that regardless of where your subject is in the frame, the camera autofocuses on the subject, not on anything else in the foreground or background.

4. Experiment by taking the same basic shot but repositioning your subject along a different intersection point on the "Rule of Thirds" grid to see how it impacts the overall visual appeal of the image.

5. Pay attention to the direction your subject is facing, the direction his or her eyes are pointing, and if applicable, the direction the subject is moving.

> **TIP**
>
> Using the Cropping tool within iPhoto, you can often reframe your images after they're shot and still take the "Rule of Thirds" into account. Chapter 7, "Using iPhoto '11's Simple Photo Editing Features," explains how to use the Cropping feature in iPhoto '11.

Choosing the Best Subjects, Foreground, and Background When Taking Pictures

The real world is three dimensional. However, when you take a photograph, you're capturing a piece of the multidimensional world using a two-dimensional medium.

The trick to adding a sense of depth in your photos is to pay careful attention to the foreground and background, as well as the primary subject within your photos. When it's applicable, include your surroundings in creative ways. Sometimes, by capturing something in the foreground (in front of the image's subject) and/or in the background, you can give your photo a true multidimensional feel.

Figure 5.5 provides an example of how you can frame your image with something from your surroundings in your photo's foreground, plus showcase an interesting background to add a sense of depth to the image.

Figure 5.5 *You can position objects in front of or behind your subjects to create a sense of depth in your photos. In this case, the main subject is the background, and the object in the foreground was used to make the photo more interesting visually.*

When using this technique, make sure your camera focuses on the subject—not the foreground or background. To avoid having your camera autofocus on the wrong thing in a photo, read your camera's manual and become familiar with its autofocus operation.

On most digital cameras, you should start off by focusing only on your subject at first. Press the camera's shutter button down halfway so that the camera's autofocus feature kicks in and focuses on your intended subject. Next, zoom out or reposition your subject to include the foreground and/or background (while keeping the shutter button halfway pressed down).

On many cameras, when you take your image, your intended subject is in focus, while the foreground or background is visible but most likely slightly out of focus.

Keep in mind that you don't necessarily need to have people in your photo for this technique to work. As you're taking your photos, think about how you can frame your images using the landscape or objects around you, paying attention to what's in front of your subject, the subject itself, and what's behind the subject.

Combine this technique with the "Rule of Thirds" and try experimenting by shooting from a few different angles or perspectives. You'll quickly discover your photos adopt a more professional quality.

How Light Impacts Your Photos

When you're shooting photos outside on a sunny day, the sun itself can be a help or a hindrance. As a general rule, you never want to point the camera toward the sun when taking a photo. This causes glare and reflections that can wreck your images. If the sun is behind the subject (facing the photographer), this is generally a no-no because it causes your subject to appear as a dark silhouette.

> **TIP**
>
> If you're shooting a subject in front of a sunset, for example, or there is too much light behind and not enough in front of your subject (which causes your subject to appear as a dark silhouette), try standing within a few feet of your subject and using the camera's flash, even in daylight or during a sunset. This technique lights up the subject but also helps you capture what's in the background. If your camera has a "slow/synchro" flash mode, you should use it in this situation. This technique is referred to as using a "fill flash."

When the sun or primary light source is to your back (and shining on your subjects), it lights up the people or objects you're photographing. What you need to be on the lookout for are unwanted shadows caused by the light. Make sure shadows do not appear within your photos in a distracting way.

During daylight hours, when you point the camera toward the sun, you almost always see flares, glare, or reflections in your photos (as shown in Figure 5.6). To get rid of them, you can simply alter your position and/or change the position of your subjects. Sometimes, even the slightest change in position creates a totally different visual within your camera's viewfinder.

To reduce glare and reflections, you can sometimes place your hand just above the camera's lens to block the direct light from shining into the lens. However, make sure you don't cover up the lens; otherwise, you wind up with a photo of your hand, as opposed to the intended subject. You can also use an optional lens hood, which attaches to the front of your camera's lens if you're shooting with a Digital SLR camera.

On occasion, however, having a glare appear in your photo can add an artistic element to it, as you can see in Figure 5.7. Here, the sun was pointing toward the camera's lens, but in a controlled way, because trees partially blocked the incoming light.

Figure 5.6 *If the main light source where you're shooting is in front of the camera (shining into the lens) as opposed to shining onto the subject, unwanted glare, flares, or reflections appear in your photos.*

Figure 5.7 *Sometimes, glare from the sun can be used to add an artistic element to your images.*

 SHOW ME Media 5.2—Working with sunlight when taking pictures
outdoors

Access this video file through your registered Web Edition at
http://www.quepublishing.com.

 LET ME TRY IT

Positioning Your Subject Based on the Sun's Position

To avoid unwanted glare, flares, and reflections in your photos, follow these steps:

1. Look around your surroundings and determine your main source of light.

2. Make sure the light is positioned in front of your subject and behind you, the photographer.

3. If you can't control the light in the background, you can add more light on your subject by using the camera's flash, even in daylight shooting situations. You would do this, for example, if your subject is standing outside under the shade from a tree but is otherwise surrounded by daylight. Or, perhaps your subject is standing in front of a gorgeous sunset, but there is little light in front of your subject to light up his or her face.

Planning Your Shots

Whether you're shooting photos of kids at play, taking pictures during a vacation, capturing exciting happenings at a party you're attending, taking a family portrait to use within a holiday card, or capturing spontaneous moments with friends to share on your Facebook page, you should perfect your ability to take both posed and candid photos of people in a wide range of indoor and outdoor situations.

Posed Photos

Posed photos are great because you can tell your subjects where to stand and what facial expressions to have. You can decide when and where the photo will be taken, and if necessary, you can often adjust the lighting situation as well as the angle from which you're shooting.

When taking posed shots, as shown in Figure 5.8, you also can carefully select each image's foreground and background. Plus, you have the luxury of taking multiple shots to ensure that you capture the perfect image—with everyone looking at the camera and smiling.

Figure 5.8 *A posed shot gives you maximum control over your subjects, surroundings, and lighting.*

As you'll discover, if you're trying to shoot a large group, getting all the subjects to look at the camera at the same time and smile is a challenge, especially if there are young kids in the group. In these situations, be patient and plan on investing a few extra minutes to take a bunch of photos in succession (safety shots) to ensure that you capture the perfect posed image.

TIP

If you're using a flash and you're worried about people closing their eyes when the flash goes off, one trick for reducing this problem is to ask all the subjects to close their eyes at the start. Tell them that when you count to three, you want them to open their eyes at the same time. Get ready to snap the photo and begin counting. When you say "Three," wait a second for all the subjects to open their eyes and then snap the photo.

TIP

When you're taking posed photos, having your subjects looking toward the camera and smiling is one traditional way to go. Occasionally, however, having your subjects *not* look directly into the camera makes for a more interesting photo, especially if you can capture your subjects looking at something in the distance that can't been seen in the image itself. This pose can create a bit of mystery for the people later looking at the photo.

Candid Photos

In addition to taking plenty of posed photos, you'll discover that if you're creating a traditional photo album or scrapbook, photo book, or digital slideshow, it will be much more interesting to look at later if you also incorporate lots of candid photos in your Photo Project.

The key to taking candid photos is to capture spontaneity. Shoot photos of people laughing, talking, interacting with one another, or just acting silly. Be ready to snap photos quickly of people reacting to various things they experience or when something unexpected or funny happens.

TIP

When taking candid photos, you (the photographer) should be as inconspicuous as possible. People sometimes get nervous or distracted around a camera. Your goal is to capture people being themselves. Try standing at a distance from your subjects and using a zoom lens to add space between you and them, allowing you to stay out of the way.

Often, those spontaneous moments are what you'll remember the most and make for the best pictures because you capture people's true expressions and emotions, as opposed to fake or forced smiles.

The trick to taking spontaneous or candid photos is to be very observant of what's happening around you and to always have your camera on hand and ready to shoot. (Keeping your camera in Auto mode, for example, will speed up the time it takes to prepare a shot and shoot it.)

TELL ME MORE Media 5.3—Anticipate what's about to happen

To listen to a free audio recording about preparing your shots, log on to
http://www.quepublishing.com.

Taking Advantage of Your Camera's Zoom

You might find that incorporating a lot of background into an image as you shoot your subject helps to tell a story or set the scene. In these situations, take less advantage of your zoom lens and show more of the surroundings.

Although you can use a wide-angle shot to set the scene, there are certainly times when zooming in on your subject pays off and allows you to capture something very special.

One issue to be mindful of as you use the zoom is that you don't always want to crop out too much background. You could wind up focusing only on the subject, preventing the location where the photo was taken from being visually represented within the image.

As you can see in Figure 5.9, the background in this shot is essential. However, when you look at Figure 5.10, you can see that sometimes the background isn't important at all, and it is just the main subject you want to focus on in your photo.

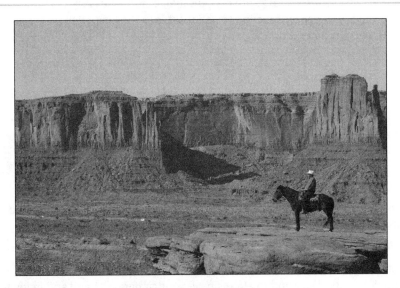

Figure 5.9 *Sometimes, the background in a photo is most important.*

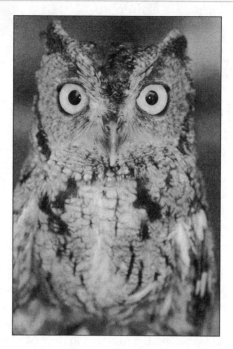

Figure 5.10 *When you're shooting close-ups, it's the subject that communicates in your photo, and an interesting background is not always necessary.*

If you're going to utilize the zoom and take ultra–close-up pictures, also take a few wider-angle images to set the scene and allow you to remember where you've been.

TIP

Using iPhoto, you can always crop an image after it's been shot and really zoom in on a subject. Especially if you're using a high- resolution digital camera, you can crop even the smallest objects within an image to make it your main focus without losing clarity.

Discover quick tips for taking pictures in specific situations and overcoming common shooting mistakes and mishaps.

6

Overcoming Common Mistakes and Mishaps

Even with the most advanced digital photography equipment in your hands, winding up with crystal-clear, well-lit, and visually impressive shots isn't always a simple process. The "auto" shooting modes built into your digital camera are designed to make the picture-taking process easier and less technical, but they're not foolproof.

In specific shooting situations (such as when minimal light is available or you can't hold the camera steady), it's easy to make common mistakes that lead to imperfect images. Although you can fix some of these problems using the editing and photo enhancement features built into iPhoto '11 after the images are shot, it's far less time consuming to avoid making the mistakes in the first place.

Before returning to all that can be done with your photos within iPhoto '11, this chapter focuses on some of the most common problems amateur photographers encounter in everyday situations when trying to take photos and offers some easy-to-implement suggestions for overcoming these challenges.

Setting the Right Shooting Mode

Most digital cameras have at least a handful of built-in, preprogrammed shooting modes designed to make it easier to shoot crystal-clear photos in a variety of situations. One of the most common causes of photography shooting problems is simply that the photographer selects the wrong auto shooting mode for a particular situation.

> **TIP**
>
> On some point-and-shoot digital cameras, the various auto shooting modes are referred to as *scene modes*. You select them from onscreen menus as opposed to physically pushing buttons or rotating dials on the camera's body.

Some of the most common shooting modes you'll use in everyday situations when taking pictures include the following:

- **Continuous Shooting mode**—This feature allows you to hold down your camera's shutter button to snap multiple photos in quick succession. On most low-cost and mid-priced digital cameras, this feature allows you to snap between three and eight shots per second. If you're using the camera's flash, however, this shooting cycle is slowed down because the flash needs time to recharge in between uses.

- **Image Stabilization mode**—This shooting mode can usually be used in conjunction with others and often requires you to activate it by adjusting a physical setting on your digital camera (as opposed to selecting an option from an onscreen menu). The purpose of this mode is to compensate for any motion of the camera as you're taking pictures, whether it's your unsteady hand, or you're attempting to snap photos from a moving vehicle or while on a rocking boat, for example. If you're on stable ground (not moving) and using a tripod to hold the camera steady, Image Stabilization is not needed. If you're simply holding the camera, however, this feature helps to ensure your images turn out clear. Without this mode, even the slightest movement of the camera when you press the shutter button results in blurs. On point-and-shoot digital cameras, this feature can usually be identified because it's depicted using an icon of a shaking hand. On Digital SLR cameras, there is a special Image Stabilization switch on the camera's removable lenses; plus, the camera itself may have an Image Stabilization setting.

- **Landscape mode**—Although you can manually hold the camera horizontally to shoot a landscape photo, if you're actually shooting a wide area, this shooting mode allows your camera to capture a greater depth of field, ensuring whatever is in your foreground and background stays in focus. If you snap a photo of someone standing in front of a tourist attraction or historic site that's off in the distance, if you don't use this mode, the person in the shot might stay in focus, but what's in the background could be blurred (or vice versa). On most digital cameras, this shooting mode is depicted using a mountain range icon.

- **Macro mode**—When you want to shoot a small object extremely close up, you use the Macro shooting mode that's built into your camera. With this shooting mode, your camera captures all the minute details of your tiny subject. The depth of field this shooting mode uses is very small. What you focus on will be clear in the photo, but everything, such as the background, will be blurry (see Figure 6.1). On most digital cameras, this shooting mode is depicted using a flower icon.

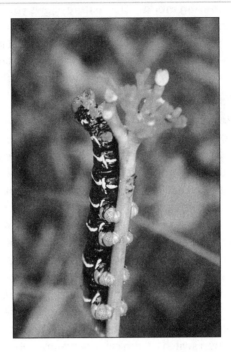

Figure 6.1 *Using your camera's Macro shooting mode, you can capture small subjects in great detail and with tremendous clarity as long as you hold the camera steady.*

- **Panoramic mode**—Depending on the camera, this mode can work in one of two ways. Either the camera allows you to take a single, extremely wide angle shot of a vast landscape, or the camera instructs you to take three or four shots of a wide area that overlap on the edges by about 30%. To do this, hold the camera stable. Starting to the extreme right of the area you want to shoot, take a shot and then rotate the camera slightly to the left and take an additional shot. Repeat this last step two or three times. The camera digitally connects the photos, creating a single panoramic image. When you use this technique, you wind up with vastly better results if you use a tripod. Also, do not alter the camera's settings in between shots. This shooting mode typically does not work well with moving subjects.

- **Portrait mode**—When you use this shooting mode, which is ideal for single subjects, the camera's autofocus feature focuses on your main subject, such as a person, but slightly blurs whatever is in the background. This is the setting to use when taking posed pictures of people. It can be used with or without your camera's flash, depending on the situation. On most digital cameras, this shooting mode is depicted using an icon of person's head or face.

- **Sports/Action mode**—This shooting mode forces your camera to use the fastest shutter speed possible to clearly capture a subject that's in motion. This mode is great for shooting sports, moving wildlife, or anything else that involves you standing still while your subject moves as you're shooting. On most digital cameras, this shooting mode is depicted using the icon of a person running. When shooting a moving subject, you can also pan the camera, as needed, to keep up with up with your "moving target."

- **Use Existing Light (a.k.a. Natural Light) mode**—In some dimly lit situations, you wind up with better images if you avoid using the camera's flash and utilize its Use Existing Light mode. After all, the flash built into most digital cameras has a very limited range and does not light up anything beyond that range. Or, if you're shooting a subject that's very close, the flash could emit too much light onto the subject, causing overexposure, red-eye, or unwanted shadows. This shooting mode allows your camera to fully utilize any available light and make the most of it. It requires the shutter speed to be set automatically to a very low setting. Thus, even the slightest camera movement results in blurry images. This shooting mode works best when using a tripod.

Avoiding Common Shooting Mistakes and Mishaps

This section focuses on overcoming some of the most common mistakes amateur photographers make in everyday shooting situations.

If your photos are not coming out as you envision they should, chances are the problem is a result of one of three issues:

- You've selected the wrong auto shooting mode for the situation.

- You haven't evaluated the available light where you're taking pictures and then properly positioned yourself and your subjects to best utilize that light.

- You're not using the camera's flash correctly, based on the situation.

Blurry Images

There are several reasons why you might end up with blurry images. Blurs typically occur when the camera isn't held perfectly steady when you press the shutter button on your camera. Your camera becomes much more sensitive in low-light situations when the shutter speed of your camera is automatically slowed down to allow more light onto the camera's image sensor.

The first thing to do if you're noticing blurs in your photos is to ensure the camera's Image Stabilization mode is activated. Beyond that, the blurs are most likely a result of one or more of four things happening:

1. The subjects suddenly moved as the photo was being taken. Tell your subjects to be still or switch to your camera's Sports/Action mode.

2. You moved the camera as you pressed the shutter button to take a photo. Either take steps to hold the camera steadier or use a tripod.

3. You did not allow the camera's autofocus feature to kick in before snapping the photo. When you're framing your shot, press the shutter button halfway down to allow your camera's autofocus lens to find and fixate on your subjects. When this occurs (it takes a fraction of a second), fully press the camera's shutter button to take the photo. If the camera doesn't have time to focus on your intended subjects, the photo often turns out blurry.

4. The camera's autofocus sensors focused on the wrong object within the frame, not the intended subjects. One method to overcome this is explained in the next section of this chapter. For Digital SLR cameras, you can also manually override your camera's settings. How you do this varies based on your Digital SLR camera's make and model.

TIP

The easiest way to avoid blurry images is to use a tripod to hold your camera steady. Tripods come in all sizes and vary in price from under $20.00 to over $200.00. For a point-and-shoot camera, a small and portable tabletop tripod, such as the $19.95 Gorillapod Original from Joby (http://joby.com/store/gorillapod/original), is ideal in most shooting situations, especially while you're on the go. An alternative is a more cumbersome full-size tripod or a monopod (available wherever photography equipment is sold).

Camera Autofocuses on the Wrong Objects

When you look through your camera's viewfinder, you see built-in autofocus sensors when you press the shutter button halfway down. These sensors determine what the camera focuses on.

Your camera probably has multiple sensors. The number of sensors used to ensure an image turns out crystal clear depends on which auto shooting mode the camera is set to use. For example, in Portrait mode, the camera uses one or two of its sensors to focus on your subject's face or body and allows some of the background to

be blurry. However, in Landscape mode, more (or all) of the sensors are used to ensure everything you see within the frame turns out clear in your photos.

Make sure the appropriate sensors light up or flash when you press the camera's shutter halfway down to activate the camera's autofocus feature. The sensors should correspond directly to your main subject as you look through the viewfinder.

If you're using a point-and-shoot camera with a display that acts as your viewfinder, a box or bracket appears around what the camera is autofocusing on (see Figure 6.2). Remember, whatever the camera's autofocus sensors focus on is what appears the most in focus within your photos.

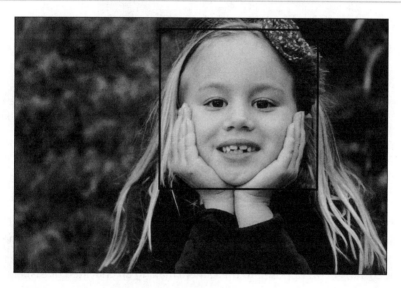

Figure 6.2 *On a point-and-shoot camera, a box or bracket appears on the viewfinder screen indicating what the camera is autofocusing on.*

Sometimes, if there's an object in the foreground, that's what your camera's auto-focus mode automatically fixates on, as opposed to the intended subject (see Figure 6.3). Here, the camera automatically focused on the plants, as opposed to the butterfly, which was the intended subject.

Figure 6.4, however, shows the same butterfly appearing blurry-free within the image, because with the photographer's help, the camera's autofocus sensors focused on the correct subject.

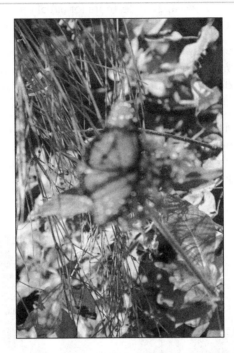

Figure 6.3 *Sometimes, a camera's autofocus mode focuses on something that's not your intended subject. In this case, the camera automatically focused on the plants as opposed to the butterfly.*

When you notice the camera isn't focusing on your intended subject, as you begin to frame your image, quickly zoom in on your subject and press and hold the camera's shutter button halfway down. This forces the sensors to focus on your intended subject (as opposed to the camera making an educated guess).

Now, while still holding the shutter button halfway down, readjust the zoom and frame your image, allowing whatever objects in the foreground or background you want seen within the photo to be visible as you look through the viewfinder. As soon as your image is properly framed, fully press the shutter button to snap the photo with the image sensors still focused in on your primary subjects.

Color Problems Within Images

Chances are, if you're looking at your images on your Mac's screen using iPhoto '11 and the colors simply don't look right, this is caused by one of two problems. Either your camera's white balance needs to be adjusted (something you can easily fix on all Digital SLR cameras), or your Mac's screen needs to be calibrated.

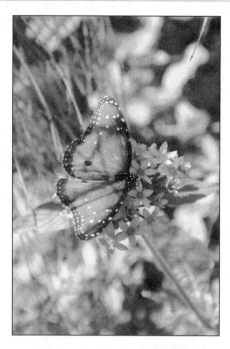

Figure 6.4 *Sometimes, it's up to the photographer to override the camera's autofocus sensors so that the correct subject appears in focus.*

NOTE

White balance refers to how your digital camera interprets solid white in an image and then adjusts all other colors accordingly. If what should be white in a photo appears to have a gray, tan, or blue hue, chances are your camera's white balance needs to be adjusted. Some digital cameras require you to select an auto white balance setting based on the type of light you're shooting in, such as bright sunlight, overcast skies, fluorescent (indoor) light, or when using a camera's flash, for example. After you make this selection, the white balance is set automatically. Some digital cameras, including all Digital SLR cameras, allow you to adjust this setting manually as well. See your camera's manual for details.

If you print out your images on a photo printer using iPhoto '11 and the colors look wrong compared to what you see on the Mac's screen, this could also be an issue with your printer (or its ink cartridges are running low or are clogged).

If you determine that your Mac's screen needs calibration, you need to use a device, called a colorimeter, to fix this. A colorimeter is a light-sensitive device that's used for measuring the color intensity of an object or color sample, based on the red, blue, and green components of light reflected from the object or sample, which in this case is your Mac's screen.

The $99 Huey Pro from Pantone (www.pantone.com) is one example of a colorimeter that attaches to your iMac or MacBook's screen. It automatically calibrates the screen using proprietary software that comes with the device. Several similar products are also available from Datacolor (http://spyder.datacolor.com/products.php).

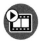 **SHOW ME** Media 6.1—Using a colorimeter on your Mac's screen
Access this video file through your registered Web Edition at
http://www.quepublishing.com.

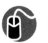 **LET ME TRY IT**

Using the Pantone Huey Pro on Your Mac

To calibrate your Mac's screen and adjust the colors you see using the Pantone Huey Pro, follow these steps:

1. Install the Pantone Huey Pro software on your Mac and run the software.

2. Attach the Huey colorimeter device to your Mac's screen and connect the cable to your computer's USB port.

3. The included software (which is separate from iPhoto '11) prompts you through the simple calibration process.

> **TIP**
> Chances are, your Mac's screen needs to be calibrated only once in a great while, if ever. If you don't want to invest in a colorimeter, simply schedule an appointment with an Apple Genius and bring your computer into any Apple Store. If your Mac is covered under Apple Care, the technician will calibrate your screen for you, if necessary. This is a service that some photography specialty stores also offer.

Chances are, if the color problems are being caused by your Digital SLR camera, fixing the issue is simply a matter of manually adjusting the white balance. Consult with the owner's manual for your camera to obtain directions on how to do this

because the process varies based on the camera's make and model. If you're using a point-and-shoot digital camera, you probably can't manually adjust the white balance (beyond choosing the type of light available where you're shooting).

Glare and Shadows

As you learned in the preceding chapter, glare is caused by unwanted light entering through the camera's lens. It can wreak havoc on your photos. Meanwhile, light can also create ugly or unwanted shadows in your photos.

Once again, the quick fix is to position the primary light source behind you so that the light is shining on your subjects. Do not allow light to shine directly at your camera.

Pay attention to the origin of the light and position yourself and your subjects accordingly. If this isn't possible, to add more light to subjects, use your camera's flash, even in the daylight. Another option is to utilize a light reflector or diffuser to redirect light or make harsh light softer when it shines on your subjects.

Reflectors are flat, lightweight, portable pieces of camera gear covered with shiny silver or gold reflective material. You can use one or more reflectors to redirect light onto your subjects. If you use a gold-colored reflector, it adds a warm and rich glow to images. However, using a silver colored reflector will offer a brighter and whiter effect.

TIP

You can purchase reflectors or diffusers from photography specialty stores or online. A professional-quality deflector costs between $10 and $100 (depending on its size and shape). Diffusers, which attach to your camera's flash, are priced starting at less than $20. Two online sources for reflectors and diffusers are Adorama (www.adorama.com) and Westcott (http://fjwestcott.com/products/reflectors/index.cfm).

As its name suggests, a light diffuser acts as a filter for hard light and makes it softer when it shines on your subjects. A diffuser can also be used to eliminate unwanted shadows. There are two types of diffusers. One looks like a reflector, but it's made using a semitransparent, thin white material that softens direct light as it shines through the light. You use this type of diffuser by positioning and holding it between the primary light source (such as the sun) and your subjects.

The second type of diffuser is used with your camera's built-in or external flash. It's used to soften the harsh light that a flash emits and helps reduce unwanted

shadows and red-eye. It also helps keep photos from being overexposed or washed out as a result of the flash.

Many different types of diffusers can be used in conjunction with a camera's flash. For a Digital SLR camera with a built-in, pop-up flash, one of the most basic and least expensive diffusers available is the Puffer Pop-Up Flash Diffuser from Gary Fong ($19.99, www.garyfongestore.com/puffer-pop-up-flash-diffuser.html). For such a basic (and inexpensive) photo accessory, it works extremely well at dramatically improving photos taken using a Digital SLR camera's pop-up flash.

For most point-and-shoot digital cameras, the Delta Point and Shoot Diffuser ($16.15, www.garyfongestore.com/flash-accessories/delta-point-and-shoot-diffuser.html) provides a simple solution to many problems, such as red-eye, overexposure, or shadows, caused by the flash.

> **TIP**
>
> There is another way to reduce unwanted light from entering through the camera's lens that you notice is causing glares: Hold your hand over the top of the lens to block the incoming sun. Just make sure your hand doesn't get into the shot itself or block your camera's flash. On a Digital SLR camera, you can use an optional lens hood accessory, which attaches to the front end of the lens.

Shooting Through Glass or in Front of It

One problem many vacationers encounter when taking pictures while participating in tours or visiting tourist attractions is the need to take pictures through glass. Perhaps you're riding on a tour bus and want to take a photo of a historic site or landmark as you're passing by. Maybe you're visiting an aquarium and want to take photos of the exotic tropical fish or there's something behind a glassed-in exhibit within a museum that you want to photograph (assuming the museum allows photographs to be taken).

When set in auto mode, your camera usually wants to use the flash when you attempt to take photos through glass. In this situation, override your camera and turn off the flash altogether. Take the photo using the Use Existing Light (or Natural Light) mode. If your point-and-shoot camera has a built-in shooting mode for shooting through glass, use it. However, if you can, avoid shooting through glass altogether—for example, by opening the car or tour bus window.

With the flash turned off, follow these steps for taking pictures through glass:

1. Make sure the glass you're shooting through is clean. Get rid of fingerprints, dirt, or smudges.

2. Hold the camera up against the glass. Do not allow any light to shine between the camera's lens and the glass. If any light seeps between the camera and the glass, it causes unwanted glare or reflections.

3. Keep the camera very still as you take your photo.

By following these steps, you should be able to take clear photos through glass, like the one depicted in Figure 6.5, which was taken while touring the old Mission Control at Johnson Space Center at NASA Space Center in Houston.

Figure 6.5 *This clear shot of the old Mission Control was taken through glass during a tour of Johnson Space Center at NASA Space Center in Houston.*

If the flash goes off when you're attempting to shoot a photo through glass, what you wind up with is unwanted glare in the image. Figure 6.6 shows glare caused by the flash in the upper-left portion of the image (also a shot of the old Mission Control within Johnson Space Center at NASA Space Center in Houston). As you can see, using the flash also washed out the entire image.

This same effect happens if you position your subject directly in front of glass, such as a mirror or window, and you use the flash when taking a photo. This is one problem that's very hard (often impossible) to fix, after a photo is shot, using iPhoto '11 or other photo editing software.

Figure 6.6 *Avoid using the camera's flash when shooting through glass or when your subject is in front of glass (or a mirror).*

Red-Eye

Red-eye occurs when photos are taken in low-light situations and the camera's flash is pointed directly into the subjects' eyes. The light enters the subject's pupils and reflects the blood vessels there, which turns the eyes red. Instead of appearing as their natural eye color, your subjects' eyes appear bright red—giving them a devil-like quality.

Red-eye can occur with any living subject, but it tends to be worse when you take pictures of people with blue, green, or hazel eyes.

After the fact, you can use iPhoto '11 to quickly fix red-eye with a few clicks of the mouse. However, there are a few steps you can take to eliminate the problem while you're shooting.

 To discover how to use iPhoto '11's Fix Red-Eye feature, **see** Chapter 7, "Using iPhoto '11's Simple Photo Editing Features."

If you're using a point-and-shoot camera with a built-in flash, that flash points straight outward (toward your subject) and isn't adjustable in any way. You can place a flash diffuser over the flash itself, however. You can also use your camera's built-in red-eye reduction mode, if applicable. (This feature is built into many digital cameras.)

As you preview your images while you're shooting, if you notice red-eye is occurring, use these techniques:

- Adjust the flash's intensity (if you're using a Digital SLR camera that has an external flash unit or an adjustable built-in flash unit).

- Adjust the flash's direction and try bouncing the flash's light off the ceiling or a wall, or angle the flash so it's not directly pointed at your subject. This technique isn't possible with a point-and-shoot camera or Digital SLR with a built-in flash that shines forward, directly at your subject.

- Attach a flash diffuser to your camera's flash. This very inexpensive accessory attaches in front of the flash and deflects the harsh light yet still lights up the subject.

- If possible, change the overall lighting situation in the room. Making it brighter reduces the red-eye effect.

- Try shooting without a flash using your camera's Use Existing Light (or Natural Light) mode.

- Move farther away from your subjects and utilize the camera's zoom, if necessary, to take your shot.

- Use your camera's red-eye reduction mode when shooting.

- Have your subject not look directly at the camera. Sometimes, having your subject stare off into the distance creates an intriguing effect.

TIP

If all else fails, fix the red-eye digitally when you edit your photos later using iPhoto '11.

 SHOW ME Media 6.2—Preview how to fix red-eye using iPhoto '11
Access this video file through your registered Web Edition at
http://www.quepublishing.com.

 LET ME TRY IT

Fixing Red-Eye Using iPhoto '11

When you load your images into iPhoto '11 and click on the Edit command icon, you have access to the software's tool for quickly fixing red-eye. Follow these steps to use it:

1. Select the photo you want to fix and display it within iPhoto '11's image viewing area.

2. Click the Edit command key in the bottom-right corner of the screen.

3. Click on the Fix Red-Eye icon that appears on the right side of the screen under the Quick Fixes tab.

4. Using the mouse, if it's not already checked, place a check mark in the Auto Fix Red-Eye box. This step often automatically fixes the red-eye within the image. If this doesn't work, proceed to step 5.

5. Place the cursor on the image, near your subject's eyes. The cursor will look like a target. Use the Size slider on the right to adjust the size of the target icon, based on the size of your subject's eyeballs. Place the target over each eye in the photo, as necessary, and click the mouse. This technique fixes the red-eye. Repeat this process in all eyes impacted by red-eye.

Specks or Dots Appear in Your Photos

The tiniest piece of dust, sand, dirt, or a water drop, for example, that gets stuck on your lens causes magnified specks or dots to appear within your photos.

The quick and easy way to avoid this situation is to carefully clean your lens using a lens cleaning solution and a microfiber lens cleaning cloth (available from eyeglass stores or photography specialty stores). To remove dirt or dust from the lens, you can also use a can of compressed air or even a clean make-up (or lens cleaning) brush with very soft bristles.

 TELL ME MORE Media 6.3—Keeping your camera and lens clean
To listen to a free audio recording about keeping your camera and lens clean, log on to *http://www.quepublishing.com.*

CAUTION
Walking around all day with your camera turned on and/or the lens cap removed (which leaves the lens fully exposed) increases your chances of the lens getting dirty or, even worse, scratched. Until you're ready to shoot, keep the lens cap on the lens. If you're using a point-and-shoot digital camera, turning off the camera automatically causes the lens door to close and protect the lens. Wind can blow dirt or dust onto your lens, and a light rain can often result in water drops sticking to the front of the lens.

If you're using a Digital SLR camera, each time you switch lenses, you leave the camera's sensor exposed. One single dust speck that lands on the sensor will cause specks or dots to appear in all your images. The mid- to high-end Digital SLR cameras have autosensor cleaners that help to remove unwanted dirt each time the camera is turned on or off. However, you may occasionally need to clean the camera's sensor using a camera cleaning kit. (Alternatively, you can take your camera into a photography specialty shop and have it professionally cleaned.)

Usually, you can use a can of compressed air or a soft brush with a blower attached (which comes with most camera cleaning kits) to remove unwanted dirt from a camera's sensor or its lens.

@ *Thankfully, you can remove some unwanted dots or specks that wind up in your photos during the editing process by using iPhoto '11's Retouch tool. **See** Chapter 7, "Using iPhoto '11's Simple Photo Editing Features."*

WARNING

When cleaning your camera, use only cleaning solution, cloths, or brushes designed for fragile camera lenses. Using the wrong cleaning tools could result in a scratched lens, which requires a costly repair.

Using iPhoto '11 to Edit and Enhance Your Digital Images

7 Using iPhoto '11's Simple Photo-Editing Features **123**

8 Adding Effects to Your Images ... **145**

9 Advanced Photo Editing with iPhoto '11 **161**

10 Exporting Your Images ... **174**

Learn how to edit your photos using the "quick fixes" built into iPhoto '11 that can dramatically improve the look of your images in minutes.

7

Using iPhoto '11's Simple Photo Editing Features

One of the most useful features of iPhoto '11 is its capability to quickly edit images using a collection of extremely powerful tools that are easy to use and quick to implement. Using these tools, you can improve upon or fix many of the most common photo problems with a few clicks of the mouse.

The editing and photo enhancement tools offered by iPhoto '11 have been vastly improved over previous versions of the software. Clicking on the Edit command icon located in the lower-right corner of the iPhoto '11 screen opens a collection of editing and photo enhancement tools divided into three main sections: Quick Fixes, Effects, and Adjust.

This chapter focuses on iPhoto '11's collection of six Quick Fixes editing tools and explains how to use them to improve the appearance of your digital images, allowing you to fix problems and give all your photos a more professional look.

Finding Quick and Easy Ways to Improve Your Photos

After you've imported your digital images into iPhoto '11 and have organized them into Events and/or Albums, you might want to edit or enhance them *before* sharing them with friends and family.

As you'll discover, the basic editing features offered by iPhoto '11 allow you to improve upon or fix common problems in your photos, such as red-eye and lighting issues, with just a few clicks of the mouse.

These editing features, however, also allow you to perform tasks, such as reframing your image after the fact, so you can better position your main subjects in your photos, zoom in on your subjects, and take full advantage of the photo composition techniques you learned in Chapter 5, "Taking Professional-Quality Photos," and Chapter 6, "Overcoming Common Mistakes and Mishaps."

NOTE

iPhoto '11 was designed to address the everyday needs of amateur photographers. Although the photo editing tools available to you are both powerful and easy to use, they're not as extensive or robust as what you can find in some other highly specialized photo editing applications designed for serious photography hobbyists and professional photographers.

Depending on your goals, you can spend less than a minute editing a photo using iPhoto '11 to fix basic problems or quickly improve its overall appearance. However, if you're willing to spend more time editing and enhancing each of your images, you can utilize some of the program's more advanced tools and ultimately wind up with some extremely impressive results.

TIP

Go ahead and experiment using the various photo editing and enhancement tools built into iPhoto '11. If you use a tool that generates an undesired result, simply use the Undo command (under the Edit pull-down menu) or click on the Undo command icon to remove whatever edit or enhancement you just made. Or, if you want to start all over again editing that image, click on the Revert to Original command icon at the bottom of the Edit window or use the Revert to Original command under the Photos pull-down menu.

Even though it's possible to revert any photo back to its original appearance using iPhoto '11, it's still a really good idea to create a backup of your images immediately after you import them from your digital camera (or whatever source they came from).

🅖 *To learn more about your photo backup options,* **see** *Chapter 18, "Burning Photos to CD or DVD from iPhoto '11," and Chapter 19, "Photo Backup Solutions."*

Aside from maintaining a full backup of all your images, if you plan to make drastic alternations, edits, or enhancements to a single image, you might want to use the Duplicate command (under the Photos pull-down menu) to create an exact copy of that original image first. This way, you can have a copy of the original image *and* the newly created edited/enhanced image stored in the same Event folder or Album.

When you use the Duplicate command, the copy of the image is given a filename that begins the same as the original but ends with a version number. So, if the filename for the original image was FloridaSunset.jpg, when you use the Duplicate command, the newly created copy is called FloridaSunset-Version 2.jpg.

As you'll discover, some of the editing and enhancement tools built into iPhoto '11 allow you to drastically change the overall appearance of your images. For example, you can use the Crop feature (explained later in this chapter) to really zoom in on your main subjects and eliminate unwanted background (which serves the same purpose as the camera's zoom lens while you're shooting, except that you can do this after the image has been shot). You can also add some impressive special effects to an image, making it look totally different from the original.

Exploring iPhoto 11's Edit Screen

The editing process in iPhoto '11 begins when you select and highlight an entire Event or Album, or an individual photo, and then click on the Edit command icon located in the lower-right corner of the screen. You can also use the Edit Photo command under the Photos pull-down menu or press the Command + E keyboard shortcut. All three of these methods result in iPhoto '11 displaying its Edit screen (see Figure 7.1).

Figure 7.1 *iPhoto '11's main Edit screen.*

At the top of this screen, iPhoto '11's pull-down menus are still present (unless you switch to full-screen mode). Likewise, the Source list is displayed on the left side of the iPhoto '11 screen (again, unless you switch to full-screen mode).

What's new on the iPhoto '11 Edit screen, however, is the Edit window, which appears on the right side of the screen, giving you access to all the program's photo editing and enhancement tools and features.

When you're looking at a single image on the Edit screen, you'll also discover the new Filmstrip feature displayed at the bottom center of the screen. It allows you to see other photos stored in the same Event or Album while you're editing a single image in the main image viewing area. It also allows you to select and edit one of the photos displayed in the Filmstrip with a click of the mouse.

To enlarge the thumbnails displayed in the Filmstrip, simply drag your mouse over any of the Filmstrip images (shown in Figure 7.2). You can quickly access a single image from the Filmstrip to begin editing it by clicking on its thumbnail. When you do this, any changes made to the image you were previously working on are automatically saved.

Figure 7.2 *The thumbnail images displayed in the Filmstrip at the bottom of the screen can be enlarged and selected by clicking the mouse on any image in the Filmstrip.*

Using Full-Screen Mode When Editing

Utilizing iPhoto '11's new full-screen mode when editing offers several advantages. First, the main image you're actually editing appears larger on your Mac's screen, allowing you to see it with more detail. Second, there is less clutter on the screen because the pull-down menus and Source list are no longer displayed.

To access the full-screen mode when editing images like those shown in Figure 7.3, click on the Full Screen command icon or use the Full Screen command under the View pull-down menu. As you can see, editing in full-screen mode still gives you onscreen access to all the program's editing tools and features in the Edit window, as well as at the bottom of the program screen.

Figure 7.3 *Editing images in full-screen mode offers less onscreen clutter and allows you to see your image larger and in greater detail.*

Improving Your Onscreen View with the Zoom Feature

Whether or not you're in full-screen mode, you can really zoom in on various areas of the photo you're currently editing or enhancing. You use the Zoom slider located in the lower-left corner of the screen to do this.

Move the slider to the extreme left (the default position), and your image is displayed as large as possible but so that it still fits on the screen (see Figure 7.4).

As you move the Zoom slider to the right, however, the image is enlarged. When you do this, an additional Navigation window appears on the screen and can be moved around by the user. This Navigation window, shown in Figure 7.5, offers a thumbnail image of the entire photo you're viewing. The small box in the window highlights the portion of the photo that's currently visible in the large image viewing area.

Place the mouse in the Navigation window and move this box around by holding down the mouse button to reposition the portion of the enlarged image that's currently visible in the main image viewing area.

The ability to zoom in on an image as you're editing it allows you to pay close attention to its detail and adjust or fix minute details in the photo as you're editing.

Figure 7.4 *When the Zoom slider is to the extreme left, the entire image is displayed in the main image viewing area of iPhoto '11.*

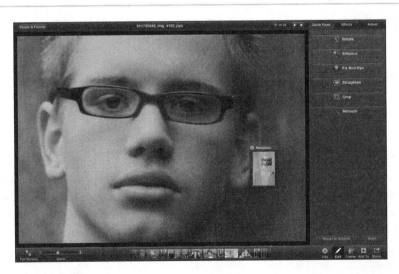

Figure 7.5 *When you use the Zoom slider, the small Navigation window appears in the main image viewing area.*

Regardless of which editing or enhancement features you plan to use, the ability to zoom in and get a close-up look at various areas of your images is extremely helpful.

> **TIP**
>
> Although you can use the Zoom slider to zoom in on any image (in regular viewing mode or in full-screen mode) as you're editing, this feature also works when you're simply viewing an image using iPhoto's Events, Photos, Faces, or Places viewing modes.

SHOW ME Media 7.1—Using the Zoom mode when editing photos

Access this video file through your registered Web Edition at
http://www.quepublishing.com.

LET ME TRY IT

Using the Zoom Mode When Editing Photos

As you're editing or enhancing your photos, sometimes being able to zoom in and get a very close-up look at a particular part of that image is helpful, especially if you're using the Retouch or Fix Red-Eye editing features, for example. Follow these steps to utilize the Zoom while you're editing a photo:

1. Select and highlight the photo you want to edit from an Event, Album, or folder. Double-click on its thumbnail so you can view that single image in iPhoto's main image viewing area.

2. Click on the Edit command icon located in the lower-right corner of the screen. The Edit screen is displayed, with the photo you want to edit displayed in the main image viewing area. The entire image is visible (and resized accordingly to fit on the screen).

3. Move the cursor over to the Zoom slider located in the lower-left corner of the screen. Using the mouse, hold down the mouse button and drag the Zoom slider to the right to zoom in on the image.

4. As you move the Zoom slider, the small Navigation window appears on the screen.

5. Use the Zoom slider to adjust how close up you want to view the image.

6. Reposition the mouse so it's inside the Navigation window, hold down the mouse button, and move the small box around to reposition the portion of the larger image that's being viewed in the main image viewing area. For example, you can position the box in the Navigation window over the subject's face in the photo to get a close-up view of his or her eyes.

7. With a portion of the photo being viewed in much greater detail, you can utilize the various editing features and tools, such as Fix Red-Eye or Retouch, and fine-tune even the most minute details in a photo.

8. When you're ready to return the image to its normal viewing size, return the Zoom slider back to its default position (to the extreme left).

Using iPhoto 11's Edit Window

One of the most notable changes in iPhoto '11 (compared to previous versions) is the look and functionality of the Edit window, which appears on the right side of the screen when you access iPhoto '11's redesigned Edit screen.

At the top of the Edit window are three heading tabs, labeled Quick Fixes, Effects, and Adjust. Quick Fixes, which is the focus of this chapter, grants you access to six powerful editing tools, including Rotate, Enhance, Fix Red-Eye, Straighten, Crop, and Retouch.

If you click on the Effects tab at the top of this window, you'll notice the content of the Edit window completely changes, giving you access to a variety of tools for adding effects to your images.

⊙ *To learn more about the Effects options,* **see** *Chapter 8, "Adding Effects to Your Images."*

If you click on the Adjust tab once again, the Edit window takes on a totally different appearance, giving you access to a wide assortment of more advanced image editing and enhancement tools.

⊙ *To learn more about the advanced editing and photo enhancement tools under the Adjust heading of the Edit window,* **see** *Chapter 9, "Advanced Photo Editing with iPhoto '11."*

This chapter focuses on the Quick Fixes tools available from the Edit window. Regardless of which edit tools you're working with, at the bottom of the Edit window, two command icons are always present.

The Revert to Original command icon allows you to restore an edited or enhanced image back to its original appearance, meaning that all the edits or enhancements you've made thus far to that image are removed and deleted.

The Undo command icon allows you to undo just the last editing or enhancement step you took.

Using the Quick Fixes Editing Tools

The six tools under the Quick Fixes tab in the Edit window are clustered together because they include the most commonly needed resources to quickly fix a problem with a photo or improve its appearance.

Each of these six tools is designed to be used in a minute or less to help you achieve professional-looking results when editing your images without putting in too much time and effort.

> **NOTE**
>
> You can use each of the six tools available under the Quick Fixes tab independently to achieve a specific result, or you can use several of these tools, one at a time, on the same image. You can also mix and match the enhancement and editing tools you need from the Effects and Adjust menus and use each tool in whatever order you desire to improve the appearance of each image you edit.

 SHOW ME Media 7.2—See demonstrations of the Quick Fixes editing features

Access this video file through your registered Web Edition at
http://www.quepublishing.com.

 LET ME TRY IT

Using the Six Quick Fixes Editing Features

To quickly improve the overall look of your images by fixing common problems or adjusting their overall appearance, follow these steps:

1. Select and highlight a photo you want to edit from an Event, Album, or folder. Double-click on its thumbnail so you can view that single image in iPhoto's image viewing area.

2. Click on the Edit command icon located in the lower-right corner of the screen. The Edit screen is displayed, with the photo you want to edit displayed in the main image viewing area. The entire image is visible (and resized accordingly to fit on the screen).

3. If it's not already being displayed, click on the Quick Fixes tab at the top of the Edit window to display the six Quick Fixes command icons: Rotate, Enhance, Fix Red-Eye, Straighten, Crop, and Retouch.

4. Click on one of these six Quick Fixes icons to use that editing feature on the photo you're currently editing. Start with the Enhance command, for example, to automatically adjust an image's contrast, coloring and other related elements with a single click of the mouse.

Rotate

The purpose of the Rotate command icon in the Edit window is straightforward. Each time you click on this icon, the image you're editing (that's displayed in the image viewing area) is rotated to the left by 90 degrees. So, if you want the photo rotated 180 degrees, you click this icon twice.

When you exit iPhoto '11's Edit mode or start editing another image, all changes, edits, or enhancements made to the current image are automatically saved. The filename for the edited image remains the same, unless you manually change it.

> **TIP**
>
> If you have two images that look very similar and you want to view and edit both of them simultaneously, select and highlight them both before clicking on the Edit command icon. When you do this, both images appear side by side in the main image viewing area as you edit your photos. You can, however, edit only one image at a time. The image you're currently working with (the active image) is surrounded by a white box. To remove one of the images from the main image viewing area, click on the small, circular X icon located in the upper-left corner of the white box surrounding the active photo.

Enhance

The auto Enhance feature is useful for quickly improving the lighting (exposure), contrast, color vibrancy, and other qualities of an image, literally with a single click of the mouse. When you use this feature, iPhoto '11 automatically analyzes the image and makes whatever adjustments it deems are necessary to improve the overall look of your photo.

When you click the Enhance command icon, within a few seconds, the changes that are automatically made to your photo are displayed in the main image viewing area. Most of the time, you see a noticeable improvement in the look of your

photos. However, if you don't like the results, simply click the Undo command icon located in the lower-right corner of the screen.

> **TIP**
> To view a "before" and "after" version of the photo you're editing in the main image viewing area, after you execute some type of edit, with the image still visible in the main image viewing area, press and hold down the Shift key on the keyboard to see the "before" version. To return to that "before" version and not save the changes just made, click on the Undo command icon. Otherwise, when you leave the editing mode or start editing another image, your changes are saved.

Even if you like the outcome when you click on the Enhance command icon, you can still fine-tune various settings to further improve your image using the editing features available in the Effects and Adjust sections of the Edit window.

Fix Red-Eye

One of the most common problems photographers have when using a camera's flash is that it causes red-eye on the living subjects in their photos. In Chapter 6, you learned several strategies for overcoming this problem while shooting. However, if the photos you've imported into iPhoto '11 suffer from the red-eye effect (and the people in your photos look as though they've been possessed by the devil), you can use the Fix Red-Eye feature to quickly eliminate this problem.

When you click on the Fix Red-Eye command icon, the Edit window expands, as shown in Figure 7.6, to include additional options. You can have iPhoto '11 automatically try to fix the red-eye problem in your photo by using the mouse to place a check mark in the box titled Auto-Fix Red-Eye (if it's not already checked by default). This approach works between 80% and 90% of the time to remove the red-eye problem from your photos.

If using the Auto-Fix Red-Eye option doesn't work, you can manually fix the problem in less than 30 seconds. Start by unchecking the "Auto-Fix Red Eye" option. With the Fix Red-Eye options displayed in the Edit window, move the cursor to the main image viewing window, close to your subject's eyes. Notice that the cursor is now shaped like a round target.

Using the Size slider displayed back in the Edit window's Fix Red-Eye section, move the slider left or right until the target cursor is the same size as the currently red eyeballs of your subject in the photo displayed in the main viewing area.

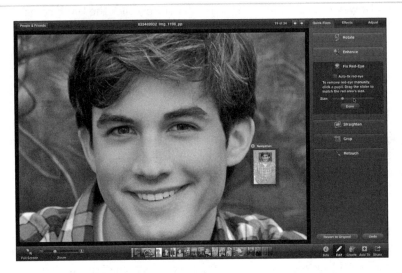

Figure 7.6 *You can have iPhoto '11 fix the red-eye problem automatically, or you can fix it manually.*

After you adjust the target cursor to the right size, move the cursor over each eyeball so the circular target fully surrounds the eyeball and click the mouse button once. Repeat this step for each eye affected by red-eye.

TIP

As you're manually fixing red-eye within a photo, it's often helpful to use the Zoom feature to get an extreme close-up view of each subject's eyes, allowing you to more accurately size the Fix Red-Eye target cursor and place it over each eyeball. If the target isn't properly centered over the eyeball, the "fix" won't look right. In this case, click the Undo command icon and try again.

Straighten

In Chapters 5 and 6, you learned that it takes a steady hand to shoot crystal-clear and well-framed, properly composed images. However, there are plenty of situations when holding the camera perfectly still (and level) simply isn't possible.

For example, you may try snapping photos in a moving car, boat, or bus or while chasing after your kids. Whatever the reason, if you happened to snap a photo while not holding the camera level, this too is an easy fix after the fact using the Straighten tool built into iPhoto '11.

TIP

Some tripods actually have a leveler built in, so you can determine (before snapping a photo) if the camera is perfectly level.

If your photo appears crooked, click on the Straighten command icon. When you do this, two things happen. In the main viewing area, the image you're editing is overlaid with a yellow grid composed of straight horizontal and vertical lines. These gridlines are added to help you straighten your photo and are only temporary. They automatically disappear when you're done using this feature.

You'll also notice that in the Edit window, the Straighten command icon has expanded and now displays a slider labeled Angle. While holding down the mouse button, move this slider slowly to the left or right to straighten your image. Moving the Angle slider to the left rotates the image slightly to the left. Likewise, moving the Angle slider to the right rotates the image in a rightward direction.

Use the yellow grid that's displayed in the main image viewing area to help determine when your image is straight. After you make the proper adjustments, click on the Done icon located directly below the Angle slider to finalize your edits. Alternatively, click the Undo icon to return the image to its original crooked appearance and try again.

Figure 7.7 shows an example of a crooked photo before iPhoto '11's Straighten feature was used. This crooked image was caused because the photographer didn't hold the camera level when snapping the photo. In Figure 7.8, you can see the newly straightened image after the Straighten feature of iPhoto '11 was used.

TIP

Make very slow and subtle movements as you're adjusting the Angle slider while using the Straighten feature. Pick something displayed in the image itself that's straight and use the yellow gridlines as guides to make your adjustments.

Sometimes, you can add some really interesting visual effects by purposely making an image look crooked (either by holding the camera at a strange angle while shooting or making the adjustments after the fact using the Straighten tool in iPhoto '11). Figure 7.9 shows an example of a photo that looks more visually interesting when rotated slightly (on purpose) using the Straighten command. In this case, the feature was used to unstraighten the image.

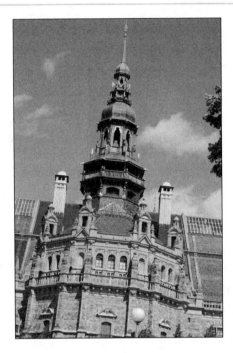

Figure 7.7 *When this photo was shot, the photographer didn't hold the camera level, resulting in this crooked image.*

Crop

The main purpose of the Crop feature built into iPhoto '11 is to allow you to remove unwanted areas of a background from an image and put more attention on your main subject.

However, this feature can also work instead of (or in addition to) a camera's zoom lens and allow you to choose your subject in a photo that's already been shot and really zoom in on that subject, creating a close-up image (see Figure 7.10). This feature works particularly well if you're using a high-resolution digital camera, and the shot itself was taken using the highest resolution possible for that camera.

CAUTION

If you attempt to zoom in too closely on a subject in an image that wasn't shot using a high enough resolution digital camera, you'll notice that unwanted pixelation occurs. You can clean up some of this "digital noise" using the De-Noise feature under the Adjust tab of the Edit window, or you may have to zoom in less on your intended subject using this method.

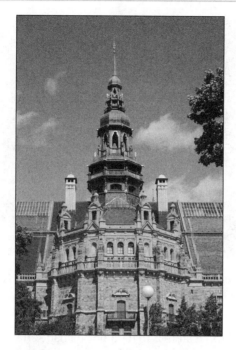

Figure 7.8 *Using the Straighten tool in iPhoto '11, you can easily fix crooked images.*

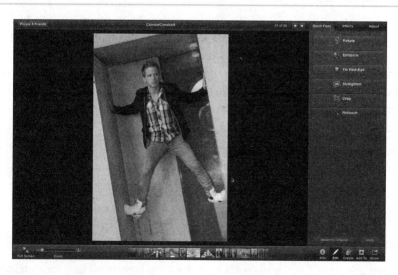

Figure 7.9 *Sometimes, making an image look crooked adds an interesting visual or artistic element to the photo.*

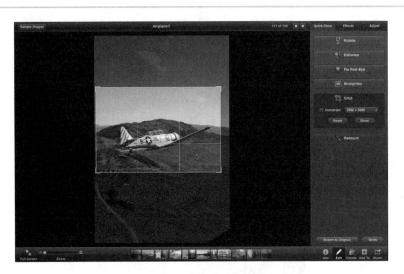

Figure 7.10 *The Crop tool can be used to zoom in on a subject and create a close-up image featuring that subject.*

Another use of the Crop feature is to reframe an image after the fact, allowing you to take the "Rule of Thirds" into account. Figure 7.11 shows how you can cut out some unwanted background, reposition your main subject, and reframe an image *after* it's been shot.

In this case, the photographer zoomed in on the main subjects, the airplane and the pylon (see Figure 7.11), and positioned these two subjects more toward the right side of the frame (keeping the "Rule of Thirds" in mind). The photographer also took into account the direction the airplane was traveling and allowed plenty of sky on the left side of the image to add a sense of motion. People viewing the photo can imagine where the airplane is headed.

What started as a wide shot with little of interest for someone to focus on (and lots of blue sky) wound up as an interesting close-up image that is nicely framed using the photo composition techniques covered in Chapters 5 and 6.

The Crop tool has several uses when editing digital images, each of which can dramatically improve or change the overall appearance of a photo.

Putting the Crop Feature to Use

To begin using the Crop feature, click on the Crop command icon located in the Edit window. It's one of the Quick Fixes options. After you click on this icon, additional Crop options are displayed in the Edit window (see Figure 7.12). For example, you have the option to place a check mark next to the Constrain label and then adjust the size of the image.

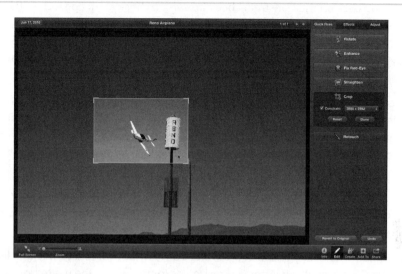

Figure 7.11 *You can use the Crop tool to reframe an image, allowing you to incorporate the "Rule of Thirds" after the fact.*

Figure 7.12 *This is what the Edit window looks like after you click on the Crop command icon.*

Adding a check mark here is important if you plan to create hard-copy prints of your images in a standard size, such as 4" × 6", 5" × 7", or 8" × 10". If you don't constrain your crops, the image size and shape you end up with won't be appropriate for printing in a standard size print. So, as a general rule, add the check mark next to the Constrain label.

As for the image size option located next to the Constrain label, the default is the image's current size. Unless you know specifically how you'll be using the image later, leave the default option alone.

However, if you know you'll want to create an 8" × 10" print, generate a 20" × 30" poster-size enlargement, or display the image as a wallpaper on your iPhone, for example, you can choose one of the other image size options.

When you click on the Constrain check box and a check mark appears, in the main image viewing area, you see a white box, which you can resize using the mouse. What you see in the white box determines how you'll crop your image (and cut away unwanted background). What appears in the white box is exactly what the image will look like after it's cropped.

Notice that each corner of the white box is highlighted. While holding down the mouse button, go to any corner of this white box and move the entire box inward or outward, on a diagonal, to resize the box and/or zoom in on a subject in your photo.

If you place the mouse anywhere in the white box (as opposed to at one of the corners) and hold down the mouse button, you can reposition the box anywhere in the current photo. When you do this, a white "Rule of Thirds" grid appears to help you reframe your image.

Remember, whatever you see in the white box is what your image will look like after the Crop is finalized. After you resize and/or reposition the white box in your image, click on the Done icon in the Edit window to save your edits. Your newly cropped image is displayed in the image viewing area.

TIP

If you make a mistake when cropping your image, you can reset the size of the white box by clicking the Reset command icon that appears in the Edit window, or you can use the Undo command.

Not placing a check mark next to the Constrain label in the Edit window allows you to alter the size and shape of the white box any way you desire. For example, you can move the mouse to any edge or side of the white box and move it inward or outward. The result, however, is an odd-shaped or nonstandard size image that may be difficult to print in a standard size. For other purposes, such as online viewing, cropping an image without the Constrain option checked works fine.

SHOW ME Media 7.3—See how to crop an image to create a close-up of your subject
Access this video file through your registered Web Edition at
http://www.quepublishing.com.

LET ME TRY IT

Cropping an Image to Create a Close-Up

One of the uses of the Crop feature is to be able to really zoom in on a subject, eliminate much of the ancillary background, and create a close-up of your subject. Follow these steps to do this:

1. Select and highlight the photo you want to crop from an Event, Album, or folder. Double-click on its thumbnail so you can view that single image in iPhoto's image viewing area.

2. Click on the Edit command icon located in the lower-right corner of the screen. The Edit screen is displayed, with the photo you want to edit displayed in the main image viewing area.

3. Click on the Crop command in the Edit window. It's one of the Quick Fixes options.

4. Place a check mark next to the Constrain label by clicking the mouse on the check box.

5. When the white box appears in the main image viewing area, resize the box around your subject, so you can zoom in on just that main subject and get rid of unwanted background (see Figure 7.13).

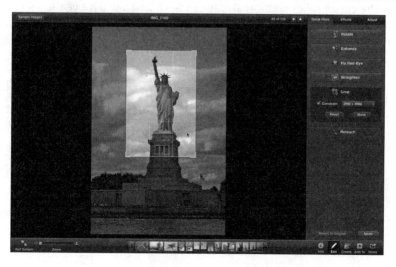

Figure 7.13 *Use the Crop feature to select an object in a photo and create a close-up image featuring that subject.*

6. Reposition the box to frame your subject in the image.

7. Click on the Done icon in the Edit window.

Retouch

The Retouch command enables you to remove unwanted blemishes or small objects from a photo. It works like a magical paintbrush that simply erases what you don't want and then re-creates a new background in that area to blend in with the rest of the photo.

You can use Retouch to remove wrinkles, pimples, or scars from someone's face or body in a photo or to get rid of some other small object that appears in the photo.

WARNING

The Retouch tool built into iPhoto '11 is useful for removing small unwanted items or objects within a photo, but if you want to keep the photo looking natural, you should use this tool sparingly and only in small areas. For example, you might use it to remove a blemish on someone's face within a portrait.

When editing a photo, to use the Retouch tool, click on the Retouch icon, which is one of the Quick Fixes options in the Edit window. When you do this, a slider labeled Size appears. It controls the size of the Retouch tool you use when you move the cursor over to the main image viewing area.

Notice the cursor takes on a circular appearance when you move the mouse cursor into the main image viewing area. The size of this circle is determined by the Size slider adjustments you make. Move the slider left to shrink the size of the circular cursor or move it to the right to enlarge the cursor's size.

TIP

As you're using the Retouch tool, it's often helpful to use the Zoom feature to get an extreme close-up view of what you're trying to remove from that photo.

Based on what you're trying to remove from the photo, adjust the Retouch cursor size accordingly. Then position the cursor directly over whatever you want to remove, press and hold down the mouse button, and make slight up-and-down or small circular movements around the area of the object you want to remove, as if you're using a pencil eraser.

When you release the mouse button, iPhoto automatically erases whatever object you attempted to retouch and replaces it with a background that matches whatever surrounded that object, creating a seamless blend that you won't even notice.

Depending on the object you're trying to retouch and the complexity of the background in the photo, the level to which this feature works well (and keeps the photo looking realistic) varies. You might need to repeat the Retouch procedure a few times, slightly adjusting the size of the Retouch tool with each attempt to create a natural look as you attempt to erase something from the photo.

When you achieve the results you desire, click the Done icon located directly under the Size slider in the Edit window to save your edits. Alternatively, use the Undo command to erase the edit you just made and redo it.

Figure 7.14 shows how you can easily edit someone's face and remove unwanted blemishes, pimples, or wrinkles, for example. In this figure, the Duplicate command was used to make two copies of the same image. Both images were selected and highlighted before the Edit command icon was clicked so they would appear in the main image viewing area simultaneously (for demonstration purposes).

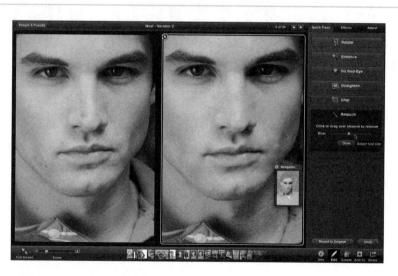

Figure 7.14 *Removing blemishes from a portrait of someone's face is easy using the Retouch tool in iPhoto '11.*

The Retouch tool was then used on the photo located on the right, after the Zoom feature was used to move in close on the subject's face to see the area to be retouched in greater detail. The Retouch command was used to clean up the subject's complexion and remove unwanted blemishes. To accomplish this, the Retouch tool was used to paint over what needed to be removed from the subject's nose and mouth area. When you compare the "after" image on the right with the "before" image on the left, you can see how useful the Retouch tool can be.

Out of all the editing tools offered in iPhoto '11, this one takes the most practice to use correctly (and to make your retouch edits look natural in the photo), yet how to use it is a relatively straightforward process.

NOTE

If your editing needs go beyond what the Retouch tool is capable of doing when it comes to removing something unwanted from a photo (such as an entire background or a large object that's in front of a highly detailed background), you probably need to use alternate photo editing software, such as Apple's Aperture 3, Adobe's Photoshop Elements 9 ($79.99, www.adobe.com/products/photoshopel), or the professional-level Adobe Photoshop CS5 ($699.00, www.adobe.com/products/photoshop). For editing portraits of people and making the subjects look flawless in just minutes, the Portrait Professional 10 ($49.95, www.portraitprofessional.com) is an incredibly easy-to-use yet very powerful editing program.

Learn to use the Effects image enhancement and special effects tools offered by iPhoto '11.

8

Adding Effects to Your Images

In addition to fixing visual problems with photos or using the Crop command to reframe photos after they've been shot, you can use iPhoto '11 to quickly add a handful of special effects to your photos that will dramatically alter their overall appearance.

Although each special effect can be added with a single click of the mouse, you also are able to adjust the intensity of most effects, so you can customize them in a way that will make your photos stand out in a positive way and be unique.

Especially if you're creating a traditional photo album or scrapbook, photo book, or slideshow that showcases multiple images, adding a few special effects to several of your featured photos can add visual appeal to the overall Photo Project.

This chapter focuses on the special effects you can add to your photos using the Effects features offered in iPhoto '11's Edit window. Each of these effects can be used in conjunction with the other editing tools offered in the program, which are described in Chapter 7, "Using iPhoto '11's Simple Photo Editing Features," and Chapter 9, "Advanced Photo Editing with iPhoto '11."

Discovering the Edit Window's Effects Options

To begin adding special effects to your images or fine-tune their colorization, select and highlight an image you want to edit while viewing your image thumbnails from the Events, Photos, Faces, or Places viewing modes. Double-click on that image's thumbnail so it appears in the main image viewing area.

Next, click on the Edit command icon located in the lower-right corner of the screen to open the Edit window. At the top of this window are three tabs, labeled Quick Fixes, Effects, and Adjust. Click on the middle tab, labeled Effects. Notice the content of the Edit window completely changes (see Figure 8.1).

Displayed under the Effects tab at the top of the Edit window are a handful of colored spheres. Nine additional effects thumbnail command icons are positioned toward the center of the window. At the bottom of the Edit window are the familiar

Revert to Original and Undo icons, which remain constant regardless of which Edit window tab you access.

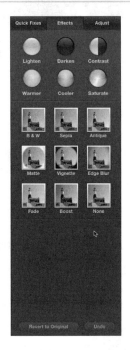

Figure 8.1 *The edit and image enhancement tools are displayed under the Effects tab of the Edit window located on the right side of the screen.*

Each icon and effects thumbnail command icon displayed in the Edit window represents a different type of effect or enhancement you can add to your photos. After you select a particular effect, in most cases, you can control the intensity of that effect and fine-tune the impact it has on each of your images. You can also easily mix and match effects to give each of your photos a truly unique and often more professional appearance.

The effects spheres at the top of the Edit window allow you to fine-tune the colorization and contrast of your images by clicking on one or more of the spheres using your mouse. The effects thumbnail command icons allow you to add more dramatic special effects to your photos. For example, with a single click of the mouse, you can transform a vibrant and colorful photo into a black-and-white image. Alternatively, you can blur the edges of an image so the focus of attention is on its main subject when viewers look at your photo.

Anytime you add a special effect to one of your images, the impact of your action is immediately reflected on the photo you're editing in the main image viewing area. If you don't like a particular effect or you want to try something else, click on the Undo command icon, use the Undo command from the Edit pull-down menu, or press Command + Z on the keyboard to undo the last action you did in iPhoto '11.

Lightening or Darkening an Image

This section focuses on the six effects spheres located at the top of the Edit window when you click on the Effects tab. In the upper-left corner is the Lighten effect sphere. Immediately to the right of it is the Darken effect sphere.

The Lighten and Darken effect spheres allow you to adjust a photo's exposure with a single click of the mouse. *Exposure* refers to a photo's overall lightness and darkness.

Each time you click on the Lighten effect sphere, the exposure of the photo you're editing lightens slightly. To make this effect more dramatic, click on the Lighten effect sphere multiple times in a row. This impacts everything in the photo. The first two or three times you click this effect sphere, the overall impact is subtle. However, after four to eight clicks, the colors in your image start to wash out and become severely distorted.

Use this effect to lighten an otherwise dark image slightly. If the image is extremely dark, you see more dramatic results if you utilize this effect in conjunction with the

Shadows adjustment tool available as one of the Adjust settings (discussed in Chapter 10).

As with any of the effect spheres, after you click on it one or more times, the impact of the photo is immediately apparent, and your edits/enhancements are automatically saved as soon as you exit iPhoto 11's Edit mode or begin editing another photo.

Offering the exact opposite effect as the Lighten effect sphere, the Darken effect sphere slightly darkens the overall exposure of the image you're editing. The impact of this effect is subtle at first (when you click the sphere between one and three times), but its impact becomes increasingly more dramatic and apparent the more you click on it. Eventually, if you keep clicking this Darken effect sphere, your image will turn totally black.

CAUTION

Every time you alter an image, your changes impact the primary version of that image that's stored in an Event. By extension, those changes immediately are incorporated into any Photo Projects (including Albums, slideshows, and greeting cards) in which that image also appears. If you don't want the changes to impact all uses of that image, make a duplicate of the image first before you start adding effects. Use the Duplicate command under the Photos pull-down menu to create a duplicate (an exact copy) of the original image.

SHOW ME Media 8.1—Lightening or darkening a photo using iPhoto '11

Access this video file through your registered Web Edition at http://www.quepublishing.com.

LET ME TRY IT

Lightening or Darkening a Photo

To lighten or darken a photo with a few clicks of the mouse, follow these steps:

1. Select and highlight the photo you want to edit. Double-click its thumbnail to display that photo in full size in the main image viewing area.

2. Click the Edit command icon located in the lower-right corner of the screen.

3. When the Edit window appears on the right side of the screen, click the Effects tab located at the top of the Edit window.

4. To lighten a photo, click on the white Lighten sphere that's located in the upper-left corner of the Effects window. You can click on this sphere multiple times until you achieve the designed impact on your image. The alternative (which gives you greater control to customize your image) is to click on the Adjust tab at the top of the Edit window and then use the Exposure, Contrast, Definition, Highlights, and Shadows sliders, for example, to adjust various aspects of your image's lighting and color.

5. To darken a photo, click on the black Darken sphere that's located at the top of the Effects window (between the Lighten and Contrast) spheres. You can click on this sphere multiple times until you achieve the desired impact on your image.

Adjusting the Contrast in Your Photos

The Contrast effect sphere located in the upper-right corner is half white and half black. In photography, *contrast* refers to the difference between the light and dark areas of a photo.

On most photos, the impact of clicking the Contrast effect icon is subtle for the first few clicks, especially if you've already used the Enhance command under Quick Fixes (described in Chapter 7).

Each time you click on the Contrast icon, the difference between the light and dark aspects of your photo is intensified slightly. So theoretically, the colors in your photos should appear more vibrant, and the level of detail visible in your image should improve slightly.

NOTE

You have much greater control over a photo's exposure, contrast, and color, for example, when you fully utilize the edit and enhancement commands offered under the Adjust tab of the Edit window.

Tinkering with a Photo's Coloring

There are three main ways to adjust coloring in your photos using iPhoto:

- The easiest method is to use the Enhance command under Quick Fixes. This is considered a fully automated approach to adjusting or fixing colors that appear in your images. It's covered within Chapter 7.

- A semi-automatic approach to color adjustment using iPhoto '11 is to utilize the effect spheres under the Effects tab in the Edit window.

- The fully manual method of adjusting color in your images, and the option that gives you maximum customization ability and control, is to use the editing features offered under the Adjust tab of the Edit window. This is covered in Chapter 9.

This section focuses on taking the semi-automatic approach to adjusting the colors that appear in your photos. To do this, you can utilize the second row of effect spheres located under the Effects tab in the Edit window. These spheres are labeled Warmer, Cooler, and Saturate.

The Warmer and Cooler effect spheres have the opposite effect on one another When you click one or more times on the Warmer effect sphere, the tone of the colors in your image appears (as the name suggests) warmer. The reds and oranges, for example, become more vibrant, and the overall colorization looks more like the photo was taken on a bright and sunny day.

> **NOTE**
>
> When you use the Warmer and Cooler effect spheres, the greatest impact occurs on aspects of your photo that are lighter in color.

When you click on the Cooler effect sphere, other colors, such as the blues and grays in the photo, become more enhanced, making the image look more like it was shot outside on an overcast, cloudy, or murky day.

Because the Warmer and Cooler effect spheres are opposites of each other, if you click twice on the Warmer effect sphere and then click twice on the Cooler effect sphere, the image winds up looking exactly the same as when you started. As you're editing a photo, you need to use only one of these effects based on the overall colorization of your photo and the visual effect you're trying to achieve.

Once again, you'll notice the impact on the image each time you click the Warmer or Cooler effect sphere is subtle. The more times you click on that effect sphere, the greater the impact is on the photo. At some point, your image will become too light and washed out, or too dark, and using the Warner or Cooler effect will cease to have any further impact on your image.

The Saturate effect sphere is used to enhance the overall vibrancy of the colors appearing in your photo. The impact, once again, is subtle when you click on this effect sphere between one and three times, but with more clicks, the impact on

your photo becomes more dramatic. This effect brightens the bright colors in your image by removing or lightening some of the grays or darker colors in the image.

> **NOTE**
> Saturation is the measure of a color's intensity within a photo.

Easily Adding Special Effects to Your Pictures

Being able to manipulate the colors, as well as adjust the contrast and exposure of your photos, can have a positive and significant impact on their appearance. If you use these editing tools correctly, you can fix problems in a photo or give an image a more artistic appearance.

Going beyond basic photo editing, iPhoto '11 allows you to add special effects to your images that have an instant and often dramatic impact on them. Located on the bottom of the Edit window when you click on the Effects tab are nine Effects thumbnail command icons.

Each of these Effects thumbnail command icons is labeled based on what type of effect it creates. Your options include the following:

- **B&W**—Transform a full-color image into B&W with a click of the mouse.

- **Sepia**—Give your images an "old-time photo" appearance using this special effect.

- **Antique**—Make your photos look like prints stored up in an attic for several decades when you add this aging special effect to them.

- **Matte**—Add a white, oval-shaped frame as a digital border around your image.

- **Vignette**—Add a black, oval-shaped frame as a digital border around your image.

- **Edge Blur**—Create an effect commonly used by professional photographers to enhance portraits. The outer edges of the photo are blurred (on purpose) to draw attention to the main subject of the photo.

- **Fade**—Use this effect to fade the color in an entire image.

- **Boost**—Use this effect to enhance the colors in a photo to make everything look brighter and more vibrant.

- **None**—Remove all the effects you've added in one click of the mouse and return the photo to its original appearance before you added any effects. Any other edits or enhancements, however, remain intact.

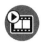 **SHOW ME** **Media 8.2—View a sampling of the special effects you can add to your photos using iPhoto '11**
Access this video file through your registered Web Edition at http://www.quepublishing.com.

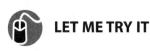 **LET ME TRY IT**

Adding Special Effects to Your Photos

Adding special effects to your photos is easy. The trick is to do it tastefully. To add one or more special effects to your photos, such as the Vignette effect, follow these steps:

1. Select and highlight the photo you want to edit. Double-click its thumbnail to display that photo in full size in the main image viewing area.

2. Click the Edit command icon located in the lower-right corner of the screen.

3. When the Edit window appears on the right side of the screen, click the Effects tab located at the top of the Edit window.

4. Choose which effect you want to add to your photo and click its respective icon in the Edit window, such as Vignette, which adds a circular black border around your image.

5. When it's applicable, adjust the intensity of that effect. For example, with the Vignette effect, you can click on this effect icon up to 24 times to determine the size of the circular black border that appears around your image. As you do this, you will be able to preview the effect immediately in the main image viewing area. To remind yourself of how the image looked before you added the effect, press the Shift key.

Transforming a Color Image into B&W

With a single click of the mouse, you can transform a full-color image into black and white. Some photos actually become more visually striking or interesting when you remove the distraction of color and force the person viewing your images to really focus on the subject or what's happening in a photo.

iPhoto '11 offers the ability to use the B&W effect in conjunction with other visual effects. For example, you can use Lighten or Darken on a black-and-white image or adjust its contrast before or after it's been transferred into black and white. You can also add a matte or vignette or blur the edges of that photo.

When you're creating a slideshow, photo book, or traditional photo album or scrapbook, for example, mixing in a few black-and-white images with your full-color photos adds variety to the overall composition of your Photo Project. Depending on the subject, a single black-and-white photo that's transformed into an 8" × 10" print (or larger) and then framed on a wall can also add to the décor of any room.

> **TIP**
>
> Sometimes a full-color outdoor image that looks dreary because it was shot on a dark, overcast, cloudy, or rainy day can be transformed into an extremely eye-catching image by converting it into black and white.

Making a Photo Look Old Using the Sepia Effect

The Sepia effect drains all the colors from an image and replaces them with shades of browns, tans, and whites, giving the photo an aged appearance. You can add to this overall effect by using the Edge Blur effect to help make a modern photo look older.

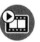 **SHOW ME** Media 8.3—Using the Sepia and Edge Blur effects to make your photos look old
Access this video file through your registered Web Edition at
http://www.quepublishing.com.

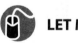 **LET ME TRY IT**

Using the Sepia and Edge Blur Effects

You can quickly transform any full-color photo you just shot into an image that looks as though it was taken decades ago. To achieve this visual effect, follow these steps:

1. Select and highlight the photo you want to edit. Double-click on its thumbnail to display that photo in full size in the main image viewing area. For this example, a photo taken in 2010 at the Cheyenne Frontier Days Rodeo is being used. (The final result is shown in Figure 8.6.)

2. Click on the Edit command icon located in the lower-right corner of the screen.

3. When the Edit window appears on the right side of the screen, click on the Effects tab located at the top of the Edit window.

4. Click on the Sepia thumbnail effect icon. The word *On* appears at the bottom of the icon. The colors in your image are replaced by shades of browns, tans, and whites.

5. To enhance the aged look, click on the Edge Blur thumbnail command icon. This effect allows you to control its intensity, based on the number of times you click on the thumbnail command icon. With each click, the number displayed at the bottom of the thumbnail command icon increases by one, and the intensity of this visual effect increases in the image itself. Click on the Edge Blur icon four times to create the effect used in the example showcased in Figure 8.2.

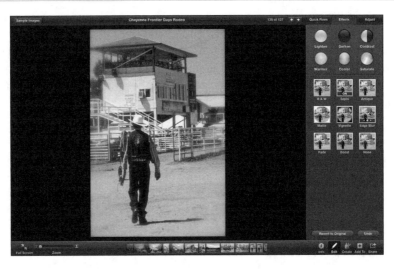

Figure 8.2 *Another example of how the Sepia and Edge Blur effects can be used together.*

Instantly Aging an Image with the Antique Effect

The Antique effect works very much like the Sepia effect. Instead of removing the original colors in your image and replacing them with shades of browns, tans, and whites, however, the Antique effect dramatically dulls the existing colors in your photo and enhances the grays to give the photo a more subtle aged appearance.

Like several of the other effects you can add to your photos using iPhoto '11, the Antique effect is customizable. You can determine how strong and visually striking you want the effect to be in your image based on the number of times you click on the Antique thumbnail command icon in the Edit window.

Clicking the Antique thumbnail command icon once only slightly dulls the colors in your image. Click on the icon three or more times, and the effect becomes that much more apparent.

With each click, the number displayed at the bottom of the thumbnail command icon increases by one (see Figure 8.3). The available intensities are between one and nine for the Antique effect (and up to 24 for some other effects). After you've clicked on an adjustable effect multiple times, you can lessen its impact by clicking on the small left-pointing arrow that appears next to the number in the effect thumbnail command icon. Alternatively, you can increase the effect's impact by clicking on the right-pointing arrow icon that appears on the opposite side of the number.

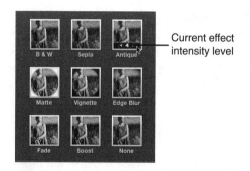

Current effect intensity level

Figure 8.3 *Some of the Effects in iPhoto '11, such as Antique, Matte, Vignette, Edge Blur, Fade, and Boost, can be adjusted by clicking on that thumbnail command icon multiple times.*

NOTE

How much of an effect you use and which effects you mix and match are a matter of personal preference based on the overall look for a photo you're trying to achieve. Don't be afraid to tap your creativity and experiment to create some dazzling effects.

Adding a Matte or Vignette to the Photo

When framing a traditional print, you have the option to add a single, double, or triple cardboard matte around that photo to make it look more impressive in the frame. Most traditional mattes are rectangular, square, circular, or oval shaped, and they come in a variety of colors.

Using iPhoto '11, when you're ready to print your images, you can easily add and customize digital mattes around your images (which replace the need for traditional cardboard mattes). These digital mattes are useful if you plan to showcase your images online or in a photo book, or even if you plan to create prints for framing but don't want to use traditional cardboard mattes.

To learn more about adding digital mattes and borders to your images, **see** Chapter 11, "Printing Photos Using Your Own Home Photo Printer."

The Matte and Vignette effects available under the Effects tab in the Edit window allow you to digitally add either an oval white matte or an oval black vignette around your image. When used correctly, these effects draw the viewers' eyes to the center of your photo and force them to focus on the subject.

Both the Matte effect (shown in Figure 8.4) and Vignette effect (shown in Figure 8.5) are customizable, based on the number of times you click on the thumbnail command icon for that effect. Clicking it once creates a subtle oval around the image, like a border. Clicking the effect icon up to 24 times intensifies the look of these effects by increasing the amount of white or black you see, thus reducing the amount of the actual photo that's visible.

NOTE

In Figure 8.4, the Matte effect thumbnail command icon was clicked on three times. In Figure 8.5, the Vignette effect thumbnail command icon was clicked on 10 times. Beyond the color of the oval around the image, you can easily see the difference varying the intensity of either effect makes.

TIP

You can easily create some unique and visually interesting effects by using the Matte and Vignette commands in conjunction with each other.

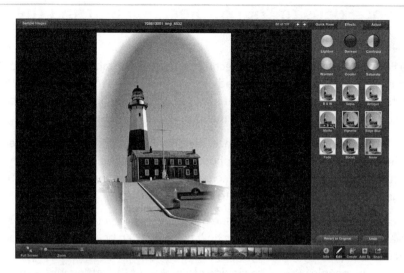

Figure 8.4 *The Matte effect after being clicked on three times.*

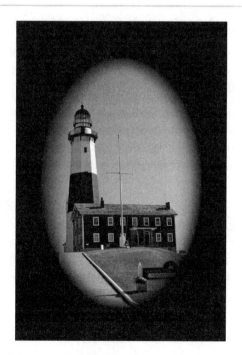

Figure 8.5 *The Vignette effect after being clicked on 10 times.*

Drawing Focus to Your Subjects by Blurring the Image's Edges

The Edge Blur effect is a common technique used in portraits to draw viewers' attention to the main subject. This adjustable effect was demonstrated earlier in this chapter. Edge Blur can be adjusted based on the number of times you click on the Edge Blur effect thumbnail command icon (between 0 and 11).

When you click on this effect just once, the blurriness added to the image remains on the extreme outer edges of the photo and is very subtle. As you increase this effect's intensity, the blurriness impacts a greater area around the outer edge of the image, causing more of that photo to appear out of focus.

You can use the Edge Blur effect alone or in conjunction with other effects, such as Sepia, for example. Figure 8.6 shows how this effect can be used on a full-color image to blur part of the background yet still keep enough of the background intact so the people viewing the image can make out the setting where the photo was shot. A greater emphasis is also put on the subject. In this example, the Edge Blur effect was clicked on five times.

Fading or Boosting the Colors in Your Photos

The Fade and Boost effects available in iPhoto '11 are also adjustable, up to a level of nine. As its name suggests, the Fade effect dulls the colors in an image and draws out the grays.

The Boost effect makes all the colors in your image appear more vibrant. Typically, you want or need to click on the Boost effect only between one and three times to really enhance an image's color. However, you can create some dramatic visual effects if you click on this effect five or more times.

As with all the effects available, you can mix and match Fade or Boost with other effects and enhancement features to create truly one-of-a-kind images. Keep in mind, however, that Fade and Boost serve the exact opposite purpose and counteract each other. So, if you click the Fade effect thumbnail command icon twice and then click the Boost effect thumbnail command icon twice, the net effect is what your original image looked like before you started using these two effects.

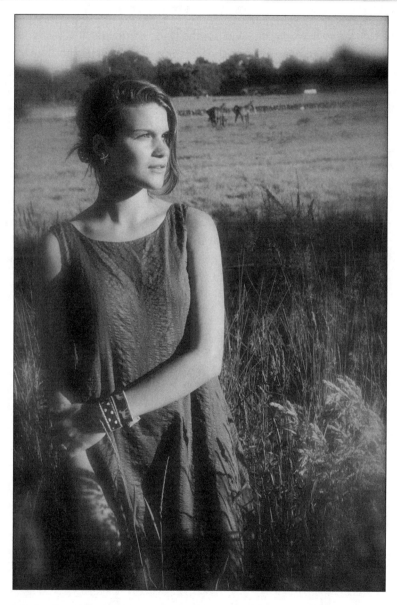

Figure 8.6 *The Edge Blur effect used on a full-color photo to make some of the background appear out of focus yet still keep some of the background clear enough to make out where the photo was shot.*

Removing Special Effects You've Added

You already know that any time you use the Undo command, it allows you to take one step back and remove or undo the last thing you did in iPhoto '11. Likewise, when you use the Revert to Original command, with one click of the mouse, all the edits and enhancements you made to a photo are deleted and removed, restoring that image to its original appearance.

The None effect thumbnail command icon under the Effects tab of the Edit pull-down menu allows you to remove all the effects you've added to a photo using any of the features under the Effects tab but leaves any other edits or enhancements you've already made to that photo intact.

TELL ME MORE Media 8.4—Listen to a brief discussion about what iPhoto '11's editing features can't do

*To listen to a free audio recording to discover some of what iPhoto '11 cannot do when it comes to editing photos, log on to **http://www.quepublishing.com**.*

Advanced Photo Editing with iPhoto '11

Thus far, you've learned easy ways to edit your photos using the Quick Fixes tools built into iPhoto '11 (see Chapter 7, "Using iPhoto '11's Simple Photo Editing Features") and discovered how to add special effects to your favorite photos (in Chapter 8, "Adding Effects to Your Images").

Now, if you're willing to invest at least a few minutes extra to manually edit each of your images (or at least your favorites), iPhoto '11 includes a handful of manually controlled sliders and advanced editing tools that allow you to enhance your images by fine-tuning specific elements of each photo, such as its exposure, contrast, saturation, clarity, and colorization.

This chapter focuses on the more advanced editing tools available under the Adjust tab within iPhoto '11's Edit window. For the most part, you use these tools to manually edit specific aspects of your photos, using a series of mouse-controlled sliders.

As you look at your images after they've been imported into iPhoto '11, if an image appears overexposed, underexposed, or a little bit blurry, or the coloring isn't perfect, for example, don't give up hope and simply delete that image. Instead, invest some time and use iPhoto '11's various editing and enhancement tools to see whether you can salvage the photo. More often than not, you'll be pleasantly surprised by the results and how easily you can fix what you thought were poor images.

> **NOTE**
>
> The tools available under the Adjust tab are more advanced than those offered under Quick Fixes; they offer you the ability to manually alter and improve various aspects of your photos.

Discovering the Edit Window's Adjust Options

The rightmost tab located at the top of the Edit window is labeled Adjust. It's from this window that you can gain access to a handful of controls and tools for manually adjusting the exposure, contrast, clarity, saturation, and other color-related aspects of your photos.

Located near the top of the Adjust window is a three-color histogram, with three sliders directly beneath it. Below the histogram are three standalone sliders, labeled Exposure, Contrast, and Saturation.

Moving downward within the Adjust window, you'll find five additional sliders, labeled Definition, Highlights, Shadows, Sharpness, and De-Noise. Finally, beneath those are two more sliders, labeled Temperature and Tint, along with an eye-dropper tool.

Each of these sliders can be manually adjusted using the mouse. The default position for the top three sliders (Exposure, Contrast, and Saturation) is the middle. If you look at the numbers to the right of each slider, they say 0, 0, and 50, respectively. All the other sliders in the Adjust window are in their default 0 position.

However, if before you access the Adjust window, you used certain editing tools under the Quick Fixes or Effects windows, some of the Adjust settings may already be altered. For example, if you click on the Enhance icon under the Quick Fixes tab in the Edit window, this command causes iPhoto '11 to automatically adjust a handful of settings related to contrast, exposure, saturation, and other aspects of color. Thus, when you return to the Adjust window after using the Enhance command, some of the settings are already altered.

Unlike the editing and photo enhancement adjustments you make using the Quick Fixes and Effects tabs, all the adjustments you can make to your photos using the tools in the Adjust window are made manually by moving the various sliders either to the left or right to achieve the desired results.

NOTE

Sometimes, the problems you wind up with in photos are caused by setting your camera to the wrong "auto" shooting mode when shooting. Depending on the problem, chances are you can compensate for the mistake you made while shooting and fix it using iPhoto '11 after the fact.

Figure 9.1 shows what the Edit window looks like when you click on the Adjust tab. In this case, in addition to the Levels histogram, what you see are 10 sliders for manually adjusting various aspects of your photos.

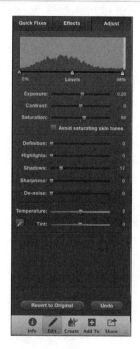

Figure 9.1 *The Edit window looks like this when you click on the Adjust tab at the top.*

Understanding How the Levels Histogram Works

Fixing color within an image, regardless of what photo editing software you use, can be a tricky endeavor. iPhoto's Enhance command takes much of this guesswork away from you by automatically analyzing and fixing color, exposure, tonal, and contrast issues in your photos. This tool isn't foolproof, however.

Even after you use the Enhance command, in some situations when you're viewing your images as you're editing them, you'll want to go in and manually adjust one or more settings using the offerings in the Adjust palette.

The Levels histogram is a graphic representation of the tonal range within a photo. When it comes to digital photography, an individual color can be displayed in any one of 256 levels of brightness. Zero represents pure blackness, and 255 represents solid, bright white.

The Levels histogram you can view in iPhoto '11 is a graphic representation of how your colors are distributed in a photo. The left side of the graph represents black, and the extreme right side of the graph represents white. Every other color that appears in your photos falls between one of these two points. Instead of dealing with numbers (0 to 255), iPhoto '11 uses a 0% to 100% measurement within its Levels histogram.

As you look at the Levels histogram, if none of the red, green, or blue measurements touch the left side of the graph, there is no black whatsoever in your image. Likewise, if none of the red, green, or blue measurements touch the right side of the graph, there is no white whatsoever within that image.

When the three colors of the Levels histogram—blue, green, and red—are spread out across the entire graph, that's a good indication that the image you're looking at and editing is well exposed and has good contrast. These three colors represent the individual color channels of red, green, and blue (RGB) that make up a digital image.

If the Levels histogram bars are crammed together on one side, this is an indication that the image is either overexposed (too light) or underexposed (too dark) and that the definition in your photo isn't as sharp and detailed as it could or should be.

NOTE

The Levels histogram is a graphic representation of the tonal range within your photo. The blue, red, and green in the histogram represent the highlights, midtones, and shadows, respectively, in your image and can be adjusted independently using the three sliders on the bottom of the histogram.

Directly below the Levels histogram are three sliders: one on the left, one in the middle, and one on the right (see Figure 9.2). These sliders allow you to manually and separately adjust a photo's highlights, midtones, and shadows.

TIP

Learning to read and use the histogram is a skill unto itself, and not one you need to master to expertly edit your photos using iPhoto '11. Basically, you can use this graphic depiction to quickly determine whether you're losing detail in your photo because it's overexposed or underexposed. Ideally, the three colors in the histogram graph should be centered and peak toward the center of the graph but appear very low along the left and right edges.

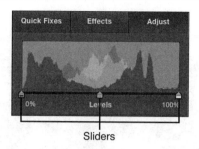

Figure 9.2 *The histogram is a graphic representation of the tonal range within your photo.*

Use the mouse to adjust the three sliders at the bottom of the Levels histogram. The leftmost slider can be moved to the right, from 0% (the leftmost setting) up to the percentage point where the middle slider is set. The middle slider can be moved left or right, between 0% and 100%. The slider on the bottom right of the histogram can be moved to the left, from 100% down to wherever the middle slider is set.

Figure 9.3 showcases a photo that's very dark. The background appears entirely black, the model is wearing black, and he's sitting on a black chair. When you look at the Levels histogram, the red, green, and blue channels are all clustered around the 0% to 13% area (on the extreme left).

You can brighten up this photo a bit and showcase more detail by moving the middle slider under the Levels histogram to the left—in this case, to where the red, green, and blue levels stop peaking (around the 20% mark). You can also move the extreme right slider left, to where the red, green, and blue levels stop registering on the histogram (around the 83% mark).

When you look at the photo after these modifications to the levels within the histogram are made (as shown in Figure 9.4), you can see more detail in the photo itself. The background appears gray, and the shadows in the image are less harsh, especially on the left side (the well-lit side) of the model's face.

TIP

Apple's support website offers an online tutorial for understanding the fine nuances of how the Levels histogram works and why you might want to use it, as opposed to the various other sliders under the Adjust tab. Visit http://support.apple.com/kb/HT1946. Most photographers do not ever need to use this tool to edit their images and achieve professional-quality results, however.

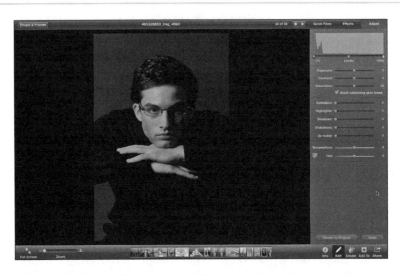

Figure 9.3 *A dark image showcasing a model wearing black, sitting in a black chair, in front of what appears to be a black background.*

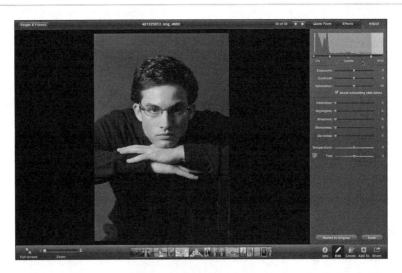

Figure 9.4 *By adjusting the sliders under the Levels histogram, you can lighten up parts of the image to enhance the detail. The background, for example, now appears gray, and the shadows on the left side of the model's face are less intense.*

Manually Fixing Your Photos Using the Adjust Sliders

Below the Levels histogram are a total of 10 sliders that you can use to manually adjust various settings within your photos. Depending on the problems with your photo and what you're trying to fix, or the visual effect you're trying to achieve, you can use combinations of these sliders to achieve the desired result. You will never need to use all these sliders to fix a single image.

Often, you'll discover that a minor adjustment to just one or two of the sliders in the Adjust window, combined with a few of iPhoto's other editing tools, will help you fix your images quickly and without a lot of tinkering.

> **TIP**
>
> You'll have a much easier time using these sliders to fine-tune your edits after you've used the automated editing tools under the Quick Fixes tab in the Edit window. Try using the Enhance command first and allow iPhoto '11 to analyze and fix your image as its sees fit; then use the sliders in the Adjust window to fine-tune the results and make them perfect. Especially for amateur photographers, it's much more difficult and time consuming to edit an image using just the manual Adjust settings.

 SHOW ME Media 9.1—Use the Shadows slider and other editing tools to quickly improve a dark (underexposed) image
Access this video file through your registered Web Edition at
http://www.quepublishing.com.

 LET ME TRY IT

Using iPhoto '11's Shadows Tool and Other Editing Tools to Quickly Fix an Underexposed Image

If you're editing a photo that's underexposed, and you want to brighten it and bring out more of the color and detail, following these steps will help you enhance almost any dark photo:

1. Start by clicking the Enhance tool (under the Quick Fixes tab of the Edit window). Allow iPhoto '11 to automatically make adjustments to the image you're editing.

2. Click the Effects tab at the top of the Edit window and use the Boost command between one and three times to enhance the colors in your image. This makes all the colors look more vibrant.

3. Access the Adjust window and move the Shadows slider slightly to the right. The Shadows slider allows you to reduce the dark shadows within an image.

4. If necessary, use the Highlights slider to regain some of the minute detail in the photo you might have lost by lightening the shadows.

Manually Fixing the Exposure of Your Photos

With a quick slide of the mouse (hold down the mouse button when moving the slider to the left or right), you can adjust a photo's overall exposure using the slider labeled Exposure.

To lighten an image's exposure, move the slider to the right. To darken the image, move the slider to the left. This slider serves the same purpose as the Lighten and Darken spheres found under the Effects tab in the Edit window, except that the slider option allows you to be more precise when manually making exposure adjustments.

Exposure refers to the amount of light that's allowed to reach your digital camera's image sensor when a photograph is being taken. Thus, it determines the overall lightness or darkness. Using iPhoto, you can alter this setting after the fact as you're editing your images to make them lighter or darker.

Several other editing features offered by iPhoto '11 allow you to control the lightness or darkness within a photo, but each modifies your image in a slightly different way. The difference between adjusting your photo's Exposure and Contrast or Shadows, for example, might be subtle. Thus, it becomes a matter of personal taste when it comes to choosing which editing tool to use.

Adjusting the Contrast in Your Images

Located below the Exposure slider is the Contrast slider. Both sliders work the same way—by holding down the mouse button and moving the slider to the left or right to achieve the desired result.

Simply put, *contrast* is the amount of difference between light and dark colors within your image. Colors with opposite characteristics tend to contrast strongly when placed together within an image. You'll discover that each color highlights the qualities of the others, thus allowing all the colors within an image to stand out more dramatically.

Contrast can also be applied to black-and-white photos because the shades of grays, for example, can be adjusted. In iPhoto '11, you can adjust a photo's contrast automatically using the Enhance command, semi-automatically using the Contrast sphere (under the Effects tab in the Edit window), or manually using the Contrast slider in the Adjust window.

Fine-Tuning an Image's Saturation

Like the Exposure and Contrast sliders, the Saturation slider in the Adjust window can be moved to the left or right. Saturation determines the richness of colors within your image. Once again, when you use the Enhance command, iPhoto '11 automatically adjusts an image's saturation. Likewise, you can semi-automatically make adjustments to a photo's saturation using the Saturation sphere (under the Effects tab in the Edit window).

Your third option for adjusting saturation is to use the slider, which gives you the maximum level of control over this setting as you're editing a digital photo. When you move this slider to the extreme left, for example, your photo becomes black and white. All the colors are drained out of the image. As you move the slider to the right, the colors become much more vibrant.

CAUTION

Located directly below the Saturation slider is a check box labeled Avoid Saturating Skin Tones. When you're using the Saturation slider to adjust colors in photos that contain people, place a check mark within this check box to avoid changing the skin tones of the people in your photos. If you don't add the check mark here, when you move the Saturation slider to the right, the skin tone of your subjects begin to look bright red or orange, taking on a very unnatural quality.

Altering the Definition of an Image

The Definition slider allows you to tinker with the clarity of a photo by making minor adjustments to the contrast and by simultaneously eliminating haze. Using this feature can help bring out subtle detail within a photo.

NOTE

If you've already used the Enhance command, chances are you won't need to manually adjust this Definition setting (or most of the other settings within the Adjust window) when editing your photos.

Using the Highlights Slider to Improve a Photo's Clarity

Using the Highlights slider increases or reduces the brightness of the highlights within an image as you're editing it. This feature, when used in conjunction with the Shadows slider, can help enhance the detail within an image. When using this feature, it impacts your entire image. Look at several areas of the photo to make sure it has the desired impact. This tool is useful for enhancing the color in an otherwise dull or washed-out sky, for example.

Using the Shadows Tool to Brighten an Image

Almost every image contains shadows. Sometimes they're very subtle and barely perceptible to the human eye. Other times, the shadows are much more obvious or even distracting within a photo and can ruin an otherwise perfect image.

The Shadows slider is one that you'll probably use frequently when editing photos because it allows you to brighten shadowy areas of images while improving their detail. Even if you use the Enhance command to automatically edit your images, you can often brighten a photo and bring out more detail in it by manually moving the Shadow slider to the right. Often, you need to make only a very small adjustment.

Eliminating Blurriness with the Sharpness Tool

The Sharpness slider can be used to enhance the detail you see within an image, or it can be used to soften an image to give it a more artistic quality. For example, when editing portraits of people, you can use this tool to soften a photo, which can reduce the appearance of wrinkles and blemishes on someone's face, plus soften harsh lighting.

Likewise, if a photo is slightly blurry or out of focus, the Sharpness slider can help smooth out the blurriness and add more crispness or clarity to an image. Don't expect miraculous results if you're trying to repair a very out-of-focus or blurry image. The Sharpness tool is better for making minor adjustments.

Using De-Noise to Clean Up an Image's Clarity

To fix visual problems in an image, such as pixelation, graininess, or minor distortion, which can be a result of low light or caused by zooming in too much on a lower-resolution digital image, you can use the De-Noise tool to somewhat smooth out pixelation or graininess problems.

 SHOW ME Media 9.2—Use the Sharpness and De-Noise sliders to bet-ter focus an image and make it clearer

Access this video file through your registered Web Edition at
http://www.quepublishing.com.

 LET ME TRY IT

Using iPhoto '11's Sharpness and De-Noise Sliders

If you're editing an image that appears blurry or grainy, for example, the Sharpness and De-Noise sliders available in the Adjust window can be useful tools. Follow these steps to use them, either separately or together:

1. Start by clicking on the Enhance tool (under the Quick Fixes tab of the Edit window). Allow iPhoto '11 to automatically make adjustments to your image.

2. To improve the sharpness of an image, click the Adjust tab at the top of the Edit window and move the cursor down to the Sharpness slider.

3. Move the Sharpness slider to the left or right to decrease or increase the intensity of this tool and its impact on your photo. If a photo is slightly blurry, moving the image slider to the right will sharpen the image. The effect is subtle and won't fix a dramatically out of focus image. But, if an image has a slight blur you want to fix, this tool is ideal.

4. Further smooth out an image and improve its clarity by using the De-Noise slider (which is ideal for reducing or removing pixelation or graininess within a photo). Keep the adjustments you make using this slider subtle; otherwise, the result may look unnatural when you view, share, or print the edited image. This tool works best when a photo was taken in a low-light situation.

Adjusting a Photo's Temperature and Tint with the Sliders

The Temperature and Tint sliders are used in conjunction with each other to manu-ally adjust color within a photo, making them warmer or cooler, based on which way you move each slider.

The Temperature slider controls the blues and yellows in a photo and allows you to control the intensity of the colors in this range within your images. The Tint slider controls the intensity of the colors within the reds and greens range.

With the Temperature slider, moving it to the left brings up or intensifies cooler tones, whereas moving it to the right enhances the warmer tones in an image. The Temperature slider can also be used to correct white balance issues or to compensate for colors being washed out as a result of a photo being shot in a specific type of artificial light, such as harsh fluorescent lighting.

> **CAUTION**
>
> If your Mac's screen isn't properly calibrated in terms of how it displays colors, when you start tinkering with color adjustments in your images, you could distort the colors more, as opposed to fixing them. See Chapter 6 for more information about calibrating your Mac's screen.

These two sliders offer manual control over the coloring in your images. You can also use the semi-automatic approach to fixing an image's temperature by using the Warmer and Cooler spheres under the Effects tab, or allow iPhoto '11 to automatically adjust these settings by using the Enhance command (under the Quick Fixes tab).

Using the Eye-Dropper Tool to Fix Temperature and Tint

Located directly to the left of the Tint slider is an eye-dropper icon that allows you to automatically adjust an image's tint and temperature. To do so, you select something white or gray within the image itself and then allow iPhoto '11 to adjust the rest of the colors in the image accordingly.

 SHOW ME Media 9.3—How to use the eye-dropper to fix a photo's temperature and tint

Access this video file through your registered Web Edition at http://www.quepublishing.com.

 LET ME TRY IT

Using the Eye-Dropper Tool Manually

When you click on the eye-dropper icon once, you can quickly and automatically adjust the tint and temperature. Follow these steps:

1. Click the eye-dropper icon once.

2. Move the cursor into the main image viewing area. The cursor takes on a plus-sign (+) shape.

3. Place this cursor somewhere on your photo where a solid white or neutral gray color is displayed and click the mouse. The entire photo is automatically and instantly adjusted. You may want or need to use the Zoom feature to get a closer look at a specific area of your photo.

4. To see what the image looked like before doing this, press and hold down the Shift key on the keyboard.

5. Your edits are saved automatically when you leave the Editing mode of iPhoto '11 or begin to edit another photo. Remember, your edits impact the primary photo you're editing that's saved within an Event but also instantly alter other versions of that same photo used in Albums, slideshows, greeting cards, or other Photo Projects. (To prevent your edits from impacting other versions of the photo, use the Duplicate command first and make your desired edits to the copied image instead of the original.)

TIP

After making edits using any of the Adjust sliders, if you don't like the result, you can always click on the Undo or Revert to Original command icons at the bottom of the Edit window. Alternatively, you can use the Undo or Revert to Original pull-down menu commands or their respective keyboard shortcuts. With this freedom, you don't ever have to worry about permanently messing up an image. Go ahead and experiment using the various editing tools in the Adjust window and try combining them with editing and enhancement tools under the Quick Fixes and Effects tabs.

Learn how to export your digital images from iPhoto '11 so they can be shared or used with other applications.

10

Exporting Your Images

In Chapter 3, "Loading Your Digital Images into iPhoto '11," the focus is on how to import or load your images into iPhoto '11 (directly from your digital camera or from another source) so that you can fully utilize all the features and functions of the program. Using iPhoto '11, you can handle such tasks as organizing, viewing, editing, enhancing, printing, sharing, and archiving your digital photos.

After you've organized, viewed, edited, and enhanced your photos, for example, you might want or need to export them from iPhoto '11 so that they can be used with other applications or shared in ways that can't be achieved in this program.

 ⓒ *Exporting photos from iPhoto '11 is an entirely different process than importing your digital images into the software. To learn how to import your photos into iPhoto '11, **see** Chapter 3, "Loading Your Digital Images into iPhoto '11."*

For example, you might want to add one or more of your photos into a document you're creating using Microsoft Word, or maybe one of your photos would make a perfect addition to a PowerPoint presentation you're creating.

You might also want to utilize the photo editing tools of another application, such as Photoshop Elements 9, Photoshop CS5, or Portrait Professional 10, to alter or manipulate your images in ways that iPhoto '11 doesn't have the tools to handle. This might include removing or replacing an entire background in a photo or adjusting specific elements of a photo, such as contrast, saturation, or exposure in only part of the image (not the entire image). These are some of the more specialized editing functions iPhoto '11 wasn't designed to handle.

Exporting your images from iPhoto is also necessary if you want to use third-party online photo services, professional photo labs (to create prints), or services for creating Photo Projects that aren't supported in iPhoto '11.

TIP

Although iPhoto '11 makes it easy to create and order professional-quality photo prints in a variety of popular sizes, you must wait several days to receive those prints after they're created and shipped from the lab. An often less-costly and faster alternative is to export your photos to a disc or flash drive and then take the digital files to a local one-hour photo processor (in a pharmacy, such as CVS or Walgreens) or a professional photo lab in your area to have prints created (often while you wait). How to do this is the focus of Chapter 12, "Creating Prints Using a Professional Photo Lab."

Although the capability to create photo books is built into iPhoto '11, for example, you must use Apple's own photo book printing services and the templates built into the software to design, lay out, and then order your photo books. However, by exporting your images from iPhoto '11, you're free to use other photo book publishing services, such as Blurb.com, that offer entirely different book designs and templates, along with potentially more competitive pricing. You can also order photo gifts, such as mouse pads, coffee mugs, and poster-size enlargements on canvas, that feature your photos but that can't be created and ordered directly from iPhoto '11.

Also, to be able to share your photos online, using services aside from Facebook, Flickr.com, and MobileMe, you first need to export your images from iPhoto '11 before uploading them to such services. This includes online-based remote backup and photo archiving services, which are discussed in Chapter 19, "Photo Backup Solutions."

NOTE

When you export a photo from iPhoto '11, you automatically create a copy of that image. The original image remains intact in its proper Event folder.

The main focus of this chapter is on how to export photos from iPhoto '11 and make sure that when you do this, you export the image in the most suitable file format and file size for whatever reason you'll be using the photo. If you plan to display your exported image on the Web, the file format and file size you choose when exporting the images from iPhoto '11 are different than if you plan to create a poster-size enlargement of that image using a professional photo lab.

Your Exporting Options

In iPhoto '11, you have the option to export one photo at a time; pick and choose multiple photos and export them simultaneously; or export all the photos in a particular Event, Album, or folder.

After you decide which photos you want to export, go to the File pull-down menu at the top of the screen and select the Export command (see Figure 10.1). This opens a separate Export window in the center of the main image viewing area of iPhoto '11 (see Figure 10.2).

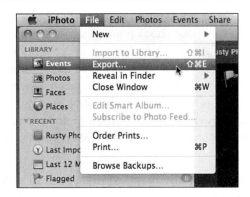

Figure 10.1 *Choose the Export command from the File pull-down menu at the top of the iPhoto '11 screen.*

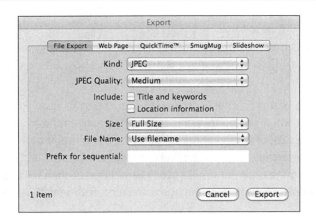

Figure 10.2 *The Export window with the default File Export tab highlighted.*

From this Export window, you need to adjust a variety of settings to customize the way your images are exported based on how they'll ultimately be used. You also need to select where they'll be exported, such as the following:

- A specific directory or subdirectory on your Mac's primary hard drive (for example, the Pictures folder)

- A specific directory on an external hard drive that's connected to your Mac or a portable flash drive (thumb drive)

- To a CD or DVD

The options and decisions you need to make when exporting photos from iPhoto '11 using the Export window are explained later in this chapter.

 TELL ME MORE Media 10.1—Learn some money-saving reasons why you should export images from iPhoto '11

To listen to a free audio recording about the benefits of exporting your images to use them with various online-based photo services, as well as local photo labs, log on to http://www.quepublishing.com.

Exporting Individual Photos

In iPhoto '11, you can simultaneously export a single image; groups of images; or the contents of an entire Event, Album, or folder. When you're exporting a single image, the version of that image containing any edits or enhancements you've made to it is what gets exported.

⊙ *To learn how to export multiple images simultaneously, **see** the "Show Me" and "Let Me Try It" elements in the "iPhoto '11's Export Window" section of this chapter.*

TIP

If you want to export an original image, without any enhancements or edits, first use the Duplicate command to create a copy of the image. Then use the Revert to Original command to restore that copy to the image's original appearance.

After an image is exported, a copy of it appears in the format and image size you selected in the directory of the hard drive (or other media) you chose. The image also remains intact within iPhoto '11 (within in its original Event folder).

> **TIP**
> Be sure to review the "iPhoto '11's Export Window" section of this chapter for details about how to set each of the options appearing in the Export window.

 SHOW ME Media 10.2—Export a single photo from iPhoto '11 using the Export command and options available from the Export window
Access this video file through your registered Web Edition at http://www.quepublishing.com.

 LET ME TRY IT

Exporting a Single Photo

To export a single image from iPhoto '11 to a specific destination on your Mac's hard drive, an external hard drive, or a flash drive, for example, follow these steps:

1. Choose the photo you want to export. From the Event, Photos, Faces, or Places viewing mode, highlight and select that photo. You can also double-click on the thumbnail to view the full-size version of the image in the main image viewing area, but this isn't necessary.

2. Select the Export command from the File pull-down menu.

3. When the Export window appears, make sure the File Export tab at the top of the window is highlighted; then choose the file format (Kind) and image quality you want. Also, adjust the other options available from this window if they're appropriate to your needs. Otherwise, leave the default settings intact.

4. Click the Export icon in the lower-right corner of the Export window when you're ready to continue.

5. From the finder window that appears, select the destination to which you want the exported image saved. Make sure you select the appropriate hard drive, as well as a specific directory or subdirectory.

6. Click the OK icon to complete the export process. Your image is exported, and a copy of it, in the format and image quality you selected, is saved on the drive and in the directory you selected. The original image remains in iPhoto '11, stored in its proper Event folder.

Exporting Entire Events

Sometimes you might want to export the entire contents of an Event folder, Album, or another type of folder. When you export an entire Event folder, for example, all the images in that folder are exported to a specific location on your Mac's hard drive (or another destination that you select).

> **CAUTION**
>
> When you export your images from an entire Event, Album, or folder into a directory on your Mac's primary hard drive, in essence you create a copy of each image onto the same drive. Storing the same photo twice on a hard drive (the exported version and the version that remains in iPhoto '11) takes up a lot of storage space. So, if your Mac's hard drive space is limited, consider exporting the images to an external hard drive or another destination.

 SHOW ME Media 10.3—Export an entire Event or Album folder (all the images stored in that folder) from iPhoto '11 using the Export command and options available from the Export window
Access this video file through your registered Web Edition at
http://www.quepublishing.com.

 LET ME TRY IT

Exporting an Entire Event Folder or Album

To export all the images stored in a specific Event folder or Album from iPhoto '11 to a specific destination on your Mac's hard drive, an external hard drive, or a flash drive, for example, follow these steps:

1. Choose and highlight the Event or Album you want to export. All the images in that folder will be exported simultaneously. When an Event folder is highlighted and selected, it is surrounded by a yellow border. When you highlight and select a Faces folder, it is surrounded by a blue border.

2. Select the Export command from the File pull-down menu.

3. When the Export window appears, make sure the File Export tab at the top of the window is highlighted; then choose the file format (Kind) and image

quality you want (refer to Figure 10.2). Adjust the other options available in this window if they're appropriate to your needs. Otherwise, leave the default settings intact.

4. Click the Export icon in the lower-right corner of the Export window when you're ready to continue.

5. Select the destination where you want the exported images to be saved. Make sure you select the appropriate hard drive, as well as a specific directory or subdirectory.

6. Click the OK icon to complete the export process. Your images are exported, and a copy of each, in the format and image quality you selected, is saved on the drive and in the directory you chose. The original images remain in iPhoto '11 stored in their proper Event folders.

Exporting to a Web Page

You can instantly create an online photo gallery using just the images you select with the Export to Web Page option available from the Export window. The result of using this feature is basic HTML web pages, which you can upload and ultimately publish via your own website hosting service.

NOTE

HTML (which is an acronym for Hypertext Markup Language) is a primary programming language used to create websites. When you create a web page using iPhoto '11 to showcase your photos online, all of the programming is done for you. You simply need to copy the relevant HTML files to the appropriate location(s) on your website hosting service to make the page pages available to the web surfing public.

This option is best used if you already host or maintain your own website. Using other features of iPhoto (described in Chapter 14, "Emailing or Publishing Your Photos Online," Chapter 16, "Using Apple's MobileMe with iPhoto '11," and Chapter 17, "More Ways to Share Your Photos"), you can create photo-intensive web pages or online galleries to be displayed on Facebook, MobileMe, or Flickr.com without having to manually export your photos.

After selecting and highlighting the photos you want to export to a web page, select the Export command from the File pull-down menu. When the Export window appears, click on the Web Page tab at the top of the window (it's to the right of File Export).

As you can see in Figure 10.3, the content of the Export window totally changes and is now divided into three sections, giving you a new set of options for exporting your photos and having iPhoto create customized HTML website pages using your images.

Figure 10.3 *The Web Page Export window is divided into three sections: Page, Thumbnail, and Image.*

Under the Page section of the Web Page Export window, using the keyboard, enter the title of the web page you want to create. Next, decide how many rows and columns you want on the page to display your photos.

The number of photos you're exporting, combined with the number of rows and columns you want on the page, determines the number of web pages needed to showcase the photos. This number is automatically displayed to the right of the Rows field in the Page section in the Web Page Export window.

From the Template field located under the Column field in the Page section of the Web Page Export window, you can choose to have the photos on your soon-to-be-created web page displayed in a frame or plain. This is a decision made based on your personal taste, as is the color of the background and color of the text that will be displayed on the web page.

To choose the color of the web page's background or text, click on the color sample next to the Background or Text Color label, and select your colors via the Colors window that appears (see Figure 10.4).

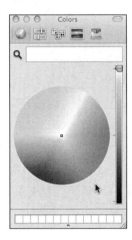

Figure 10.4 *The Colors window allows you to select the background color and text color to be displayed in the web page you're creating.*

From the Thumbnail region of the Web Page Export window (in the lower-left corner of the window), set the maximum size of each image thumbnail to be displayed on the web page and determine if the picture's filename and/or description will also be displayed below each thumbnail.

Later, when people are visiting the web page you're now creating, they will click on the thumbnail to see a larger version of the photo in their web browser. Keep in mind that the larger you display each thumbnail on the page, the more detail visitors to this web page will be able to see without actually opening the image. The default selection is 240×240 pixels.

Keep in mind, however, that larger image sizes utilize larger file sizes, which translates to longer downloading time, particularly for someone with a slow Internet connection.

To the right of the Thumbnail region of the Web Page Export window is the Image area. From here, you can determine the maximum width and height of an image to be displayed after visitors click on the thumbnail to see a larger version of the photo in their web browser.

By placing check marks in the appropriate check boxes, you can also decide what text-based information pertaining to each photo will be displayed when the people visiting your web page click on that image. Your options include having the title, description, metadata (keywords), or location displayed below the image.

In the lower-left corner of the Web Page Export window, the total number of images you selected to be exported and published as part of the web page is displayed.

After all the web page settings have been adjusted and customized, click on the Export icon located in the lower-right corner of the Web Page Export window to begin the export and web page creation process. A Finder window appears, allowing you to determine where the exported web page and image files will be saved. Choose the destination location, including the directory and subdirectory, as appropriate.

The Web Page export process could take several minutes, based on the number of photos being exported. When the process is done, the Web Page's HTML files are stored at the destination you selected in several subdirectories created by iPhoto '11. The software separates the main HTML pages with their required images, thumbnails, and resources (placed in separate directories), all of which are now ready to transfer and publish on your website hosting service.

Figure 10.5 shows an example of what your online web gallery could look like using the Web Page Export feature of iPhoto '11.

Figure 10.5 *A sample online photo gallery created using iPhoto's Web Page Export options.*

Exporting to QuickTime

The Export to QuickTime feature of iPhoto '11 allows you to create no-frills slideshows in QuickTime format that can be incorporated into a website or blog, for example, to showcase your photos. Keep in mind that you can create much more elaborate slideshows in iPhoto '11 by clicking on the Create command icon and selecting the Slideshow option.

 ⓖ *To learn more about creating slideshows using iPhoto '11's impressive Slideshow feature, **see** Chapter 15, "Creating and Sharing Slideshows."*

To use the Export to QuickTime feature, select a group of photos or an entire Event, Album, or folder to be exported using the Export command under the File pull-down menu. When the Export window appears, click on the QuickTime tab located in the top center of the window.

Once again, the entire contents of the Export window change, giving you a new set of options for customizing the QuickTime animated slideshow movie you want to create using your photos. Figure 10.6 shows what the QuickTime Export window looks like.

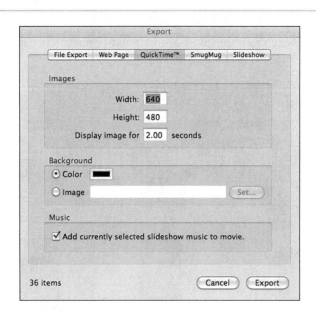

Figure 10.6 *The QuickTime Export window.*

 LET ME TRY IT

Creating a QuickTime Movie with Your Images

Follow these steps to create a QuickTime movie using your images:

1. Select and highlight an Event folder or Album that contains the images you want to create into a QuickTime movie.

2. Access the File pull-down menu and select the Export command.

3. When the Export window appears on the screen, click on the QuickTime tab at the top-center of the window.

4. Under the Images heading, choose the display size (in pixels) for each image. The default setting is 640 x 480 pixels. However, if you're creating an animated photo sequence you want to add into a website or blog, you might want to create a much smaller movie window.

5. After setting the window size, choose the amount of time (in seconds) you want each photo to be displayed. The default option is two seconds. If you choose anything shorter, the photos will not be clearly visible when people watch your QuickTime movie because the photos will literally flash on the screen and disappear too quickly.

6. From the Background section of the QuickTime Export window, select the background color for the entire "movie" you're creating or select a separate background color for each individual image as it's displayed.

7. Toward the bottom of the QuickTime Export window, choose whether to add music to your "movie" by placing a check mark in the appropriate check box.

TIP

When you add a check mark next to the Add Currently Selected Slideshow Music to Movie check box, the music selection is the default music file from the Create Slideshow feature of iPhoto '11. You must access the Slideshow creation tools to change the default setting to any other music you choose, such as a music file stored on your Mac's hard drive (in your iTunes library).

8. In the lower-left corner of this window, the total number of images to be exported and included in the QuickTime movie is displayed. After you customize all the options available from this window, click on the Export icon to continue the export and QuickTime file creation process.

9. When the Finder window appears, choose the destination where you want the relevant QuickTime file exported and saved. Click on the OK icon to continue. The exporting process could take several minutes, based on the number of photos being exported and the size of the "movie" file being created.

Exporting a Slideshow

If you've already created a slideshow using iPhoto '11, you can export that entire slideshow file so it can be published online, shared via email, or viewed using other applications, for example.

 LET ME TRY IT

Exporting a Slideshow

Follow these steps to export a Slideshow you've already created using iPhoto '11:

1. From the Source list, select and highlight the slideshow you want to export, or choose a group of photos (or an entire event) you want to create into a slideshow and then select the Export command from the File pull-down menu.

2. When the Export window appears, click on the Slideshow tab located on the top-right corner of this window. Once again, the content of the Export window changes. What you see now is a screen that allows you to decide in what format the slideshow should be exported, based on how it will be displayed and on what type of device.

3. Your slideshow export options include Mobile (480 × 300 resolution), Medium (640 × 400 resolution), Large (864 × 540 resolution), or Display (1280 × 800 resolution). By placing a check mark next to the appropriate check box, shown in Figure 10.7, you can also automatically send a copy of your exported slideshow to iTunes so that it can become part of your iTunes library; viewed in iTunes; or easily transferred to your iPod, iPhone, or iPad.

4. When you click on the Custom Export icon in the lower-left corner of the Slideshow Export window, a Finder screen appears allowing you to determine where the exported slideshow file will be saved. Plus, you can determine in what file format the slideshow will be exported. Your choices include the following:

 - Movie to 3G
 - Movie to Apple TV

- Movie to iPhone

- Movie to iPhone (cellular)

- Movie to iPod

- Movie to MPEG-4

- Movie to QuickTime

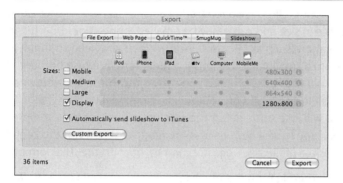

Figure 10.7 *The Slideshow Export window offers a chart to help you choose the best file size, based on what device or screen size will be used to view the slideshow.*

By clicking on the Options icon located next to the Export format field, you can fine-tune and customize the adjustments for each format setting, based on how you'll be viewing and/or sharing the exported slideshow. The options you pick determine the file size and the resolution in which the slideshow can ultimately be viewed. Unless you understand the specifics of these options, stick with the default settings and simply choose what device you'll be using to view the slideshow, such as your Mac's display or your iPhone or iPod.

What You Need to Know Before You Export

Before exporting an image, think about what that digital file will be used for. If it will be transformed into a print, stick with a higher resolution and larger file size. However, if the image will be viewed online or on an iPhoto or iPod screen, for example, using a lower resolution and smaller file size is more efficient.

From the Export window, you are able to select the file format and file size for the images you export.

Choosing the Right File Format

When exporting images, you can choose to export each image and retain the original format in which it was shot. You can also opt to keep it in its current format if the format has since been altered or change its format altogether to .JPEG, .TIFF, or .PNG. Here's a brief description of each file format:

- **.JPEG**—This popular digital image compression format allows you to modify resolution to reduce file size. On almost all digital cameras, the default setting is to shoot in .JPEG (also referred to as .JPG) format. This type of file is manageable in size and can easily be emailed, printed, or imported into another application (such as Microsoft Word). When you need to shrink an image down to a smaller file size, this is a great format to use because it preserves as much detail as possible, and you can adjust the balance between image quality and file size based on your needs. When you use this image format, your photo will lose some detail and resolution because data compression is being used. If you have a high-resolution image that you want to keep as detailed as possible (if file size does not matter), go with the .TIFF format.

- **.TIFF**—This file format is much less flexible when it comes to file size compression. Thus, .TIFF file sizes tend to be larger and are not as widely supported as .JPEG images in web browsers and by other applications. When image quality is of utmost importance and file size doesn't matter, go with the .TIFF format. When dealing with this format, you never have to worry about a loss of resolution or detail as you import and export .TIFF image files between applications.

- **.PNG**—This file format has become much more popular in recent years. It's also wildly compatible with many types of applications and web browsers and is an open-source standard. PNG is an acronym for Portable Network Graphics. When dealing with this format, you never have to worry about a loss of resolution or detail. A full explanation of this file format and why it's useful can be found at www.libpng.org/pub/png/pngintro.html.

> **NOTE**
>
> If you imported a photo that was shot in RAW format (an option available on higher-end Digital SLR cameras), but you edit that photo using iPhoto '11, the file format is converted to .JPEG. Thus, when you export the edited photo, choosing to export it in its original format returns it back to RAW format.

Selecting the Appropriate Image Quality

When exporting an image using .JPEG format, you can choose the export quality, which directly impacts file size. Your choices in iPhoto '11 are Low, Medium, High, and Maximum. For online use only, go with the Low or Medium settings because this creates small and easily manageable file sizes. The quality of the image will be lower, but for online viewing, this probably won't be noticeable.

If you're creating prints from the digital file, for example, the High or Maximum Quality setting should be used. For 8" × 10", 8.5" × 11", or poster-size (or larger) prints, go with the Maximum Quality setting.

NOTE
Better-quality or higher-resolution images require larger file sizes.

Understanding That File Size Does Matter

Regardless of which file format you choose to export your images, you can adjust the size of the file from the Export window. Choose the Small option for emailing images or to display them on the Web. However, if you try to print a photo exported in a Small file size, the print's quality will be very poor.

The Medium quality allows for more detail and a better-quality image to be displayed on the Web or in an email, for example, but it's better used by people with a high-speed Internet connection because the file sizes are larger. The Medium size is better suited for online or onscreen viewing, but not adequate for printing.

The Large file size is ideal for printing standard size photos (4" × 6" or 5" × 7" prints) or for viewing the images on a computer screen or online if you have a fast Internet connection.

Use the Optimized size for creating large-size prints or for publishing your photos. This option does compress the file size a bit, so there may be some loss in resolution and detail.

The Actual Size/Full Size setting is best for printing, viewing, and publishing. The file size associated with these exported images is larger, so they take a bit longer to upload or download. No compression is used, however. So, whatever image size and resolution the photo was shot in is how it remains. Images shot with a 12MP (megapixel) resolution digital camera are significantly larger than images shot with a 5MP camera.

Keeping Your Filenames Straight

During the export process, you have the option to rename an image file for the version of the image that's being exported. The original image that stays in iPhoto '11 retains its original filename, but the new image file that's created and saved on your Mac's hard drive (or another destination) will contain the new filename if you provide one.

If you don't change the filename when you have access to the Finder window and you're selecting the image's destination, it retains its current filename. When exporting groups of images or an entire Event, Album, or folder, you can set a base or prefix filename and then for each image have iPhoto '11 add a sequential number to each image's filename.

So, if all the images are of Joe's birthday party, you can set iPhoto '11 to export all the images and use the filename prefix JoesBirthday, but each will have a unique (and sequential) number, such as JoesBirthday1.jpg, JoesBirthday2.jpg, JoesBirthday3.jpg, and so on. To utilize this feature, in the File Export window, for the File Name field option, select Sequential. Below that, in the Prefix for Sequential field, type the prefix for the filename, which for this example is **JoesBirthday** (see Figure 10.8).

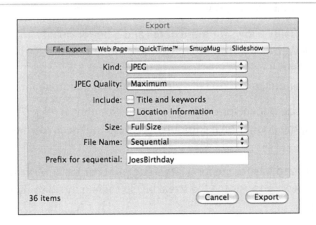

Figure 10.8 *When exporting multiple images simultaneously, you can use the Sequential File Name option.*

You also have the option to export groups of files and have them all use the existing name of the Album or folder, followed by a sequential number for the filename. To use this feature, select the Album Name with Number option from the File Name pull-down menu that appears in the File Export window.

TIP

Especially if you're dealing with a large collection of image files, you're better off custom-naming your photos as you export them. This makes them easier to identify and find later.

iPhoto '11's Export Window

As you've already discovered, the Export window, which is accessible from the File pull-down menu and by choosing the Export command, allows you to customize the file settings related to an image before it gets exported from iPhoto '11.

Most of the time, you can rely on the default settings in this window; they've been chosen because they address the typical needs of amateur photographers. However, customizing these settings based on your specific needs for the image files after they are exported is a worthwhile endeavor.

Depending on how the image will be used and what you're exporting from iPhoto '11, as soon as the Export window appears, click on the appropriate tab displayed at the top of this window. Your options include File Export, Web Page, QuickTime, and Slideshow.

If, however, you use another photo editing software package or online photo service that's designed to be fully compatible with iPhoto '11, such as the SmugMug online service (www.SmugMug.com), you may have the option to install a plug-in into iPhoto '11 that allows you to easily export and upload your images directly to the third-party service without leaving iPhoto '11.

When you install the free SmugMug.com plug-in, for example, a new tab permanently appears at the top of the Export window (see Figure 10.9). This is a feature that Apple doesn't support or endorse, but that makes it more convenient to export, upload, and publish your images to online services that iPhoto '11 doesn't support by default.

NOTE

Other third-party websites or software packages may also offer plug-ins for exporting images from iPhoto '11. In this case, additional tabs appear at the top of the iPhoto '11's Export window.

ⓖ *To learn more about exporting, uploading, and publishing your photos to often-free, online-based photo services, other than Flickr.com or Apple's fee-based MobileMe service,* **see** *Chapter 16, "Using Apple's MobileMe with iPhoto '11."*

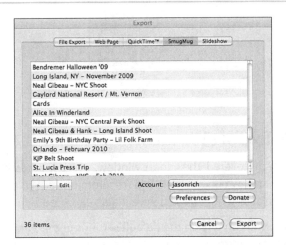

Figure 10.9 *The free SmugMug.com plug-in has been installed, allowing you to export and upload your images from iPhoto '11 directly to the SmugMug service without leaving iPhoto '11.*

 SHOW ME Media 10.4—Export multiple photos from iPhoto '11 using the Export command and options available from the Export window
Access this video file through your registered Web edition at
http://www.quepublishing.com.

 LET ME TRY IT

Exporting Multiple Photos

To export multiple images simultaneously from iPhoto '11 to a specific destination on your Mac's hard drive, an external hard drive, or a flash drive, for example, follow these steps:

1. Choose the photos you want to export. From the Event, Photos, Faces, or Places viewing mode, highlight and select those photo thumbnails. If they're not located next each other, hold down the Command key as you select and highlight each image to highlight and select several image thumbnails simultaneously. Figure 10.10 shows several images in an Event highlighted and selected. The highlighted and selected images are surrounded by a yellow border. You can also create a separate Album that contains all the photos you want to export if the images are currently in separate Event folders and you don't want to repeat this process multiple times in each Event folder.

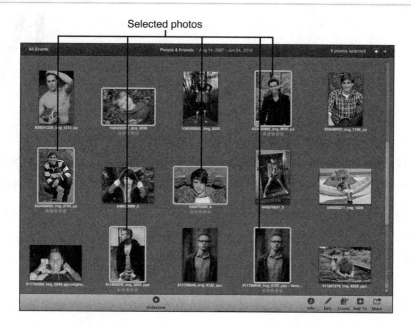

Figure 10.10 *Multiple images selected in an Event are about to be exported.*

2. Select the Export command from the File pull-down menu.

3. When the Export window appears, make sure the File Export tab at the top of the window is highlighted. Then choose the file format (Kind) and image quality you want and adjust the other options available from this window if they're appropriate to your needs. All the photos you're exporting simultaneously are exported using the same file format and file size that you select here. Each retains its current filename, unless you manually change it.

4. Click the Export icon in the lower-right corner of the Export window when you're ready to continue.

5. From the Finder window that appears, select the destination where you want the exported images to be saved. Make sure you select the appropriate hard drive, as well as a specific directory or subdirectory.

6. Click the OK icon to complete the export process. Your images are exported, and copies of it, in the format and image quality you selected, are saved on the drive and in the directory you selected. The original images remain in iPhoto '11, stored in their proper Event folders.

IV

Printing Your Photos Using iPhoto '11

11 Printing Photos Using Your Own Home Photo Printer **195**

12 Creating Prints Using a Professional Photo Lab **211**

13 Creating Photo Projects and Photo Gifts **220**

Discover how to create professional-quality prints from your images using iPhoto '11 and your home photo printer.

11

Printing Photos Using Your Own Home Photo Printer

If you want to create professional-quality prints to frame, insert into a traditional photo album or scrapbook, or hand out to friends and loved ones, you have several options with iPhoto '11.

You can use the Order Prints feature built into the software, upload your images to Apple's photo lab, and then have the prints shipped to your door in a matter of days. This can be done without leaving the iPhoto application.

Alternatively, you can upload your images to an online photo service that's not affiliated with Apple and order prints from that service to be shipped to your door.

Another option is to export your favorite images; save them on a CD, DVD, or flash drive; and then take the digital files to a local one-hour photo processor or professional photo lab to have prints created while you wait.

*To learn more about ordering prints in iPhoto '11 or using another online-based photo service, **see** Chapter 12, "Creating Prints Using a Professional Photo Lab."*

In terms of convenience, flexibility, and the opportunity to save money, you have the ability to print your photos from iPhoto '11 directly to a home photo printer connected to your Mac via a USB cable or wireless (Bluetooth or Wi-Fi) connection.

Home photo printers from companies such as Canon, Epson, HP, and Kodak have recently dropped in price, yet their features and capabilities now rival what a professional photo lab is able to achieve when it comes to generating prints from your digital photos in a wide range of sizes.

This chapter provides the information you need to create awesome-looking prints in iPhoto '11 using a home photo printer.

What You Should Know About Photo Printers

If you visit any computer store, office supply superstore, or consumer electronics retailer that sells computer equipment, you'll see three main types of printers for

sale—laser printers, inkjet printers, and photo printers—in addition to all-in-one or multifunction printers.

To create professional-quality prints, like what you'd receive by having your prints created at a photo lab, you should use a photo printer (not a standard color inkjet printer or color laser printer), along with the appropriate type of ink and high-quality photo paper.

Photo printers range in price from around $50 to $400 and are manufactured and sold by well-known companies, including the following:

- **Canon**—www.canon.com

- **Epson**—www.epson.com

- **HP**—www.hp.com

- **Kodak**—www.kodak.com

When it comes to photo printers for home use, some models are compact and designed exclusively for printing 4" × 6" and/or 5" × 7" size prints. Others are full size, can create prints up to 8.5" × 11", and can also serve as a traditional inkjet printer. More costly, wide-carriage photo printers are available from companies such as Epson; they allow for poster-size prints to be created (up to 13" × 19").

As you begin shopping for a photo printer, you'll notice that each manufacturer offers a handful, sometimes dozens, of different models, each offering slightly different features. For example, some all-in-one printers print photos but serve as a traditional inkjet printer, as well as a flatbed scanner, fax machine, and photocopier.

What to Consider Before Buying a Photo Printer

When shopping for a photo printer, begin by asking yourself if you need just a photo printer or you want the printer to handle traditional printing and/or other functions as well. If your plan is to create all your prints from home using a photo printer, think about what size prints you'll most often want and need. A compact photo printer allows you to create prints only up to 5" × 7", but a full-size photo printer allows you to create any size print up to 8.5" × 11".

Next, think about the printer's cost. Don't just look at its price tag, however. The big cost associated with photo printers is the price of the ink.

Depending on the printer, it may require a black ink cartridge plus a separate multicolor ink cartridge (sold separately). Or the printer could require up to seven different colored ink cartridges, each sold separately. Determine how much the ink

cartridges cost and, on average, how many 5" × 7" prints, for example, you can expect to be able to create with each set of cartridges.

Calculate the average cost per photo (based on a standard, full-color, 5" × 7" print). This is often listed as part of the printer's technical specifications or features.

CAUTION

Don't be fooled by low printer prices! You may find an amazing photo printer on sale for under $75. However, that printer might require ink cartridges that sell for $15 to $25 each, and to keep the printer operational, you may need black *and* multicolor ink cartridges (or up to seven different colored ink cartridges). In other words, the amount of money you spend on ink cartridges to keep your photo printer operational could quickly become significant, especially if the ink capacity of each cartridge is small, and you don't get more than 50 to 75 5" × 7" prints from each set.

TIP

To save a fortune on ink, shop online for compatible ink cartridges for your photo printer. Visit a price comparison website, such as Nextag.com (www. nextag.com), and in the Search field, type in the exact make and model of your photo printer, followed by the words **ink cartridges** or **replacement ink cartridges**. A handful of companies that sell genuine, name-brand ink, as well as compatible ink cartridges for your printer, are displayed. Shop from an online merchant that offers the best prices but that also has the highest customer feedback ratings and lowest shipping fees.

 TELL ME MORE Media 11.1—What you should know about photo printer ink that could save you money

To listen to a free audio recording about some of the ways you can save money buying ink for your photo printer, log on to **http://www.quepublishing.com.**

Choosing the Right Photo Paper to Meet Your Needs

In addition to starting with a good-quality photo printer and using quality ink in that printer, if you want to wind up with professional-quality prints from your photos without going to a photo lab, you need to invest in high-quality photo paper.

Photo paper comes in different qualities and is rated using a star system. In general, always use four- or five-star photo paper when creating prints that you want to dry quickly as they come out of the printer and showcase the vibrant colors in your photos. Higher-quality photo paper won't fade after a few months or even many years.

Along with the photo paper's quality, you must choose the paper's finish. Most photo paper manufacturers offer a standard matte, semi-gloss, and high-gloss finish. A few also offer a finish called Luster; this is what many professional photographers use when creating wedding albums or portraits for their clients.

Each photo paper finish gives your prints a slightly different appearance. The finish you select is a matter of personal preference. Here's what you need to know about each finish type:

- **Matte**—Prints created on photo paper with a matte finish have no shine and don't reflect light. This finish is particularly useful if you'll be framing your images behind glass. The colors in your prints, however, may seem less vibrant because there is no glossy finish to reflect the light.

- **Semi-gloss (soft gloss)**—Prints created on photo paper with a semi-gloss or soft gloss finish have a small amount of shininess to them. Because they reflect light, colors often appear more vibrant. This type of print is best suited for inclusion in a traditional photo album or scrapbook.

- **High gloss**—Prints created using a high-gloss paper finish appear very shiny, almost as if the ink is still wet (even long after it's dry). Colors appear bright and vibrant, but the glare caused by direct light could be distracting when viewing the photos, especially through a plastic or glass frame.

- **Luster**—This rich and classy finish is ideal for portraits and photos that will be presented in a fancy album. Photos look as if they have a satin-like finish. Luster photo paper is often used by professional photographers. It's more expensive and often difficult to find unless you buy it from a photography specialty store. The results, however, tend to be worth the extra expense if you're looking to create quality prints.

TIP

All the printer manufacturers sell their own brand-name photo paper. However, despite what the printer companies want you to believe, all photo paper works in all photo printers as long as the paper size is appropriate for that printer. So, if you have an Epson printer, you can buy and use Epson, HP, Canon, Kodak, Office Max, or any other brand of photo paper. You can determine the paper's quality

by the industry-standard star rating and the paper's finish. Always shop for the best deals. Office supply superstores, for example, often run buy-one-get-one-free promotions or other sales on certain brand names of photo papers.

Using iPhoto '11's Print Function

When your photo printer is set up and connected to your Mac, loaded with ink, and has the appropriate size photo paper inserted in the paper tray, start by running a printer check to ensure everything is working properly.

TIP

If there are long stretches of weeks or months in between uses of your photo printer, you can preserve the life of your ink cartridges, prevent them from drying out, and avoid the printer's print heads from getting clogged if you remove the ink cartridges from the printer, wrap them in airtight plastic wrap, and store them in a cool, dry place until they're needed again.

If your printer is connected to your Mac, turned on, and its "Ready" light (or equivalent) is lit, you're ready to start creating prints using iPhoto.

First, select and highlight the image you want to print in iPhoto '11. Next, select the Print command from the File pull-down menu (see Figure 11.1).

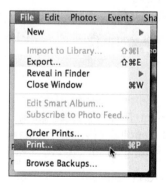

Figure 11.1 *The Print command is available from the File pull-down menu or by pressing Command + P on the keyboard.*

> **TIP**
>
> With an image's thumbnail highlighted and selected, or when viewing an image in iPhoto's main image viewing area, you can also use the keyboard shortcut Command + P to execute the Print command.

iPhoto's Print Settings window, shown in Figure 11.2, is displayed after you execute the Print command. It's from this window that you can adjust various settings based on the size print you want to create.

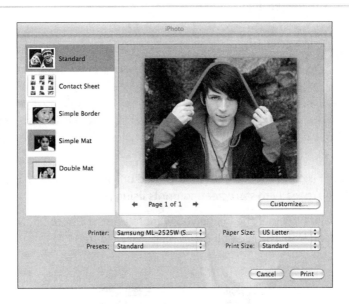

Figure 11.2 *This Print Settings window shows all the default settings.*

On the left side of the Print Settings window is the Themes section. With a single click of the mouse, choose the Theme thumbnail that corresponds to the type of print you want to create. Regardless of which theme you select, click the Customize icon to adjust the various settings associated with each theme.

Your theme options (from top to bottom) include the following:

- **Standard**—Create a print on standard photo paper.

- **Contact Sheet**—Print thumbnails of multiple images on a single sheet of photo paper. You can determine the size of the thumbnails and choose whether to print their respective filenames below each thumbnail.

- **Simple Border**—This feature automatically creates a single, thick border around the image when it's printed.

- **Simple Mat**—This feature automatically creates a single mat around an image. You can choose the mat's color and style by selecting this theme and then clicking on the Customize icon and using the various Print command icons displayed at the bottom-right corner of the screen.

- **Double Mat**—This feature automatically creates a digital double mat around the photo. You can select the color and style of each mat by clicking on the Customize icon after choosing this theme and then using the various Print command icons displayed at the bottom-right corner of the screen.

Toward the bottom of the Print window, there are four pull-down menus, labeled Printer, Presets, Paper Size, and Print Size. Here's an explanation of what each setting does:

- **Printer**—If you have multiple printers connected to or accessible from your Mac, you need to select your Photo Printer from the pull-down list. All the printers available to your Mac are displayed here.

- **Presets**—If you have custom printer settings that you want to refer back to and use often, you can save them and then call upon them again later by using this setting.

- **Paper Size**—Photo paper comes in a wide range of sizes based on standard-size prints. For example, you can use 4" × 6", 5" × 7", or 8.5" × 11" photo paper. Select the appropriate size photo paper based on what's currently loaded in your printer. If you have a compact photo printer, your options in terms of paper size are more limited.

- **Print Size**—In addition to choosing the paper size, you must select the print size you want to create. If you have 8.5" × 11" photo paper installed in your printer, you can choose to use only a fraction of that paper and create a smaller 4" × 6" or 5" × 7" print, or you can fit multiple prints on a single page, for example.

TIP

When selecting a standard paper size for prints, such as 4" × 6" or 5" × 7", you have the option to print your photos with or without a thin white border. If you choose a borderless print, the image is printed right up to the extreme edges of the photo paper. When you use a professional photo lab, however, most add a thin white border around your prints, which you can do as well on your photo printer at home.

CAUTION
The print size you select must be the same size as or smaller than the paper size inserted into your printer.

After you adjust the settings in the Print Settings window, click the Print icon located in the lower-right corner of the window to send your image to the photo printer and create your print. Or, to exit this window without printing your image, click on the Cancel icon located to the immediate left of the Print icon.

Before clicking Print, however, you can further customize your printing options (or customize a particular print theme) by clicking on the Customize icon located below and to the right of the image preview area.

 SHOW ME Media 11.2 **The print themes and how they differ**
Access this video file through your registered Web Edition at
http://www.quepublishing.com.

 LET ME TRY IT

Creating a Contact Sheet

A Contact Sheet is a great way to print a many thumbnails of images on a single page to use them for reference. To create a Contact Sheet, follow these steps:

1. Select and highlight a photos you want to print (or select an entire Event or Album).

2. Access the Print command from the File pull-down menu or press Command + P on the keyboard. The Print Settings window appears.

3. Choose the Contact Sheet setting from the left side of the Print Settings window and then click on the Customize icon to see how you can customize that theme.

4. Using the Columns slider found at the bottom-center of the screen, choose how many columns of thumbnails you want to appear on each page. The more columns you choose (between one and 10), the smaller the image thumbnails will appear on the page. For easy viewing, choose three or four columns.

5. Using the command icons in the lower-right corner of the screen, you can adjust the background color by clicking on the Background icon.

6. Click on the Print command to print your Contact Sheet.

Customizing Your Print Job

Depending on which print theme you select, the options available to you when you click on the Customize button vary. Starting with the Standard theme, as soon as you click on the Customize icon, the entire iPhoto '11 screen changes.

In the bottom-right corner of the screen, there are Cancel and Print command icons. Immediately below them are seven new command icons, labeled Print Settings, Themes, Background, Borders, Layout, Adjust, and Settings. In the middle of the screen is a large print preview area (which showcases what your print will look like before you actually print it).

By selecting the Standard theme, for example, you can use the various command icons that appear at the bottom-right corner of the screen to change the background color, border, and layout.

To zoom in or out and reposition a photo to change how it will appear when it's printed, click on the actual image in the preview area. A frame appears around the image, and a Zoom slider appears in the image preview viewing area.

Use this Zoom slider to zoom the photo in or out. Click on the hand icon once, move the cursor over the preview image, and hold down the mouse button to move the image around in the frame after you've zoomed in or out to reposition it.

Shown in full-screen mode, Figure 11.3 shows how you can zoom in on an image in the preview window and then preposition it in the frame before printing.

The Print Command Icons and What They Do

When you click on the Customize icon in the Print Settings window, the Cancel and Print command icons appear in the lower-right corner of the screen. Below them are seven additional command icons, which are described in this section. Figure 11.4 shows what these command icons look like.

Print Settings

Click on the Print Settings command icon to quickly return to the Print Settings window.

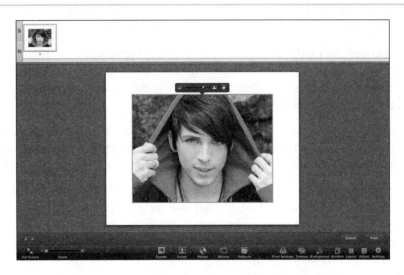

Figure 11.3 *Click on the image in the preview window to zoom in or out and preposition it in the frame before printing.*

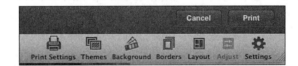

Figure 11.4 *The command icons found in the lower-right corner when you click on the Customize icon from the Print Settings window.*

Themes

When you click on the Themes command icon, a new window appears (see Figure 11.5). The Themes window allows you to quickly switch print themes without returning to the Print Settings window. In this example, it's shown in full-screen mode.

Background

Depending on which print theme you selected, you are able to choose from several different colors for your background. Your choices can be previewed in the image preview area before you click the Print icon to create your print. Use the mouse to click on the background color of your choice.

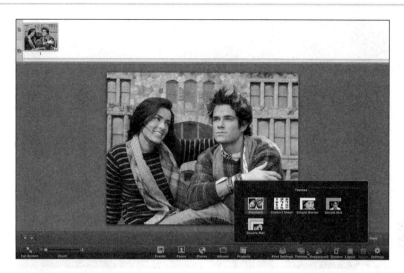

Figure 11.5 *Quickly switch between print themes by clicking on the Themes command icon.*

NOTE
What appears in the print preview window is exactly what gets printed.

Borders

Again, depending on which print theme you select, you are able to choose from a variety of different border styles prior to printing. The border you select appears in the image preview window.

Figure 11.6 shows the available border choices if you select to create a print using the Standard print theme.

Layout

Click on the Layout command icon to choose from a variety of different print layouts. Your options vary based on which print theme you selected. If you have multiple images preselected and highlighted, you are able to choose extra layouts that can accommodate between two and four images per page, allowing you to quickly create eye-catching photo collages.

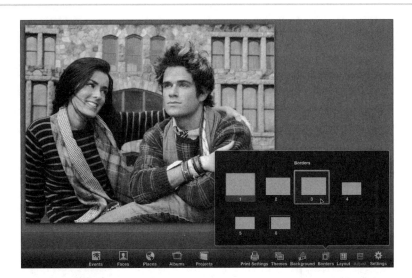

Figure 11.6 *You can add a custom border to your image before printing it.*

TIP

By adding a line or two of text to a layout, you can create professional-looking actor or model headshots, for example, or simply add a text-based caption to your print. Use the Settings command icon to choose a font, font size, and type-style (bold, italic, and so on).

Figure 11.7 shows an example of a three-image collage created by prehighlighting and selecting three images from an Event, accessing the Print window, choosing the Simple Mat theme, and then selecting a three-image photo collage layout from the choices offered by clicking on the Layout command icon.

 SHOW ME Media 11.3—Create and print a multiphoto collage
Access this video file through your registered Web Edition at
http://www.quepublishing.com.

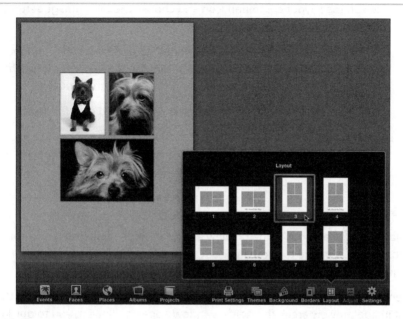

Figure 11.7 *Create a multiphoto collage with ease using the options available from the Layout command icon.*

 LET ME TRY IT

Creating and Printing a Multiphoto Collage

Instead of printing a single image, you can quickly create and print a multi-image collage and customize its layout and appearance in iPhoto. Follow these steps to create your own photo collage:

1. Select and highlight between two and four photos you want to appear in your collage. For this example, go with three images.

2. Access the Print command from the File pull-down menu or press Command + P on the keyboard. The Print Setting window appears.

3. Choose the Simple Border, Simple Mat, or Double Mat theme from the left side of the Print Settings window and then click on the Customize icon. For this example, choose the Simple Mat option.

4. Click on the Background command icon to select the color of your mat. Go with black for this example.

5. Click on the Layout command icon and choose the three-image setting. Choose one of the templates that appears.

6. Click on each image in the preview window to use the zoom in/out feature and adjust its position in the frame. You can also move photos into different positions by dragging and dropping them using the mouse.

7. Add a text-based caption if the template you selected calls for one.

8. When the collage is fully customized and laid out the way you like it, click on the Print icon to send your creation to your photo printer and create a print. You can preview it first in the Prints Settings window, however.

Adjust

While looking at a photo in the preview area of iPhoto's Print screen, you can click on that preview image to zoom in or out, reposition it in the frame, and edit the image using the features available from the Adjust command icon.

When you click on this icon (an image must be selected and highlighted in the print image preview area), the Adjust window appears, allowing you to quickly add special effects to an image (B&W, Sepia, or Antique) or adjust the image's Exposure, Contrast, or Saturation settings. Using sliders in the Adjust window, you can also fine-tune the image's Definition, Highlights, Shadows, Sharpness, De-noise, Temperature, and Tint settings.

Figure 11.8 shows what the Adjust window looks like, plus showcases the Zoom slider and hand-shaped repositioning icon that appears in the image preview area when you click on the image being previewed.

 ⊙ *To discover how to use the features and functions offered in the Adjust window, see Chapter 8, "Adding Effects to Your Images," and Chapter 9, "Advanced Photo Editing with iPhoto '11."*

Settings

If you've chosen to add a text-based caption to your photos before printing them, the options available when you click on the Settings command icon allow you to adjust the font, typestyle, and font size that's displayed. You can also adjust the font if the filename will appear under a thumbnail in a Contact Sheet.

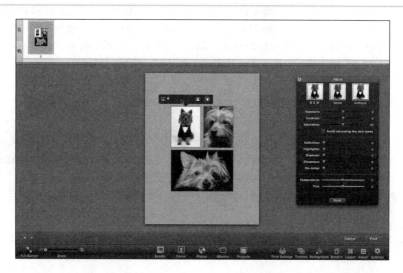

Figure 11.8 *The Adjust window allows you to customize and edit a photo while in iPhoto '11's print preview mode.*

From this Settings window, shown in Figure 11.9, you can also set the Photos Per Page option, allowing a single photo to be printed per page or multiple (different) photos to be printed per page (which can save on photo paper). You can even select to print multiple copies of the same photo on a page (space permitting).

Figure 11.9 *The Settings window.*

As you print your photos, you can also opt to display crop marks around the prints and choose to autoflow pages. With this feature, if you're working with multiple prints that will take up multiple pages, iPhoto '11 automatically places them, or in the case of a Contact Sheet or multiphoto collage, iPhoto '11 determines their positions on the page.

TIP

When you look at your prints, if the colors don't look right, based on what you see on your screen, either the Mac's screen could require calibration, or one of the ink cartridges or print heads in your printer could be clogged. Run the printer diagnostics software that came with the printer to correct any printer-related issues.

Learn how to order prints directly from iPhoto '11 or use another photo processing service.

12

Creating Prints Using a Professional Photo Lab

While you're viewing your photos in iPhoto '11, with a few clicks of the mouse, you can order custom prints of your favorite images without ever leaving the program. Your photos are automatically uploaded to Apple's photo lab, printed, and shipped directly to your door within a few days. After you input your credit card information once, ordering prints becomes a fast and convenient process.

Aside from Apple's own photo lab, however, there are literally hundreds of online photo processing services that allow you to upload your image files and have prints shipped to your door. The prices for these services are as varied as the print sizes and product quality offered. Plus, many different additional products and services are provided by these online-based photo labs.

By exporting your images and saving them onto some type of portable media, such as a flash drive, CD, or DVD, you can also take your digital images into a local one-hour photo processor or professional photo lab and have prints created while you wait.

This chapter focuses on using a professional photo lab or photo processing service to create standard-size prints (4" × 6", 5" × 7", or 8" × 10", for example) from your digital images and discusses your various options based on what services are available (as well as their convenience factor, processing time, quality, and cost).

Using the Order Prints Feature in iPhoto '11

As you view your photos in any of the viewing modes of iPhoto '11, at any time you can highlight and select one or more images, click on the Share command icon (located in the lower-right corner of the screen), and choose the Order Prints option (see Figure 12.1). You can also use the Order Prints command under the File pull-down menu.

If you want to use this feature, your Mac must be connected to the Internet, and you need a debit or credit card to set up an Apple ID account and pay for your online orders.

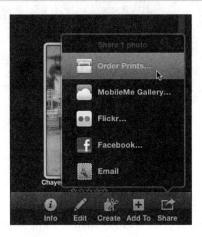

Figure 12.1 *Order prints in iPhoto '11 using the Order Prints command available when you click on the Share command icon.*

When you view the Order Prints screen, shown in Figure 12.2, it displays a thumbnail of each image you selected on the left side of the screen. Here, you can manually enter the number of wallet-size, 4" × 6", 5" × 7", 8" × 10", 16" × 20", or poster-size 20" × 30" prints you'd like to order of each image. The price per image is also displayed on this screen.

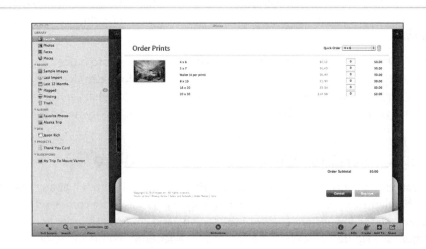

Figure 12.2 *The Order Prints screen.*

In the upper-right corner of the screen is a Quick Order field. From the pull-down menu, select the print size you want. Use the tiny up- or down-arrow icons next to

the pull-down menu to determine how many of each size print you want to order. Your selections are automatically entered into the main Order Prints screen, and your order subtotal is calculated. This feature is particularly useful if you're ordering the same number of prints (in the same size) of multiple images. Prices for prints range from a few cents to around $15, depending on size.

> **NOTE**
>
> Although Apple's prices for prints are extremely competitive, there is an additional shipping and handling fee of at least $2.99 per order; plus, local sales tax is added.

After selecting what size prints you want to order and how many copies of each size print you want, click on the Buy Now icon located in the lower-right corner of the Order Prints screen. To cancel your order and exit this option, click on the Cancel icon located to the left of the Buy Now icon.

The Your Order screen replaces the Order Prints screen when you click on the Buy Now icon (see Figure 12.3). This screen displays a summary of your order, automatically adds Apple's shipping and handling fee to the subtotal, and prompts you to enter the ZIP Code for the address where the order will be shipped so that the local sales tax can also be added to the subtotal.

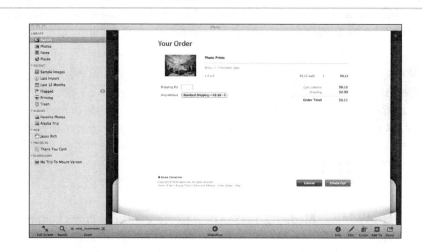

Figure 12.3 *The Your Order screen.*

To continue processing your order, click on the Check Out icon located in the lower-right corner of the screen. The Sign In screen then appears. If you already have an iTunes or Apple ID account set up, enter your iTunes or Apple ID username

under the Returning Customer prompt on the left side of this window, followed by the password associated with the account. Click the Sign In icon (located below the Password field) to continue processing your order.

☞ *If you don't yet have an iTunes or Apple ID account set up,* **see** *the "Setting Up Your Apple ID Account" section later in this chapter.*

The final step in the Print ordering process involves reviewing your order from the Confirm Order Details screen and manually entering the security code associated with the credit or debit card you have on file.

From this Confirm Order Details screen, you also have the following options: Edit Shipping Information (change the address where the order will be shipped), Edit Payment (change the credit card used to pay for the order), Edit Order (modify which prints or the number of prints you want to order), or Enter Promo Code (used if you have an Apple-approved discount available to you). To adjust any of these settings, click on the applicable blue-colored link displayed in the Confirm Order Details screen.

To finalize and process your order, click on the Place Order icon located in the lower-right corner of the Confirm Order Details screen. Your order is automatically processed, printed, and shipped within a few business days.

Within a few minutes after finalizing your order, you'll receive an email from Apple confirming the order. Another email will be sent within one to three business days, informing you when your order has shipped. Then, within a few more days, your prints will arrive at your door (sooner if you paid for express shipping).

NOTE

All prints smaller than 8" × 10" ordered from Apple's photo lab directly in iPhoto '11 are printed with a glossy finish, and the prints do not include borders around them. Larger-size prints are given a matte finish. Customers are not currently able to customize this option. Full print customization is available from other online photo processors, however.

 SHOW ME Media 12.1—See how to use the Order Prints command in iPhoto '11

Access this video file through your registered Web Edition at
http://www.quepublishing.com.

LET ME TRY IT

Ordering Prints in iPhoto '11

Follow these steps to quickly order prints in iPhoto '11:

1. Select and highlight one or more images in iPhoto '11 for which you want to order prints. You can do this from the Events, Photos, Faces, or Places viewing mode or from any Album or Folder.

2. Click on the Share command icon and choose the Order Prints command.

3. From the Order Prints screen, enter the number of prints you want that corresponds with the print sizes listed. Leave the quantity field for unwanted print sizes set at zero. Click on the Buy Now icon to continue.

4. When viewing the Your Order screen, enter the ZIP Code for where the order will be shipped and choose between the standard or express shipping method. Click the Check Out icon to continue.

5. From the Sign In screen, enter your iTunes or Apple ID account information into the Returning Customer section of this window. If you're a new customer, click on the blue Create Apple ID link now (it's located on the right side of the screen, under the New Customer? heading).

6. When the Confirm Order Details screen appears, enter the security code for the credit or debit card you have on file. You can also click on any of the blue-colored links on the screen to make adjustments to the order. These links include Edit Shipping, Edit Payment, Edit Order, and Enter Promo Code.

7. Click on the Place Order icon in the lower-right corner of the Confirm Order Details screen to finalize and process your order. Your order will be shipped within one to three business days.

TIP

To learn more about the Print products available from Apple via iPhoto '11, visit www.apple.com/ilife/print-products.html.

Setting Up Your Apple ID Account

With an Apple ID account, you can quickly place orders for prints, as well as for any other Photo Projects you create in iPhoto. The same Apple ID can be used for making purchases in iTunes, or from the online Apple Store, iWork applications, other iLife applications, or Apple's MobileMe service.

An Apple ID account needs to be set up only once. When you set up the account, you are asked to create a username and password for the account and enter all your personal information, including your full name, address, phone number, email address, and credit card (or debit card) information.

Your Apple ID account information is kept securely by Apple, so you can quickly place orders without constantly having to re-enter your personal information and credit card details.

Setting up an Apple ID takes just minutes. When placing an order for the first time in iPhoto '11, click on the Create Apple ID link under the New Customer? heading when you see the Sign In screen. Fill in the prompts when the Create an Apple ID window appears.

NOTE

If you already use iTunes on your Mac (possibly in conjunction with your iPhone, iPad, or iPod), you may already have an Apple ID account established.

Exporting Your Images and Uploading Them to Another Online-Based Photo Lab

Ordering prints from Apple's photo lab in iPhoto '11 offers convenience, but this isn't a full-service photo lab. Your print choices are limited to just six popular print sizes, and you cannot decide on a custom print finish (such as matte, semi-gloss, glossy, or luster), nor can you choose whether you want a thin white border to appear around each of your prints. When you order smaller-size prints from Apple, your prints will have a glossy finish. Images printed larger than 8" x 10" will have a matte finish.

If you want more options when ordering your prints, you can export your images from iPhoto '11 and then upload them to any online-based photo lab. See Appendix A, "Digital Photography Websites," for a partial listing of these services.

Each of these online services offers a different selection of print products and product options (such as print sizes and paper finishes), charges different prices,

and offers a different level of quality. Ultimately, you should visit a few of these services on the Web, have a few sample images printed, and decide which you'd like to order prints from over the long term.

To use any of these online-based photo labs, first export your images into .JPEG or .TIFF files using the highest resolution and file size possible. How to do this is explained in Chapter 10, "Exporting Your Images." Next, visit the online photo service's website and follow the provided directions for uploading and ordering prints. You order prints and visit the lab's website using your Mac's web browser (such as Safari). This can't be done in iPhoto '11 unless the photo service offers an iPhoto '11 plug-in (described in Chapter 11, "Printing Photos Using Your Own Home Photo Printer").

TIP

In addition to being able to order prints, you can order a wide range of photo products from these online photo labs, including mouse pads, posters, T-shirts, calendars, buttons, magnets, wall clocks, blankets, greeting cards (including custom-printed holiday cards), and dozens of other products that can be imprinted with your full-color photos.

Taking Your Digital Images to a One-Hour Photo Processor

If you're impatient or just in a hurry to have prints created from your digital images, you have the option of exporting your images from iPhoto '11 to some type of portable media, such as a flash drive, CD, or DVD, and then taking those digital images into any one-hour photo lab or professional photo lab in your area to have prints made while you wait.

The benefits to using one-hour photo labs include the following:

- **They're local**—Most large pharmacies, including Walgreens, Rite Aid, and CVS, for example, have one-hour photo labs, as do most Target and Walmart locations. If you live or work near a mall, chances are there's a Ritz Photo or another one-hour lab there as well.

- **You can wait for your prints**—A one-hour photo lab generally takes 60 minutes or less to create prints from your digital images, so you can wait for them.

- **You can see the results quickly**—You don't have to wait more than one hour to have the prints in your hands and see the finished results. If there's a problem, you can have the one-hour processing service fix it immediately.

- **There are no shipping and handling charges**—All the online-based photo services charge a shipping and handling fee of at least several dollars. If you need only one or two prints made, the cost of the prints might be under $0.50 each, but you wind up having to pay several dollars extra for shipping.

- **Sometimes, you can print the photos yourself**—Many one-hour photo labs, as well as FedEx Office locations, tourist attractions, and pharmacies, for example, have do-it-yourself photo kiosks, like the Kodak Picture Maker. You can insert your camera's memory card, a flash drive, CD, or DVD that contains your digital images and then use the kiosk's touch screen to pick and choose your print options. You can have prints created in standard sizes up to 8.5" × 11" in less than five minutes. (To find a Kodak Picture Kiosk location near you, visit www.Kodak.com, select the Kodak Store pull-down menu, and choose the Kodak Picture Kiosk option.)

CAUTION

Although one-hour photo processing locations are fast and inexpensive, you almost always wind up with higher-quality prints if you take your digital images to a professional photo lab instead. The one-hour photo processors use a completely computerized processing system, with little human interaction. Thus, there's nobody to fine-tune or adjust the processing equipment and perform manual color correction based on the needs of your particular images. Your prints typically receive more personalized attention if you use a professional photo lab. However, you pay more.

Taking Your Digital Images to a Professional Photo Lab

Instead of taking your photos to a one-hour processor to have prints created, you almost always wind up with higher-quality results if you have your digital images processed by a professional photo lab.

To find a professional photo lab in your area, check the Yellow Pages or do a Google search using the phrase "Professional Photo Lab, [your home city]." These labs are staffed by trained personnel who manually check the quality of your images as they're being processed. These labs also typically use higher-quality inks and photo paper and give you a broader range of options in terms of print sizes and photo paper finishes.

Using a professional photo lab to create prints from your digital images almost always costs a bit more, but from a quality standpoint, it's worth the expense. Plus, most labs can create prints while you wait or within a few hours.

Many photography specialty stores also offer professional photo lab services, and many are independently owned and operated by highly skilled photographers.

TELL ME MORE Media 12.2—Learn the benefits of using a local professional photo lab

*To listen to a free audio recording about why you should use a professional photo lab to create prints from your images, log on to **http://www.quepublishing.com**.*

13

Creating Photo Projects and Photo Gifts

In addition to offering you the ability to order prints directly, iPhoto '11 offers a handful of powerful design tools that allow you to drag and drop your photos into professionally designed templates and, in a matter of minutes, easily create great-looking Photo Projects.

Currently, the Photo Projects you can create in iPhoto '11 include photo books (an incredible-looking alternative to traditional photo albums or scrapbooks), greeting cards, holiday cards, note cards, and picture calendars. After designing your projects in iPhoto '11, you can upload and order them without ever leaving this software. Plus, iPhoto '11 allows you to organize and manage all your Photo Projects in one place.

> **NOTE**
> To order any photo project, you need an Internet connection for your Mac.

When it comes to creating and ordering customized and great-looking Photo Projects, your options go beyond what's available in iPhoto '11. You can easily export your photos and use an independent online photo service (like the ones described in Chapter 12, "Creating Prints Using a Professional Photo Lab"), as well as online services such as CafePress (www.cafepress.com). There, you can choose from hundreds of additional products to customize, design, and order that showcase your photos.

The focus of this chapter is how to create personalized Photo Projects and unique photo gifts using the images you upload, edit, and enhance with iPhoto '11.

Creating Photo Projects Using iPhoto '11

In iPhoto '11, the design tools and templates you need to create highly personalized photo books, greeting cards, and picture calendars are built into the software.

When you use these tools, it takes just minutes to choose a template design you like for a particular Photo Project, drag and drop your photos into that template, customize the colors and design elements of the template, add your own text (if applicable), and then order your Photo Project with a few mouse clicks.

*To learn more about creating an Apple ID account, **see** "Setting Up Your Apple ID Account" (Chapter 12).*

TIP

When Apple released the first version of iPhoto '11 in October 2010, it didn't include the capability to create customized picture calendars or holiday-themed greeting cards. This functionality was added to the software through a free update several weeks later. Over time, Apple may make additional Photo Projects available for iPhoto '11. Be sure to periodically use the Check for Updates command (from the iPhoto pull-down menu) to determine whether a new iPhoto '11 update has been released.

As you're viewing your images from the Events, Photos, Faces, or Places viewing modes in iPhoto '11, or viewing images in an Album or another folder, at any time you can click on the Create command icon located in the lower-right corner of the screen.

Figure 13.1 shows the Create command icon and the options available from it for creating personalized and customized Photo Projects using your photos.

Figure 13.1 *The Photo Projects available when you click on the Create command icon.*

The Create command icon allows you to begin working on a new Photo Project, such as an Album, photo book, card, calendar, or slideshow. Select the Photo Project you want to begin working on.

> **NOTE**
>
> Albums are one way to organize and view photos in iPhoto '11. The process of creating and using Albums is covered in Chapter 4, "Organizing Your Photos." When you create an Album, it can include copies of photos stored in several different Events, making them easier to find, view, and work with.

⊙ *To learn more about creating slideshows,* **see** *Chapter 15, "Creating and Sharing Slideshows."*

As you create Photo Projects, each of them is listed separately in iPhoto '11's Source list on the left side of the screen, so you can easily access that project at any time. (Double-click on the project name in the Source list to open it.) In the Source list, Photo Projects are sorted by project type, as well as the filename you assign to each project.

> **CAUTION**
>
> Even after a Photo Project has been created and saved, if you later edit or enhance an individual image used in that project, the project is automatically updated with the new version of the now-edited image. If you want to edit an image but keep the current version of that image intact in your existing Photo Projects, first use the Duplicate command to create a copy of the image before editing or enhancing it.

Publishing Full-Color, Professionally Bound Photo Books

For as long as photography has been in existence (since the nineteenth century), people have been creating traditional photo albums and scrapbooks with their prints as a means to collect, organize, showcase, and archive memories and be able to reminisce about later.

You can create a photo book to showcase photos from a recent vacation, party, or special event. You can also create a book that chronicles the first year of a baby's life through pictures and captions. The possibilities are limited only by your own creativity and imagination. However, whatever you choose to be the focus of your

photo book, chances are iPhoto '11 has a perfect theme for it. Thus, it is easy to design your book and give it a professional yet unique and personalized look.

It took nearly 200 years for the traditional photo album concept to take a major technological advance forward. That advancement came with the introduction of digital printing and print-on-demand technology. Using this technology that's readily available today, professionally bound, full-color photo books can easily and inexpensively be produced and printed, one copy at a time.

At a price starting around $20, your images can be printed and published in a professionally bound hard-cover, soft-cover, or wire-bound book, on glossy paper, and show up at your door looking like a book you purchased from a bookstore, except that it will contain your photos, captions, and customized design elements.

Photo books are a wonderful, extremely impressive, and easy-to-create alternative to traditional photo albums and scrapbooks. Plus, they take a lot less creativity and time to produce, thanks to the professionally designed templates that come with the iPhoto '11 software.

After designing your photo book, you can easily preview the cover and its contents on your Mac's screen, make whatever edits or adjustments you'd like, and then upload the photo book to Apple's print-on-demand publishing system. This system allows your unique book to be printed, bound, published, and shipped to your door within a few days.

TELL ME MORE Media 13.1—Learn more about the Blurb photo book service and other options

To listen to a free audio recording about using Blurb.com to create your photo books, as opposed to iPhoto '11, log on to **http://www.quepublishing.com.**

Choosing a Theme for Your Photo Book Using iPhoto '11

The first step when it comes to creating a photo book is choosing a theme for it, and then customizing that theme. This will determine the appearance of your book, its trim size, and its cover type, for example.

LET ME TRY IT

Choosing a Theme for Your Photo Book

To produce the most visually stunning photo book possible, choose a theme that best fits the story you're trying to tell with your photos, and then customize the photo book. To choose a theme for a photo book, follow these steps:

1. To begin creating a photo book, click and highlight either an Event folder in iPhoto or a particular Album that contains the images you want to include in the pages of your soon-to-be created hard-cover, soft-cover, or wire-bound book. You can also select images you've flagged from a variety of Events, for example.

2. Click the Create command icon and select the Book option to open the Photo Book Creation (and theme selection) screen. This screen is much less confusing to look at if you view it in full-screen mode (see Figure 13.2).

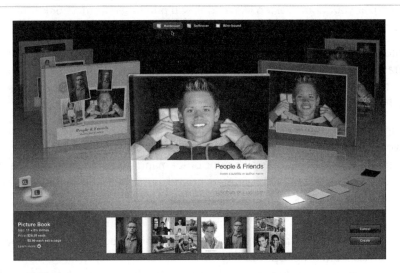

Figure 13.2 *The Photo Book Creation screen shown in full-screen mode. Choose your book's theme, cover design, and trim size.*

3. In the center of the screen is a large preview area, which initially show-cases what the cover and binding of your book will look like, even before your start customizing anything. Use the left- or right-arrow keys on your keyboard or the mouse to select which cover design template you want to use for your book, keeping in mind you can change the color scheme, cover photo, and text-based title.

4. Using the photos in the Event folder or Album that you preselected, the iPhoto '11 software automatically lays out and designs a sample photo book for you, placing the photos into your book sequentially, based on their date. You can, however, totally customize the photo order, layout of each page, and size that each photo will be displayed in your book.

5. At the top of the Photo Book Creation screen, choose the type of binding and cover you want for your book project. Your options include Hardcover, Softcover, or Wire-bound. Place a check mark in the appropriate check box.

6. Based on the cover and binding type you select, choose the trim size of your photo book. In the lower-left corner of the Photo Book Creation screen's preview area are book icons with letters on their covers corresponding to Small (S), Medium (M), Large (L), and Extra Large (XL). However, not all trim size options are available for each cover and binding type, so choose from what's available based on your personal preference.

NOTE

The cover type, binding style, and trim size you choose for your photo book help to determine its price. Another determining factor is the total number of pages you ultimately add to your book.

7. From the lower-right corner of the preview window, choose a color scheme for your photo book project. A selection of color swatches is displayed, based on which cover design template is selected.

8. If you look to the extreme lower-left corner of the screen, shown in Figure 13.3, you'll see details about your current photo book project, including the name of the cover template currently selected, trim size (displayed in inches), base price of the photo book (based on the number of pages it currently contains, taking into account all the photos you want to use and that iPhoto automatically placed in your book), and cost of adding additional pages.

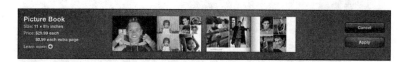

Figure 13.3 *View details about your photo book, including its price, in the lower-left corner of the Photo Book Creation screen.*

9. Located at the bottom center of the screen are thumbnails of your book's internal layout (again, you can fully customize all aspects of each page's layout). When you're ready to start the customization process, click on the Create command icon located in the lower-right corner of the screen.

Customizing the Layout and Design of Your Photo Book

After you select your photo book's theme, it's time to begin the individual page layout process. You can allow iPhoto '11 to handle most of this task for you and rely on the default selections to have your entire photo book completed and ready to order in a few minutes. Alternatively, you can tap your own creativity and customize every page to create a photo book that's truly one of a kind and that does an amazing job showcasing your particular images.

 LET ME TRY IT

Customizing the Layout and Design of Your Photo Book

Follow these steps to customize the overall layout and design of your book, including how each individual page will look:

1. After clicking the Create icon on the Photo Book Creation screen, you see a thumbnail layout of each page of your book in the preview area (see Figure 13.4).

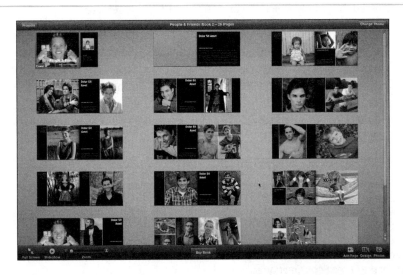

Figure 13.4 *See an overview of your entire book via page-by-page thumbnails.*

2. Using the Zoom slider in the lower-left corner of the screen, you can make each thumbnail appear larger on the screen. Or you can double-click on any thumbnail page in the preview window to edit that page while seeing it in a larger two-page spread (see Figure 13.5).

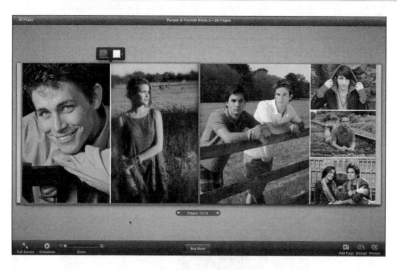

Figure 13.5 *Double-click on any page's thumbnail to see and edit that page on the screen.*

3. While viewing a single two-page spread of your book, click and highlight one page at a time to edit. Above that page is a window containing two icons. The icon on the left allows you to select a new page design template for that specific page, as shown in Figure 13.6, and the icon on the right allows you to choose a new color scheme for that page.

4. When selecting a new page layout, choose how many photos you want to display on the page (the number you can include will vary based on the template you've selected) and/or choose between a Text Page, Map Page, Photo Spread Page, or Blank Page design. After you select any of these options, a new selection of available layout templates is made available to choose from.

5. View available layout templates as you edit your photo book by clicking on the Design command icon located in the lower-right corner of the screen. This opens a new window on the right side of the iPhoto '11 screen that contains thumbnails for layouts and other design options (see Figure 13.7).

6. Although iPhoto '11 autoplaces the photos you've selected, you can override these placements and choose which photos you want to appear on which page. Plus, you can select your own template or color scheme for each page. When you click on the Photos command icon located in the lower-right corner of the screen, the entire right section of the screen is

replaced by thumbnails of your selected photos, allowing you to simply drag and drop them into a template. Click on and select the photo thumbnail you want to add to your book, hold down the mouse button, and drag it to the appropriate location of the template in the preview window.

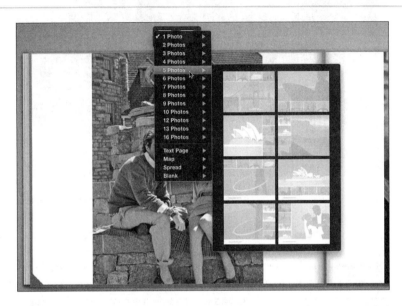

Figure 13.6 *You can change the layout or color scheme displayed on every page of your book as you customize it.*

7. At the top of this window, there's a pull-down menu from which you can choose to display thumbnails of your photos. Alternatively, you can view just the placed photos (photos already included in your book), unplaced photos (preselected photos yet to be inserted into a page of your book), all preselected photos, or a variety of other options.

 With the Photos command active and the thumbnails displayed on the right side of the screen, the photos that have already been used in your photo book have a small check mark in the lower-right corner of their thumbnails.

8. You can click on the Clear Placed Photos icon below this thumbnail preview window to remove all the photos that iPhoto '11 automatically placed in your book, allowing you to pick and choose the location, size, and placement of each photo. Alternatively, you can click on the Auto Flow icon located to the left of the Clear Placed Photos icon to have iPhoto '11 automatically reinsert your photos into pages of the book.

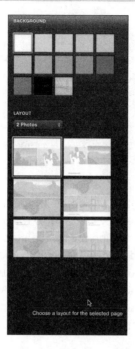

Figure 13.7 *Click on the Design command icon to reveal your available templates and color schemes.*

TIP

You'll probably find it easier to select your book's theme and then use the Clear Placed Photos command so you can pick and choose the order in which your photos will appear in the book, as well as how each image will appear. Keep in mind that, for each page, you can choose the page's layout, color scheme, and photo placement. Plus, you can customize the look of each photo on every page of your book by adding captions or special effects, zooming into a photo, or including a custom border.

9. By picking and choosing your own page designs and photo placement, you can, for example, create a book that tells a chronological story using your images. Or, depending on which theme you've selected, you can cluster up to 16 similar images together on a page to create themed photo collages.

TIP

As you're editing each page, you can double-click a photo in the preview window and select a border for that photo. When you double-click an image, a Zoom slider appears above the image in the preview window; plus, a new Design window appears on the right side of the screen. From this window, you can choose a custom border by clicking on a graphic icon representing that border. You can also add an effect to the photo (B&W, Sepia, or Antique), or click the Edit icon and go into iPhoto's Edit mode. This can be done for each individual image in your book.

10. After editing a single page, click the All Pages arrow icon located in the upper-left corner of the preview window to return to the thumbnail view of all pages in your book. During the design process, you can click the Add Page command icon located in the lower-right corner of the screen to add a single page to your book (you need to choose a layout and color scheme for that page and then drag and drop photos into it). Alternatively, you can delete a page of your book by selecting and highlighting the thumbnail for it and then pressing the Delete key on the keyboard.

NOTE

The minimum number of pages that can be featured in a photo book is 20. However, you can add as many pages as you'd like (for an additional fee) by clicking on the Add Page command icon located in the lower-right corner of the screen.

After you've completed the layout and design process for each page of your book, and you're satisfied with the look of it based on the preview of the cover and each page you see on the screen, click on the Buy Book icon located at the bottom center of the screen.

If any errors exist in the book, such as blank text captions or unused slots for photos in a template, warning messages appear. Otherwise, the process for ordering the book continues.

The ordering process is virtually identical to ordering prints in iPhoto '11, so see Chapter 12 for details on how to place your photo book order directly in iPhoto '11, using your Apple ID account.

After you complete the design or ordering process, your photo book project is listed under the Projects heading in iPhoto's Source list. You can always go back and edit it later or quickly order additional copies of your book. To delete the

project altogether, highlight its listing on the Source list and press the Delete key on your keyboard. Or you can drag the listing to the Trash folder, also found on the Source list.

 SHOW ME Media 13.2—Create a photo book in iPhoto '11
Access this video file through your registered Web Edition at
http://www.quepublishing.com.

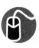 **LET ME TRY IT**

Creating a Photo Book in iPhoto '11

If you want to create a professional-looking hard-cover, soft-cover, or wire-bound book to showcase your photos, follow these steps:

1. Preselect an Event or Album folder or a collection of flagged photos you want to feature in your book.

2. Click on the Create command icon and choose the Book option.

3. Choose your photo book's template, trim size, and color scheme; then click on the Create command icon.

4. Use the layouts and options available from the Design command icon to customize each page of your book.

5. Drag and drop the photos into your book from the window that appears when you click on the Photos command icon. You can view the progress you're making in the preview area of the screen.

6. When choosing the placement for your photos, have people's faces and bodies or pictures showcasing motion pointing toward the center of the book, not toward the outer edges. This arrangement helps the pages of your book flow better from a visual standpoint.

7. Customize or edit the appearance of each photo by adding a border or special effect, for example.

8. Preview each page of your book and make any last-minute edits or customizations. You can add text-based captions, for example.

9. Click on the Buy Book command to order your book.

10. Follow the steps outlined in Chapter 12 for purchasing a Photo Project you create in iPhoto '11.

Creating Your Own Custom-Imprinted Greeting or Holiday Cards

You can walk into any store that sells greeting cards and spend between $3 and $6 to purchase a generic, mass-produced card, which you can sign and send to the intended recipient. Or you can spend that same amount, invest about five minutes of your time, and create a customized greeting card using your own photos and message.

In iPhoto, you can order one or more copies of your custom greeting card and have it delivered within a few days. Whether you're looking to say "Happy Birthday," "Get Well Soon," or "Happy Holidays," the iPhoto '11 software comes with a handful of greeting card templates that you can combine with your photos and message to create a card suitable for any occasion.

New to iPhoto '11 is the capability to create and order Letterpress cards (priced at $2.99 each), which are classy looking and will definitely impress recipients. (See Chapter 2, "Upgrading to iPhoto '11: What's New and Noteworthy," for a description of these cards.)

The process for creating greeting cards in iPhoto '11 is similar to creating photo books, except less step intensive. Start by highlighting and selecting between one and four photos to be featured on the card's cover or inside your card. Next, click the Create command icon located in the lower-right corner of the screen and choose the Card option.

The Card Template Selection screen is displayed. At the top of the screen, choose from the three main card formats: Letterpress, Folded, or Flat. The Letterpress option is shown in Figure 13.8. Based on your selection, templates are displayed in the main card preview area in the center of the screen. Use the left- or right-arrow keys on the keyboard or the mouse to scroll through the available template options.

In the lower-left corner of the screen, information about each card template is displayed, including its name, size (in inches), and price. At the bottom center of the screen is a thumbnail image of what the card will look like, inside and outside, based on the card template selected. If you choose to design a Letterpress card, you can also watch a short video that describes how the Letterpress cards are created and what makes them unique.

In the main preview window, scroll through the available templates for each card type and choose one that can best conveys your message or sentiment. If you're creating a folded or flat card, at the bottom-left corner of the preview window are icons allowing you to set the card's orientation (horizontal or vertical). On the bottom-right corner of the preview window, you can choose a color scheme to use with the template.

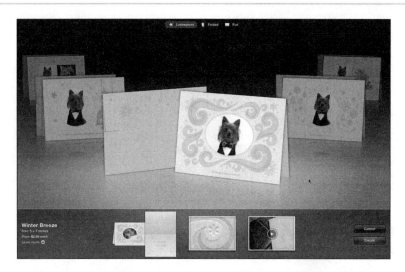

Figure 13.8 *Choose your card format from the Card Template Selection screen.*

Automatically inserted into the preview of each card template are the photos you preselected. However, you can easily change the appearance, order, or orientation of each photo after you confirm your template selection.

> **NOTE**
> For folded or flat cards, Apple offers quantity discounts when you order more than 25 of the same card. Quantity discounts are not currently available for Letterpress cards, which are priced at $2.99 each.

After choosing your template, click on the Create icon located in the lower-right corner of the screen. To exit this card creation mode, click the Cancel icon located to the immediate left of the Create icon.

The main preview area of the screen displays the entire front and inside of the card template you selected after you click on the Create icon. A Zoom slider is available in the lower-left corner of the screen. In the lower-right corner of the screen are two command icons: Design and Photos. Either opens an additional window on the right side of the iPhoto '11 screen.

The Design command icon displays available templates for either the front or inside of the card, based on what's highlighted and selected in the preview window. As you can see in Figure 13.9, you are able to select various templates that combine one or more photos with your customized text message. (For the inside of a card, you can either opt to display photos and text or just a text message.)

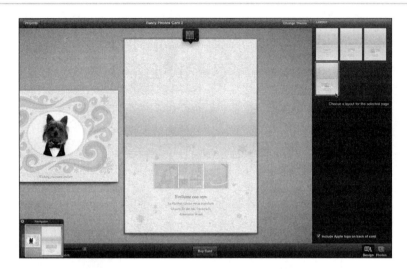

Figure 13.9 *Choose a customizable layout for the front and/or inside of the card you're creating.*

Click the Photos command icon to open a window on the right side of the screen that contains thumbnails of the selected photos. You are able to drag and drop the photos from this window directly into the card template shown in the preview area. The Photos window is shown in Figure 13.10. As you can see, at the top of this window is a pull-down menu that allows you to determine what image thumbnails are displayed.

To further customize your card in the preview window, click on any text area of the template. If you're in Design mode, the new window that appears on the right side of the screen allows you to choose a font, typestyle, font size, font color, text justification, and other formatting options related to the text that will appear on the cover or inside your card (see Figure 13.11). If you've clicked on the Photos icon, you can choose your font customization from the window that appears in the preview area, over the text field.

At the same time you click on a text area of the card template, the text available for customization in the card is highlighted in blue in the preview window. Using the keyboard, enter your personalized message.

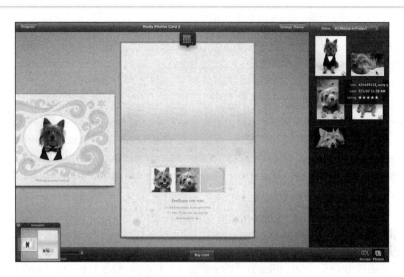

Figure 13.10 *Drag and drop selected photos from the Photo window into the card template displayed in the preview area to the left.*

Figure 13.11 *Customize the look of the text in your card.*

TIP

For ideas about what message text to include in your cards, visit any of these websites: www.greetingcardmessages.com, www.bestcardmessages.com, www.giftcardmessages.com, or www.poemsource.com.

When you click on any photo that appears in the card template you're working with, you can edit that photo. As soon as you click on it, the photo is surrounded by a blue box. Above that box is a Zoom slider. After you zoom in or out, you can reposition the cursor (which is now shaped like a hand) in the blue box and reposition the zoomed photo.

After clicking on the Design icon, you can also edit the photo itself using options displayed on the right side of the screen. With one click of the mouse, you can add a B&W, Sepia, or Antique effect to that photo. Alternatively, you can click on the Edit Photo icon to access iPhoto '11's full arsenal of photo editing and enhancement tools.

When your card's template, layout, text, and photos are customized and look the way you want them to on the preview screen, click on the Buy Card icon located at the bottom center of the screen to order one or more copies of this card.

The ordering process for greeting cards is almost identical to ordering prints or photo books. See Chapter 12 for details on how to complete this quick and straightforward procedure using your Apple ID. The cards you create and order will be printed within three business days and shipped to your door.

TIP

By mixing and matching templates, layouts, color schemes, your own photos, and your custom-written text messages, you can create one-of-a-kind cards that look as professional as greeting cards you'd buy at the store. Matching envelopes are provided with each card ordered.

Keeping Track of Important Dates with a Picture Calendar Featuring Your Images

In addition to enabling you to create professional-quality prints, photo books, and greeting cards, iPhoto '11 includes the templates and tools necessary to create and order customized picture calendars (prices starting at $19.99 each).

TIP

Creating any Photo Project, including picture calendars, is easier in full-screen mode because the iPhoto screen is less cluttered.

To begin creating a picture calendar, preselect at least 13 photos you want to showcase in your calendar—at least one for each month of the year, plus a cover photo. (For each month, you can use multiple photos, if you choose, to create a photo collage.) Or you can easily add extra months to the calendar by adding extra pages (and photos) for an additional fee of $1.49 per month/page.

Next, click on the Create command icon and choose the Calendar option. The Calendar Theme selection page, shown in Figure 13.12 using full-screen mode, is displayed.

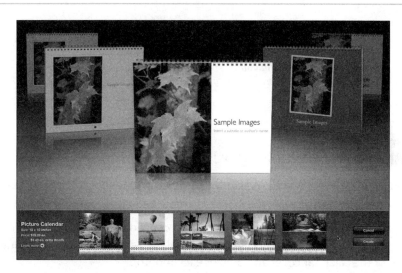

Figure 13.12 *Choose a template for your photo calendar.*

You can ultimately determine whether your calendar will automatically display all national holidays. From the pull-down menu, choose which country's holidays you want inserted and printed in the calendar.

If you use iCal to keep track of anniversaries, birthdays, or your own special occasions, you can also choose to have events from your iCal calendar on your Mac imported and printed in your picture calendar. Plus, you can add birthdays and holidays stored in the Address Book application on your Mac.

For each page of the calendar, choose a template and color scheme. This process is the same as when you're customizing a photo book or greeting card.

> **TIP**
>
> To save layout and design time, you can have iPhoto '11 automatically place your photos into the picture calendar you design by clicking on the Autoflow icon in the Photos window (which you open by clicking the Photos command icon). Alternatively, you can manually place your photos in whatever order you want by using the template and layout you select.

When you're done customizing each page of your picture calendar, click the Buy Calendar icon located at the bottom center of the screen. The ordering process for picture calendars is almost identical to ordering prints, photo books, or greeting cards.

 SHOW ME Media 13.3—Create a picture calendar in iPhoto '11
Access this video file through your registered Web Edition at
http://www.quepublishing.com.

 LET ME TRY IT

Creating a Picture Calendar in iPhoto '11

If you want to create a picture calendar to showcase your photos, follow these steps:

1. Preselect an Event or Album folder or a collection of flagged photos you want to feature in your calendar. You must select at least 13 photos (one for the calendar cover and one for each month).

2. Click on the Create command icon and choose the Calendar option.

3. Choose your Calendar's template and color scheme.

4. Customize your calendar's start month and date, length, and what holidays you want preprinted in it from the Calendar Customization window.

5. Use the layouts and options available from the Design command icon to customize each page of your calendar. For example, you can choose to showcase a single photo or create a collage using up to four photos based on the layout template you select.

6. Drag and drop the photos into your calendar from the window that appears when you click on the Photos command icon into the template displayed in the preview window.

7. Customize or edit the appearance of each photo by adding a border or special effect, for example.

8. Preview each page of your calendar and make any last-minute edits or customizations.

9. Click on the Buy Calendar command to order your calendar.

10. Follow the steps outlined in Chapter 12 for purchasing a Photo Project you create in iPhoto '11.

Creating Photo Projects and Photo Gifts Outside iPhoto '11

Although it's very convenient to create and order Photo Projects in iPhoto '11, you do have many other options. All the online-based photo processing services listed in Chapter 12, as well as numerous other companies, such as CafePress (www.cafe-press.com), allow you to upload your images to their respective websites to design and order a vast selection of photo products and gifts that go well beyond just prints, greeting cards, photo books, and picture calendars.

These independent services offer different photo products and gift options at different prices. Plus, when it comes to prints, greeting cards, photo books, and picture calendars, they often offer different styles, designs, and templates than what's available in iPhoto '11.

For example, some companies specialize only in photo greeting cards, such as Cards Direct (www.cardsdirect.com/custom-photo-greeting-cards.aspx). This site offers hundreds of different card designs with various themes, as well as discounts for ordering cards in larger quantities.

Some companies, such as FotoFlōt (www.fotoflot.com), offer extremely unique ways to create and display enlargements of your photos, in this case by printing your images onto thin plastic sheets that don't require a frame. FotoFlōts look extremely contemporary when hung on any wall, and the image will never tear or fade.

Short Run Posters (www.shortrunposters.com) is one example of a company that does nothing but offer extremely inexpensive poster-size enlargements of any photos you upload. Prices start at just $2 each for a single 18" × 24" poster.

A company called Wallzaz (www.wallzaz.com) creates inexpensive, large-size wall decals from your images that can be stuck on and easily removed from any wall.

To use most of these third-party companies, you need to export your photos from iPhoto and then use your Mac's web browser (such as Safari) to visit the company's website to create and order your photo products or gifts. In some cases, the companies have sites designed to work in conjunction with iPhoto '11, so the export process isn't necessary.

Consider using any of the third-party photo product companies if you're looking for more variety and options, as well as innovative ideas for items you can create using your favorite images.

TIP

Many one-hour photo processing locations and professional photo labs also allow you to create and order a wide range of photo products and gifts, such as large canvas prints, photo T-shirts, Christmas tree ornaments, tote bags, magnets, buttons, coffee mugs, mouse pads, or even cozy woven blankets featuring your photos.

V

Sharing Your Photos Using iPhoto '11

14 Emailing or Publishing Your Photos Online **242**

15 Creating and Sharing Slideshows ... **257**

16 Using Apple's MobileMe with iPhoto '11 **270**

17 More Ways to Share Your Photos ... **279**

Learn how to email photos, plus post pictures to
Flickr and Facebook in iPhoto '11.

14

Emailing or Publishing Your Photos Online

iPhoto has always offered a handful of ways to share your photos via the Internet. However, iPhoto '11 offers several significant improvements to the ways you can email and publish your photos on the Web.

For the first time, you can email photos directly to one or more recipients from your email account without leaving iPhoto. There's no need to export your photos or drag and drop them into another application. iPhoto '11 not only allows you to directly email photos, but also offers a handful of templates for creating and sending attention-getting and sometimes whimsical themed emails.

In addition, iPhoto '11 has made it even easier to upload and publish one or more photos directly to a Flickr account or your Facebook page and then manage all aspects of those photos, such as comments and tags, in iPhoto '11.

This chapter focuses on how to email photos in iPhoto '11, as well as how to share your photos via Flickr or Facebook, providing your Mac has access to the Internet.

Sharing Photos via the Web

From any photo viewing mode in iPhoto '11, select and highlight one or more images. Then click on the Share command icon located in the lower-right corner of the screen to share your photos via the Web.

You can choose to publish your photos on MobileMe, Flickr, or Facebook. Alternatively, you can directly email photos to specific recipients using themed email messages with your photos embedded in them.

☞ *To learn more about uploading photos to MobileMe and creating online galleries,* **see** *Chapter 16, "Using Apple's MobileMe with iPhoto '11."*

Sending Emails from iPhoto '11

Using older versions of iPhoto, you needed to utilize a separate email application and either drag and drop or export your images from iPhoto before sending them as email attachments to your desired recipients.

Now, as long as you have any type of email account set up for use with the Mac's Mail program, you can send images via email (viewable in the email message itself and, if you wish, as an attachment) without leaving the iPhoto program.

After highlighting at least one image, click the Share command icon and choose the Email option (see Figure 14.1). The screen is replaced by an email message screen, with your selected photos already embedded in the body of the message. At the top of the screen is a To field, as well as Subject and From fields. Fill out these fields just as you would when composing and sending an email message from your regular email program.

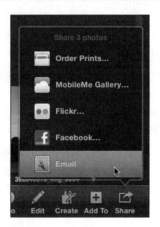

Figure 14.1 *Send an email from iPhoto. Choose your favorite images and click on the Share command icon.*

When you look at the main body of the email message, you see your selected photos already displayed. Where you see the text message "Insert Your Message Here," you can manually enter your own message to the recipient.

NOTE

After iPhoto '11 was first released, several revisions to the software were later made available by Apple. Within iPhoto '11 (Version 9.1.1), for example, several new email templates were added to the program, giving users a total of 10 email template choices.

On the right side of the email screen are 10 email templates, each offering a different theme and appearance:

- **Classic**—This is a basic-looking email message template with your photos and message displayed on a white background.

- **Journal**—This slightly more formal-looking template allows you to display your photos within the body of an email message, along with a text-based message, plus captions for each photo.

- **Snapshots**—This is a generic-looking email message with a solid light-gray background. The selected photos are displayed in the body of the email and are surrounded by thin white borders. Above the photos, there is an area to enter your text-based message (see Figure 14.2).

- **Corkboard**—The background of this email template looks like a corkboard, and the photos look as though they're attached to the board using pushpins. In one area of this template, which looks like a sheet of paper, you can enter your text message to the recipient.

- **Cardstock**—This template can be used for sending a formal email invitation to the recipient. The color scheme uses shades of gray, and the design is somewhat elegant yet contemporary. You'll find several text fields in this template to add text to.

- **Announcement**—You can use this template to send a more casual announcement that includes your text and photos. The design is simple and uses a light color scheme.

- **Celebration**—This theme is perfect for creating electronic birthday party invitations that can be emailed to recipients, complete with party time, date, and location details.

- **Collage**—This is a contemporary and sleek-looking collage design that is useful for sending multiple images in a single email. The theme allows you to enter a headline and your own text message above the display of photos.

- **Letterpress**—This theme has a textured look, just like the Letterpress greeting cards you can create using the Create Card feature of iPhoto (described in Chapter 13, "Creating Photo Projects and Photo Gifts"). This is a classy-looking template for sending one or multiple photos in the same email message.

- **Postcard**—Ideal for sending vacation or travel photos, this template looks like the front and back of a postcard. Figure 14.2 shows a sample of this template with images from Alaska added for demonstration purposes. The heading "Hello from Alaska!" has been added in one of the text fields in the template on the front of the postcard.

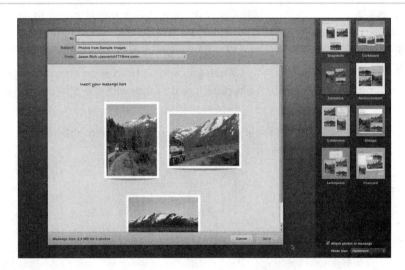

Figure 14.2 *The Snapshots template offers an area to manually type the text that will accompany the photos in the body of your message. This is the most basic looking of the templates.*

To add a theme to your email, simply click on one of the theme templates displayed on the right side of the screen. Otherwise, the last theme chosen is automatically used.

Each template allows you to customize various text elements. To add your own text to these template fields, click on any of them in the preview window and start typing. Above the text field, a formatting window appears, allowing you to choose your favorite font, font size, justification, and spacing for the text.

TIP

While previewing an email template with your photos displayed in it, you can click on any of the photos. This causes the photo to be framed with a blue box, indicating that it's been selected, and a Zoom slider to appear above the photo. You can zoom in on any of your photos to change its appearance and then use the mouse to reposition it within the blue frame before sending the email.

Below the eight theme thumbnails displayed on the right side of the screen is a check box labeled Attach Photo to Message. Using the mouse, add a check mark to this check box if you want the photos to be sent as an email attachment, as well as in the main body of the email message as part of the themed template. The attached version will contain your images without the email theme graphics.

The file size of the email increases when you add a photo as an attachment, but doing this makes it easier for the recipient to do more with the photo than just view it.

In the lower-right corner of the screen, you can select the photo size if you choose to attach the photo to the message.

CAUTION

Some email service providers have a maximum email file size that you can send or receive. Thus, if you opt to send actual size photos, you may be able to attach only one, two, or three of them to a single message; otherwise, the total message size will become too big. In the lower-left corner of the email window, the total file size of the email message you're creating is displayed. If you're sending from a Google Gmail account or sending an email to a Gmail account, the maximum file size is 25MB. Yahoo! Free Mail, however, allows attachments only up to 10MB.

After you fill in all the fields on the email screen, click the Send icon in the lower-right corner of the email window. Your message is automatically sent to its recipients.

When the email has been sent, the email window disappears, and you return to the Events viewing mode in iPhoto.

 SHOW ME Media 14.1—Learn how to send a theme email containing your photos in iPhoto '11

Access this video file through your registered Web Edition at
http://www.quepublishing.com.

LET ME TRY IT

Sending an Email in iPhoto '11

With a few clicks of the mouse, you can send an email containing one or more of your photos to individual recipients. To accomplish this, follow these steps:

1. Select and highlight one or more images.

2. Click on the Share command icon and choose the Email option.

3. When the email window appears, fill in the To, Subject, and From fields.

4. Select an email template from the right side of the screen.

5. Decide whether to also attach photos to your message and whether the attached photos should be sent in their actual size or optimized.

6. Fill in the text-based fields in the email message's body. The available fields vary, based on which template you select.

7. Preview your outgoing email on the screen.

8. Click Send to send your email.

Publishing Photos on Flickr.com

When it comes to sharing your photos on the Web, one of the most popular services with which to do this is Flickr (www.flickr.com). After setting up a free account, you can upload and share individual photos, or you can create complete online galleries (referred to on Flickr as *Sets*) that showcase dozens or hundreds of your images. It's also possible to create animated slideshows for others to watch or to order prints and photo products that feature your favorite photos that have been uploaded to your Flickr account (a fee applies).

NOTE

Flickr.com is a worldwide online community based around sharing digital photos. Setting up a Basic Flickr account is free. A Pro account, which gives you access to more features, costs $24.95 per year. Benefits of a Pro account include unlimited uploads, unlimited image storage space, and the ability to use Flickr without seeing advertisements when you access the service from your web browser.

After you upload your photos, you can decide exactly who will be able to access them using their own web browser. For example, you can invite just immediate friends and family to view your images, or you can create a public gallery that anyone with web access is able to visit and view.

Normally, it would be necessary to access your Flickr account using your Mac's web browser (such as Safari). However, iPhoto '11 offers functionality that allows you to upload files directly to your Flickr account and then view and manage them.

To do this, highlight and select the photos you want to upload to Flicker, click on the Share command icon, and choose the Flickr option. The first time you do this, a window appears asking if you want to set up iPhoto to publish to Flickr. This process takes just minutes and needs to be done only once.

Set up your free Flickr account and follow the prompts for linking the account directly with iPhoto '11. This process involves iPhoto opening your default web browser to initially access the Flickr.com website.

After your Flickr account is established and linked to iPhoto '11, the next time you click on the Share command icon and choose Flickr in iPhoto, a window appears in iPhoto, called *Flickr Sets*, which displays thumbnails representing each Set of photos you've already uploaded (see Figure 14.3).

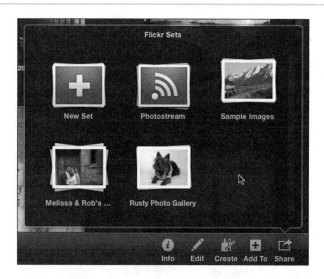

Figure 14.3 *Add new photos from iPhoto '11 to your Flickr account by creating a new Set or adding the selected photos to a pre-existing Set in your Flickr account.*

From this window, decide if you want to add photos to an existing photo Set on Flickr, create a new Set, or add to your Photostream. To create a new Set, click on the empty New Set thumbnail.

A pop-up window appears asking you to enter a Set name. You must also decide who will be able to view the photos. For this option, a pull-down menu offers a handful of choices, such as Only You, Your Friends, Your Family, Your Friends and Family, or Anyone.

You also need to select a photo size for uploading. The Web option uses compression but keeps the files so they look perfect on your Mac's monitor. The Half Size and Full Size options are available if you have a Flickr Pro account. Uploading a file in full-size mode uses no compression and is an ideal solution for creating an online backup of your images or for showcasing your images in their highest possible resolution.

 To learn more about creating a backup of your images and archiving them, **see** Chapter 18, "Burning Photos to CD or DVD from iPhoto '11," and Chapter 19, "Photo Backup Solutions."

When you click on the Publish icon located in the lower-right corner of this window, your images are uploaded, one at a time, into the Set you just created (or into the pre-existing Set you selected). iPhoto then displays the Flickr viewing screen, shown in Figure 14.4, which looks similar to the Events viewing mode, but the image thumbnails that are displayed are of the images you have uploaded and published on Flickr. You can also access this screen anytime from iPhoto '11's Source list located on the left side of the screen (when not in full-screen mode).

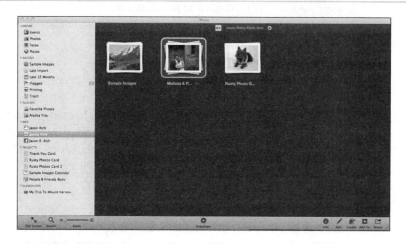

Figure 14.4 *iPhoto '11's Flickr viewing mode. View photos that have been published online in iPhoto '11.*

At the top of this screen is the Flickr logo displayed to the left of your Set name. On the right of your Set name is a small right-pointing arrow icon. Click this icon to open your Mac's default web browser and view your Flickr account in a traditional way as you surf the Web.

NOTE

After images are published on Flickr, the Set is listed within iPhoto '11's Source list, under the heading Web. A Set is just like an Album. It's a collection of your images that you compile and to which you assign a specific name.

While in Flickr viewing mode, you can highlight and select any thumbnail image and use any of iPhoto '11's features or functions. For example, you can edit the photo by clicking on the Edit command icon. You can also print the image or use it in a Photo Project you're creating. It's as if the photo stored online is part of your iPhoto '11 photo library. Any edits you make while in Flickr Viewing mode will be saved in iPhoto, but not on the Flickr service.

TIP

In addition to creating individual Sets of images using Flickr, you can use this service to create a Photostream, which is a single gallery of all images you upload, displayed in reverse chronological order (with the newest images shown first). From within Flickr, you can customize the look of your Photostream.

Beyond uploading and viewing your images on Flickr (which you can do in iPhoto '11), to use Flickr's other features and functions, such as the service's capability to create slideshows or order prints, for example, you need to access Flickr using your Mac's web browser.

Sharing Photos on Facebook

Facebook is an ever-evolving, global online community that's become a multicultural phenomenon with more than 500 million members. Creating a Facebook account is free, and thanks to iPhoto '11, posting individual photos to your Wall (one public aspect of your account) or creating entire online Photo Albums that can be viewed by specific people whom you select, or the entire online community, is extremely easy.

One reason Facebook is so popular is that it encourages people to interact. Thus, when you post photos online, other people can post comments about your images and engage in online dialogues about them. Plus, you have the ability to tag photos.

When a photo gets tagged with someone's name (because that person is featured in a photo), that photo can be searched by the tagged person's name and viewed on his or her Facebook page, as well as the page where the photo was originally posted. This makes the online distribution of photos spread faster, but it also diminishes a person's privacy.

Part of the seamless integration between iPhoto '11 and Facebook includes the optional sharing of Faces tags when you upload your images to Facebook.

CAUTION

Before tagging yourself or your children, for example, in photos, think about the content of the photo and who will potentially be able to see those images (based on the privacy settings you select). Photos of you drunk and dancing on tables at a bar probably shouldn't be tagged with your name associated with them and published in a public Photo Album that your boss might wind up seeing after using your name in a Google search or searching for you on Facebook. In other words, tag your photos responsibly and invest a few minutes to learn about Facebook's privacy options before publishing your photos and making them viewable to the public. To learn about Facebook's Privacy settings, visit www.facebook.com/privacy/explanation.php or click on the Privacy link at the bottom of Facebook's main screens.

Until iPhoto '11 was released, if you wanted to upload your images to Facebook, you needed to export them from older iPhoto versions and then access your Facebook page using your Mac's browser. In Facebook, it was then necessary to use the service's photo uploading and management tools.

Today, iPhoto '11 offers seamless integration with Facebook, allowing you to upload your photos, add captions and tags, and manage photo-related comments.

Uploading Your Photos to Facebook

After selecting and highlighting the photos you want to share on Facebook while using iPhoto '11, click on the Share command icon and then select the Facebook option.

You can initially add your Facebook account information to iPhoto '11 by selecting the Preferences pull-down menu and clicking on the Accounts option. Choose the Add option in the Accounts window, select Facebook from the pop-up menu, and then manually type your existing Facebook username and password.

Alternatively, the first time you try to upload photos to Facebook in iPhoto, the Facebook login window appears. Enter your email address and password; then click on the check box acknowledging that you agree to Facebook's terms of service. Click the Login icon (in the lower-right corner of the Login to Facebook window) to continue.

TIP

After selecting images that you want to publish onto Facebook, you can also select the Facebook option from iPhoto '11's Share pull-down menu or access Facebook from iPhoto '11's Source list.

Above the Share command icon, the Facebook Albums screen appears on the iPhoto screen (see Figure 14.5). This window offers three main options, plus the capability to add your selected photos in iPhoto '11 to a pre-existing Album you have on Facebook.

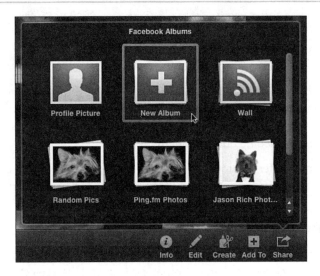

Figure 14.5 *Choose where in Facebook you want to publish your photos.*

The available options include the following:

- **Profile Picture**—If you've selected one photo while in iPhoto, you can upload it to Facebook and make that image your new profile picture using this option.

- **New Album**—If you're uploading one or more photos, use this command to create a new Album, to which you can add a custom name.

- **Existing Album**—Using this option, you can add new photos (currently stored in iPhoto '11) to an Album already created and being displayed on Facebook.

- **Wall**—Instead of publishing photos in your Albums area of Facebook, you can publish one or more photos directly to your Wall for public viewing.

If you choose to make the photo you're uploading your Facebook profile picture, a window appears asking you to confirm this decision. Click on the Set icon in this window to continue.

If you opt to add the photos to a new Album, a window appears prompting you to enter an Album name and then, from a pull-down menu, choose privacy options for that Album. Your options include Everyone (the images can be viewed by the general public), Only Friends (the images can be viewed only by your Facebook friends), or Friends of Friends (the images can be viewed only by your Facebook friends and their respective friends). Click on the Publish icon to continue publishing your photos to a new Album on Facebook.

If you choose to add the photos to your Wall, before you publish the photos, a window appears allowing you to enter comments (equivalent to a caption) related to those images. Enter the text in the dialog box that appears in the window and then click the Publish icon displayed in the lower-right corner of the window.

If you select to have your images uploaded to an existing Facebook Album, the images are automatically uploaded and saved in that Album and then can be viewed based on the privacy settings already set for that particular Album.

NOTE

Whenever you upload new images to Facebook, thumbnails and your photo captions are automatically displayed as part of your Facebook news feed.

SHOW ME Media 14.2—Upload Your Photos to Facebook
Access this video file through your registered Web Edition at
http://www.quepublishing.com.

 LET ME TRY IT

Uploading Your Photos to Facebook

To upload your photos directly from iPhoto '11 into Facebook, follow these steps:

1. Select and highlight the photos you want to share.

2. Click on the Share command icon and select Facebook.

3. From the window that appears above the Share command icon, choose which option you want related to publishing photos on Facebook. You can make one photo your profile picture, create a new Album, import photos to an existing Album, or publish photos directly to your Facebook Wall.

4. Depending on which option you choose, follow the onscreen prompts that appear in whatever pop-up window is displayed in iPhoto '11.

Managing Your Photos, Tags, and Comments on Facebook Using iPhoto '11

After you link your Facebook account with iPhoto '11, the account is listed in iPhoto's Source list on the left side of the screen, under the Web heading. When you click on your Facebook account name listing from the Source list, the Facebook view is displayed on the screen (see Figure 14.6).

Figure 14.6 *The Facebook view in iPhoto '11 looks like and works the same as the Events view.*

The Facebook view looks just like iPhoto '11's Events view; however, the Album thumbnails displayed represent Albums already published online on Facebook.

To access your Facebook account using your Mac's browser, simply click on the small right-pointing arrow at the top center of the Facebook view screen. The icon is located to the right of your Facebook account's name and the Facebook logo.

To view the individual image thumbnails in a Facebook Album, double-click on one of your Album thumbnails from the Facebook view. When you're viewing your individual photo thumbnails contained in a Facebook Album, you can highlight and select one or more of those images and use any of iPhoto '11's features. For example, you can edit, print, or change the data related to that image.

You can also manage online tags and comments other people have added to your photos in iPhoto '11. To do this, access your Facebook account by clicking on the listing for your account in the Source list. Choose one of your published Albums and double-click its thumbnail to open it. That Album then "syncs" with iPhoto '11, a process that may take a few minutes, depending on how many photos are in the Album.

From the Facebook view of that Album's contents in iPhoto '11, you are able to see whether anyone has added comments or tags to individual photos. To do this, double-click on a photo to see a larger version of it in the image-viewing area and then click the Info command icon (located in the lower-right corner of the screen) to reveal the Facebook Sharing window on the right side of the screen.

If comments and/or tags related to that photo from other people exist, they are displayed in this window (see Figure 14.7). This information corresponds to what you'd see if you visited Facebook directly to view one of your uploaded images. You can also add your own tags and captions (comments) to Facebook photos from the Facebook Sharing window.

NOTE

Any changes you make in iPhoto to Facebook Albums or individual photos stored on Facebook are updated immediately and automatically updated on your Mac and on Facebook.

Figure 14.7 *In iPhoto '11, you can view comments and tags other people add to the photos you publish on Facebook.*

15

Creating and Sharing Slideshows

One way to showcase your photos in a highly engaging and entertaining way is to create a slideshow that includes text-based titles, animated transitions, special effects, and your favorite music. Being able to create a Hollywood-style production used to require many hours of time, not to mention specialized software, creativity, and production skills. But not anymore!

iPhoto '11 allows you to create extremely impressive and entertaining slideshows from your photos. Just as it does with other Photo Projects, the process for creating slideshows involves inserting your images into professionally designed templates that allow you to add animated transitions, special effects, titles, and music to your presentations without having to do any programming or even tap your own creativity.

Slideshows are a fun and entertaining way to share groups of your images or enjoy them yourself. This chapter focuses on how to create and share slideshows using the features and functionality built into iPhoto '11.

Creating a Slideshow That Tells a Story

The best use of a slideshow is to tell a story using pictures, music, and text-based titles. Your story might be about a vacation, wedding, honeymoon, birthday party, anniversary celebration, special event, look back at the first year in your baby's life, or it might show off a group of similarly themed images.

You might opt to tell your story by showcasing photos in a chronological order or set your photos to music and arrange for the images to appear in a way that ties into specific song lyrics. There are many ways to use iPhoto '11's slideshow feature. The trick, however, is to use the special effects, animations, and capability to add music to your presentation to add to the experience of others enjoying your pho-tos—not distract them with too much eye candy or make them dizzy because too much is happening on the screen at once.

You can include any number of images in your slideshows. However, to ensure that people stay interested and engaged, keep your presentations short. As a general rule, pick no more than 30 to 40 of your favorite images to showcase in a slideshow, and if you add music, don't draw out the slideshow's duration by longer than one or two songs.

To create a slideshow, begin by choosing the images you want to feature. The best way to do this, especially if the images are spread out in several Event folders, is to create a separate Album that contains just the images you want to use in your slideshow.

After you select and highlight the photos to feature in your slideshow, click on the Create command icon and select the Slideshow option. The iPhoto software will produce a slideshow for you, which you can now customize. To begin this process, click the Themes command icon in the lower-right corner of the screen. iPhoto '11's Slideshow Production screen is displayed (see Figure 15.1).

Figure 15.1 *iPhoto '11's Slideshow Production screen.*

At the top of this screen are thumbnails of the images to be included in your slideshow. In the main image viewing area, you now see a preview window for editing and watching your slideshow as you're creating it.

Located at the bottom of the screen is a handful of command icons, which provide all the features, functions, and tools needed to create a really impressive presentation.

Starting with the Full Screen command icon located in the lower-left corner of the screen and moving to the right, these command icons include the following:

- **Full Screen**—Switch into full-screen mode. The pull-down menus at the top of the screen, as well as the Source list on the left side of the screen, disappear, giving you more onscreen real estate to view your images and slideshow.

- **Zoom (Slider)**—Zoom in on whatever you're looking at in the preview window. Move the slider to the left to zoom out or to the right to zoom in.

- **Preview**—Play your slideshow as is, in the preview window.

- **Play**—Play your slideshow as is, in full-screen mode. Press the Esc key to exit this mode and return to the main iPhoto screen.

- **Export**—Share your completed slideshow with others by saving it as a standalone file on your Mac's hard drive (or another form of recordable media), in a format and file size that will work best, based on how you plan to share your presentation. The Export command offers a handful of options for creating a slideshow that can be viewed on an iPod, iPhone, iPad, Apple TV, a full-size computer monitor, or through the MobileMe service.

- **Text Slide**—Add text to your slides in the form of short captions that will be displayed during your slideshow, placed over selected images.

- **Themes**—Select the theme that best suits your photos and the story you're trying to convey from the 12 extremely different slideshow themes featured in iPhoto '11.

- **Music**—Easily add music to your presentation, using a selection of sample instrumental arrangements bundled with iPhoto '11, or use any song that's stored in your iTunes library on your Mac.

- **Settings**—Adjust the settings for your slideshow that determine, for example, how long each slide will be displayed and whether you want to fit the slideshow to a specific song (which autoadjusts as the duration slides are displayed). With some themes, you can also adjust slide transition effects and speeds, decide whether your slideshow will automatically repeat, and determine whether photos will automatically be scaled to fit the screen.

After you select your photos and click on the Create command, followed by the Slideshow option, iPhoto takes those photos and creates a basic slideshow that you can then fully customize. Start by adjusting the order in which your slides will appear. This is done with a drag-and-drop method using the image thumbnails displayed along the top of the screen. Select one image at a time using the mouse, click on it and hold down the mouse button, and then drag the thumbnail to the desired location to determine the slide order. Slides are displayed in the order in which you'll see them during the slideshow, from the leftmost image thumbnail to the rightmost image thumbnail.

When the images are in the correct order, continue customizing your slideshow using the command icons located in the lower-right corner of the screen, starting with the Text Slide command icon.

Incorporating Titles and Text into Your Slides

To overlay text onto any slide, choose an image and then click on the Text Slide command icon located in the lower-right corner of the screen. In the preview window, you see a line of text that says "Subtitle Text Here." Click on this text to highlight and edit it. Enter whatever text you want.

Next, press Command + T to make your font selection using the font customization window that appears. From this window, you can choose a font, typestyle, font size, and font color. With the text on a slide highlighted, make your selections. The alterations you make appear instantly in the preview window and become part of your slideshow. To get rid of the font selection window, click on the small red dot in the upper-left corner of this window. Figure 15.2 shows an example of a slide that has a title, with the font selection window showing.

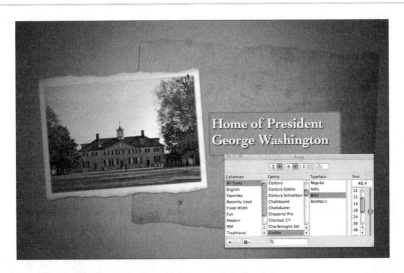

Figure 15.2 *Add text to your slides using the Text Slide command icon.*

At the top of the screen, notice that the text you add to a slide is displayed in a separate thumbnail from the image onto which you overlaid it. A black thumbnail containing the letter *T* is placed immediately before the image thumbnail.

SHOW ME Media 15.1—Add titles and text to your slides
Access this video file through your registered Web Edition at
http://www.quepublishing.com.

LET ME TRY IT

Adding Titles and Text to Your Slides

Follow these steps to add titles or text to your slides:

1. When creating or editing a slideshow, highlight one slide and view it in the main preview area.

2. Click on the Text Slide command icon.

3. When you see the text message "Subtitle Text Here" overlaid on the slide in the preview window, double-click on that text to highlight it.

4. Type your new title or text-based message.

5. With all the text highlighted, press Command + T to access the font selection window and adjust the font, font size, typestyle, and font color.

6. To finalize your text addition, reposition the mouse anywhere in the preview area and click it.

Giving Your Slideshow Pizzazz Using a Theme

The best way to quickly and easily add entertainment value and pizzazz to your slideshow is to add a theme. Click on the Themes command icon located in the lower-right corner of the screen and choose from one of a dozen themes built into iPhoto '11. Each theme can be customized and will give your presentation a totally different vibe, regardless of whether you add music.

 ⓖ *To see a video sampling of the slideshow themes built into iPhoto '11,* **see** *Media 2.2, which is part of Chapter 2, "Upgrading to iPhoto '11: What's New and Noteworthy."*

The available themes include the following:

- **Ken Burns**—This is a television production effect that adds slight movement to still images to give them a sense of motion. It's a subtle effect that can add a professional quality to your presentation. To learn more about Ken Burns, the American a documentarian who created this now-popular visual effect, visit http://en.wikipedia.org/wiki/Ken_Burns_effect.

- **Origami**—This theme displays each photo alone or as part of a collage (which iPhoto '11 creates) and uses a folding transition effect to make the slideshow visually interesting. Because multiple images are used simultaneously, this is a great theme to use if you have a lot of photos to include in your presentation. Just make sure you display each slide long enough (say, five to seven seconds) for the people viewing it to be able to take in everything they're seeing. A sample of a multiphoto collage displayed as part of an Origami slideshow is shown in Figure 15.3.

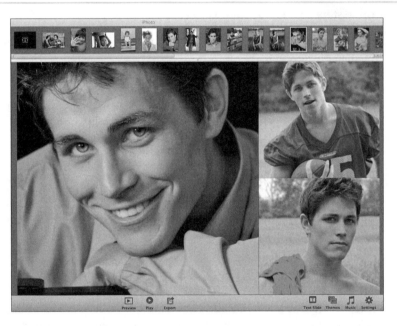

Figure 15.3 *iPhoto '11 automatically creates multiphoto collages as part of your slideshows when you select certain themes.*

- **Reflections**—To give your slideshow a contemporary and professional look, choose this theme. Your slides are displayed alone or in photo collages containing two, three, or four photos, but there is a constant solid color background, and reflections of the images are displayed at the bottom of the screen.

- **Vintage Prints**—This theme makes your images look like individual snapshots placed in a pile. The animation shows one or multiple images at a time in a slow-moving animated sequence that simulates viewing the pile of images from different perspectives.

- **Snapshots**—By making your images look like individual snapshots, this theme places one snapshot on top of another using a slow-moving animated sequence with a solid color background. One photo is displayed at a time for several seconds before another snapshot is dropped on top of the virtual pile.

- **Sliding Panels**—This theme divides the screen in one, two, or four sections and then creates animated collages using your images. Use this theme to showcase a larger group of photos in relatively quick succession.

- **Scrapbook**—Imagine flipping through the pages of a virtual scrapbook. Each page of the scrapbook has a different layout that looks as though your images are mounted on paper pages. This animated slideshow theme automatically turns the pages of the virtual scrapbook as you watch it. Use this theme to showcase a large group of photos in an interesting way.

- **Photo Mobile**—Each one of your images is displayed as a print hung by a virtual string on a mobile that continuously rotates, revealing one full image at a time. This is a really cool, multidimensional visual effect for showcasing a small handful of photos, but after 60 seconds or so, the visual novelty of this effect wears off. Figure 15.4 shows a sample of this theme.

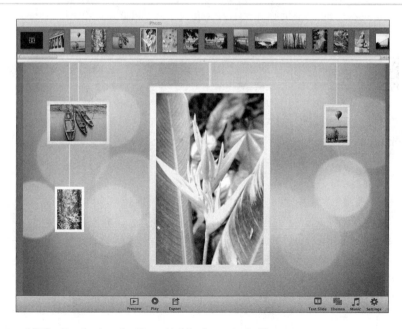

Figure 15.4 *Here's what the Photo Mobile theme looks like.*

- **Holiday Mobile**—This theme works just like the Photo Mobile theme, but the background has more of a winter holiday look that features animated snowflakes. Add some holiday music, and you'll have a great way to show off your favorite holiday photos.

- **Shatter**—This animated effect is high-tech looking and slick. Image transitions involve a photo breaking apart or shattering, while the next photo materializes into place. This template does not work well, however, with vertically oriented photos.

- **Places**—If you utilize geo-tagging with your photos, this theme creates customized maps for each of your photos that allows you to display where the photo was taken, as well as the photo itself. In between animated map slides, your photos are displayed using a variety of different photo collage layouts. Geo-tagging can be added to images in order to use this theme.

- **Classic**—This is the default slideshow template. It simply displays one photo at a time, with a fade-out and fade-in transitional effect in between slides.

TIP

When multiphoto collages are created and displayed, you can edit which photo appears where by first clicking on and selecting the thumbnail image for a picture displayed within a collage (from the top of the screen). In the preview window, the collage slide is displayed. Drag and drop images from the thumbnails above into the location you want them to appear in the collage slide. This action replaces the placeholder photo. When you replace an image, the image that previously appeared is returned to the lineup of thumbnails at the top of the screen, so you can use that image later. When you click on one of the images in a collage, a hand-shaped cursor appears. Use it to reposition the photo within the collage frame by dragging it around.

CAUTION

Some of the themes work better just with horizontally or vertically oriented photos. If a photo's orientation doesn't fit into a template, it is automatically cropped to fit, which could distort the photo or delete important elements of the image.

Using Animated Transitions and Special Effects

Depending on which slideshow theme you select, by clicking on the Settings command icon located in the lower-right corner of the screen, you can customize various aspects of that template.

For the Classic slideshow template, for example, from the Slideshow Settings screen (see Figure 15.5), you can make adjustments to all slides in the presentation or individual slides, based on which tab (All Slides or This Slide) is highlighted at the top of the window.

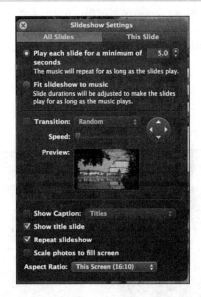

Figure 15.5 *Use the Settings adjustments to customize a slideshow theme.*

Some of the adjustments you can make include how long each slide will be displayed, what transitional effect will be used in between slides, and whether photos should be automatically scaled to fit the screen.

The options for customizing each slideshow theme vary. When you adjust the settings for other themes, you can pick the background color displayed behind the images, for example.

If you're including music in your presentation, when you click on the Fit Slideshow to Music option, iPhoto '11 automatically determines how long each slide should

be displayed to fit perfectly (timing wise) with the music selection. However, if you don't use this feature, you can set all slides to be displayed for the same amount of time (there is a different default time for each theme), or you can determine the amount of time each individual slide will be displayed if you make adjustments after clicking on the This Slide tab, as opposed to the All Slides tab in the Settings window.

Adding Music to Your Presentation

One of the best ways you can bring your slideshow to life, so to speak, and set the mood for the people viewing it, is to select applicable music to play in the background. Whether you use a slow instrumental music bed, ballad, high-energy pop song, or techno song as background music, it will make a huge difference in the emotions that are conjured up when people watch your presentation.

To make your music selection, click on the Music command icon located in the lower-right corner of the screen. The Music Settings window appears (see Figure 15.6).

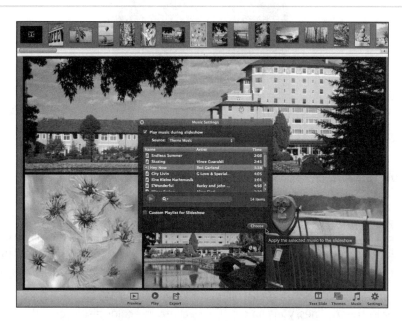

Figure 15.6 *Use the Music Settings window to add music to your slide presentation.*

From the Source pull-down menu of the Music Settings screen, view the selections of music available to you. The Sample Music and Theme Music libraries are collections of instrumental pieces built into iPhoto '11. If you have Garage Band (part of iLife '11) installed on your Mac, you also have access to a selection of Garage Band demo songs. Alternatively, from this pull-down menu, you can pick any song you have stored in your personal iTunes music library.

Using iTunes, you can easily download virtually any song you want to add to your slideshow (a fee applies) and then incorporate it into your presentation when that song is saved in your iTunes library.

To select a single song to add to your slideshow, simply click on its title from the list that appears below the pull-down menu, highlight it, and then click on the Choose icon located in the lower-right corner of the window.

If you want to add several songs to a slideshow, add a check mark to the Custom Playlist for Slideshow check box and then drag your song title choices from the song list in the middle of the Music Settings window to the Custom Playlist window.

 SHOW ME　Media 15.2—See how to add music to your slideshow
Access this video file through your registered Web Edition at
http://www.quepublishing.com.

 LET ME TRY IT

Adding Music to Your Slideshow

To add music to your slideshow, follow these steps:

1. As you're editing a slideshow, click on the Music command icon.

2. Use the pull-down menu at the top of the window to select a source, such as Sample Music, Theme Music, or your iTunes library.

3. To use just one song or track in a slideshow, highlight one song from the list and click on the Choose icon.

4. To use multiple songs in a slideshow, add a check mark to the Custom Playlist for Slideshow check box and then drag and drop song selections from the displayed list to the bottom of the window, where you can arrange your slideshow's multisong playlist. Click the Choose icon when you're done.

Sharing Your Slideshow

After you make all your customizations to a slideshow, its title is displayed in iPhoto '11's Source list under a Slideshows heading. It is automatically saved and can be viewed at any time on your Mac in iPhoto.

> **TIP**
>
> iPhoto '11 automatically makes the first slide in your presentation the title slide. The text you enter as the title is displayed on this first slide during your presentation but also serves as the filename for the entire slideshow. (The filename is then listed on iPhoto '11's Source list.)

However, you can easily export your presentation, making it available to share with other people via email or by publishing it onto a website or into a blog, for example. It can even be uploaded and shared on YouTube, if you export the slideshow into the MPEG-4 or QuickTime Movie format.

After the slideshow is exported, it can also be synced to an iPod, iPhone, iPad, or Apple TV unit and viewed, or saved to a CD (or DVD) and viewed on any computer or on a TV that's equipped with a DVD player, for example.

Click the Export icon located at the bottom center of the screen when creating a slideshow to open the Export Your Slideshow window (see Figure 15.7).

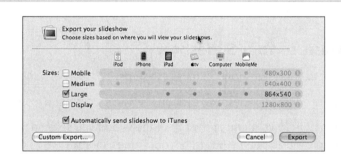

Figure 15.7 *The Export Your Slideshow window.*

Select the file size (Mobile, Medium, Large, or Display) that corresponds on the displayed chart with the device on which you want to view your slideshow. Then click on the Export icon in the lower-right corner of the window.

If you click on the Custom Export option located in the lower-left corner of the Export Your Slideshow window, you can choose the destination where the

exported file will be saved (the default is in your iPhoto Slideshows folder). You also can choose specifically in what file format you want the slideshow exported.

> **TIP**
>
> If you want to watch your slideshow on a full-size television set, export it into MPEG-4 format. If you plan to view it on the Web (as part of a website or blog), save it in the QuickTime Movie format.

Using Your Other Slideshow Options

In addition to being able to create animated slideshows from iPhoto '11, you can export your photos and create dazzling slideshow presentations using many of the online-based photo services.

⊙ *For a list of popular online photo services, such as KodakGallery.com, Snapfish.com, and SmugMug.com, **see** Chapter 12, "Creating Prints Using a Professional Photo Lab."*

There are also dedicated photo websites, such as Slide.com (www.slide.com), that just allow you to create animated slideshows using your photos. These slideshows can be shared through websites, email, blogs, or almost any online social networking sites, such as Facebook.

For the Mac, third-party software packages, such as FotoMagico 3 ($29, www.boinx. com/fotomagico/overview), are designed exclusively for producing professional-looking animated slideshows using your photos and video clips. This software offers many special effects and editing features not available in iPhoto '11.

 TELL ME MORE Media 15.3—Hear a discussion about your other options for creating slideshows outside iPhoto '11

*To listen to a free audio recording about your other options for creating impressive slide shows using your images, log on to **http://www.quepublishing.com**.*

> **TIP**
>
> For even more control, features, functions, and effects, instead of using iPhoto 11's slideshow feature, you can create a video presentation to showcase your photos using iMovie '11, which is also part of iLife '11.

Use Apple's MobileMe online service to create
and share online photo galleries.

16

Using Apple's MobileMe with iPhoto '11

Apple has its own fee-based online service, called MobileMe, which offers a handful of useful functions for Mac users (as well as users of other Apple devices, such as an iPhone or iPad).

One of the ways you can use MobileMe is to create, publish, and share online-based photo galleries or to create simple personal web pages that showcase your images.

Subscribing to Apple's MobileMe service is optional. It requires you to pay an annual membership fee of $99 per year (single user) or $149 per year (for a family membership). When you buy a new Mac, Apple periodically offers a discounted membership rate for the first year.

Keep in mind that just about all the features MobileMe offers are available from other online services, sometimes free. However, these services don't seamlessly integrate with Mac-based applications from the iLife '11 or iWork '11 suites, for example.

This chapter offers an introduction to MobileMe and describes how to use it in conjunction with iPhoto '11 to create and publish online-based photo galleries that you can share with family and friends via the Web.

> **TIP**
>
> To learn more about the MobileMe service and sign up for a free 60-day trial membership, visit www.apple.com/mobileme.

An Introduction to MobileMe

MobileMe is an online service designed to make file sharing, data synchronization, and archiving of files among multiple Macs or Apple devices a simple process. For example, you can use the Email functionality of MobileMe to keep all your email boxes on your various machines and devices (including your Mac, iPhone, and

iPad) synchronized. You can also synchronize your calendar and address book data (if you use your Mac's iCal and Address Book applications).

For iPhone and iPad users, MobileMe also offers an online-based device tracking service. Plus, with the service's iDisk feature, you can wirelessly share any type of file (including digital photos) among multiple Macs, PCs, and mobile devices.

MobileMe membership includes 20GB of online storage space with which you can store remote backup copies of important files, store files to be shared with other people or devices, or host online photo galleries and personal web pages.

iPhoto '11 is designed to work seamlessly with MobileMe, allowing you to create, publish, and manage attractive online photo galleries without having to use your Mac's web browser.

CAUTION

If you stop paying for your MobileMe membership when it expires, after a certain grace period, any photo galleries or online files you have backed up or stored using this service are deleted.

What's an Online Photo Gallery?

An *online photo gallery* is a collection of images, grouped together in a single Album, that can be displayed online and that is accessible to any visitors via their computer's web browser. After they're published, online galleries created using iPhoto '11 can be viewed using Macs, PCs, iPhones, iPads, or any device that connects to the Web.

When visitors access one of your online galleries, they see thumbnails of each image in that gallery but are able to click on any image to see a larger-size version of that photo. Depending on how you set up the gallery, visitors can also copy your photos to their computer, print images, share images electronically (via email, for example), or upload their own pictures to your gallery.

TIP

After you create an online gallery using iPhoto '11, if you ever make changes to that gallery on your Mac (using iPhoto '11), those changes automatically take effect on MobileMe as well. So, you can easily add or delete images or edit individual images and know that what's on your Mac and what's on MobileMe remain fully synchronized.

Part of the online gallery creation process involves MobileMe assigning a unique URL (Internet address) to that gallery. You can set the privacy options to make the online gallery available and accessible to the general public (any visitors who simply enter the gallery's URL into their web browser), or you can password-protect each individual gallery to limit access to only people you want to see your photos.

You can also determine if visitors to your gallery are able to download all the images from that gallery to their computer or add their own images to the gallery from their web browser or via email.

Online photo galleries are a fast and easy way to share large numbers of images with friends, family, coworkers, or the general public. As an iPhoto '11 user who subscribes to MobileMe, you simply need to create an Event or Album containing the images you want to share in iPhoto '11 and then use the software's Share via MobileMe functionality.

When your images are uploaded into a gallery, simply give out the gallery's unique URL to whomever you want to be able to see and access your photos via the Web (whether they're using a Mac, PC, or any type of wireless mobile device, such as an iPhone or iPad).

Creating an online gallery to share images is a great alternative to emailing a handful of photos to individual people because you can have an unlimited number of photos in the gallery.

> **TIP**
>
> The capability to create online galleries is not unique to MobileMe. In fact, you can do it for free with just about any popular online photo service, as well as online social networking sites, such as Facebook. The benefit to using MobileMe if you're an iPhoto '11 user is that you save a step by not having to first export your photos from iPhoto '11 to upload them to an online photo service and create an online photo gallery on that service.

Creating a MobileMe Online Photo Gallery from iPhoto '11

Thanks to the seamless integration between iPhoto '11 and MobileMe, if you have an active MobileMe account, you can publish as many online galleries as you'd like, until you fully utilize your 20GB allocation of available online storage space. (If you do exceed this available storage, which isn't much when you consider each of your images can be 5MB or larger, you can pay extra for additional storage.)

To create an online gallery from iPhoto '11 and then publish it on MobileMe, first select the photos you want to feature in the online gallery. Then save them into a separate Album while using iPhoto '11.

Next, select and highlight that Album and click on the Share command icon located in the lower-right corner of the iPhoto '11 screen. Select the MobileMe Gallery option.

Alternatively, with the Album selected and highlighted, use the MobileMe Gallery command under the Share pull-down menu located at the top of the iPhoto '11 screen.

TIP
You can just as easily upload and share the contents of an entire Event folder in iPhoto '11 instead of creating a separate Album.

When the MobileMe Galleries window, shown in Figure 16.1, is displayed on your screen, click on the gallery icon with a gray plus sign displayed in it to create a new online gallery, or select an existing online gallery that you want to add photos to (or edit).

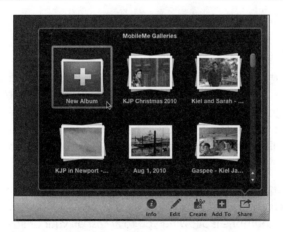

Figure 16.1 *Create a new gallery to upload to MobileMe from this window. To access it, click on the Share command icon and choose MobileMe Gallery.*

After you click on the Add Gallery icon, a new window appears with the heading "Would you like to publish '[insert Album name]' to your MobileMe Gallery?" In this window is an Album Name field into which you should type the title of the gallery to be published. The current Album name is used as a default title.

Next, from the window shown in Figure 16.2, choose your gallery's privacy options from the Album Viewable By pull-down menu and then choose whether or not people will be allowed to download the photos from your gallery or upload and share their own photos to your gallery. Make these decisions by adding check marks next to the three different check boxes under the Allow heading.

Figure 16.2 *Customize the settings for your MobileMe gallery.*

Under the Show heading in this window, using the mouse, add a check mark to the Photo Titles check box if you want the filename for each photo to be displayed under the image's thumbnail in the gallery. Also under this heading, if you chose to allow people to email their photos to be included in the gallery, you can decide whether the gallery itself will display the special email address to send the images to.

If you click on the Advanced icon, you can also determine whether or not the gallery you're creating will be displayed on your central MobileMe Gallery Page (which displays thumbnails allowing you to access all your online galleries on one screen). After adjusting all the appropriate customization options, click on the Publish icon located in the lower-right corner of the window to begin uploading and publishing your gallery on MobileMe.

The uploading process may take awhile, based on the speed of your Internet connection and the number of photos included in the gallery. As soon as you click on the Publish icon, a listing for that gallery appears on iPhoto '11's Source list under the Web heading. Simultaneously, the main iPhoto '11 screen displays thumbnails

of the images being uploaded, and a progress bar is displayed in the upper-right corner of the screen (see Figure 16.3).

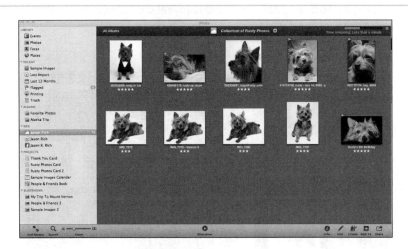

Figure 16.3 *The iPhoto '11 screen looks like this as you're uploading images to MobileMe.*

While still in iPhoto '11, you can access your new MobileMe gallery by clicking on the right-pointing arrow icon located next to the gallery title at the top center of the screen. This opens your web browser and automatically points you to the newly created gallery's URL (see Figure 16.4).

Figure 16.4 *A first look at how your MobileMe gallery looks online.*

TIP

When you subscribe to MobileMe, you are able to access your online home page using a special URL that's assigned to you. From here, you can access all the service's features and functionality, including the capability to view and manage online photo galleries. However, your "guests" need to use the URL created for the gallery (or the URL for your main gallery page) to access it.

Any time you or any others visit your MobileMe gallery via a web browser, you or they can customize how the gallery looks on the screen by adjusting the options at the bottom of the screen. For example, you can choose the default Grid view shown in Figure 16.5, a mosaic view, the carousel view shown in Figure 16.6, or a slideshow view.

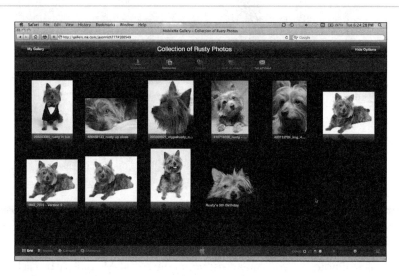

Figure 16.5 *The MobileMe Online Gallery's default Grid view.*

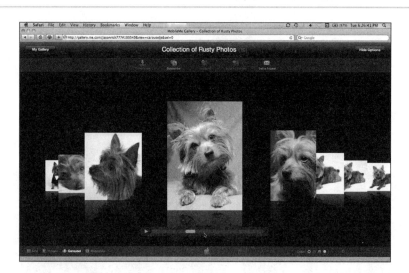

Figure 16.6 *The MobileMe Online Gallery's Carousel view.*

You can also change the solid background color to any color you like and use the Zoom slider to make the image thumbnails appear larger or smaller to customize the gallery viewing experience.

At the top center of the MobileMe gallery, located under the gallery's title, are five additional command icons:

- **Download**—Visitors can download one image, several images, or the contents of the entire gallery to their computer (if you've set up the gallery to allow this).

- **Subscribe**—As changes are made to the gallery, subscribers can automatically be notified.

- **Upload**—This command icon allows any visitors to upload their images and add them to the gallery (if you've set up the gallery to permit this).

- **Send to Album**—This command icon allows you to transfer images from the online gallery to an Album in iPhoto '11.

- **Tell a Friend**—This command icon allows you to email friends to tell them of the gallery's existence and provide them with its unique URL, allowing them to access it.

SHOW ME Media 16.1—See how to create an online gallery using MobileMe
Access this video file through your registered Web Edition at http://www.quepublishing.com.

LET ME TRY IT

Creating an Online Gallery Using MobileMe

To create an online-based MobileMe gallery using iPhoto '11, follow these steps:

1. Create an Album or highlight and select the photos you want to upload to a MobileMe gallery in iPhoto '11. You can also choose to create a gallery using the entire contents of an Event folder, for example.

2. With the Album or Event highlighted, click on the Share command icon and choose the MobileMe Gallery option.

3. Click on the New Gallery icon in the window that appears above the Share command icon.

4. Customize your gallery settings from the gallery setup window that appears and click on the Publish icon when you're done.

5. Your photos are uploaded into the gallery you've created. An upload progress bar is displayed in the upper-right corner of the screen, and a listing for the gallery appears in iPhoto '11's Source list.

6. To access the gallery using your Mac's web browser, click on the right-pointing arrow located at the top center of the screen, next to the gallery's title.

7. Adjust the view settings for the gallery using the command icons located at the bottom of the screen.

Discover a few additional ways to share your photos in iPhoto '11.

17

More Ways to Share Your Photos

So far, you've learned about many different ways to use iPhoto to edit and enhance your photos and then share them—both in the real world and in cyberspace. There are, however, several more ways you can use iPhoto '11 to showcase and share your favorite digital photos.

This chapter discusses how to publish photos onto a website using the Share to iWeb feature of iPhoto '11. You also discover how to customize your Mac's Desktop wallpaper and screen saver using your photos and how to enjoy your favorite images while you're on the go by transferring them to your iPhone, iPod, or iPad using iTunes' Sync feature.

 © *To learn more details about burning a large number of your photos to CD or DVD in iPhoto '11, to share, view, or archive them,* **see** *Chapter 18, "Burning Photos to CD or DVD from iPhoto '11."*

Creating a Web Page with iWeb

When you access the Share pull-down menu and select the iWeb option, you'll discover an option for creating a photo page or blog. In addition to publishing single or multiple photos from Events or Album folders in iPhoto '11 onto the Web using iWeb, you can also use this feature to publish slideshows created in iPhoto '11.

To use this feature, first highlight and select an Event or Album folder or individual images in a folder (or a slideshow listed on the Source list) that you want to publish. Next, select the Photo Page or Blog command under the Share pull-down menu.

iWeb is one of the other applications built into the iLife '11 suite of applications. When you select the iWeb feature, this app automatically launches (assuming you have it installed on your Mac). If iWeb isn't installed, the menu option in iPhoto '11 is not available to you.

TIP

iWeb is a separate application from iPhoto '11, but it's also part of the iLife '11 suite of applications. To learn more about iWeb, its features, and how to use this program, visit www.apple.com/ilife/iweb.

When iWeb loads, you are asked to select a template for your photo page or blog. Click on your favorite template and then click the Choose icon to continue (see Figure 17.1). The images you preselected in iPhoto '11 are automatically exported and loaded into iWeb and placed in the photo page or blog you're now creating.

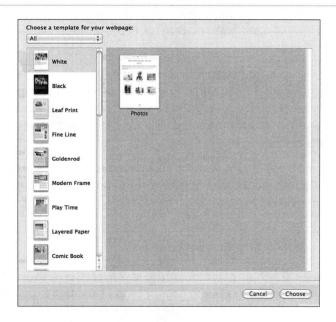

Figure 17.1 *iWeb allows you to publish photos from iPhoto '11 on the Web in the form of a photo page or blog entry.*

You can now begin customizing the page using iWeb's various features. For example, you can add or modify the headline and text on the page, add widgets (which are built into iWeb to add functionality to the photo page or blog), or customize the color scheme and other elements of the page itself. An example of a basic web page created in less than two minutes using iWeb is shown in Figure 17.2. These photos were automatically imported from iPhoto '11 and formatted on the page based on the template that was selected.

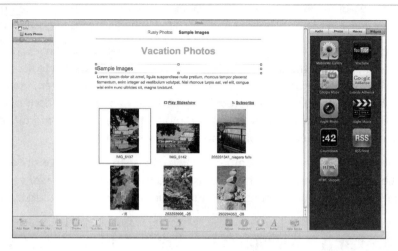

Figure 17.2 *Creating a custom web page to showcase your photos takes just a few minutes.*

After customizing the page using iWeb, click the Publish command located at the bottom of the screen. A progress bar appears, and your photo page or blog is published online.

iWeb automatically assigns a unique URL to all websites, blogs, or photo pages created. When the site is published, a message appears on the screen informing you of your new URL (website address).

Click on the Announce icon to share details about your new site to others via email. Alternatively, click on the Visit Site Now icon to launch your Mac's web browser (such as Safari) and visit your new site on the Web. You can also click the OK icon and return to iWeb.

NOTE

Creating a photo page or blog entry offers different customization options than creating a MobileMe online gallery, so how your photos look when someone visits the web page versus an online gallery will be different. Photo pages and blog entries created with iWeb can easily be integrated into existing websites or blogs.

Originally, iWeb was created as a way to design web pages for the MobileMe online service (which requires a paid membership). This is no longer the case. Although the default is for this application to seek out a MobileMe account when trying to

publish a website, photo page, or blog, for example, you can adjust the settings in iWeb so that you can publish your pages or sites using any website hosting service.

To customize where your iWeb creations will be published, while in iWeb, click on the Sites heading at the top-right side of the screen. This allows you to access the Site Publishing Settings screen. In the Publishing section of this screen, use the Publish To pull-down menu to determine where you want your creations published. Based on your selection, you are prompted to enter specific information pertaining to your website or blog account and hosting service.

If you're already a MobileMe member and you choose to publish your site or page creations using MobileMe, all the settings are automatically adjusted for you, and your MobileMe account information is automatically imported and used by iWeb.

Customizing Your Mac's Desktop Wallpaper and Screen Saver

In iPhoto, select and highlight one photo that you'd like to make your Mac's Desktop wallpaper image. Use the Share pull-down menu and then choose the Set Desktop option. Immediately after doing this, when you view your Desktop, you'll discover the photo you selected is displayed behind the icons and the Dock. This is a great way to personalize your overall experience using your Mac.

Figure 17.3 shows what a photo looks like when it's used as a Desktop wallpaper on a Mac. (This particular image was taken at a beach in Bermuda. You can use your own vacation photos to help you reminisce while you're supposed to be hard at work on your computer.)

Another thing you can do is create an animated screen saver that showcases a selection of your images. To do this, begin by selecting a group of images and create a separate Album. Alternatively, you can simply use all the images in an Event folder, for example.

Next, access the Mac's System Preferences by clicking the System Preferences program icon on the Dock or by using the Finder to access your Applications folder. From the System Preferences window, click the Desktop & Screen Saver option.

Click the Screen Saver tab at the top of the Desktop & Screen Saver window. On the right side of this window is a list of files and folders under the Screen Savers heading. Scroll down to the iPhoto heading and choose the Album or Event name that contains the photos you want to use as your animated photo screen saver.

A preview of the screen saver appears on the right side of the Desktop & Screen Saver window (see Figure 17.4). Immediately under this window are three command icons with the heading Display Style; they allow you to choose the animation

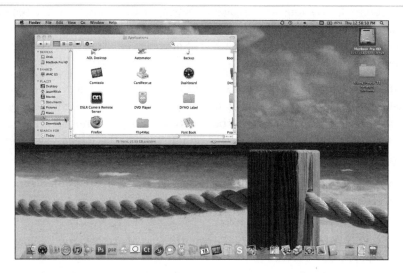

Figure 17.3 *Be able to reminisce about a vacation by choosing your favorite photo from a trip and using it as your Desktop wallpaper image.*

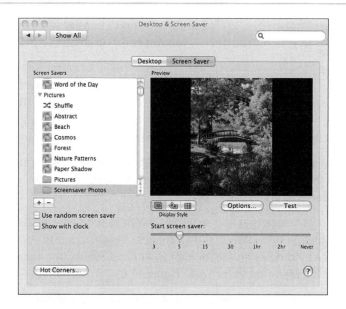

Figure 17.4 *You can access the Desktop & Screen Saver window from your Mac's System Preferences.*

style used to display your screen saver photos. Click the Options icon to see a list of check box options that allow you to further customize your screen saver. The Test icon shows a preview of the screen saver after you've adjusted the customization options.

Use the slider labeled Start Screen Saver below the screen saver preview window to determine how many minutes of inactivity the Mac will wait before it begins displaying the screen saver. You can choose between three minutes and two hours, or you can move the slider to the extreme right to turn off the screen saver option altogether.

When you exit this window by clicking on the red dot in the upper-left corner, your screen saver is saved and ready to use.

 SHOW ME Media 17.1—Customize Your Mac's Desktop Wallpaper and Screen Saver
Access this video file through your registered Web edition at
http://www.quepublishing.com.

Transferring Photos to Your iPhone, iPod, or iPad

If you have an iPhone, iPod, or iPad, and you want to transfer some or all of your iPhoto photos to your mobile device, you can easily do so by using iTunes' sync capabilities.

Connect your iPhone, iPod, or iPad to your Mac using the USB cable that came with your device and launch iTunes on your Mac. On the left side of the iTunes screen is a list of connected devices (under the Devices heading), as shown in Figure 17.5. Click and highlight the device to which you want to send your photos.

When the selected device's summary screen appears in the main area of the iTunes screen, click the Photos icon located at the top of the screen to the right of the TV Shows and Books icons.

From the Photos screen that appears, you can opt to send all your Events, Albums, Faces, and other picture folders (and all images in each folder) to your Apple mobile device by clicking on the All Photos, Albums, Events, and Faces option located near the top of the screen (see Figure 17.6).

The alternative is to click on the Selected Albums, Events, and Faces... option, and then manually pick and choose which Albums, Events, and Faces folders you want to export (transfer) to your iPhone, iPod, or iPad. Using the mouse, place check marks next to each Album, Events, or Faces folder name.

Figure 17.5 *In iTunes, select the Apple mobile device to which you want to send your photos.*

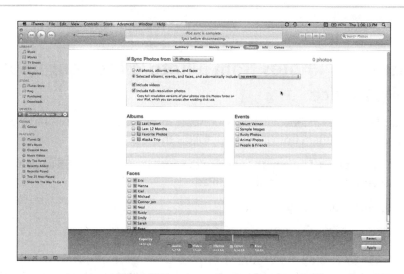

Figure 17.6 *Select which Events, Albums, or Faces folders you want to sync between your Mac and your iPhone, iPod, or iPad.*

In the upper-right corner of the screen, the number of photos you've chosen to transfer is displayed. When your selections are made, click on the Sync icon located in the lower-right corner of the window.

iTunes then syncs with your Apple mobile device, and your selected images are transferred. This process could take several minutes, depending on the number of images and sizes of the files being transferred.

When the sync process is done, eject your mobile device from iTunes and view your images by accessing the Photos app on your Apple mobile device.

> **NOTE**
> If you've taken photos using the camera built into your iPhone, for example, when you initiate a Sync, iPhoto '11 launches and you are prompted to import those images from your iPhone directly into a new iPhoto '11 Events folder. This process is covered in Chapter 3, "Loading Your Digital Images into iPhoto '11."

 SHOW ME Media 17.2—See how to transfer photos from iPhoto '11 to your Apple mobile device (iPhone, iPod, or iPad)
Access this video file through your registered Web edition at
http://www.quepublishing.com.

 LET ME TRY IT

Transferring Photos from iPhoto '11 to Your Apple Mobile Device

To transfer images in iPhoto '11 to your Apple mobile device without having to first manually export them from iPhoto '11, follow these steps:

1. Connect your Apple mobile device to your Mac using the USB cable supplied with your iPhone, iPod, or iPad.

2. Launch iTunes on your Mac.

3. Under the Devices heading on the left side of the iTunes screen, click on your Apple mobile device.

4. When the Summary screen for that device appears in the main iTunes program window, choose the Photos option at the top right of the page.

5. Choose to transfer all images stored in iPhoto '11 to your mobile device or select individual folders.

6. Click on the Sync icon located in the lower-right corner of the iTunes screen to initiate the transfer.

NOTE

After you customize your sync preferences in regard to which iPhoto '11 Events, Albums, or folders to synchronize, whenever you make changes in iPhoto to any of those folders, the corresponding images and files on your Apple mobile device are updated accordingly the next time you sync your Mac and your mobile device. You can set up different customized photo synchronization preferences for each separate Apple mobile device you own.

VI

Backing Up and Archiving Your Images

18 Burning Photos to CD or DVD from iPhoto '11 **289**

19 Photo Backup Solutions .. **294**

Learn how to burn a large collection of your photos to CD or DVD from iPhoto '11.

18

Burning Photos to CD or DVD from iPhoto '11

If you want to share a large number of photos with someone else and don't want to publish your images on an online photo service to do so, one of the more practical ways to accomplish this is to burn your images onto a CD or DVD. After all, when sending high-resolution photos via email, due to file size restrictions on most email accounts, you can't directly email more than a handful of images at a time. So, if you're trying to share 25, 50, 100, or more photos with someone, email is not a practical option.

Burning your photos to CD is also useful if you want to view your images on another computer. Transferring the images to a DVD also offers several benefits. For example, you can view your images on a television set that's equipped with a DVD player. DVDs also hold much more data than CDs, so many more high-resolution digital images can be stored on them.

A single, blank CD-R that's compatible with the Mac's optical drive can hold up to 700MB of data. A blank DVD-R that's compatible with most recent and current-model Mac SuperDrive optical drives can hold up to 4.7GB of data.

Transferring your photos to CDs or DVDs is also useful for maintaining a safe archive of your images. This chapter explains how to transfer images from iPhoto '11 to a CD or DVD using your Mac's SuperDrive optical drive (and blank CD or DVD media).

TIP

You can purchase blank (writable) CDs and DVDs from any office supply or consumer electronics store. They typically come in packs of 5, 10, 25, 50, or 100. Be sure to purchase the optical media format that's compatible with your Mac's optical drive.

Burning Photos to DVD Using iPhoto '11's Share Using iDVD Command

iDVD is a standalone application that is part of the iLife '11 suite. It's used for creating DVD presentations that can be burned onto a DVD and then viewed on almost any computer or television set that's equipped with a DVD player. Like other applications in the iLife '11 suite, iDVD uses themes, so you can create extremely impressive presentations and distribute them on DVD without having to do any programming or know anything about video production or graphic design.

CAUTION

iDVD is a powerful program that, like iPhoto '11, takes some time to learn how to use. For more information about this program, visit www.apple.com/ilife/idvd/.

When you use this application exclusively with iPhoto '11, you can create engaging slide presentations using your images stored on DVD for easy distribution and viewing.

Start by selecting the images you want to create into a DVD-based slideshow presentation. This process is totally separate from creating a slideshow photo project in iPhoto '11. In this case, you can choose a group of individual images or use the contents of entire Albums, Events, or folders.

After highlighting and selecting your image selections, access the Share pull-down menu from iPhoto '11 and select the iDVD option. This launches the iDVD application and exports your preselected images from iPhoto '11 and imports them into iDVD.

NOTE

If the iDVD application is not installed on your Mac, the Share Using iDVD menu option in iPhoto '11 is not available to you.

After selecting a theme for your DVD presentation, you can include titles, subtitles, music, and other effects. iDVD requires that you edit the introductory animated sequence that viewers will see when they insert the DVD into a computer or DVD player connected to a television. This step might include creating separate chapters for your DVD presentation, depending on the theme you select.

You also need to customize the photo slide presentation for the DVD using the customizable options offered by iDVD. This step includes choosing your background music, slide transition effects, and length of time each slide is displayed on the screen. A wide range of customizable options is available.

At any time during the customization process, you can preview your DVD presentation on your Mac's screen. When the entire presentation is edited and ready for its debut, click on the Burn DVD icon located at the bottom of the iDVD program window, next to the Play Preview icon. Insert a blank DVD into your Mac's optical drive and follow the prompts.

After your presentation is burned onto DVD, it will play in any DVD player or any computer (including a PC running Windows) that's equipped with an optical drive capable of playing movie DVDs. The DVD's intro screen automatically appears when the DVD is inserted into a player and the Play button is pressed (just as it would be when watching any DVD movie).

By combining the entertaining and visually impressive themes built into iDVD with your own digital images, you can create engaging slideshow presentations and distribute them via DVD (as opposed to publishing them online).

TIP

As you already know, all the applications built into iLife '11 are designed to work together seamlessly. So, if you want to create a presentation that combines video footage, still images, music, sound effects, titles, subtitles, animated transitions, and a wide range of other production elements, you can produce it using iMovie in conjunction with iPhoto. You then can use iDVD to create DVDs of your movie presentations, which can incorporate your still digital images currently stored in iPhoto '11.

Copying Photos to CD or DVD Using the Burn Command

When you use the Burn command to copy image files to a CD or DVD, your Mac treats the optical media as it would any other external hard drive or flash drive, allowing you to export files and copy them to another location. This process copies the images you select to a CD or DVD, but the photos can be viewed only on another Mac running iPhoto.

After the CD or DVD is inserted into your Mac's optical drive, and you've accessed the Burn command from the Share pull-down menu, at the bottom of the iPhoto screen you see a prompt asking you to enter a name for the disc. The default option is iPhoto Library – [Today's Date]. Directly under this prompt, you see the number of images to be copied and the available space remaining on the disc.

To continue the Burn process, click on the Burn icon located in the lower-right corner of the screen. A confirmation window with the heading Burn Disc appears. From this window, if you click on the small blue and black downward-pointing arrow icon, the window expands and several additional Burn options are displayed. You can customize these options by changing the pull-down menu and check box selections, or you can simply leave the default selections intact. Again, click on the Burn icon to continue.

A progress window is displayed as the disc is being burned. How long this process takes depends on the read/write speed of your optical drive and the number of images being copied. Keep in mind that you're creating a copy of your images. Thus, the images being burned on the disc also remain intact in iPhoto '11, stored in their original Event folders.

When the burn process is complete, the disc is ejected from your Mac. Place the disc in a CD box or envelope to protect it from getting scratched. Again, the CD or DVD you just burned can be read only by other Macs running iPhoto.

CAUTION

To burn a CD or DVD that allows your iPhoto images to be viewed by any computer (including PCs running Windows), you must first export your images from iPhoto using the Export command under the File pull-down menu and then use the Burn Disc command available in the Finder. See the following "Show Me" and "Let Me Try It" sections for step-by-step directions on how to do this.

 SHOW ME Media 18.1—Burn photos to a CD or DVD that can be read by any computer, including PCs running Windows
Access this video file through your registered Web Edition at
http://www.quepublishing.com.

 LET ME TRY IT

Burning Photos to a CD or DVD That Can Be Read by Any Computer

The Burn command available in iPhoto allows you to create a disc that contains image files readable only by a Mac running iPhoto. To create a disc of your images that can be read from any computer (including PCs running Windows), follow these steps:

1. Select and highlight the images, Events, Albums, or folders you want to copy to the disc.

2. Use the Export command under the File pull-down menu to export the images from iPhoto and store them in a directory on your Mac's internal hard drive (or on an external drive). See Chapter 10, "Exporting Your Images," for directions on how to do this. The files are exported in a file format that you select and that can be read by Macs and PCs, regardless of what software is being used to access them from the disc. The most common file format in which to export digital pictures is JPEG. (Choose the highest quality when exporting to have the most flexibility with the images later.)

3. Using the Mac's Finder, locate the directory where you exported the photos. Either select the entire folder containing your images by clicking on it once or double-click on the folder to open it and view thumbnails of the images the folder contains.

4. With the images or folder selected in the Finder (not in iPhoto '11), access the Burn to Disc command under the File pull-down menu. To continue the process, insert a blank disc into your computer's optical drive. Make sure the comprehensive file size of all images does not exceed the capacity of the disc; otherwise, an error message is displayed telling you to choose fewer images to burn to the disc.

5. A window appears prompting you to enter a name for the disc. Below the Disc Name field is a pull-down menu allowing you to select the burn speed. Click the Burn icon in the lower-right corner of the window to continue.

6. A progress window is displayed as your files are being copied and burned onto the disc. The disc is ejected from the drive when the burn process is completed. This process takes several minutes, depending on the read/write speed of your Mac's optical drive and the number of images being copied.

Photo Backup Solutions

Using iPhoto '11 has covered a lot of ground in terms of how to shoot better-quality images and then use iPhoto '11 to view, organize, edit, enhance, and share them.

One final lesson that is essential for you to learn from this book is that it's absolutely necessary for you maintain at least one reliable backup for your digital images, preferably in a remote location.

Although Macs are incredible machines, from time to time their hard drives do crash or data stored on them becomes corrupted. When this occurs, it's sometimes possible to retrieve lost or corrupted data but not always—unless you have a reliable backup from which you can restore your computer.

Chances are, as you begin taking more and more pictures, especially of people who are close to you and of important events in your life, the photos you take will become cherished keepsakes and represent fond memories that you won't want to forget.

Vacation photos, birthday party photos, wedding and honeymoon photos, graduation photos, snapshots of your kids growing up, and pictures of your pets are just some of the valuable images you won't ever want to lose.

If you don't have a reliable backup of your images, and your computer crashes, gets stolen, or somehow becomes damaged (if it gets dropped or caught in a flood or fire, for example), all your photos could be lost forever.

CAUTION
Don't wait until you have a major computer problem and lose some or all of your data, including important digital images, before you initiate an ongoing backup solution for your pictures.

This chapter offers a description of the various photo backup and archiving solutions available and discusses the pros and cons of each. Whatever backup option

you ultimately go with, make sure it's reliable and continuously maintained so that you always have copies of even your most recent images, as well as your most cherished digital photos from years gone by.

Apple's Time Machine

The Mac OS X operating system on every Mac desktop and laptop computer comes with a built-in data backup solution called Time Machine. If you're not already using this backup and data archiving tool, you should be using it to protect all your most important programs, data, and files, including your digital photos.

When you use Time Machine, your Mac automatically maintains a backup of your entire computer's hard drive contents (all programs, folders, data, and files), using an external hard drive that's connected to your computer wirelessly or via a USB or FireWire cable.

TIP

To learn more about Apple's Time Machine software, visit www.apple.com/find-outhow/mac/#timemachinebasics. This free software comes bundled with every Mac, but it requires an optional external hard drive, with a capacity that's equal to or greater than your Mac's internal hard drive, to utilize.

These days, a portable, external hard drive that offers at least 1TB of storage costs under $100. This is a worthwhile investment for all Mac users. Purchase an external hard drive (from any Apple Store, computer store, office supply superstore, or consumer electronics superstore) and connect it to your Mac. Next, be sure to set up and activate the Time Machine software.

When Time Machine is running, as you import and store new photos on your Mac's hard drive, a backup copy of each image is automatically created on the external hard drive.

Time Machine is designed to work in the background, with any external hard drive. However, Apple also offers a wireless external hard drive solution called the Time Capsule ($299 and up, www.apple.com/timecapsule), which is ideal for maintaining backups on one or more Mac desktop and/or laptop computers connected to a wireless network.

> **TIP**
>
> If you're a MacBook, MacBook Pro, or MacBook Air user, you can attach an external hard drive to the computer when you're at home or at work (allowing for Time Machine to back up your most recent files), but you do not have to leave the drive continuously attached to your computer while you're on the go.

Should something happen to your Mac's primary hard drive, with a few clicks of the mouse (and maybe the help of an Apple Genius from an Apple Store or through a call to the Apple Care hotline), you can retrieve and restore lost or corrupted files with relative ease.

This backup solution is a good first step to protecting your most valuable data and files, including all your digital images. But it's not infallible. For example, a power surge could potentially destroy your computer, as well as the external hard drive. Likewise, if you keep the hard drive next to your Mac, if the computer gets stolen or caught in a flood or fire, for example, the hard drive will be lost along with the computer.

Backing Up Images to CDs or DVDs

To maintain a backup of your iPhoto '11 images on CD or DVD, you can use the Burn command under the Share pull-down menu. This requires you to manually create backups of your images and then label, protect, and store the discs in a safe place.

Although perfectly viable, this backup method requires that you remain diligent when it comes to actively creating your backup files, which can be a time-consuming process, depending on how many images, Events, Albums, and folders you need to maintain backups of. Plus, if you later edit or modify images, you need to manually create an all-new backup by burning the updated versions of your photos to CD or DVD.

　To learn more about backing up your images to CD or DVD, **see** "Copying Photos to CD or DVD Using the Burn Command" (Chapter 18).

Using Online Photo Services

When you want to maintain a backup of all your images remotely, using an online photo service is an excellent strategy. The backups of your images are stored on a remote server located far away from your actual computer; plus, you can access the backup files from any computer via the Web.

Many of the online photo services described in Chapter 12, "Creating Prints Using a Professional Photo Lab," and Appendix A, "Digital Photography Websites," allow you to upload photos and archive them online. However, these services are designed to maintain backups and enable you to archive only your digital images—not the contents of your computer's entire hard drive.

When you're choosing which online-based photo service to use for backup and archival purposes, there are a few very important issues to consider, including the following:

- **Annual fee**—If you want to store an unlimited number of digital photos online, some services charge a monthly or annual fee. When you commit to using a service, you need to pay this fee on an ongoing basis (year after year) to maintain your backup files. If you stop paying for the service, after a grace period, your images are deleted from the service.

- **Online storage limits**—Some online photo services limit the total amount of online storage space available to users. When you reach this limit, you need to purchase additional space, set up a secondary account, or find a new service for backing up your images. Look for a service that offers unlimited online storage.

- **Whether or not your images will be compressed**—To save storage space, some online photo services and most of the online social networking sites (including Facebook) automatically compress your images as they're being uploaded. If you're trying to maintain a backup of your images, it's essential that they be preserved in their original resolution and file size. It's okay to have your images compressed and their resolution reduced if you're publishing photos online so they can be viewed and shared with others, but for archival purposes, it is important that images retain their original file size and resolution.

- **Reliability of the service**—You should choose a service that is well established and most likely won't go out of business anytime soon. When you upload all your images to the service for backup and archival purposes, you don't want to have to do it again if you discover the online service you used shut down.

Many of the online photo services allow you to maintain backups of your images. However, you must manually and continually create these backup files. The process is not automatic. Each time you create a new Event or Album in iPhoto '11 or edit older images, for example, you need to export them out of iPhoto '11 and upload them to one of these online-based photo services.

TIP

With a MobileMe or Flickr account, the image backup process can be done in iPhoto '11. However, MobileMe limits available storage to 20GB. (Additional storage space costs extra, beyond the $99.00 annual fee.) For unlimited storage space without compressing your images on Flickr, you need to upgrade to a fee-based Flickr Pro account. The cost is $24.95 per year.

Using Remote Data Backup Services

A remote data backup service offers the functionality of Time Machine (in that backups of all files on your computer are automatically created and saved), with the benefit of storing your files and images on a remote server that's accessible via the Web.

You pay a monthly or annual fee to use one of these remote backup services, but like any type of insurance policy, what you're investing in is peace of mind. You know that should something happen to your computer or its data, a complete backup of your files is securely stored offsite and is accessible from any computer connected to the Internet.

Several companies offer remote backup services for the Mac that work completely in the background after they're set up. However, before signing up with one of these services, read all the fine print.

For example, one of the most popular online remote backup services offers unlimited online storage for a flat annual fee, but when your backup reaches a certain size, the upload speed for backing up your computer is throttled down, so backups take a lot longer to create.

Another potential problem is that although you might think you have a current and complete backup of your Mac's entire hard drive, when you attempt to recover lost, accidently deleted, or damaged files, you could discover that the service was many gigabytes behind on its backup (meaning you could wind up losing important data and images).

With these caveats in mind, if you find yourself looking for a solid online backup solution that's compatible with the Mac, perform a search using Google and the search phrase "Remote data backup for Mac." Plan on spending at least $50 per year for a remote backup service with unlimited storage capacity.

> **CAUTION**
>
> Based on the speed of your Internet connection and the policies of the remote backup service, your Mac may be able to back up only 3GB to 4GB worth of new or revised files and data per day. If you have an almost full 500GB hard drive, for example, the initial backup process could take over two months to create.

Choosing the Perfect Backup Solution

Unfortunately, there is no perfect, failsafe, and 100% reliable backup solution for any Mac. However, by implementing one or two of the backup strategies outlined in this chapter, you'll know that your digital images are relatively secure, backed up, and easily accessible to you if anything happens to your primary computer.

In addition to utilizing Apple's Time Machine in conjunction with an external hard drive, seriously consider also backing up and archiving your photos using some type of remote online backup solution.

What to Do When Disaster Strikes

If your computer suddenly crashes, don't panic. However, unless you understand the technical complexities of your Mac's operation, don't start trying to fix the problem yourself. You could make the situation worse.

When you first purchase your new Mac, seriously consider investing in the Apple Care program so that your hardware will be protected against most technical problems. Plus, you get access to Apple's top-notch technical support network either by phone or at any Apple Store for at least three full years.

> **TIP**
>
> For information about Apple Care and technical support available from Apple, visit www.apple.com/support or call (800) APL-CARE (800-275-2273). Or simply visit any Apple Store, walk up to the Genius Bar, and make an appointment to speak with an Apple Genius in person. (Appointments can be made in advance from the Apple website. Visit www.apple.com/retail/geniusbar.)

Have a professional computer technician (or Apple Genius) diagnose your computer's problem and perform whatever repairs are necessary before restoring any files using your backup. If you determine your hard drive's data is corrupted, it may

still be salvageable (assuming you don't have a backup). However, you might need to hire a data recovery service, and this can get expensive (which is why maintaining a reliable backup is so important).

 TELL ME MORE Media 19.1—Learn how to deal with major computer problems that result in lost or damaged data files

To listen to a free audio recording about how to handle a data-related disaster that results in the loss or corruption of your image files, log on to http://www.quepublishing.com.

What to Do If Your Camera's Memory Card Malfunctions

In addition to your computer's hard drive having technical problems, on occasion, a camera's memory card could also fail. If this happens before you are able to transfer your images from the memory card to your Mac, you might need to use a specialized memory card data recovery program yourself or hire a data recovery service to salvage the image data.

> **TIP**
>
> The following website offers information and reviews of various memory card data recovery programs, some of which are available for the Mac (such as PhotoRescue and MediaRECOVER for Mac): www.ultimateslr.com/memory-card-recovery.php.

To help prevent problems occurring with your camera's memory cards (which are typically extremely reliable), follow these basic guidelines:

- When it's not in use, store the memory card in a cool, dry place within the plastic case that it came in.

- Do not expose the memory card to dirt, dust, water, or extreme temperatures. Be particularly careful to avoid touching the area of the memory card that contains its exposed connectors.

- In between uses, after you've safely transferred your images to your computer, erase and reformat the memory card.

- Avoid deleting photos from your camera while you're taking pictures.

VII

Appendixes

A Digital Photography Websites ... **302**

B iPhoto '11 Keyboard Shortcuts .. **306**

Digital Photography Websites

This appendix provides a comprehensive listing of digital photography-related websites. They're divided into categories and listed alphabetically, based on what each site or online service offers.

Digital Photography Information, News, and Product Reviews

The following are websites for the online editions of popular photography magazines, as well as online-only publications covering all aspects of digital photography:

- **Digital Camera Resource Page**—www.dcresource.com
- **Digital Camera Tracker**—www.digitalcameratracker.com
- **Digital Photography Review**—www.dpreview.com
- **Digital Photo Magazine**—www.dpmag.com
- **Digital PhotoPro**—www.digitalphotopro.com
- **Picture Correct (Photography Tips & Techniques)**— www.picturecorrect.com
- **Popular Photography**—www.popphoto.com

Digital Camera Manufacturers

By visiting the websites operated by specific digital camera manufacturers, you can learn about their newest camera models, get support or download software updates for your existing digital camera, or access free tutorials for using your specific camera.

The following are the most popular digital camera companies and their respective websites:

- **Canon**—www.usa.canon.com

- **Casio**—www.casio.com/products/Cameras

- **FujiFilm**—www.fujifilmusa.com

- **Kodak**—www.kodak.com

- **Lumix (Panasonic)**—www.panasonic.com/Lumix

- **Nikon**—www.nikon.com

- **Olympus**—www.getolympus.com

- **Pentax**—www.pentaximaging.com

- **Polaroid**—www.polaroid.com

- **Samsung**—www.samsung.com

- **Sigma**—www.sigmaphoto.com

- **Sony**—www.sony.com

Online Photo Services for Sharing Images, Creating Prints, and More

After exporting your digital images from iPhoto '11, you can share them in an online forum, order prints using a service other than Apple's photo lab, or create and purchase a wide range of photo products using any of these popular online services:

- **CVS Pharmacy Photo Lab**—www.cvsphoto.com

- **Flickr**—www.flickr.com

- **Google's Picasa**—http://picasa.google.com

- **Kodak Gallery**—www.kodakgallery.com

- **MPIX**—www.mpix.com

- **Photobucket**—www.photobucket.com

- **RitzPix (Ritz Camera)**—www.ritzpix.com

- **Shutterfly**—www.shutterfly.com

- **SmugMug**—www.smugmug.com

- **SnapFish**—www.snapfish.com

- **Target Photo Center**—http://sites.target.com/site/en/spot/
 page.jsp?title=photo_center

- **Walgreens Pharmacy Photo Lab**—http://photo.walgreens.com/walgreens/
 welcome

- **Walmart Photo Center**—www.walmart.com/photo-center

Specialized Photography Websites

The following websites offer some type of specialized service or product of interest to amateur photographers:

- **Blurb** (www.blurb.com)—An extremely impressive alternative way to create stunning soft-cover, hard-cover, and ImageWrap-cover photo books using photos edited and stored in iPhoto, but without using Apple's Photo Book service. The free BookSmart photo book design software offered from this site includes hundreds of templates and customizable options that are different from what's offered in iPhoto; you can use them to create high-quality yet extremely affordable photo books. The BookSmart software works seamlessly with iPhoto '11, so you don't need to manually export your images.

- **CafePress** (www.cafepress.com)—Order hundreds of different photo products and photo gifts that feature images you upload. Mouse pads, T-shirts, tote bags, magnets, photo puzzles, and wall clocks are among the offerings.

- **CanvasOnDemand** (www.canvasondemand.com)—Have your images enlarged, printed on canvas, and wrap-mounted on wooden frames.

- **Cards Direct** (www.cardsdirect.com/custom-photo-greeting-cards.aspx)— Design and print customized photo greeting cards using any of the hundreds of professionally designed templates offered on this site. Quantity pricing is available, and the card design selection is far greater than what's offered by Apple in iPhoto '11 when it comes to creating and printing greeting cards using your images.

- **FotoFlot** (www.fotoflot.com)—A unique and ultracontemporary way to showcase your images by having them printed on thin plastic sheets that can be hung on any wall without using a frame.

- **Miller's Professional Imaging** (www.millerslab.com)—One of many full-service photo labs that cater to the needs of amateur and professional photographers alike. Order prints, photo books, and a wide range of other products that showcase your images.

- **Short Run Posters** (www.shortrunposters.com)—Have full-color posters created from your images, for as little as $2 each, with no minimum order required.

iPhoto '11 Keyboard Shortcuts

For many of iPhoto 11's most commonly used features and functions, there are several ways to access and use them. First, you can access commands from the pull-down menus at the top of the screen. Second, you can access many of the program's features from the command icons located on the bottom of the screen. And third, for many commands, you can use keyboard shortcuts, which require you to press combinations of two or three keys on the keyboard.

For a complete list of keyboard shortcuts used in iPhoto '11, access the Help pull-down menu and select the Keyboard Shortcuts option. After you start to memorize some of the more commonly used keyboard shortcuts, they become timesavers as you're using iPhoto '11. The following is a list of the most commonly used keyboard shortcuts.

Commonly Used iPhoto '11 Keyboard Shortcuts

Command or Action	Keyboard Sequence	The Result
Import Photo(s)	Shift + Command + I	Imports photos into iPhoto. Same as using the Import to Library command from the File pull-down menu.
Export Photo(s)	Shift + Command + #	Exports photos from iPhoto. Same as using the Export command from the File pull-down menu.
Create a New Folder	Option + Shift + Command + N	Creates a new folder. Same as using the New and then Folder commands from the File pull-down menu.
Create a New Album	Shift + Command + N	Creates a new (empty) Album. Same as using the New and then Album commands from the File pull-down menu.
Open or Close Full-Screen Mode	Option + Command + F	Opens and closes full-screen mode. Same as clicking on the Full Screen command icon located in the lower-left corner of the screen.
Open Info Window (Reveals Folder or Image Information)	Command + I	Opens an information window. Same as clicking on the Info command icon located in the lower-right corner of the screen.

Commonly Used iPhoto '11 Keyboard Shortcuts

Command or Action	Keyboard Sequence	The Result
Rotate a Photo	Command + R	Rotates a photo 90 degrees to the left. To rotate a photo 90 degrees in the opposite direction, press Option + Command + R.
Duplicate Photo	Command + D	Creates an exact copy of a photo in the same event, album, or folder and automatically gives the copy a new filename.
Cut Photo	Command + X	Deletes a selected photo. Could be used as part of a cut-and-paste sequence to delete a highlighted photo.
Copy Photo	Command + C	Places a photo temporarily in the Mac's virtual Clipboard until you paste it somewhere else, such as into a new folder or a different location in a Photo Project, for example.
Paste Photo	Command + V	Relocates a photo into a new location after copying it into the Mac's virtual Clipboard. Could be used as part of a cut-and-paste sequence.
Change Viewing Size of Image Thumbnails	0, 2, 3, 1	Changes the size of thumbnails based on keypresses you make. When viewing image thumbnails in an Event or Album, for example, press 0 to make the thumbnails as small as possible. Press 1 to make them as large as possible. For mid-size settings, press 2 or 3. This is equivalent to using the zoom slider located in the lower-left corner of the screen.
Flag or Unflag a Photo	Command + Period Key	Flags or unflags an image, which can also be done by clicking on the Flag icon displayed in the upper-right corner of an image thumbnail in iPhoto '11's various viewing modes, or by using the Flag command under the Photos pull-down menu.
Move a Selected Photo, Album, or Folder to iPhoto's Trash Folder	Delete	Moves a highlighted and selected photo, image thumbnail, or folder to the Trash folder when you press the Delete key.
Empty iPhoto's Trash Folder	Shift + Command + Delete	Permanently erases files that have been moved into iPhoto's Trash folder. Same as using the Empty iPhoto Trash command from the iPhoto pull-down menu.
Select and Highlight a Photo, Image Thumbnail, Album, Event, or Folder	Click on the thumbnail or photo	Enables you to use any of iPhoto's features or tools on a photo, album, or image thumbnail if it is first selected and highlighted.

Commonly Used iPhoto '11 Keyboard Shortcuts

Command or Action	Keyboard Sequence	The Result
Select All Photos	Command + A	Same as using the Select All command under the Edit pull-down menu.
Rate a Photo with One Star	Command + 1	Same as using the My Rating command under the Photos pull-down menu and clicking on a one-star rating.
Rate a Photo with Two Stars	Command + 2	Same as using the My Rating command under the Photos pull-down menu and clicking on a two-star rating.
Rate a Photo with Three Stars	Command + 3	Same as using the My Rating command under the Photos pull-down menu and clicking on a three-star rating.
Rate a Photo with Four Stars	Command + 4	Same as using the My Rating command under the Photos pull-down menu and clicking on a four-star rating.
Rate a Photo with Five Stars	Command + 5	Same as using the My Rating command under the Photos pull-down menu and clicking on a five-star rating.
Remove a Photo's Star Rating	Command + 0 (zero)	Same as using the My Rating command under the Photos pull-down menu and clicking on the None option.
Stop a Slideshow While It's Playing	Esc	Enables you to stop when viewing a slideshow.
Pause Slideshow While It's Playing	Spacebar	Enables you to pause when viewing a slideshow.
Move Through Slides in a Slideshow Manually	Right Arrow or Left Arrow	Enables you to manually look through the individual slides within a slideshow.
Edit a Photo	Command + E	Same as clicking the Edit command icon or choosing the Edit Photo command from the Photos pull-down menu.
Access the Remove Red-Eye Options When Editing a Photo	R	Enables you to access red-eye options when a photo is selected and iPhoto is in Edit mode.
Print	Command + P	Prints a photo on your Mac's Photo printer.
Access iPhoto Help	Command + ?	Same as using iPhoto Help from the Help pull-down menu.
Hide iPhoto	Command + H	Hides iPhoto but keeps the application running.

Commonly Used iPhoto '11 Keyboard Shortcuts

Command or Action	Keyboard Sequence	The Result
Hide or show a hidden photo	Command+L	Once the Show Hidden Photos command is used, this command allows a photo that has previously been hidden to be revealed or unhidden.
Manage keywords	Command+K	Allows users to add or edit the keyword list associated with a photo.
Undo last action	Command+Z	Take a step back and undo the last action taken or the last command used.
Show preferences	Command+Comma	Opens the Preferences window associated with a photo and allows for options to be customized.
Quit iPhoto	Command + Q	Exits the iPhoto program.

index

A

Adjust command icon, 208-209

Adjust sliders, 167
 Contrast, 168-169
 Definition, 169
 De-Noise, 171
 exposure, fixing, 168
 Highlights, 170
 Saturation, 169
 Shadows, 170
 Sharpness, 170
 Temperature/Tint, 171-172
 underexposure, fixing, 167-168
 undoing, 173

Adjust window, 162-163, 208-209

Adobe photo-editing software, 144

Adorama website, 115

advanced editing
 Adjust window, 162-163
 contrast, 168-169
 Definition slider, 169
 de-noising, 171
 exposure, fixing, 168
 highlights, 170
 Levels histogram, 163-166
 adjusting tonal ranges, 164-165
 Apple tutorial, 165
 example, 165-166
 reading tonal ranges, 164
 viewing, 164
 saturation, 169
 shadows, 170
 sharpness, 170
 sliders, 167
 temperature/tint
 eye-dropper tool, 172-173
 Temperature/Tint sliders, 171-172
 underexposure, fixing, 167-168
 undoing, 173

aged appearance effects
 Antique effect, 154-155
 Sepia/Edge Blur effects, 153-154

albums
 benefits, 75
 creating, 75-76, 306
 deleting, 77, 307
 events, compared, 75
 exporting, 179-180
 Facebook, 253
 MobileMe photos, transferring, 277
 photos
 adding, 75-77
 arranging, 76
 editing, 76
 organization, 14-15
 viewing, 76
 selecting, 307
 Smart Albums, 77-80
 conditions, setting, 78-79
 creating, 78-80
 names, 78
 viewing, 79
 viewing, 75

announcement email template, 244

Antique effect, 154-155

Apple
 Apple Care, 299
 ID accounts, 216
 print products website, 215

applications, switching between, 34

archiving photos, 24-25
 CDs/DVDs, 296
 MobileMe, 298
 online photo labs, 296-297
 remote data backup services, 298-299
 solutions, choosing, 299
 Time Machine, 295-296

auto shooting modes, 88-89
 choosing, 90
 shutter lag, 90-91

autoflow pages, 210

B

Background icon, 204
backgrounds
 MobileMe online photo galleries, 277
 printing, 204
backing up photos
 CDs/DVDs, 296
 MobileMe, 298
 online photo labs, 296-297
 remote data backup services, 298-299
 solutions, choosing, 299
 Time Machine, 295-296
black and white effect, 152-153
Blurb
 BookSmart software, 26
 website, 304
blurriness, adjusting, 109-110, 170
BookSmart software, 26
Boost effect, 158
borders
 photo books, adding, 230
 printing, 201, 205-206
Borders icon, 205-206
brightening, 170
burning photos to DVDs
 Burn command, 291-292
 naming discs, 292
 options, 292
 progress window, 292
 iDVD presentations, 290-291
 editing, 290-291
 photo selection, 290
 playing, 291
 previewing, 291
 readable from any computer, 292-293

C

CafePress, 239, 304
calendars, 236-239
 costs, 236
 creating, 238-239
 holidays, 237

iCal events, importing, 237
 ordering process, 238
 photos
 selecting, 237
 placing, 238
 templates, 237
candid photos, 103
Canon website, 303
CanvasOnDemand website, 304
Cards Direct, 239, 304
cardstock email template, 244
Casio website, 303
CDs
 archiving photos, 296
 burning photos, 291-292
 naming discs, 292
 options, 292
 progress window, 292
 readable from any computer, 292-293
 importing photos from, 48
celebration email template, 244
clarity, fixing
 De-Noise sliders, 171
 Highlights slider, 170
classic email template, 244
Classic theme, 264
close-ups, creating, 136-138, 141
closing full-screen mode, 306
collage email template, 244
colorimeters, 114
colors
 black and white transformations,
 152-153
 boosting, 158
 effects, 149-151
 saturate, 151
 warmer/cooler, 150
 fading, 158
 greeting cards, 232
 problems, fixing, 112-115
 Levels histogram, 163-166
 printing, 113
 screen calibration, 114
 white balance, 113

temperature/tint, fixing
 eye-dropper tool, 172-173
 Temperature/Tint sliders, 171-172
tonal ranges
 fixing, 164-165
 viewing, 164
commands
 File menu
 Export, 176
 Import from Scanner, 53
 Import to Library, 46-48
 Order Prints, 211
 Print, 199
 Full Screen (View menu), 126
 Photos menu
 Edit Photo, 125
 Revert to Original, 124
comments (Facebook), 255-256
common shooting mistakes, 109
 autofocusing on wrong objects,
 110-112
 blurry images, 109-110
 color problems, 112-115
 printing, 113
 screen calibration, 114
 white balance, 113
 glares/shadows, 115-116
 red-eye, 118-120
 shooting through glass, 116-118
 specks/dots on photos, 120-121
compatibility, 26
Confirm Order Details screen (Apple), 214
contact sheets, printing, 202-203
continuous shooting mode, 107
contrast, adjusting
 Contrast effect sphere, 149
 Contrast slider, 168-169
cooler color effect, 150
copying photos
 DVDs/CDs, 291-292
 naming discs, 292
 options, 292
 progress window, 292
 keyboard shortcut, 307
 readable from any computer, 292-293
copyright laws, 55

corkboard email template, 244
cropping, 136-141
 close-ups, creating, 136-138, 141
 reframing, 138-139
 resetting, 140
 sizing, 138-140
 without constrains, 140
Customize icon (Print Settings window),
 203
customizing. *See* editing
cutting, 307
CVS Pharmacy Photo Lab website, 303

D

darkening, 147-149
Datacolor website, 114
definition, adjusting, 169
deflectors, 115
deleting
 albums, 77
 photo book pages, 230
 photos, 83
 photos from memory cards, 44
 projects, 82
 special effects, 160
Delta Point and Shoot Diffusers, 116
De-Noise sliders, 171
depth, adding, 97-98
descriptions (photos)
 adding, 17, 65
 customizing, 56-57
 viewing, 64
Design command icon, 233
desktop wallpaper photos, 282-283
diffusers, 115-116
Digital Camera Resource Page
 website, 302
Digital Camera Tracker website, 302
digital cameras
 auto shooting modes, 88-89
 selecting, 90
 shutter lag, 90-91

autofocusing on wrong objects, 110-112
color problems, 112-115
display image quality, 93
good-quality, 9
lenses, cleaning, 86, 120-121
manufacturer websites, 303
memory cards
 geo-tagging, 18
 malfunctions, troubleshooting, 300
 photos, deleting, 44
 read/write speeds, 91
 wireless, 45
picture-taking skills, improving, 85-88
 angles, choosing, 87
 auto shooting modes, 88-89
 camera practice, 86
 candid photos, 103
 creativity, 88
 lenses, cleaning, 86
 lighting, 86, 99-101
 posed photos, 101-103
 preparedness, 86
 settings/subjects, evaluating, 86
 specks/dots on photos, 120-121
 stability, 87-88
 timing, 88
 zooming, 104-105
practicing, 86
preparedness, 86
shooting modes
 auto, 88-89
 choosing, 92
 continuous, 107
 existing lighting, 109
 image stabilization, 107
 landscape, 107
 macro, 107-108
 panoramic, 108
 portrait, 108
 sports/action, 109
stability, 87-88, 93
transferring photos to Mac, 41-45
 deleting photos from memory cards, 44
 ejecting, 44
 USB cables, 43-44
 wirelessly, 45

white balance, 113
zooming, 104-105
Digital Photo Magazine website, 302
digital photography
 benefits, 9
 online service websites, 303-304
 specialized photography websites, 304-305
 websites
 Digital Camera Resource Page, 302
 Digital Camera Tracker, 302
 Digital Photo Magazine, 302
 Digital Photography Review, 302
 Digital PhotoPro, 302
 Picture Correct, 302
 Popular Photography, 302
Digital Photography Review website, 302
Digital PhotoPro website, 302
disaster recovery
 memory card malfunctions, 300
 system crashes, 299-300
dots on photos, fixing, 120-121
duplicating photos, 124
 keyboard shortcut, 307
 names, 124
DVDs
 archiving photos, 296
 burning photos to
 Burn command, 291-292
 iDVD, 290-291
 readable from any computer, 292-293
 importing photos from, 48

E

Edge Blur effect
 aged appearance, creating, 153-154
 applying, 158-159
Edit Photo command, 125
Edit screen, 125-126
Edit window, 130
 Adjust tab, 162-163
 effects, viewing, 146-147
 opening, 145

editing
See also fixing
advanced, 20
 Adjust window, 162-163
 contrast, 168-169
 Definition, 169
 de-noising, 171
 exposure, fixing, 168
 highlights, 170
 saturation, 169
 shadows, 170
 sharpness, 170
 sliders, 167
 temperature/tint, 171-173
 tonal ranges. See tonal ranges
 underexposure, fixing, 167-168
 undoing, 173
albums, 76
clarity
 De-Noise sliders, 171
 Highlights slider, 170
descriptions, 56-57
duplicate copies, 124
Edit screen, 125-126
Edit window, 130
effects
 aged appearance, 153-155
 black and white, 152-153
 boosting colors, 158
 coloring, 149-151
 contrast, 149
 deleting, 160
 edges, blurring, 158-159
 fading colors, 158
 lightening/darkening, 147-149
 mattes, 156
 viewing, 146-147
event names, 56
Export window, 191
filenames, 56
Filmstrip view, 126
full-screen mode, 126-127
greeting cards, 233-236
keyboard shortcut, 308
overview, 123-124
new features, 39-40
photo book pages, 226-228
photo editing software, 144

Quick Fixes, 19-20, 131
 accessing, 131-132
 cropping, 136-141
 enhancing, 132-133
 red-eye, 133-134
 retouching, 142-143
 rotating, 132
 straightening, 134-137
red-eye removal, 308
reverting to original, 124
selecting images, 145
slideshow themes, 265-266
while previewing, 208-209
zooming, 127-130
effects, 21
coloring, 149-151
 saturate, 151
 warmer/cooler, 150
contrast, 149
lightening/darkening, 147-149
photo books, adding, 230
special, 151-152
 adding, 152
 aged appearance, 153-154
 antique, 154-155
 black and white, 152-153
 deleting, 160
 edges, blurring, 158-159
 fading/boosting colors, 158
 mattes, 156
viewing, 146-147
ejecting cameras, 44
email
importing photos from, 48-50
MobileMe online photo galleries, 274, 277
sending photos, 35-36, 243
 attaching photos, 246
 editing text, 245
 entering text, 243
 example process, 247
 file size, 246
 photo selection, 243
 previewing, 246
 Send icon, 246
 templates, 244-245
 themes, 245
 To/Subject/From fields, 243

emptying Trash, 83, 307

enhancing photos, 21
 See also effects
 new features, 39-40
 Quick Fixes, 132-133

events
 albums, compared, 75
 arranging, 15
 creating, 62
 exporting, 179-180
 key photos, 63
 merging, 62
 names, 56, 61
 photo organization, 14-15
 same photo in multiple event
 folders, 61
 selecting, 307
 splitting, 63
 transferring photos between, 63
 viewing, 61

existing lighting shooting mode, 109

Export command, 176

Export window
 albums, 179-180
 editing, 191
 events, 179-180
 Export to QuickTime option, 184-186
 Export to Web Page option, 180-183
 multiple photos, 192-193
 overview, 176-177
 single photos, 177-178
 slideshows, 186-187
 third-party plug-ins, 191-192

Export Your Slideshow window, 268

exporting
 albums, 179-180
 events, 179-180
 Export window
 editing, 191
 overview, 176-177
 files
 formats, choosing, 188
 size, choosing, 189
 names, 190-191
 keyboard shortcut, 306

mobile devices, 284-287
 connecting devices to iTunes, 284
 sync preferences, 287
 syncing with iTunes, 284-286
multiple photos, 192-193
online photo labs, 216-217
quality, selecting, 189
to QuickTime, 184-186
single photos, 177-178
slideshows, 186-187, 259, 268-269
third-party
 photo product companies, 240
 plug-ins, 191-192
to web pages, 180-183

exposure
 fixing with Adjust sliders, 168
 lightening/darkening, 147-149

eye-dropper tool, 172-173

Eye-Fi, 18, 45

F

Facebook, 250-256
 account access, 254-255
 compatibility, 34-35
 Facebook view, 254-255
 photos
 adding to albums, 253
 adding to Wall, 253
 comments, viewing, 255-256
 tags, 250-251, 255-256
 thumbnails, viewing, 255
 upload location, choosing, 252
 uploading, 251-254
 privacy settings, 251

Faces (face-recognition)
 accuracy, 69
 faces
 tags, adding, 69-71
 viewing, 67-68
 misidentifications, 69
 photo organization, 15, 67

Fade effect, 158

File menu commands
 Export, 176
 Import from Scanner, 53
 Import to Library, 46-48
 Order Prints, 211
 Print, 199
files
 email sizes, 246
 exporting
 formats, 188
 size, 189
 slideshow formats, 269
 names
 editing, 56
 exporting, 190-191
 photo organization, 14
 viewing, 64
Filmstrip preview, 32-33, 126
fixing
 blurriness, 109-110, 170
 camera autofocusing mistakes,
 110-112
 clarity
 De-Noise sliders, 171
 Highlights slider, 170
 color problems, 112-115
 Levels histogram, 163-166
 printing, 113
 screen calibration, 114
 white balance, 113
 exposure, 168
 glares/shadows, 115-116
 red-eye, 118-120
 automatically, 133-134
 manually, 133-134
 shooting through glass, 116-118
 specks/dots on photos, 120-121
 temperature/tint
 eye-dropper tool, 172-173
 Temperature/Tint sliders, 171-172
 tonal ranges, 164-165
 underexposure, 167-168
flagging photos, 16-17
 events, creating, 62
 keyboard shortcut, 307
 recent, viewing, 81-82

Flickr, 247-250
 accounts, 247
 archiving photos, 298
 photo upload sizes, 249
 Photostreams, 250
 restricting access, 248
 sets, creating, 249-248
 uploading files, 248
 viewing mode, 249-250
 website, 303
folders
 creating, 306
 moving to Trash, 307
 selecting, 307
FotoFlot, 239, 304
FotoMagico 3, 269
FujiFilm website, 303
Full Screen command, 126
full size photos, viewing, 65
full-screen mode, 30-34
 benefits, 32
 editing photos, 126-127
 Filmstrip preview, 32-33
 multitasking, 32-33
 new main screen, 30-31
 opening/closing, 306
 slideshows, 259
 switching between applications, 34

G

Genius Bar website, 299
geographic locations, 71-74
 adding, 57
 geo-tags
 manually adding, 73, 74
 overview, 17-18
 wireless, 18
 Map viewing mode, 71-73
 sorting photos by location, 73-74
 viewing, 74
geo-tags
 manually adding, 73, 74
 overview, 17-18
 sorting photos by location, 73-74
 viewing, 74
 wireless memory cards, 18

glares, reducing, 99-100, 115-116

Google's Picasa website, 303

Gorillapod, 110

greeting cards, 232-236
 Cards Direct, 239
 color schemes, 232
 creating, 38-39, 232
 editing, 233-236
 envelopes, 236
 layouts, 233
 Letterpress Cards, 232
 message idea websites, 236
 ordering process, 236
 photos
 editing, 236
 placing, 234
 previewing, 233
 quantity discounts, 233
 templates, choosing, 232
 text, 234

H

hard-copy photos, importing, 53-54

help
 See also troubleshooting
 keyboard shortcut, 308
 memory card malfunctions, 300
 system crashes, 299-300

hiding
 iPhoto, 308
 photos, 309

high gloss photo paper, 198

highlights, 170

Holiday Mobile theme, 264

home photo printers, 22, 196
 borders, 201
 contact sheets, 202-203
 costs, 196-197
 functions, 196
 ink cartridges
 costs, 197
 preserving, 199
 manufacturers, 196
 multiphoto collages, 207-208

paper choices, 197-199
 finish types, 198
 manufacturer brand paper, 199
 quality, 198
photo sizes, 196
print jobs, customizing, 203-204
Print Settings window, 200
 Adjust icon, 208-209
 Background icon, 204
 Borders icon, 205-206
 closing, 202
 Customize icon, 203
 Layout icon, 205-207
 Paper Size menu, 201
 Presets menu, 201
 Print Settings icon, 203
 Print Size menu, 201
 Printer menu, 201
 Settings icon, 208-209
 themes, 200-201
 Themes icon, 204-205
printing photos, 199

HTML (Hypertext Markup Language), 180

Huey Pro, 114

I

iDVD, 290-291
 DVD presentations
 editing, 290-291
 photo selection, 290
 playing, 291
 previewing, 291
 website, 290

iLife, 8

image stabilization shooting mode, 107

Import from Scanner command, 53

Import to Library command, 46-48

importing photos
 CDs/DVDs, 48
 cell phones/Smartphones, 52
 digital cameras, 41-45
 deleting photos from memory
 cards, 44
 ejecting, 44
 USB cables, 43-44
 wirelessly, 45

email, 48-50
flash drives, 46-48
hard drives, 46-48
hard-copy photos, 53-54
iPhone/iPad, 51-52
keyboard shortcut, 306
memory card readers, 45-46
MobileMe, 52-53
Web, 54-55
improvements, 30-31
Info Window, 306
ink cartridges
costs, 197
preserving, 199
interface, 30
iPad/iPhone
integration, 51-52
transferring photos to, 284-287
connecting devices to iTunes, 284
sync preferences, 287
syncing with iTunes, 284-286
iPhoto
compatibility, 26
hiding, 308
improvements, 30-31
interface, 30
new features
editing photos, 39-40
emailing photos, 35-36
enhancing photos, 39-40
full-screen mode, 30-34
greeting cards, 38-39
main screen, 30-31
photo books, 37
professional-quality slideshows, 36
sharing photos on Facebook, 34-35
quitting, 309
upgrading, 28
photo library, 29-30
purchasing options, 29
iWeb, 279-282
exporting to MobileMe, 282
pages, customizing, 280
photo selection, 279
publish locations, choosing, 282
templates, 280
URLs, 281

J

journal email template, 244
JPEG file format, 188

K

Ken Burns theme, 261
key photos, 63
keyboard shortcuts
albums
creating, 306
moving to trash, 307
selecting, 307
events, selecting, 307
folders
creating, 306
moving to Trash, 307
selecting, 307
full-screen mode, opening/closing, 306
help, 308
hiding iPhoto, 308
Info Window, opening, 306
keywords, 309
listing of commonly used, 306-309
photos
copying, 307
cutting, 307
deleting star ratings, 308
duplicating, 307
editing, 308
exporting, 306
flagging/unflagging, 307
hiding/showing, 309
importing, 306
moving to Trash, 307
pasting, 307
rating, 308
rotating, 307
selecting, 307
selecting all, 308
preferences, viewing, 309
print, 308
quitting iPhoto, 309
red-eye removal, 308

slideshows
 manually moving through, 308
 pausing, 308
 stopping, 308
 thumbnails
 selecting, 307
 sizing, 307
 Trash, emptying, 307
 undo, 309
keywords
 adding, 57
 keyboard shortcut, 309
Kodak Gallery website, 303
Kodak website, 303

L

landscape shooting mode, 107
Last 12 Months, viewing, 80
last import, viewing, 80
Layout icon, 205-207
layouts
 greeting cards, 233
 photo books, 226-230
 adding pages, 230
 autoflow pages, 228
 borders, adding to photos, 230
 clearing placed photos, 228
 deleting pages, 230
 editing, 226-228
 effects, adding to photos, 230
 minimum number of pages, 230
 page-by-page thumbnail view, 226
 pages, viewing, 226
 placing photos on pages, 228
 templates, choosing, 227-229
 thumbnails, viewing, 228
 viewing placed photos, 228
 print, 205-207
lenses, cleaning, 86, 120-121
Letterpress
 cards, 38-39, 232
 email template, 245
Levels histogram, 163-166
 Apple tutorial, 165
 example, 165-166

tonal ranges
 adjusting, 164-165
 reading, 164
 viewing, 164
library
 Source list, 61
 upgrading, 29-30
lightening, 147-149
lighting
 brightening, 170
 diffusers, 115-116
 glares, reducing, 99-100, 115-116
 impact on photos, 99-100
 picture-taking skills, improving, 86
 reflections, reducing, 99-100
 reflectors, 115
 shadows, reducing, 115-116
 subjects, positioning, 101
Lumix website, 303
luster photo paper, 198

M

macro shooting mode, 107-108
main screen, 30-31
manufacturers
 digital cameras, 303
 home photo printers, 196
 printer paper, 199
Map viewing mode, 71-73
Matte effect, 156
matte photo paper, 198
memory cards
 geo-tagging, 18
 malfunctions, troubleshooting, 300
 memory card readers, 45-46
 photos, deleting, 44
 read/write speeds, 91
 wireless, 45
merging events, 62
Miller's Professional Imaging website, 305
mobile devices, transferring photos
 to, 284-287
 connecting devices to iTunes, 284
 sync preferences, 287
 syncing with iTunes, 284-286

MobileMe
 archiving photos, 298
 importing photos from, 52-53
 iWeb imports, 282
 membership, 270
 online home page, accessing, 275
 online photo galleries, 271-272
 accessing from iPhoto, 275
 backgrounds, 277
 benefits, 272
 Carousel view, 276
 central Gallery Page options, 274
 creating, 277-278
 default Grid view, 276
 downloading photos, 277
 email options, 274
 names, 273
 photo filenames, viewing, 274
 privacy settings, 272, 274
 sharing process, 272
 storage space, 272
 subscribing, 277
 *transferring photos to iPhoto
 albums, 277*
 upload screen, 275
 uploading photos, 273, 277
 URLs, emailing, 277
 viewing, 271
 overview, 271
 website, 270
movies, creating, 185-186
MPIX website, 303
multiphoto collages
 printing, 207-208
 slideshows, 264-262
multiple photos, exporting, 192-193
multitasking, 32-33
music (slideshows), 259, 266-267

N

names
 CDs/DVDs, 292
 duplicate photos, 124
 events, 56, 61
filenames
 editing, 56
 exporting, 190-191
 organization, 14
 viewing, 64
 online photo galleries (MobileMe), 273
 Smart Albums, 78
Navigation window, 127
new features
 editing photos, 39-40
 enhancing photos, 39-40
 full-screen mode, 30-34
 greeting cards, 38-39
 main screen, 30-31
 photo books, 37
 professional-quality slideshows, 36
 sharing photos
 email, 35-36
 Facebook, 34-35
Nextag.com, 197
Nikon website, 303
None effect, 160

O

Olympus website, 303
one-hour photo labs
 photo products, 240
 prints, 217-218
online photo galleries (MobileMe),
 271-272
 accessing from iPhoto, 275
 backgrounds, 277
 benefits, 272
 Carousel view, 276
 central Gallery Page options, 274
 creating, 277-278
 default Grid view, 276
 email options, 274
 names, 273
 photos
 downloading, 277
 filenames, viewing, 274
 transferring to iPhoto albums, 277
 uploading, 273, 277

privacy settings, 272, 274
sharing process, 272
storage space, 272
subscribing, 277
upload screen, 275
URLs, emailing, 277
viewing, 271
online photo labs
archiving photos, 296-297
ordering prints, 216-217
photo product companies, 239-240
CafePress, 239
exporting photos, 240
greeting cards, 239
plastic sheet enlargements, 239
posters, 240
wall decals, 240
slideshows, creating, 269
websites, 303-304
Order Prints command, 211
Order Prints screen (Apple), 212
ordering
calendars, 238
greeting cards, 236
photo books, 230-231
ordering prints
Apple, 211-215
Apple ID accounts, 216
buying, 213
checking out, 214
costs, 213
finalizing orders, 214
order confirmation, 214
Order Prints screen, 212
print products website, 215
process overview, 215
Quick Order field, 213
standard finishes, 214
Your Order screen, 213
one-hour photo labs, 217-218
online photo labs, 216-217
professional photo labs, 22-23, 218-219
organization, 13-18
albums, 14-15
adding photos, 75-77
arranging photos, 76
benefits, 75
creating, 75-76

deleting, 77
editing photos, 76
events, compared, 75
MobileMe photos, transferring, 277
Smart Albums, 77-80
viewing, 75
viewing photos, 76
events, 14-15
albums, compared, 75
creating, 62
key photos, 63
merging, 62
names, 56, 61
same photo in multiple event
folders, 61
splitting, 63
transferring photos between, 63
viewing, 61
Faces (face-recognition), 15
accuracy, 69
face tags, adding, 69-71
faces, viewing, 67-68
misidentifications, 69
photo organization, 67
filenames, 14
flagging/tagging/rating, 16-17
Places, 71-74
adding, 57
geo-tagging, 17-18, 73, 74
Map viewing mode, 71-73
sorting photos by location, 73-74
viewing, 74
Origami theme, 262

P

Panasonic, 303
panoramic shooting mode, 108
Pantone Huey Pro, 114
paper (printer), choosing, 197-199
finish types, 198
manufacturer brand paper, 199
quality, 198
Paper Size menu (Print Settings
window), 201
pasting, 307
pausing slideshows, 308

Pentax website, 303

Photo Book Creation screen, 224

photo books
BookSmart software, 26
borders, adding to photos, 230
costs, 223
creating, 25-26, 37, 222-223
effects, adding to photos, 230
example, creating, 231
layouts, 226-230
autoflow pages, 228
clearing placed photos, 228
editing, 226-228
page-by-page thumbnail view, 226
pages, viewing, 226
placing photos on pages, 228
templates, choosing, 227-229
viewing placed photos, 228
minimum number of pages, 230
ordering, 230-231
pages
adding, 230
deleting, 230
themes, 223-225
thumbnails, viewing, 228
viewing in Source list, 231

photo composition, 91
camera stability, 93
depth, adding, 97-98
multiple shots, 92
Rule of Thirds, 93-97
shooting modes, choosing, 92
subjects
choosing, 91
creativity, 92
framing, 92
prefocusing, 96

Photo Mobile theme, 263

photo product companies. *See* online
photo labs

Photobucket website, 303

photos
archiving, 24-25
CDs/DVDs, 296
MobileMe, 298
online photo labs, 296-297

remote data backup services, 298-299
solutions, choosing, 299
Time Machine, 295-296
brightening, 170
clarity, fixing
De-Noise sliders, 171
Highlights slider, 170
copying, 307
cropping, 136-141
close-ups, creating, 136-138, 141
reframing, 138-139
resetting, 140
sizing images, 138-140
without constrains, 140
cutting, 307
deleting, 83
descriptions
adding, 17, 65
editing, 56-57
viewing, 64
duplicating, 124
keyboard shortcut, 307
names, 124
editing. *See* editing effects, 21
adding, 152
aged appearance, 153-154
antique, 154-155
black and white, 152-153
coloring, 149-151
contrast, 149
deleting, 160
edges, blurring, 158-159
fading/boosting colors, 158
lightening/darkening, 147-149
mattes, 156
viewing, 146-147
enhancing, 21
new features, 39-40
Quick Fixes, 132-133
exporting
albums, 179-180
events, 179-180
Export window, 176-177, 191
file formats, 188
file size, 189
filenames, 190-191
individually, 177-178

keyboard shortcut, 306
mobile devices, 284-287
multiple, 192-193
online photo labs, 216-217
quality, 189
to QuickTime, 184-186
slideshows, 186-187
third-party photo product
 companies, 240
third-party plug-ins, 191-192
to web pages, 180-183
flagging/unflagging, 16-17
events, creating, 62
keyboard shortcut, 307
recent, viewing, 81-82
hiding, 309
importing
CDs/DVDs, 48
cell phones/Smartphones, 52
digital cameras, 41-45
email, 48-50
flash drives, 46-48
hard drives, 46-48
hard-copy photos, 53-54
iPhone/iPad, 51-52
keyboard shortcut, 306
memory card readers, 45-46
MobileMe, 52-53
Web, 54-55
keywords, adding, 57
library
Source list, 61
upgrading, 29-30
lighting
brightening, 170
diffusers, 115-116
glares, reducing, 99-100, 115-116
impact on photos, 99-100
picture-taking skills, improving, 86
reflections, reducing, 99-100
reflectors, 115
shadows, reducing, 115-116
subjects, positioning, 101
moving to Trash, 307
organizing. See organization
pasting, 307
printing. See printing
ratings, 16, 17
adding, 56

deleting, 308
keyboard shortcuts, 308
photo organization, 16
viewing, 64
retouching, 142-143
rotating, 132, 307
searching, 18-19
selecting, 307, 308
sharing. See sharing photos
straightening, 134-137
tagging, 16-17
adding, 16-17, 57-58
face tags, adding, 69-71
Facebook, 250-251, 255-256
geo-tags. See geo-tags
viewing, 10-13
all as thumbnails, 66-67
detailed information, 13
keyboard shortcut, 309
one at a time, 11
Photos mode, 63-66
slideshows. See slideshows
thumbnails, 10-11
as wallpaper, 26
web photos
accessing, 82
copyright laws, 55
importing, 54-55

Photos command icon, 234

Photos menu commands
Edit Photo, 125
Revert to Original, 124

Photos mode, 63-66
all photos, viewing, 66-67
descriptions, 64
full size photos, 65
Info screen, 65-66

Photostreams, 250

Picasa website, 303

Picture Correct website, 302

picture-taking skills, improving, 85-88
angles, choosing, 87
auto shooting modes, 88-89
choosing, 90
shutter lag, 90-91
camera practice, 86
candid photos, 103

common shooting mistakes, 109
 *autofocusing on wrong objects,
 110-112*
 blurry images, 109-110
 color problems, 112-115
 glares/shadows, 115-116
 red-eye, 118-120
 shooting through glass, 116-118
creativity, 88
lenses, cleaning, 86
lighting, 86, 99-100
 glares/reflections, reducing, 99-100
 subjects, positioning, 101
photo composition, 91
 camera stability, 93
 choosing subjects, 91
 creativity, 92
 depth, adding, 97-98
 framing subjects, 92
 multiple shots, 92
 prefocusing on subjects, 96
 Rule of Thirds, 93-96-97
 shooting modes, choosing, 92
posed photos, 101-103
preparedness, 86
settings/subjects, evaluating, 86
shooting modes
 continuous, 107
 existing lighting, 109
 image stabilization, 107
 landscape, 107
 macro, 107-108
 panoramic, 108
 portrait, 108
 sports/action, 109
specks/dots on photos, 120-121
stability, 87-88
timing, 88
zooming, 104-105
Places, 71-74
 adding, 57
 geo-tags
 manually adding, 73, 74
 overview, 17-18
 sorting photos by location, 73-74
 viewing, 74
 wireless, 18
 Map viewing mode, 71-73
 sorting photos by location, 73-74
 viewing, 74

Places theme, 264
planning photos
 candid photos, 103
 posed photos, 101-103
playing
 iDVD presentations, 291
 slideshows, 259
PNG file format, 188
Polaroid website, 303
Popular Photography website, 302
Portrait Professional 10, 144
portrait shooting mode, 108
posed photos, 101-103
postcard email template, 245
posters, 240
preferences, 309
prefocusing on subjects, 96
Presets menu (Print Settings window), 201
previewing
 email templates, 246
 greeting cards, 233
 iDVD presentations, 291
 printing, 205
 slideshows, 259
Print command, 199
Print command icons
 Adjust, 208-209
 Background, 204
 Borders, 205-206
 Layout, 205-207
 Print Settings, 203
 Settings, 208-209
 Themes, 204-205
Print Settings icon, 203
Print Settings window, 200-201
 closing, 202
 Customize icon, 203
 menus
 Paper Size, 201
 Presets, 201
 Print Size, 201
 Printer, 201
 Print command icons
 Adjust, 208-209
 Background, 204

Borders, 205-206
Layout, 205-207
Print Settings, 203
Settings, 208-209
Themes, 204-205
themes, 200-201
Print Size menu (Print Settings
window), 201
Printer menu (Print Settings window), 201
printing, 22-23
 autoflow pages, 210
 backgrounds, 204
 borders, 201, 205-206
 color problems, fixing, 113
 contact sheets, 202-203
 crop marks, viewing, 209
 customizing, 203-204
 editing while previewing, 208-209
 home photo printers, 22, 196
 costs, 196-197
 functions, 196
 ink cartridges, 197, 199
 manufacturers, 196
 paper choices, 197-199
 photo sizes, 196
 keyboard shortcut, 308
 layouts, 205-207
 multiphoto collages, 207-208
 one-hour photo labs, 217-218
 ordering from Apple, 211-215
 Apple ID accounts, 216
 buying, 213
 checking out, 214
 costs, 213
 finalizing orders, 214
 order confirmation, 214
 Order Prints screen, 212
 print products website, 215
 process overview, 215
 Quick Order field, 213
 standard finishes, 214
 Your Order screen, 213
 ordering from online photo labs,
 216-217, 303-304
 ordering from professional photo labs,
 22-23, 218-219
 photo books, 26
 photos per page, 209

previewing, 205
Print command, 199
print settings, 203
Print Settings window, 200
 closing, 202
 Customize icon, 203
 Paper Size menu, 201
 Presets menu, 201
 Print Size menu, 201
 Printer menu, 201
 themes, 200-201
 recent, viewing, 82
 settings, 208-209
 themes, 204-205
professional photo labs
 photo products, 240
 prints, 22-23, 218-219
projects
 calendars, 236-239
 costs, 236
 creating, 238-239
 holidays, 237
 importing events from iCal, 237
 ordering process, 238
 photo selection, 237
 placing photos, 238
 templates, 237
 creating, 25, 221-222
 deleting, 82
 edited-photos, 222
 greeting cards, 232-236
 Cards Direct, 239
 color schemes, 232
 creating, 38-39, 232
 editing, 233-236
 editing photos, 236
 envelopes, 236
 layouts, 233
 Letterpress Cards, 232
 message idea websites, 236
 ordering process, 236
 placing photos, 234
 previewing, 233
 quantity discounts, 233
 templates, choosing, 232
 text, 234
 multiphoto collages, printing, 207-208
 one-hour photo labs, 240

photo books
 adding pages, 230
 autoflow pages, 228
 borders, adding to photos, 230
 clearing placed photos, 228
 costs, 223
 creating, 25-26, 37, 222-223
 deleting pages, 230
 effects, adding to photos, 230
 example, creating, 231
 layouts, 226-230
 minimum number of pages, 230
 ordering, 230-231
 placing photos on pages, 228
 themes, 223-225
 thumbnails, viewing, 228
 viewing in Source list, 231
 viewing placed photos, 228
QuickTime movies, creating, 185-186
third-party companies, 239-240
 CafePress, 239
 exporting photos, 240
 greeting cards, 239
 plastic sheet enlargements, 239
 posters, 240
 wall decals, 240
updates, 221
viewing, 222
publishing photos
Facebook, 250-256
 account access, 254-255
 albums, 253
 comments/tags, viewing, 255-256
 Facebook view, 254-255
 privacy settings, 251
 tags, 250-251
 thumbnails, viewing, 255
 upload location, choosing, 252
 uploading photos, 251-254
 Wall, 253
Flickr, 247-250
 accounts, 247
 archiving photos, 298
 photo upload sizes, 249
 Photostreams, 250
 restricting access, 248
 sets, creating, 249-248
 uploading files, 248
 viewing mode, 249-250

Web photo pages/blogs, 279-282
 customizing, 280
 exporting to MobileMe, 282
 locations, choosing, 282
 photo selection, 279
 templates, 280
 URLs, 281
Puffer Pop-up Flash Diffusers, 116
purchasing options, 29

Q

Quick Fixes, 19-20, 131
 accessing, 131-132
 cropping, 136-141
 close-ups, creating, 136-138, 141
 reframing, 138-139
 resetting, 140
 sizing images, 138-140
 without constrains, 140
 enhancing, 132-133
 red-eye, 133-134
 retouching, 142-143
 rotating, 132
 straightening, 134-137
Quick Order field (Apple), 213
QuickTime
 Export window, 185-184
 exporting photos to, 184
 movies, creating, 185-186
quitting iPhoto, 309

R

ratings, 16, 17
 adding, 56-57
 deleting, 308
 keyboard shortcuts, 308
 photo organization, 16
 viewing, 64
Recent heading, 80-82
 Flagged, 81-82
 Last 12 Months, 80
 Last Import, 80
 Printing, 82
 Trash, 82

recovering from crashes, 299-300

red-eye, fixing, 118-120
 automatically, 133-134
 keyboard shortcut, 308
 manually, 133-134

reflections, reducing, 99-100

Reflections theme, 262

reflectors, 115

reframing images, 138-139

remote data backup services, 298-299

retouching, 142-143

Revert to Original command, 124

RitzPix website, 303

rotating photos, 132, 307

Rule of Thirds, 93-97

S

Samsung website, 303

saturation
 Saturation slider, 169
 Saturation sphere, 151
 skin tones, 169

scanning hard-copy photos, 53-54

Scrapbook theme, 263

screen calibration, 114

screen savers, creating, 282-284

searching photos, 18-19

selecting
 albums, 307
 events, 307
 folders, 307
 photos
 all, 308
 calendars, 237
 editing, 145
 email, 243
 iDVD presentations, 290
 iWeb, 279
 keyboard shortcut, 307
 slideshows, 258-260
 shooting angles, 87
 shooting modes, 92
 thumbnails, 307

semi-gloss photo paper, 198

Sepia effect, 153-154

sequential filenaming, 190-191

Settings command icon, 208-209

Settings window, 209

shadows
 reducing, 115-116
 Shadows slider, 170

sharing photos, 23-24
 email, 35-36, 243
 attaching photos, 246
 editing text, 245
 entering text, 243
 example process, 247
 file size, 246
 photo selection, 243
 previewing, 246
 sending, 246
 templates, 244-245
 themes, 245
 To/Subject/From fields, 243
 Facebook, 34-35, 250-256
 account access, 254-255
 albums, 253
 comments/tags, viewing, 255-256
 Facebook view, 254-255
 privacy settings, 251
 tags, 250-251
 thumbnails, viewing, 255
 upload location, choosing, 252
 uploading photos, 251-254
 Wall, 253
 Flickr, 247-250
 accounts, 247
 archiving photos, 298
 photo upload sizes, 249
 Photostreams, 250
 restricting access, 248
 sets, creating, 249-248
 uploading files, 248
 viewing mode, 249-250
 MobileMe
 archiving photos, 298
 iWeb imports, 282
 membership, 270
 online home page, accessing, 275
 online photo galleries. See online
 photo galleries

overview, 271
website, 270
slideshows, 268-269
Web photo pages/blogs, 279-282
customizing, 280
exporting to MobileMe, 282
locations, choosing, 282
photo selection, 279
templates, 280
URLs, 281
websites, 242
Sharpness slider
blurriness, adjusting, 170
clarity, fixing, 171
Shatter theme, 264
shooting
angles, selecting, 87
auto shooting modes, 88-89
choosing, 90
shutter lag, 90-91
camera practice, 86
candid photos, 103
common mistakes, 109
autofocusing on wrong objects,
110-112
blurry images, 109-110
color problems, 112-115
glares/shadows, 115-116
red-eye, 118-120
shooting through glass, 116-118
creativity, 88
lenses, cleaning, 86
lighting, 86, 99-100
glares/reflections, reducing, 99-100
subjects, positioning, 101
modes
continuous, 107
existing lighting, 109
image stabilization, 107
landscape, 107
macro, 107-108
panoramic, 108
portrait, 108
selecting, 92
sports/action, 109
photo composition, 91
camera stability, 93
choosing subjects, 91
creativity, 92

depth, adding, 97-98
framing subjects, 92
multiple shots, 92
prefocusing on subjects, 96
Rule of Thirds, 93-97
shooting modes, choosing, 92
posed photos, 101-103
preparedness, 86
settings/subjects, evaluating, 86
specks/dots on photos, 120-121
stability, 87-88
timing, 88
zooming, 104-105
Short Run Posters, 240, 305
shortcuts (keyboard)
albums
creating, 306
moving to trash, 307
selecting, 307
events, selecting, 307
folders
creating, 306
moving to Trash, 307
selecting, 307
full-screen mode, opening/closing, 306
help, 308
hiding iPhoto, 308
Info Window, opening, 306
keywords, 309
listing of commonly used, 306-309
photos
copying, 307
cutting, 307
deleting star ratings, 308
duplicating, 307
editing, 308
exporting, 306
flagging/unflagging, 307
hiding/showing, 309
importing, 306
moving to Trash, 307
pasting, 307
rating, 308
rotating, 307
selecting, 307
selecting all, 308
preferences, viewing, 309
print, 308
quitting iPhoto, 309

red-eye removal, 308
slideshows
 manually moving through, 308
 pausing, 308
 stopping, 308
thumbnails
 selecting, 307
 sizing, 307
Trash, emptying, 307
undo, 309
shutter lag, 90-91
Shutterfly website, 303
Sigma website, 303
single photos, exporting, 177-178
sizing
 cropping, 138-140
 email files, 246
 export files, 189
 Flickr photo uploads, 249
 thumbnails, 11, 307
skin tone saturation, 169
Slide.com, 269
slideshows, 257
 creating, 258-260
 display order, 259
 duration, 258
 Export window, 186-187
 exporting, 186-187, 259, 268-269
 full-screen mode, 259
 manually moving through, 308
 multiphoto collages, 264-262
 music, 259, 266-267
 new features, 36
 number of photos, 257
 online photo labs, creating, 269
 pausing, 308
 photo selection, 258-260
 playing, 259
 previewing, 259
 Production screen, 258-259
 settings, 259
 sharing, 268-269
 Slideshow Production screen, 258-259
 stopping, 308
 text, adding, 259, 260-261
 themes, 259, 261-264
 Classic, 264

 editing, 265-266
 Holiday Mobile, 264
 Ken Burns, 261
 Origami, 262
 Photo Mobile, 263
 photo orientations, 264
 Places, 264
 Reflections, 262
 Scrapbook, 263
 Shatter, 264
 Sliding Panels, 263
 Snapshots, 263
 Vintage Prints, 262
 third-party software, creating, 269
 titles, 261, 268
 viewing, 11
 zooming, 259
Sliding Panels theme, 263
Smart Albums, 77-80
 conditions, setting, 78-79
 creating, 78-80
 names, 78
 viewing, 79
SmugMug website, 304
SnapFish website, 304
snapshots email template, 244
Snapshots theme, 263
Sony website, 303
Source list, 60-61
 Albums heading, 75
 Events heading, 61-63
 Faces option
 accuracy, 69
 misidentifications, 69
 photo organization, 15, 67
 tags, adding, 69-71
 viewing, 67-68
 library, 61
 Photos mode, 63-66
 all photos as thumbnails,
 viewing, 66-67
 descriptions, adding, 64
 full size photos, 65
 Info screen, 65-66
 Places option, 71-74
 projects, deleting, 82
 Recent heading, 80-82
 Web option, 82

special effects, 151-152
 adding, 152
 aged appearance
 antique effect, 154-155
 Sepia/Edge Blur effects, 153-154
 black and white, 152-153
 boosting colors, 158
 deleting, 160
 edges, blurring, 158-159
 fading colors, 158
 mattes, 156
specialized photography websites,
 304-305
specks on photos, fixing, 120-121
sports/action shooting mode, 109
stopping slideshows, 308
straightening photos, 134-137

T

tags
 adding, 16-17, 57-58
 face tags, adding, 69-71
 Facebook
 adding, 250-251
 viewing, 255-256
 geo-tags
 manually adding, 73-74
 overview, 17-18
 sorting photos by location, 73-74
 viewing, 74
 wireless memory cards, 18
Target Photo Center website, 304
Temperature slider, 171-172
templates
 calendars, 237
 email, 244-245
 greeting cards, 232
 iWeb, 280
 photo books, 227-229
text
 emailing photos
 adding, 243
 editing, 245
 greeting cards, 234
 slideshows, 259-261

themes
 email, 245
 photo books, 223-225
 printing, 200-201, 204-205
 slideshows, 259-264
 Classic, 264
 editing, 265-266
 Holiday Mobile, 264
 Ken Burns, 261
 Origami, 262
 Photo Mobile, 263
 photo orientations, 264
 Places, 264
 Reflections, 262
 Scrapbook, 263
 Shatter, 264
 Sliding Panels, 263
 Snapshots, 263
 Vintage Prints, 262
Themes icon, 204-205
third-party
 export plug-ins, 191-192
 photo product companies, 239-240
 archiving photos, 296-297
 CafePress, 239
 exporting photos, 240
 greeting cards, 239
 ordering prints, 216-217
 plastic sheet enlargements, 239
 posters, 240
 slideshows, creating, 269
 wall decals, 240
 websites, 303-304
thumbnails
 contact sheets, printing, 202-203
 Facebook photos, viewing, 255
 online photo galleries, 271
 photo book page-by-page view, 226
 selecting, 307
 sizing, 11, 307
 viewing, 10-11
 all photos as, 66-67
 full size, 65
 Photos mode, 63-66
 web page exports, 182
TIFF file format, 188
Time Capsule, 295
Time Machine, 295-296

Tint slider, 171-172

tonal ranges
 adjusting, 164-165
 example, 165-166
 reading, 164

Trash, 82
 albums, 307
 emptying, 83, 307
 folders, 307
 photos, 307
 viewing, 83

tripods, 110

troubleshooting
 color problems, 112-115
 Levels histogram, 163-166
 printing, 113
 screen calibration, 114
 white balance, 113
 common shooting mistakes, 109
 autofocusing on wrong objects,
 110-112
 blurry images, 109-110
 glares/shadows, 115-116
 red-eye, 118-120
 shooting through glass, 116-118
 specks/dots on photos, 120-121
 memory card malfunctions, 300
 system crashes, 299-300

U

underexposure, fixing, 167-168

undoing actions
 Adjust sliders, 173
 keyboard shortcut, 309

unflagging photos, 307

updating projects, 221

upgrading, 28
 photo library, 29-30
 purchasing options, 29

V

View menu commands, Full Screen, 126

viewing
 albums, 75
 all photos as thumbnails, 66-67
 crop marks while printing, 210
 descriptions, 64
 effects, 146-147
 events, 61
 Facebook view, 254-255
 filenames, 64
 Filmstrip preview, 32-33
 Flickr viewing mode, 249-250
 full size photos, 65
 full-screen mode, 30-34
 benefits, 32
 editing photos, 126-127
 Filmstrip preview, 32-33
 multitasking, 32-33
 new main screen, 30-31
 opening/closing, 306
 slideshows, 259
 switching between applications, 34
 Levels histogram, 164
 online photo galleries, 271
 photo books
 page-by-page thumbnails, 226
 pages, 226
 Source list, 231
 photos, 10-13
 detailed information, 13
 keyboard shortcut, 309
 one at a time, 11
 Photos mode, 63-66
 slideshows. See slideshows
 thumbnails, 10-11, 66-67
 Places, 74
 preferences, 309
 previewing
 email templates, 246
 greeting cards, 233
 iDVD presentations, 291
 printing, 205
 slideshows, 259

projects, 222
ratings, 64
recent activity
 flags, 81-82
 last 12 months, 80
 last import, 80
 printing, 82
 Trash, 82
slideshows, 11
Smart Albums, 79
thumbnails, 10-11
 Facebook, 255
 full size photos, viewing, 65
 Photos mode, 63-66
Trash, 83

Vignette effect, 156

Vintage Prints theme, 262

W

Walgreens Pharmacy Photo Lab
 website, 304

wall decals, 240

wallpaper photos, 26, 282-283

Wallzaz, 240

Walmart Photo Center website, 304

warmer color effect, 150

Web Page Export window, 181-183

web photo sharing
 Facebook, 34-35, 250-256
 account access, 254-255
 albums, 253
 comments/tags, viewing, 255-256
 Facebook view, 254-255
 privacy settings, 251
 tags, 250-251
 thumbnails, viewing, 255
 upload location, choosing, 252
 uploading photos, 251-254
 Wall, 253
 Flickr, 247-250
 accounts, 247
 archiving photos, 298
 photo upload sizes, 249
 Photostreams, 250
 restricting access, 248

sets, creating, 249-248
 uploading files, 248
 viewing mode, 249-250
 MobileMe
 archiving photos, 298
 iWeb imports, 282
 membership, 270
 online home page, accessing, 275
 online photo galleries. See online
 photo galleries
 overview, 271
 website, 270
 photo pages/blogs, 279-282
 customizing, 280
 exporting to MobileMe, 282
 locations, choosing, 282
 photo selection, 279
 templates, 280
 URLs, 281
 websites, 242

web photos
 accessing, 82
 copyright laws, 55
 importing, 54-55

websites
 Adobe photo-editing software, 144
 Adorama, 115
 Apple Care, 299
 Apple print products, 215
 Blurb, 304
 Burns, Ken, 261
 CafePress, 239
 Canon, 303
 CanvasOnDemand, 304
 Cards Direct, 239
 Casio, 303
 CVS Pharmacy Photo Lab, 303
 Datacolor, 114
 Delta Point and Shoot Diffusers, 116
 digital camera manufacturers, 303
 digital photography
 Digital Camera Resource Page, 302
 Digital Camera Tracker, 302
 Digital Photo Magazine, 302
 Digital Photography Review, 302
 Digital PhotoPro, 302
 Picture Correct, 302
 Popular Photography, 302

exporting photos to, 180-183
Eye-Fi, 18
FotoFlot, 239
FotoMagico 3, 269
FujiFilm, 303
Genius Bar, 299
Google's Picasa, 303
Gorillapod, 110
greeting card message ideas, 236
iDVD, 290
Kodak Gallery, 303
Kodak, 303
Levels histogram tutorial, 165
Lumix, 303
memory card data recovery
 programs, 300
Miller's Professional Imaging, 305
MobileMe, 270
MPIX, 303
Nextag.com, 197
Nikon, 303
Olympus, 303
Pantone Huey Pro, 114
Pentax, 303
photo services, 303-304
Photobucket, 303
Picasa, 303
Picture Correct, 302
PNG file format, 188
Polaroid, 303
Portrait Professional 10, 144
Puffer Pop-up Flash Diffusers, 116
RitzPix, 303
Samsung, 303
Short Run Posters, 240
Shutterfly, 303
Sigma, 303
Slide.com, 269
SmugMug, 304
SnapFish, 304
Sony, 303
specialized photography, 304-305
Target Photo Center, 304
Time Capsule, 295
Time Machine, 295
Walgreens Pharmacy Photo Lab, 304
Wallzaz, 240
Walmart Photo Center, 304
Westcott, 115

Westcott website, 115
white balance, 113
windows
 Adjust, 162-163, 208-209
 Edit, 130
 Adjust tab, 162-163
 effects, viewing, 146-147
 opening, 145
 Export
 albums, 179-180
 editing, 191
 events, 179-180
 Export to QuickTime option, 184-186
 Export to Web Page option, 180-183
 multiple photos, 192-193
 overview, 176-177
 single photos, 177-178
 slideshows, 186-187
 third-party plug-ins, 191-192
 Export Your Slideshow, 268
 Navigation, 127
 Print Settings, 200, 201
 Adjust, 208-209
 Background icon, 204
 Borders icon, 205-206
 closing, 202
 Customize icon, 203
 Layout icon, 205-207
 Paper Size menu, 201
 Presets menu, 201
 Print Settings icon, 203
 Printer menu, 201
 Settings icon, 208-209
 themes, 200-201
 Themes icon, 204-205
 QuickTime Export, 185-184
 Settings, 209
 Slideshow Export, 186-187
 Web Page Export, 181-183
wireless external hard drive, 295

Y - Z

Your Order screen (Apple), 213
zooming
 digital cameras, 104-105
 slideshows, 259
 while editing, 127-130